134

136

138

CHARLES RENNIE MACKINTOSH
AND THE ART OF THE FOUR

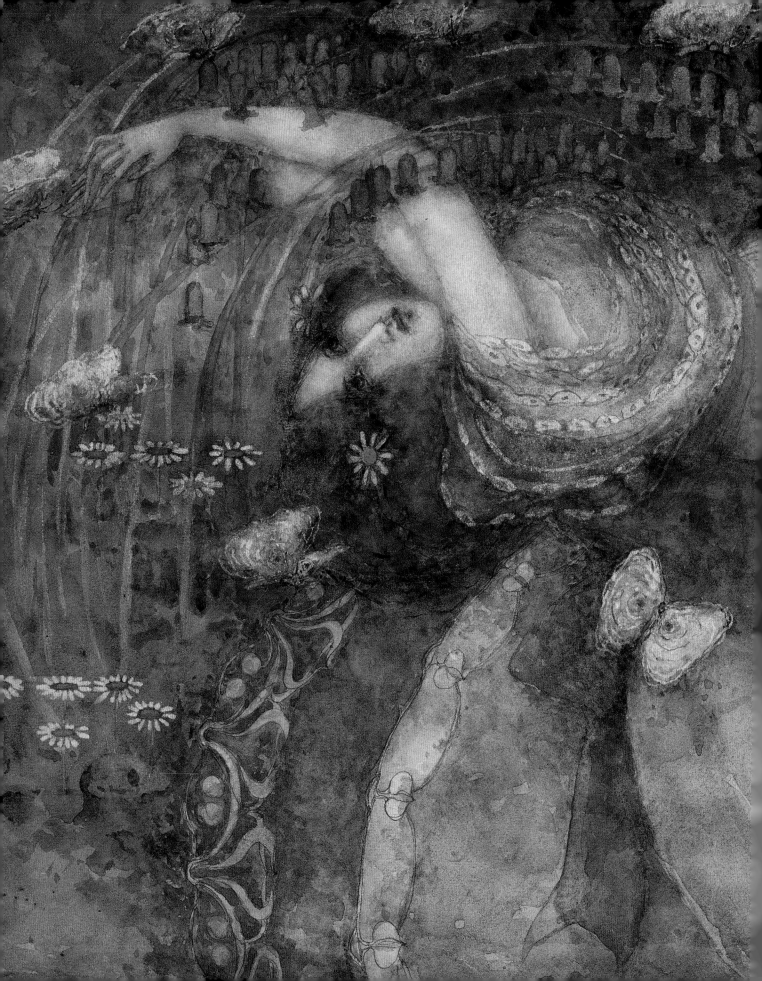

ROGER BILLCLIFFE

CHARLES RENNIE MACKINTOSH
AND THE ART OF THE FOUR

FRANCES
LINCOLN

For
Christine

Detail from 255. *Anemone and Pasque, Walberswick*
by Charles Rennie Mackintosh [*see* page 171]

ENDPAPERS
The Memorial Exhibition, Glasgow, 1933 (photographs by Annan)

PREVIOUS PAGE
Detail from 124. *Girl with Blue Butterflies* by Frances Macdonald
[*see* page 120]

Brimming with creative inspiration, how-to projects and useful
information to enrich your everyday life, Quarto.com is a favourite
destination for those pursuing their interests and passions.

First published in 2017.

This edition first published in 2022 by Frances Lincoln Publishing,
an imprint of The Quarto Group.
The Old Brewery, 6 Blundell Street, London N7 9BH, United Kingdom
www.Quarto.com

Charles Rennie Mackintosh and the Art of The Four
© 2017 Quarto Publishing plc
Text © 2017 Roger Billcliffe

A catalogue record for this book is available from the British Library.

ISBN 978-0-7112-7998-8

10 9 8 7 6 5 4 3 2 1

Designed by Anne Wilson

Printed and bound in China

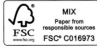

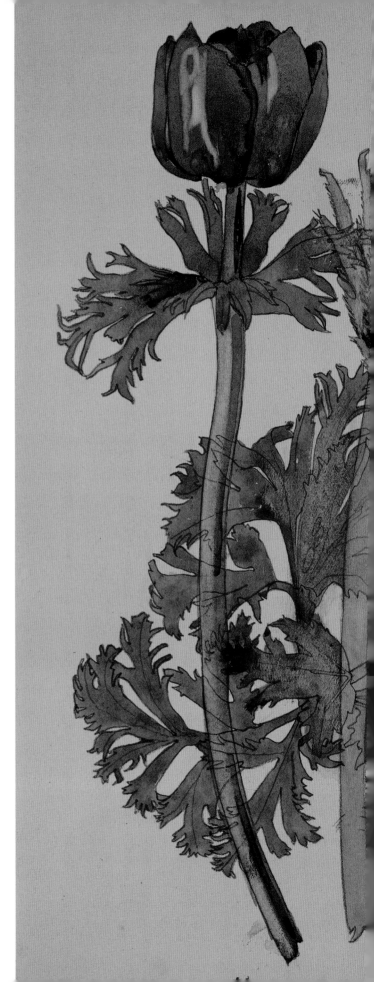

CONTENTS

PREFACE

PHILIP EADE's recent biography of Evelyn Waugh begins with the disclaimer that it is not a 'critical biography' seeking to reassess Waugh as a writer but aims to paint a fresh portrait of the man. This study is the exact opposite. Unlike Waugh – a man of many letters – useful biographical information about The Four is scant, at best, and has been well covered elsewhere, but a critical study of them as artists (although they were also much more than simply painters) has never been attempted. My focus, therefore, is on their work and the constantly changing relationships between the artists and their work within the group. I set out to establish a framework for such relationships, both chronological and critical, in an attempt to resolve the continuing questions about the sources and creators of the Glasgow Style and to put the work of the 1890s within the context of the much longer careers of each artist.

Over the last fifty years or so the origins and achievements of the Glasgow Style have become confused, partly because of the continuing (and mistaken) projection of Mackintosh as the 'leader' of the group – with the concomitant relegation of his friends to the role of 'followers' – and partly because certain assumptions and statements, often made many decades ago, have been given the status of 'evidence' in the absence of any serious critical challenge. In addition, our natural curiosity about the content of many of the early works has generated speculative studies which have put forward 'explanations' of varying credibility which are at variance with known facts and contemporary accounts from both critics and the artists themselves. Finally, several of the recent studies of the Glasgow Style have concentrated solely on the women, Margaret and Frances Macdonald, and, written from a determinedly feminist viewpoint, they have aggrandised their contributions at the expense of those of the men, Charles Rennie Mackintosh and J. Herbert MacNair. Their authors would contend that they were simply correcting a misogynistic bias that began in the 1930s and continued through to the early 1960s (and beyond to the present day if these authors are to be believed). I would agree that a historical bias was once prevalent and led to the creation of several of the 'evident truths' that formed the foundations of

many later studies; and that it was wrong. But I would also say that these authors lay themselves open to similar accusations because of their particular take on certain events and on the artistic achievements of the Macdonald sisters while ignoring those of Mackintosh and MacNair. Combined with a certain *ad hominem* antipathy towards contemporary commentators (literally, as it is not usually directed at female writers), such feminist art history has succeeded in, at the same time, both clearing the waters and muddying them.

Often, books and articles written about the Glasgow Style and its four principal artists trace a story line of rapid and spectacular development of their ideas and work in the 1890s, followed by a ten-year period of consolidation and international recognition up to 1910, and then a rapid decline in output and personal success leading to popular eclipse and early deaths in obscurity and relative poverty. It adds up to a romantic tale made plausible only by the refusal on the part of many writers to give the later works of these four artists proper attention. This study aims to show that, with the possible exception of Herbert MacNair, The Four carried on developing long after 1910 and that some of their most potent work as artists was arguably produced in a period of their lives that is all too often written off by many commentators.

In 1933 an exhibition opened in Glasgow which had a number of consequences for our understanding of the work of Charles Rennie Mackintosh and his friends in Glasgow in the 1890s. It was the first time that the term The Four was publicly used to link the Macdonald sisters, Herbert MacNair and Mackintosh; and the first time that the breadth of Mackintosh's output as a watercolourist was revealed to an audience outside his close friends and family. The exhibition was the Memorial Exhibition of the work of Charles Rennie Mackintosh and Margaret Macdonald Mackintosh (1). Mackintosh had died in December 1928 and his widow Margaret at the beginning of 1933. Their estates were inherited by their nephew, Sylvan MacNair, and were in the care of Margaret's executors in Glasgow. A close friend and

1. The Memorial Exhibition, Glasgow, 1933

patron of the Mackintoshes, William Davidson, decided to organise an exhibition in the McLellan Galleries to celebrate the two artists. He chose from the estate the items that were most suitable for exhibition, primarily finished and framed watercolours. As the exhibition's contents were to be for sale this selection had several effects – of raising money for the estate and reducing the size of the collection (which would be going into storage as the heir lived in Africa), as well as introducing the work to a wider audience.

Although the Memorial Exhibition was nominally devoted to two artists, the bulk of the work on show was by Mackintosh – unsurprising as he latterly produced far more paintings than did Margaret. A large proportion of the exhibition consisted of the first showing of the group of paintings Mackintosh had made in south-west France between 1923 and the middle of 1927, when he returned to London suffering from cancer of the tongue. The exhibition, however, by effectively excluding Frances Macdonald and MacNair inadvertently set a pattern for future exhibitions of the work of The Four as artists – they would usually be seen in groups of one, two, or occasionally three, but rarely as four artists until 1968 in an exhibition held in Edinburgh marking the centenary of Mackintosh's birth; and then in 1996, in an exhibition primarily devoted to the work of Mackintosh in the same McLellan Galleries in Glasgow. This pattern was repeated in books about Mackintosh from the 1930s onwards, first in the work of Nikolaus Pevsner and then in the major biography by Thomas Howarth published in 1952. Howarth devoted far more space to The Four than had Pevsner, but his principal subject was Mackintosh the architect, whom he treated, and lauded, separately from his friends and colleagues – Margaret and Frances Macdonald and Herbert MacNair.

The first major correction to these accounts was made in the 1968 exhibition arranged by Andrew McLaren Young for the Edinburgh Festival, shown subsequently in London, Darmstadt, Vienna and Zurich. Here, Margaret and Frances Macdonald's work was explored more thoroughly, alongside that of Mackintosh, and Mackintosh's later French watercolours were introduced to a new audience – the first time they had been seen in any number since 1933. MacNair, however, was represented only by a couple of pieces of metalwork and not by any of his watercolours (other than a poster he produced with the sisters). In 1978, for the first time, Mackintosh's watercolours were celebrated in their own right in an exhibition at Glasgow Art Gallery.[1] As a commemorative

exhibition, marking the fiftieth anniversary of his death, the emphasis was on Mackintosh which meant that the Macdonalds were represented by just a few examples of their work, and MacNair was not included at all. The catalogue, however, included a checklist of all Mackintosh's known watercolours and, for the first time, reproductions in colour of many of his paintings, particularly those made in France from 1923 to 1927. It revealed Mackintosh as an architect in whose creative life painting was crucially important.

Five years later the work of Margaret Macdonald was finally given the attention it deserved in the exhibition curated by Pamela Reekie (later Robertson), commemorating the fiftieth anniversary of Margaret's death.[2] This solo exhibition, with a checklist of all Margaret's known work, corrected any previous imbalance; Frances Macdonald, Herbert MacNair and Mackintosh were effectively excluded except where they had collaborated with Margaret. Throughout the 1970s and 1980s academic interest in the work of the Macdonald sisters had been growing. Much of it was driven by feminist art history where the gender of the artist was as important as the work produced, if not more so. Such studies certainly tackled the unjustified bias – either deliberate or incidental – towards Mackintosh in many articles and books that appeared and exhibitions that took place in the 1930s, 1940s and 1950s. Much of this new research appeared in *Glasgow Girls*, an exhibition held at Glasgow Art Gallery in 1990. It set out to correct many of the perceived injustices suffered by the Macdonald sisters and other female artists working in Glasgow at the same period. Its very well illustrated catalogue succeeded, however, in introducing new fallacies about The Four created, not least, by its numerous inaccuracies and misprints.

1996 saw work by The Four in various media exhibited together in the exhibition *Charles Rennie Mackintosh*, held in the same McLellan Galleries as the Memorial Exhibition of 1933. Mackintosh was very much the main subject of this exhibition, however, and the other members of The Four with the exception of Margaret Macdonald, received far less exposure. In 2006 Pamela Robertson corrected this in an exhibition, *Doves and Dreams*, which charted the lives and artistic careers of Frances Macdonald and Herbert MacNair, rebalancing existing perceptions of the roles of these artists within The Four.[3] For me, it was an exhibition that undermined the concept of the sisters as equally gifted with the elder naturally assuming the role of leader, as it showed that comparisons of the two would generally favour Frances,

in terms of both quality of execution and invention. The last pieces of the jigsaw were coming together and, to this author at least, the importance of Frances Macdonald within the group was now fully apparent. She was the most tenacious of The Four in the 1890s, and arguably the most inventive as an artist, incorporating much of her pictorial imagery in her metalwork and graphic designs.

In much of the scholarship of the last twenty years, following the 1996 Mackintosh exhibition, the accent has been on correcting the earlier over-emphasis of the role of Mackintosh within the group. Mackintosh's achievements as an architect and designer are often now jointly (and I think sometimes mistakenly) attributed to Margaret Macdonald. The correction, while necessary, has in my opinion gone too far, hence my decision to undertake a study that integrates the individual output of all four artists, recognises – for all of them – the links between their paintings and design work that continued for much of their working lives, and identifies the scope of their various collaborative projects. From 1890 to 1910 the work of The Four can be seen, on the whole, as interrelated – where genuine collaboration existed alongside individual achievement, yet these links have rarely been explored for all four artists together. They shared common aims, frequently a common palette and iconography, and a still secret and personal language. For the 1890s, at least, their work needs to be studied in almost forensic chronological order, such was the rapidity of change driven by the close friendships and regular contact between them. From about 1910 each spoke with a more individual voice – although until 1920 the Mackintoshes produced several collaborative works – resonant of their particular circumstances, their triumphs, hopes, disappointments and hardships.

In this study I intend to present a more coherent story of The Four, concentrating on the entirety of their artistic imagery and output. (I exclude architecture from this definition not because I do not consider it artistic but because it was an art form specific to Mackintosh alone and where he worked outside the orbit of The Four.) I believe this is a story where the supposed superiority of the architect over the art worker (and vice versa) is irrelevant, where gender is unimportant in terms of creativity, where an individual hand is as valid as collaboration. The separate hands of The Four are most clearly seen in their paintings, usually watercolours. Their collaborations usually take place in three-dimensional work, as small as candlesticks or as large as complete rooms. The latter

are generally outside the confines of this book and, in any case, take us into more contentious areas, but the former generally share an iconography common to all of these artists, no matter which of them were involved in particular collaborations. The iconography of The Four, taken together with its presentation and individual handling, was a phenomenon that attracted a great deal of attention in continental Europe – significantly more than in Scotland or Britain as a whole. Its stylistic influence may not have had a lasting effect, but it did as much as (and arguably more than) the work of the Glasgow Boys before it and that of the Scottish Colourists after it, to claim an important role for Glasgow and Scotland in the history of art and design in the twentieth century.

Roger Billcliffe

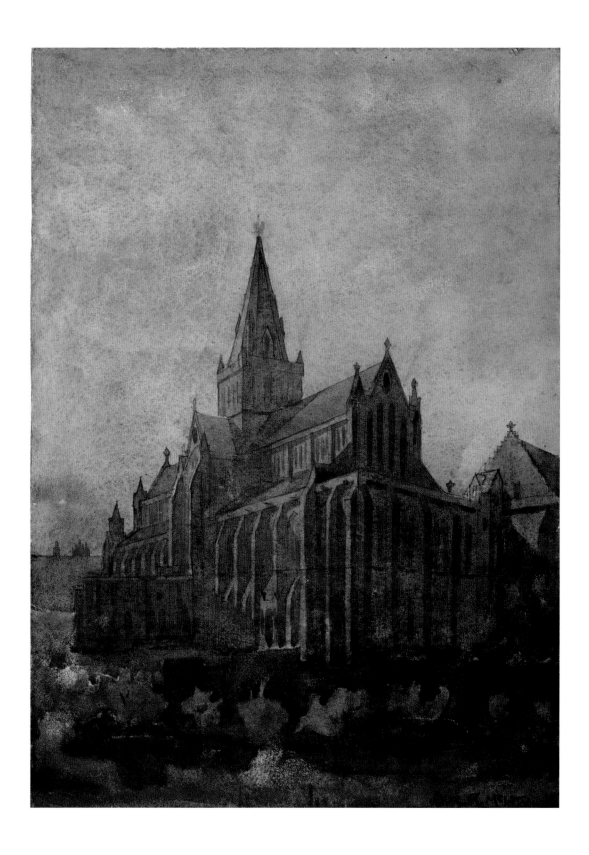

1 BEGINNINGS

I N THE EARLY 1890s the visual arts in Glasgow were riding high. A group of twenty or so young artists associated with the city – known among themselves as the Boys, and now referred to as the Glasgow Boys – had in 1890 filled the Grosvenor Gallery in London to considerable acclaim. It seems that their reception in the capital, by critics and public alike, was rather more generous than the response they were accustomed to in Glasgow. Certainly, the column inches devoted to this exhibition were considerably more than they might have expected in Scotland. This was perhaps partly due to the fact that the exhibition was the last ever show at the Grosvenor, a venue which had acquired a reputation in its relatively short life for lively and provocative exhibitions of modern painting and whose impending demise was a matter of some regret to many in the art world. This final show certainly attracted attention, and it led to the Glasgow Boys being invited to transfer their exhibition to Munich as part of the international art exhibition of 1890 in the city's Glaspalast. Their work was completely fresh to a German audience, and they received even more attention here, as well as playing a significant part in inspiring younger members of the Munich Art Society (Münchner Kunstgenossenschaft) to break away from the established order in 1892 and set up their own exhibiting organisation, the Munich Secession (Münchener Secession). During the last decade of the nineteenth century, secessionist movements were springing up across Europe, but Glasgow itself did not succumb to the fashion. The Glasgow Institute of the Fine Arts, which had regularly shown the Boys during the early 1880s, continued on its steady course of offering wall space to almost all types of painting. Naturally, as in many similar institutions, the mediocre and unadventurous predominated, as such painters were far more numerous than their forward-looking peers. Even in Munich, Scottish potboilers made their way onto the walls of the Art Society exhibitions there, while the likes of James Guthrie, John Lavery, E.A. Hornel and George Henry appeared with the avant-garde at the Secession. After Munich the Boys progressed to exhibitions in Dresden, Berlin, Vienna, Barcelona, Venice, Bruges and Brussels, and their paintings were acquired for museums across the continent. In many ways, however, their lasting achievement was to associate the name of Glasgow in the minds of critics, collectors and curators with progressive ideas in the visual arts. At home they were setting an example for a younger generation by demonstrating that

2. Charles Rennie Mackintosh, *Glasgow Cathedral at Sunset*, 1890,
watercolour, 39.3 x 28.4 cm, The Hunterian, University of Glasgow

Scottish artists could look beyond the confines of Scotland and London to the artistic centres of Europe, where the deserving would be welcomed perhaps more readily than they would be at home. This lesson was taken to heart by two very disparate groups of artists whose work, in many ways, could not be more different from that of the Boys but who were similarly drawn to Europe: four young men who came to be known as the Scottish Colourists, and four very different artists – two men and two women – whose work became known as the Glasgow Style and whom we now call, simply, The Four. They were: Frances Macdonald (1873-1921), her sister Margaret (1864-1933), Charles Rennie Mackintosh (1868-1928) and James Herbert MacNair (1868-1955).

Of the three key artistic bodies in Glasgow in the 1890s (Glasgow School of Art, Glasgow Art Club and the Glasgow Institute of the Fine Arts), only the School of Art was to have a major impact on the lives and careers of The Four. The artist members of the Glasgow Art Club played no real role in the development of the Glasgow Style – Mackintosh never joined the Art Club (despite designing its main gallery while a draughtsman at Honeyman & Keppie), nor did his friend MacNair, and the Macdonald sisters were, as women, not eligible for membership. The Glasgow Institute (the only institution open to the public) did show works by all four artists, though in quite small numbers.

Mackintosh (3) was the first of The Four to exhibit at the Institute, with watercolours from his Italian tour being included in the early 1890s. Over the next few years works by his friends and colleagues – Frances (4) and Margaret Macdonald (6) and Herbert MacNair (5) – would also be shown at the Institute, but never in the numbers that the Boys had achieved a decade earlier and continued to enjoy until the ends of their lives. It was not that the Institute actively rejected The Four, rather that they did not produce the sort of work that the Institute was established to exhibit, and, for their part, The Four did not regard the Institute as the natural showcase for their painting. Furthermore, paintings were only one aspect of the creativity of The Four. It is beyond doubt that they themselves saw all their work as art, and an artistic vision was at the foundation of everything they produced in any medium, whether as painters, embroiderers, metalworkers, furniture designers or architects. Their creativity was in itself of a different order from anything else happening in Scotland between 1890 and 1930. It produced a new vocabulary, a new intellectual vigour, and a symbolism almost unparalleled at

the time. Not for nothing were The Four sometimes referred to as 'the Spook School'.

While the Glasgow Boys were following generally in the footsteps of French contemporaries, The Four were in the vanguard of a new art that was racing across Europe. It was not exactly a homogenous style: each country produced a national variation under a different name – Art Nouveau, Jugendstil, Sezession, Stile Liberty, Glasgow Style, and so on – but they shared aims and, to some extent, an iconography. Although much of the youthful work of The Four can be said to fit within the generic mould of these contemporary developments on the continent in the early 1890s, by the time their ideas were reaching maturity they were working in relative isolation – in both Scotland and Europe – testing new concepts on each other. By 1900 they had arrived at conclusions that were similar to those of their European contemporaries, but their journey had followed a rather different route, and soon their art began to diverge still more.

In order to assess properly the achievements of The Four, it is necessary to ignore the distinctions that are usually drawn between the fine and decorative arts. The imagery used in their paintings can also be seen in sconces and cabinets, wall paintings and book illustrations, interior design and rugs, posters and bookplates, in the large-scale carved decorations on Mackintosh's buildings and even in designs for handkerchiefs. So, to examine the *art* of The Four, it is important to consider far more than their paintings (although watercolours are numerically the largest group of work), for it is only by looking at all their productions in diverse media that we can fully appreciate the breadth, complexity and intensity of their achievements. The attainments of the group as a whole are at the centre of the early part of this narrative. However, after 1905 or so, each of the artists increasingly demands individual study: as their artistic and professional careers began to diverge, so did their skills and aspirations, and their personal circumstances.

By 1910 the early promise and individuality of these four quite different artists was confirmed: Frances Macdonald was in many ways the most original in her iconography and

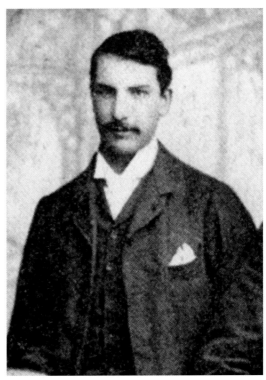

handling, her work displaying an imagination and depth of emotion – as well as emotional intelligence – rarely equalled by her friends. Herbert MacNair created perhaps the most radical and extreme imagery of the 1890s, although his later work flagged, along with his commitment. Margaret Macdonald excelled in her mastery of gesso and produced an impressive group of highly individual later watercolours, while emerging as a natural collaborator; she tended however to be repetitive in the imagery she used and was often less assured in handling than her sister. Mackintosh, gifted with an unerring natural facility, brought to the innovative ideas of his friends a rationale and formality honed by his architectural training – and like Frances and Margaret after 1910 developed an intensely individual artistic personality.

All four artists attended Glasgow School of Art during the 1880s or in the first half of the 1890s. The two men met while training as architects at the Glasgow practice of Honeyman & Keppie and attended evening classes as part of their professional training, while the women were full-time students from 1890 to 1894, attending courses at the school during the day, where their syllabus was very different from that offered by the School in the evening. The paths of the two men and the two women seem to have crossed not in the studios but in the activities of the Glasgow School of Art Club. This student body organised social events and an annual exhibition in the autumn where work of its members, often produced during the summer vacation, was presented to the public. How the four artists first met is shrouded in obscurity, as is the origin of the sobriquet 'The Four', conferred on them by the art world since the 1930s. Francis H. Newbery (1855–1946), known as Fra Newbery and Headmaster at the school from 1885 to 1917, is credited with pointing out to these artists the similarities in their work.[1] His wife Jessie Newbery (*née* Rowat, 1864–1948) – a former student and teacher at the School and close friend of the Macdonald sisters – confirmed in print for the first time the title 'The Four' (originally, and informally, bestowed by their art school friends[2]) in her introduction to the catalogue for the exhibition in 1933 in Glasgow that posthumously celebrated the achievements of Mackintosh and Margaret Macdonald (who had married in 1900, as had Frances Macdonald and Herbert MacNair in 1899).[3]

Charles Rennie Mackintosh was born in Townhead in Glasgow in 1868, the son of a police clerk who rose to become Superintendent of the Glasgow force. Unlike his future friends in The Four, Mackintosh's background was not one of privilege and his early education was at local schools, first Reid's Public School and then Allan Glen's Institution from 1877 to 1883. Allan Glen's was established 'to give a good practical education and preparation for trades or businesses, to between forty to fifty boys, the sons of tradesmen or persons in the industrial classes of society'. Throughout its history it was renowned as a cradle for scientists, engineers, architects and designers, and many of the greatest west of Scotland practitioners passed through its doors. Although notionally a fee-paying school its charges were very low and bursaries ensured that it was effectively open to all, selected according to academic ability. Presumably, Mackintosh must have set his sights on a practical career at a very early age; when he left the school in 1883 he enrolled in the evening classes for architects at Glasgow School of Art and in 1884 is recorded there as a pupil with John Hutchison, architect, in Glasgow. Alone among The Four,

7. Charles Rennie Mackintosh, *An Antique Relief*, *c*1886, watercolour, 72.3 x 54.8 cm, The Hunterian, University of Glasgow

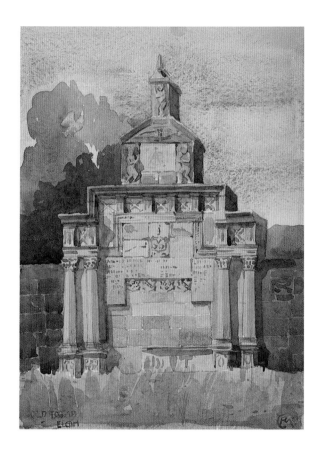

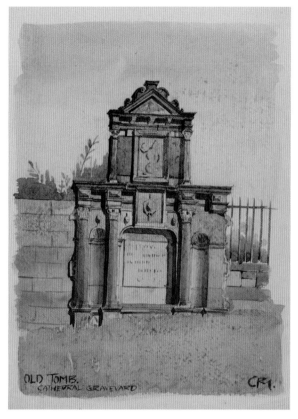

Mackintosh received no sustained formal training as an artist. However, the classes that he joined in 1883 (and continued to attend until 1894), included drawing, ornament, modelling and design, alongside the necessary technical subjects such as geometry and building construction, following the national syllabus intended for architects (Glasgow School of Art was part of the South Kensington system for art education in Britain).

At that time, architectural training in Glasgow usually took the dual route of learning on the job as an articled pupil or junior draughtsman in an established practice, while attending part-time classes in the evening or early morning at the School of Art's architecture school. Those who could afford it might enrol at a foreign school specialising in the training of architects – there were few such institutions in Britain in the nineteenth century; John Keppie, for instance, Mackintosh's employer from 1889, had trained at the École des Beaux-Arts in Paris, as did several of his contemporaries. At the core of the teaching in Glasgow was an emphasis on drawing – technical rather than imaginative – and for a boy with Mackintosh's innate facility with a pencil this must have lightened the tedium of everyday work at the draughtsman's desk. Mackintosh was a keen observational watercolourist from an early age, making studies of leaves and flowers preserved in a sketchbook with other drawings by family members – his father was an enthusiastic gardener

LEFT
8. Charles Rennie Mackintosh,
Old Tomb, Cathedral Graveyard, Elgin, 1889,
pencil and watercolour, 31.8 x 24.1 cm,
The Hunterian, University of Glasgow

RIGHT
9. Charles Rennie Mackintosh, *Tomb, Glasgow Cathedral*, 1889, watercolour, 31.7 x 24.1 cm,
The Hunterian, University of Glasgow

and presumably encouraged Mackintosh's interest in plants and trees, an interest that was to provide him with a lifelong artistic vocabulary as a painter, designer and architect. In the architectural classes that he attended, however, he was introduced to more formal subject matter, making studies from the cast (7), for instance, for which he was commended in the National Competitions in 1885 and 1886,[4] when his work was submitted for scrutiny in London under the South Kensington rules.[5] Throughout his art-school years Mackintosh regularly won prizes at both a local and national level for the drawings he produced as part of his formal education. A surviving notebook details various elementary building forms and methods of construction[6] and is possibly the book for which he won the prize, 'Best Set of Lecture Notes', in 1887. Pencil and watercolour is the medium of these drawings and although competently executed they contain no hint of how his work in watercolour would develop over the next three or four years.

At about the same time, Mackintosh began to make simple drawings of buildings that interested him, first in Glasgow and then further afield in Scotland, probably on holidays to areas well supplied with historic architecture but also in locations where he was perhaps working for the practice in the 1880s. Among the earliest of such drawings to survive are a group of watercolour studies made in Elgin (8) and several pencil sketches and watercolours showing details from Glasgow Cathedral (9), dating from the late 1880s. Similar drawings, all in pencil in a sketchbook, were made at Stirling and in Fife around this time. None of these, whether in watercolour or pencil, is out of the ordinary for an architect with an inclination towards topographical study: Mackintosh was following a well-marked trail in his profession. The watercolours, in particular, have the flavour of similar sketches by J.S. Cotman and his brother J.J. Cotman, artists whose work Mackintosh may well have seen in the dealers' galleries in Glasgow, as well as in several printed studies. And then suddenly, with no apparent precedent, Mackintosh produced in 1890 a much more painterly study of Glasgow Cathedral, *Glasgow Cathedral at Sunset* (2). Although the building is rendered in some detail, with the aid of a ruler, the colour and handling of sky and foreground presage much of the work he was to produce in the mid-1890s. The cathedral is

a brooding presence over the Molendinar valley: Mackintosh has used colour and perspective to emphasise its dramatic situation and capture the mood of the eerie cemetery from which the cathedral is viewed. Could he have been aware of George Henry's powerful and symbolic use of colour at this date? Certainly the rendering of the trees in the foreground reveals his awareness of that favourite motif of the Glasgow Boys, the cabbage (*see* Chapter 3, page 48). Interestingly, at the beginning of the following year, 1891, Herbert MacNair, by now a close friend, chose as a prize from the Art Union draw at the Glasgow Institute a painting by E.A. Hornel, so it seems not unreasonable to make such links. This painting, *The Brook* (10) anticipates many of the motifs which The Four were to use in their own work from around 1893 – an emotive, Symbolist use of colour, especially blue and green; severely foreshortened or non-existent perspective creating a flat picture plane; figures dressed in kimonos or similar robes hiding bodies and legs and, occasionally, arms. Hornel and Henry had become fascinated with Japan and Japanese art, both of which were also to have a notable influence on The Four. It is not known for how long MacNair owned this painting, but in 1891 his good friend Mackintosh must have been well acquainted with it.

Mackintosh's transition from tight pencil sketches and simple wash drawings, such as those made at Elgin and elsewhere in the late 1880s, to *Glasgow Cathedral at Sunset* is a considerable achievement. He does not seem to have attended classes within the Painting and Drawing department of the art school – his classes in 1889 and 1890 were predominantly related to architectural design – and yet this picture suggests

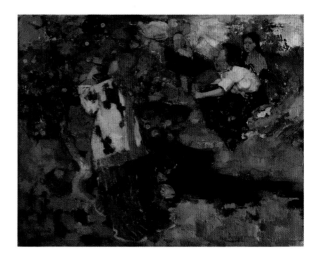

10. E.A. Hornel, *The Brook*, 1890, oil on canvas, 40.6 x 51 cm, The Hunterian, University of Glasgow

that he had spent some time studying watercolours, either in the Glasgow Art Gallery (which in 1890 shared premises with the School of Art) or at the exhibitions of the Scottish Society of Painters in Watercolour (RSW) or the Glasgow Institute of the Fine Arts (RGIFA). Alternatively, it might have been the example of MacNair, who had spent some months working alongside an artist in France before joining Honeyman & Keppie, or even encouragement from the new junior partner in the firm, John Keppie, who was himself an accomplished watercolourist and who took under his wing these two young draughtsmen in his office. Whatever happened to change Mackintosh's style – and it could just have been a growing maturity – when he set out for Italy in March 1891 as the winner of the Alexander Thomson Travelling Scholarship, he was both mentally and technically prepared to produce a variety of sketches, drawings and finished paintings recording his travels in watercolour.

Herbert MacNair (known to his friends as Bertie) had a rather more traditional introduction to painting. As a son of a wealthy family he was able to take some time in choosing his future career. In 1885 he spent a number of months working with Léon Auguste César Hodebert (c1854–1914), an artist based in Rouen, but none of his paintings from this period survives. Hodebert was a classically trained painter, specialising in landscape and figure subjects, usually female nudes, and presumably MacNair absorbed something of the artistic process while working with him. Whether this period in France was simply an interlude in a wealthy young man's stuttering career, or the moment when he realised that a future as a painter was not to be, MacNair returned to Scotland and at some point in 1888 he was apprenticed as an architect to John Honeyman, a family friend and former neighbour in Ayrshire. It was in Honeyman's office that he met first John Keppie, who joined as a partner in December 1888, shortly after MacNair's arrival, and then Mackintosh, who entered the office in the summer of 1889 at the end of his pupillage with John Hutchison in Glasgow. MacNair began attending the evening classes at the School of Art in 1889, alongside Mackintosh, and also shared experiences and interests outside the office. Their relationship with Keppie, a keen and talented watercolourist, soon extended beyond the formality of the firm as they began to spend weekends at his house in Prestwick, working together on competition designs and other projects for the practice.

Nothing remains of MacNair's output (either as an artist or as a junior draughtsman in the office) at this time; his earliest surviving work is dated 1893. However, MacNair recalled how, during quiet periods in the office, he would trace over illustrations in journals and newspapers of objects that interested him, attempting to improve or develop the designs or images. [7] Mackintosh might well have joined him in this – perhaps this was when both artists first developed their library of historical images and motifs that were to find practical application over the next few years. Certainly, it suggests a degree of experimentation by MacNair that may well have pre-dated similar ventures by Mackintosh.

Although we know nothing of the form that MacNair's painting took before 1893, we can see how Mackintosh was growing as an artist through the watercolours that he made on his tour of Italy in 1891. Having won the Alexander Thomson Travelling Scholarship (in 1890), Mackintosh left Glasgow for London in March 1891 from where he took a ship to Naples, arriving on 5 April. He was to spend four months away, working his way from Naples to Sicily – drawing, sketching and painting – and then heading north towards Milan. Most of the work he produced relates to architecture, but he made several more painterly watercolours and many of his architectural studies were worked up with colour into something approaching an exhibition standard. By August he was back in Glasgow, keen to renew his contact with the Thomson trustees in order to claim the second instalment of his prize. The trustees had insisted on seeing some work before parting with the final £30, but Mackintosh had been reluctant to trust his drawings and watercolours to the postal service in Italy and decided to finance the second part of his tour himself pending reimbursement. This probably accounts for the meticulous listing of expenses in his diary.

These months spent in Italy were to have a considerable effect on Mackintosh – they confirmed for him the importance of architectural ornament. As an architect Mackintosh was not as radical a modernist as some commentators would have us believe and a building of his without some form of sculptural decoration is very much the exception rather than the rule. What he learned in Italy, and from Ruskin who was his guide on his Italian journey, is that ornament derived from nature can complement, rather than overwhelm, a building. His sketchbooks are filled with drawings of whole façades and individual details to which he would refer when back in Glasgow, especially when making the drawings for architectural competitions which became his forte within the firm. These Italian drawings are generally rather more elegant

than the sketches he had previously made in Scotland. Perhaps he was conscious that others would see them, or at least that they would be inspected by the Thomson trustees; at any rate it is clear that he spent considerable time and care on each one. There is a growing use of watercolour, usually a simple wash, in these pencil drawings. One of his first, was a study of the doorway at Trinità Maggiore, Naples (11). What is unusual about this drawing, which distinguishes it from much of the other work made over the next four months, is the inclusion of a passing cart. Details of daily life, figures, animals rarely appear in the sketchbooks made in Italy. In fact, they hardly ever appear in Mackintosh's pictorial watercolours in general, even those made purely as paintings in the south of France in the 1920s. Mackintosh found Naples a dirty, noisy and crowded city and did not enjoy his time there; he was happy to leave it for Sicily. His journey there, however, proved him to be a poor sailor – in common with many of his fellow passengers:

> It wasn't awfully rough but the boat was about as bad as could be. Just like a Clyde tug boat [...] before we had been out 2 hours I was as sick (in company with most of the passengers) as a dog, and remained that way for about an hour [...] I quite dread the return journey.[8]

I think Mackintosh was probably surprised by the weather in southern Italy; it certainly rained quite a lot. But in between the showers, he produced the first of the finished watercolours (as opposed to sketches) that he was to make in Italy: *Cloisters, Monreale* (12). The painting clearly shows Mackintosh's eye for composition, with the cathedral tower framed within one of the arches of the cloister. The colour is applied in broad washes, with none of the deep hues of his Glasgow cathedral painting, perhaps attributable to the strength of the light in southern Italy. It is not without faults but provides a clear indication of Mackintosh's promise as a painter. From Sicily he made his way to Rome, where he produced a number of pencil-and-wash sketches and at least one finished watercolour. *The Arch of Titus* (14) sets the monument within its Roman context; the washes are carefully applied over a tight pencil drawing, and Mackintosh has signed and dated the drawing as if it were a painting. He was

obviously aware of the artistic opportunities before him; it is surprising that Rome did not inspire more watercolours like this – perhaps they are lost. But his pattern of work was, for the moment, set – detailed pencil sketches with occasional wash formed the vast majority of his work in Rome. He next set out for Florence by way of Orvieto and Siena where he found much more use for his colour box. At one point he left it on a bus in Rome, and recorded his panic in his diary before he successfully retrieved it:

> Took sketch but sun going down I started to go home for lunch. Just my luck left colour box in bus. After waiting about 1 hour and a half got bus again and also box. Gave conductor 4 francs. Was mighty glad to get them back. Got an awful fright. Fancy being with out colours. To dreadful to contemplate.[9]

Despite the bad weather in Orvieto he made several sketches, including one of his loveliest Italian watercolours, of the cathedral (13), which he again signed and dated as a finished

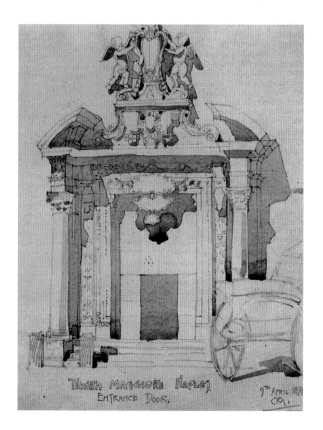

11. Charles Rennie Mackintosh, *Doorway, Trinità Maggiore, Naples*, 1891, pencil and watercolour, 24.2 x 17.8 cm, untraced

painting. The horizontal banding of the cathedral's masonry fascinated him and he was to seek out similar structures in Siena, where he found material for several paintings.

Although he thought Siena cathedral, on the whole, clumsy and vulgar he much admired the woodwork of the baptistery and made another fine watercolour, again signed, of the font with its panels by Donatello and Ghiberti (15). The use of coloured marbles in many of the Sienese buildings caught his attention and he recorded them in various drawings, the most painterly of which shows the entrance to the library at the cathedral.[10] He admired the Palazzo Pubblico and drew it from the Piazza del Campo before leaving for Florence. Not surprisingly, he spent most of his time there in the museums and churches, looking rather than sketching – he found the cathedral disappointing but the Donatello doors 'exquisite'. One of his most elegant drawings was of the tomb of Carlo Marsuppini in Santa Croce (16); he also spent two days working on a watercolour of the Pitti bridge (untraced). From Florence he made his way, via Pisa and Pistoia, to Ravenna; he was delighted with Ravenna and noted in his diary, 'S. Appolinare nuove & classe are of course the jems. Some ripping mosaic work in both'[11] (spelling was never one of Mackintosh's fortes). He made several sketches of mosaics and frescoes over three days before leaving for Venice.

Like many visitors to the city, Mackintosh was overwhelmed by Venice. He was very much aware of its theatrical power and in lectures he gave on his return to Glasgow he enthused about his arrival there, by gondola across the lagoon passing Murano and San Giorgio Maggiore and entering the Grand Canal in the late evening.[12] Still gliding forward we every moment passed some well-known church or pallace in the city, suffused with the rays of the setting sun, and reflected with all their glory of colour, on the surface of the water. I have no terms to describe the effect of the ensemble of looking up that part of the Grand Canal terminated by the Rialto. The first sight of this scene simply takes ones breath away. All attempts at a verbal rendering of this effect would be so tame and presumptuous that I will not attempt it. I can only assure you that not even in your happiest and most imaginative moments can you realise in the slightest degree what Venice is like at any time, and more especially at night under the magic influence of the setting sun. According to his diary Mackintosh

12. Charles Rennie Mackintosh, *Cloisters, Monreale*, 1891, pencil and watercolour, 36.8 x 16.5 cm, private collection

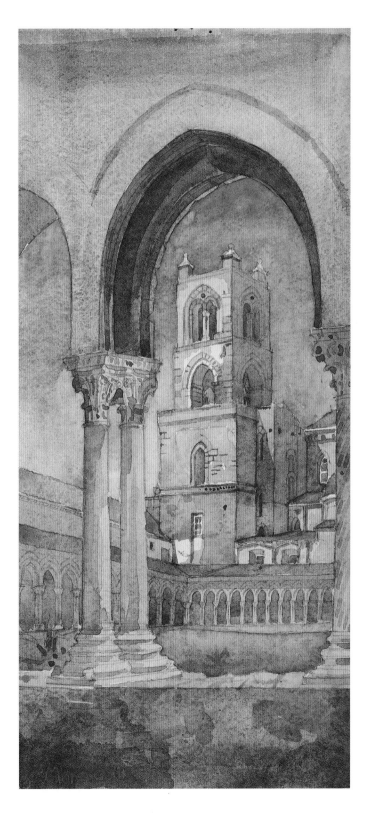

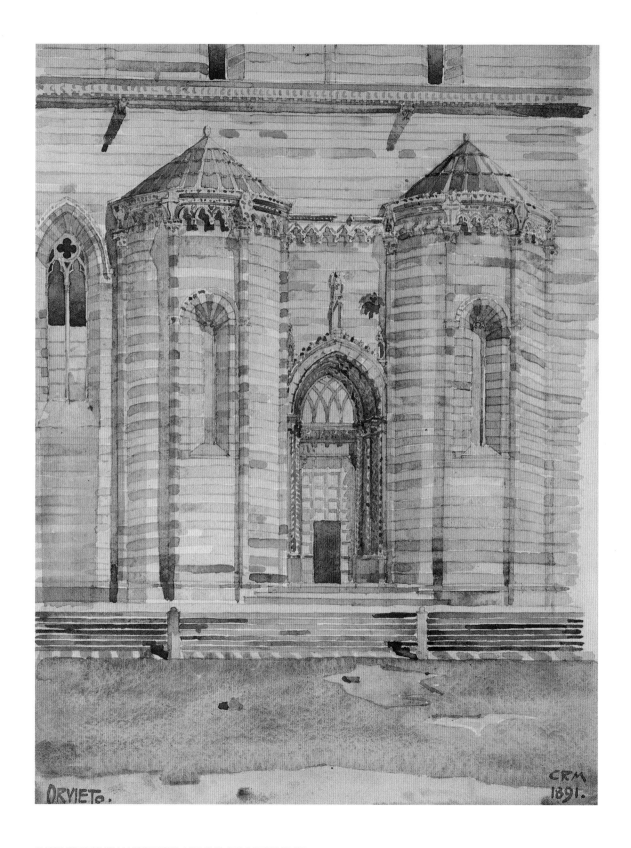

ORVIETo.

CRM
1891.

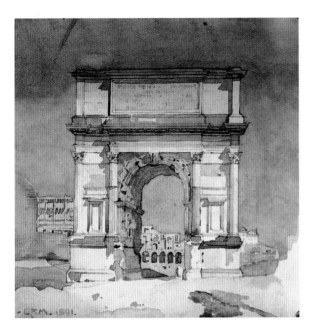

LEFT

14. Charles Rennie Mackintosh, *The Arch of Titus, Rome*, 1891, pencil and watercolour, 24.1 x 31.8 cm, untraced

BELOW LEFT

15. Charles Rennie Mackintosh, *The Baptistery, Siena Cathedral*, 1891, pencil and watercolour, 39.1 x 27.9 cm, private collection

BELOW RIGHT

16. Charles Rennie Mackintosh, *Tomb of Carlo Marsuppini, Santa Croce, Florence*, 1891, pencil and watercolour, 37 x 25.5 cm, untraced

OPPOSITE

13. Charles Rennie Mackintosh, *Orvieto Cathedral: Part of the North Façade*, 1891, pencil and watercolour, 31.8 x 24.2 cm, The Hunterian, University of Glasgow

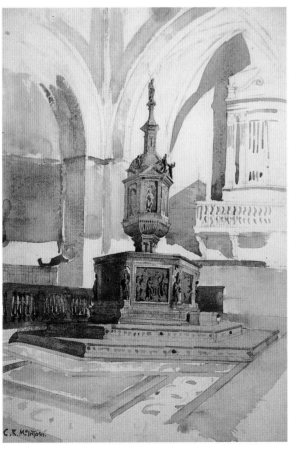

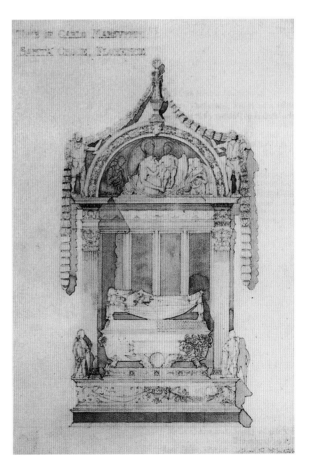

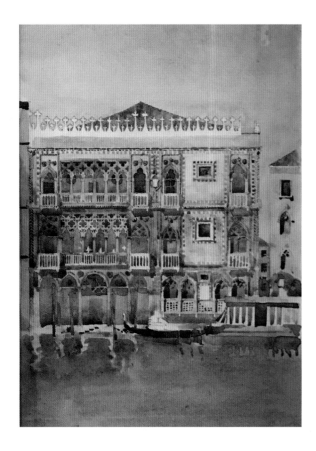

in Glasgow in 1885, Newbery had initiated a programme aimed at encouraging students to continue their studies during the summer vacation by producing sketches or other works which, later in the year, would be publicly exhibited in the nearby galleries of the Glasgow Institute on Sauchiehall Street. The exhibition was organised and hung by the students themselves, who produced invitation cards and other ephemera, possibly including a catalogue, although none of the catalogues for the exhibitions in the 1890s has survived. It was Newbery's later practice to invite a well-known artist to examine the work and talk about it during the school's annual prize-giving. In 1891, at what was possibly the first such event, he asked James Guthrie to assess the exhibition and Guthrie was reputedly very impressed by the work presented by Mackintosh. His reaction was immediate and he turned to Newbery and said, 'But hang it, Newbery, the man ought to be an artist.'[14] Did Newbery discuss this with Mackintosh; did Mackintosh consider turning from architecture to painting full-time? He was approaching the end of his apprenticeship and a relatively secure future lay ahead of him, so it is perhaps not surprising that he did not choose to embark on a new career. Whatever the case, Guthrie's words must have been encouraging and certainly vindicated Mackintosh's decision to include finished watercolours in his display of drawings. This support from one of Scotland's leading artists would not have been forgotten and surely encouraged Mackintosh in his move towards painting imaginative watercolours. Despite Guthrie's approval and Mackintosh's successful submissions to the Glasgow Institute, no watercolours from 1892, either architectural or imaginative, are known except for a single work probably made in September of the year – *The Harvest Moon*. *The Harvest Moon* (19) was a major artistic achievement for the young Mackintosh. It can be described as a 'first' on several levels – his first imaginative watercolour, first symbolist watercolour, first non-architectural exhibit at the Glasgow Institute, first use of mythological or religious imagery in a painting by The Four, and so on. On one level it can be seen as inspired by the annual phenomenon of the harvest moon – a full moon that appears near the autumn equinox at the end of September, appearing much larger as it rises above the horizon than it does at its zenith in the night sky. On another level, its elusive symbolism has led to this painting being treated as a crucial plank in the development by Timothy Neat of a highly speculative theory of personal relationships among The Four.[15] Neat proposes an interpretation of the symbols in the

arrived at midnight on 1 June, leaving on 10 June for Padua (although in his report to the Thomson trustees he stated that he was in Venice for three weeks). The first three days seem to have been spent exploring and then he started sketching in earnest. He produced at least three finished watercolours in Venice, and it seems quite possible that there were more – any artist worth the name could not but fail to be inspired by the city. His view of the Palazzo Ca' d'Oro (17) follows the format of occasional finished watercolours that he established in Sicily, Rome and Orvieto. But one painting, of a gondola on the Lido, which he subsequently framed with a Whistler style moulding, shows how Mackintosh succumbed to the pictorial possibilities of the city (18). Although he continued to make pencil drawings with coloured washes during the rest of his tour there are no other recorded finished watercolours.

In 1892 he exhibited two of the Venetian paintings at the Glasgow Institute,[13] where they were listed as not for sale, but he had previously shown a much larger group at the Glasgow School of Art Club in October 1891. Shortly after his arrival

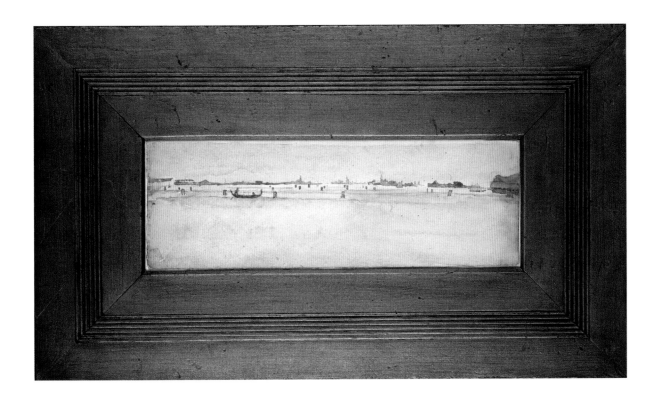

work of The Four that is dependent on his personal reading and identification of particular themes or crucial events in their lives. Often, he can only speculate about such events – with regard to their timing or even their occurrence – and such speculation is rarely supported by known facts. For me his ideas stretch our understanding of the psychological and intellectual make-up of The Four beyond what seems likely, but his hypotheses – *faute de mieux* – have gone some way towards satisfying a popular demand for some explanation of the imagery in the works of The Four throughout the 1890s.

What can we say for certain about *The Harvest Moon*? It is the largest work, of a non-architectural nature, that Mackintosh

ABOVE
18. Charles Rennie Mackintosh, *The Lido, Venice*, 1891, watercolour, 11.7 x 34.3 cm, The Hunterian, University of Glasgow

OPPOSITE
17. Charles Rennie Mackintosh *Palazzo Ca' d'Oro, Venice*, 1891, watercolour, 37 x 25.5 cm, private collection

had so far produced. Its colour echoes that of the painting of Glasgow Cathedral of 1890. Its composition is a development of some of the finished watercolours produced in Italy in 1891. As in many of those, Mackintosh chose a frontal depiction of his subject, a harvest moon rising above the horizon and viewed through a thicket of shrubs and bushes. There its relationship with reality ends. In front of the moon, centrally filling it, stands a female angel whose wings encircle it, meeting at its base. This angel appears to be standing on, or at least touching with her feet, a cloud stretching across the landscape and the base of the moon's circumference. On closer examination this cloud is seen to contain an image of a naked woman, possibly two. Without the cloud the angel could be interpreted as a figure celebrating the fecundity of the harvest, an angel of plenty. Her hands are outstretched as if welcoming the viewer or pointing to the display of nature around her. The cloud complicates this interpretation and has led to various speculative analyses. Most of these have been put forward by Neat. He has suggested that the foliage in the

foreground represents a bush of whortleberries, a symbol of the Mackintosh clan – perhaps it does. The figure in the cloud has been identified by Neat and others as deriving from *The Birth of Venus* by Alexandre Cabanel. Whether Mackintosh actually knew this painting, and why he should settle on it are questions that remain unanswered. The painting was widely known in late Victorian times, so the figure in *The Harvest Moon* might have been a conscious reference. But it could also just possibly be a figure inspired by the paintings of MacNair's tutor, Auguste César Hodebert, of Rouen; whatever its origin, Mackintosh certainly referred to *The Harvest Moon* figure several times in later works. Neat goes on to suggest that the angel and the naked figure in the cloud represent Margaret Macdonald and Jessie Keppie. He believes that this watercolour shows Mackintosh acknowledging his conflicting attachments and affections for Macdonald and Jessie Keppie, as the latter, according to Neat, became engaged to Mackintosh in 1889. His whole theory about the symbolic content of work by The Four ultimately rests on the supposed jilting of Jessie Keppie for Margaret Macdonald in 1894. But there is little hard evidence for either the engagement or its breaking off, much contradictory evidence and scant basis in known fact.

Thomas Howarth believed Mackintosh and Jessie to have been formally engaged but gives no date for the event, although in Neat's opinion this happened in 1889, soon after Mackintosh first met John Keppie at his office. Howarth's information almost certainly came from Mary Newbery Sturrock, a daughter of Fra Newbery who was not yet born when these events took place and who would have been quoting, or making deductions from, later family discussions.[16] Many years later, in discussion with this author, she modified the word 'engagement' to 'an understanding', as close, perhaps, to a withdrawal of the original suggestion as she was able to make. Neat's chronology for much of this period is highly speculative. He suggests that the engagement took place in 1889, yet it hardly seems likely that Mackintosh and his employer's sister would have entered into a formal engagement at so early a date; furthermore, no such engagement was announced in the press in the manner one would expect for a family of the social standing of the Keppies. Neat goes on to say that the engagement was terminated in 1894 and that Mackintosh marked this event by giving John Keppie his watercolour *The Harvest Moon*, and Jessie Keppie a beaten metal jewel box. If this is true, it would have been highly insensitive and inappropriate behaviour. Mackintosh

did give John Keppie the watercolour in 1894, just as Keppie had given Mackintosh one of his own watercolours in 1891.[17] The jewel box is more likely to have been made around 1895– 96 and, if given away by Mackintosh, was presumably a token of friendship, if not affection; or perhaps Jessie bought it at an exhibition. Moreover, in 1896 Mackintosh and Jessie Keppie showed a joint work at the Arts and Crafts Exhibition Society in London – hardly the behaviour of a recently estranged couple. Neat bases his opinions on the assumption that Margaret Macdonald and Mackintosh knew each other well by the end of 1892 and on the belief that Margaret was producing Symbolist watercolours long before Mackintosh painted *The Harvest Moon*. There is no evidence to support either of these suggestions and much to counter them. It goes without saying that The Four may have influenced each other once they became aware of one another's paintings, but by the end of 1892 only Mackintosh had produced any work in an identifiably new style – what was to become known as the Glasgow Style. Furthermore, there is no evidence to support, and much to deny, the possibility that Mackintosh and MacNair had met the Macdonald sisters before the middle or end of 1893.

It is easy to be distracted by questions, but the essential point about *The Harvest Moon* is that it marked one of the most important events in Mackintosh's life – his transition from topographical painting to a style that involved, and required, a powerful imagination, an emotional commitment, and the hand and eye of an artist. Mackintosh was yet to make his mark as an architect, but with this single picture he had staked a claim to be considered as a professional artist, which, surely, indicated a potentially impressive future. All of the evidence – or rather the lack of any similar paintings made between the Italian watercolours of the summer of 1891 and the autumn of 1892 – points to a step change in Mackintosh's approach to painting. Is it really an intuitive, giant step on the part of a naturally talented painter, or is it the result of progress through a number of other works, all of which are unrecorded and, if ever made, unaccounted for? Similar unexpected changes were to occur in Mackintosh's future career, but none of them, I believe, had the impact and consequences of *The Harvest Moon*. It remains a talisman, an icon, a harbinger of illustrious things to come.

19. Charles Rennie Mackintosh, *The Harvest Moon*, 1892, watercolour, 35.2 x 27.6 cm, Glasgow School of Art

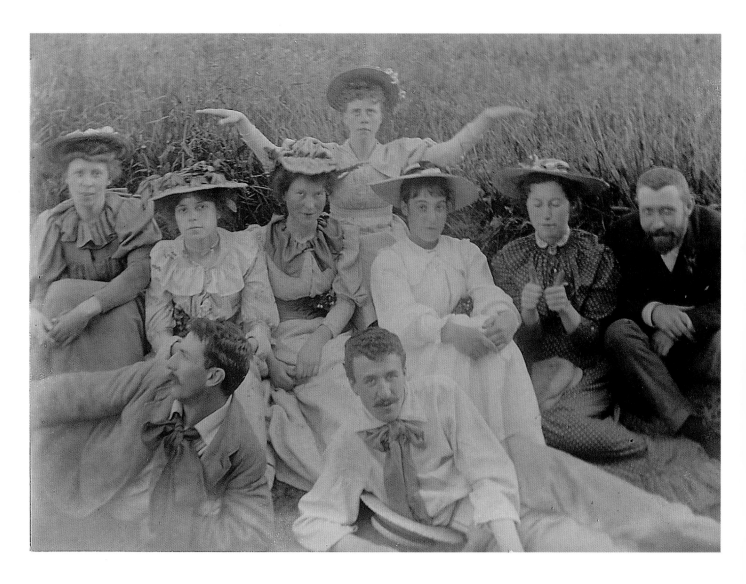

20. The Immortals, photographed by John Keppie, c1894. Back row: Frances Macdonald; middle row: Margaret Macdonald, Katherine Cameron, Janet Aitken, Agnes Raeburn, Jessie Keppie, John Keppie; front row: Herbert MacNair, Charles Rennie Mackintosh. Photograph Glasgow School of Art.

2 ART SCHOOL

STUDENT VISITORS to the Glasgow School of Art Club exhibition in 1891, where Mackintosh showed his Italian sketches, would probably have included Frances and Margaret Macdonald, sisters who had enrolled at the School in the autumn of 1890 not long after moving to the city with their parents, following their brother Charles who had recently joined a family law firm in the city. Born in England – Margaret in 1864 and Frances nine years later in 1873 – their father, John Macdonald, was a Scottish engineer and estate manager working in the English Midlands who had family connections to Glasgow; their mother, Frances Grove Hardeman, came from Staffordshire. Margaret had been privately educated at Orme's School for Girls in Newcastle-under-Lyme, where she may have received some tuition in art, and possibly spent a period of study abroad, in Germany; Frances seems to have been schooled at home.[1] As daughters of a middle-class household where the female members had an essentially domestic role there would have been no pressure on the sisters to seek meaningful or paid employment. Enrolment at art school was not an unusual choice for such women, however we do not know whether the initiative came from Frances or Margaret, or whether the commitment was equal. At twenty-six Margaret was perhaps rather mature for a first-year full-time student at the School, having shown no earlier inclination to follow such a path – nothing has survived by Margaret from the time before her enrolment at her school; at just seventeen Frances was rather young. Did Margaret accompany her younger sister as her chaperone; or did Frances follow Margaret as a companion? Or was it simply that living in the exciting new environment of a fashionable city, and meeting other young women in a similar social position, led them both to gravitate naturally towards art school?

The sisters were sociable, inquisitive and ambitious and included among their friends at the School Jessie Keppie, sister of John Keppie, Katherine Cameron, sister of Glasgow Boy David Young Cameron, and the Raeburn sisters, Lucy and Agnes. This group of young women would later (probably after 1893) spend weekends with the Keppie household at their house in Prestwick, often in the company of Mackintosh and MacNair. Some of their antics and adventures at 'the Roaring Camp', as they called it, were recorded on camera (20), probably by John Keppie. Margaret and Frances enrolled in the daytime classes at the School and in 1891 passed exams in ornamental design, freehand drawing and plant drawing. Margaret won first prize in the design section for her majolica work and also in an advanced anatomy class. In 1892–93, they studied drawing from life, composition from a given figure subject and took more design courses. Margaret seems to have attended fewer classes than

21. Frances Macdonald, *Corn Flowers*, 1892
watercolour on board, 28.8 x 49 cm,
The Hunterian, University of Glasgow

her sister, possibly indicating some earlier period of study before the move to Scotland in 1890. No works survive from the sisters' first two years at the School, however by the end of 1892 they were producing conventional flower paintings (21), although this was soon to change.

How did the sisters and their future husbands actually meet and become The Four? It was MacNair who, in the 1940s, told Mackintosh's biographer, Thomas Howarth, that Fra Newbery had seen similarities between the men's and women's work and had brought them together.[2] Newbery confirmed this to Howarth, but, like MacNair, was unable to pinpoint the exact date when they met.[3] The students attending daytime classes shared the same premises as the architects who were enrolled in the evening classes. Shortage of space in the School, crammed into every nook and cranny of the McLellan Galleries that wasn't taken up by a museum display (the Galleries were then the home of the Glasgow Corporation art collection), meant that their paths would not have crossed because the day students had to leave the premises to make space for their evening school counterparts. Both Newbery's and MacNair's account of the first meeting of The Four suggests that an encounter at one of the School of Art Club's exhibitions may not itself have been the catalyst but, rather, one of Newbery's individual monthly 'crits' of the Club's members (it was a voluntary, extra-curricular society) had alerted him to affinities between the work of the men and the women. Which begs the questions 'What had Newbery seen?' and 'When did he see it?' He would already have been well aware of Mackintosh, a winner of the prestigious Thomson prize, an exhibitor at the School of Art Club in 1891 and recipient of encouragement from Guthrie at that exhibition. But by the end of 1891 there was nothing in Mackintosh's work for which parallels can be found in the work of the sisters; their earliest exhibited (or surviving) works were relatively prosaic still lifes of flowers made at the end of 1892 or beginning of 1893.[4] Did Mackintosh submit *The Harvest Moon* to the School of Art Club show in 1892? No catalogue or review of the exhibition is recorded, but if the painting was made in September 1892 it seems likely that Mackintosh would have shown it that same year as he was still a student at the School and had had particular success in the 1891 exhibition. If it *was* in the 1892 exhibition, held in November, the sisters would almost certainly have seen it and it might therefore have acted as a spur for their work in the early part of 1893.

There is one definite association of Mackintosh with the School of Art Club exhibition that the sisters would have been aware of – the formal invitation he designed for its opening on 19 November 1892. (A year later both Margaret and Frances would produce similar cards announcing the opening of the 1893 exhibition and associated events.) His design (22) is, at first glance, almost antiquarian in tone and content, making direct references to figures on the ceiling of Michelangelo's Sistine Chapel. It is also the first piece of his graphic art which shows clear similarities in its distinctive calligraphy with contemporary perspectives, plans and elevations emanating from the Honeyman & Keppie office at the time. More specifically, certain forms and decorative motifs in the invitation are also to be found in the gallery that Mackintosh designed at the Glasgow Art Club which opened in June 1893;

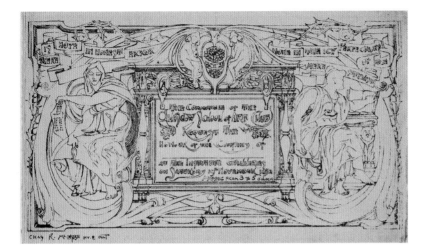

LEFT
22. Charles Rennie Mackintosh,
Invitation to the Glasgow School of Art Club
Meeting, 19 November 1892,
linocut/line block, 13.4 x 21.7 cm,
The Hunterian, University of Glasgow

BELOW
23. Charles Rennie Mackintosh,
Details of Glasgow Art Club alterations,
from *The Bailie*, 7 June 1893

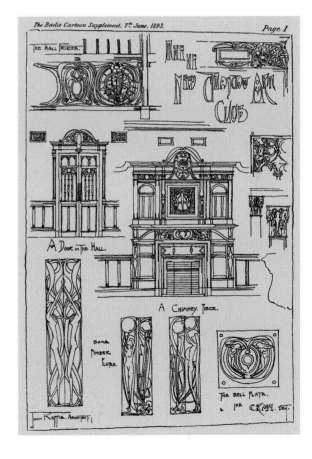

much of the decorative work in the gallery, and the design of its two fireplaces, had been discussed by the architects and their client in the autumn of 1892.[5] The strong similarities between central elements of Mackintosh's invitation design and the completed fireplaces reinforce my belief that Mackintosh was the author of much of the Art Club work that has traditionally been attributed to Keppie.

In June 1893 a composite drawing of a number of details from the Art Club commission, signed by Mackintosh (22), was published in the weekly Glasgow magazine, *The Bailie*;[6] most of these show clear evidence of Mackintosh drawing in a manner that would later be described as 'Spook School' or Glasgow Style. The emaciated and elongated figures, here female, that came to be associated primarily with the work of the Macdonald sisters, appear for the first time, not in paintings but on finger plates on doors in the Art Club's new gallery – an early example of form following function in the Glasgow Style as the plates are tall and narrow and the figures are elongated to fill them. Sometimes the figures are wreathed in long tendrils of flowing stems and sometimes they support globes – moons or suns or dandelion clocks; all were later repeated in paintings and metalwork made by the Macdonald sisters (81) (*see* page 84). These finger plates were made (to Mackintosh's design) by William Kellock Brown, then a lecturer at the School of Art and almost certainly a tutor to the sisters as they took classes in the craft of repoussé metalwork (a decorative technique in which malleable metal is hammered from the reverse side to create a pattern).[7] The drawing was published in *The Bailie*

on the day the Art Club opened, 7 June 1893 (coincidentally, this was also Mackintosh's birthday), so these sketches are of details that are likely to have been prepared some months earlier, possibly as early as the autumn of 1892. Despite being a relatively insignificant job in Mackintosh's architectural career, these details in the Art Club must now assume a crucial role in any consideration of the development of the Glasgow Style. The commission brings together key facets of Mackintosh's thinking, and this drawing links his artistic style with his work as an architect. These individual details within the building were relatively insignificant and did not on their own announce the Glasgow Style, but the handling of each motif in the *Bailie* drawing puts Mackintosh firmly at its conception.

The Macdonald sisters are unlikely to have viewed the finished Art Club, where the membership was restricted to men, but they would probably have seen the coverage in *The Bailie*. Newbery, as a distinguished member of the Art Club, would have seen all of these details at first hand and may have indicated to the sisters the relevance of the drawing to their own work. We may never know the exact circumstances of this artistic meeting of minds, but even if the sisters were unaware of the Glasgow Art Club decorations they would certainly have seen Mackintosh's School of Art Club invitation in November 1892. Apart from the classical details of the Club fireplaces that are repeated in the central panel of the invitation there are several other features that echo decorative motifs there, such as the ornamental scrolls that grow from the cartouche at the top of the invitation and encircle the design, echoed by long spiked leaves that interlace them. These leaves, stylised thistles, appear in Mackintosh's *Bailie* drawing in the carved wooden overdoor panels but they also formed the main element of his design for a stencilled frieze that encircled, at a high level, the Art Club's Gallery. These are the prototypes for the malevolent plants to be found in all later Spook School paintings. They point to the two figures at the top of the invitation that support a stylised version of the Glasgow coat of arms – a tree, a fish with a ring, a bell, and a bird. But perhaps the most important single element of this design is the banner that stretches across its width. On it Mackintosh has written: 'There is hope in honest error, none in the icy perfections of the mere stylist'. This is a borrowing from the English Arts and Crafts architect, John Dando Sedding, a designer much admired by Mackintosh. It became the key principle

that Mackintosh was to follow, as an artist and architect and designer, for the rest of his life.

By the beginning of 1893 the sisters had publicly exhibited only a few watercolours, mainly flowers, however by the end of that year they had produced a small group of images that clearly develop and extend the ideas seen in Mackintosh's *The Harvest Moon* and his work at Glasgow Art Club. Two of these can be dated to October or November 1893 as they relate to the School of Art Club exhibition held at the end of November; together with a similar drawing, a bookplate for Lucy Raeburn, they are a more assured elaboration of the attenuated female figures designed by Mackintosh for the finger plates in the Glasgow Art Club. Other works attributable to the sisters and datable to 1893 have a different aesthetic, more pictorial and less graphic that may relate more specifically to *The Harvest Moon*. The most important of these is one of the larger watercolours of the period made by any of The Four – *Ill Omen* or *Girl in the East Wind with Ravens Passing the Moon* (24). It contains elements reminiscent of Mackintosh's painting – a figure with flowing hair silhouetted against the moon; an unnatural landscape here featuring tall leafless saplings; a flight of black ravens flying across the composition, behind the figure but in front of the moon, similar in effect to the clouds in *The Harvest Moon*. There are strong vertical and horizontal elements here – trees and flowing hair and the path of the ravens – the verticals being emphasised again in the attenuated figure of the girl with her long arms crossed in front of her and ribbons from her dress dropping almost to her feet. The painting echoes the strange symbolism of *The Harvest Moon*, but an attempt to explain it is given in its title. The source of the pose of the figure, with her submissive crossed hands and bowed head, is, I believe, one of the plaster casts of figures from Chartres Cathedral (25) which were arranged around the Art School and used for student exercises in drawing from the cast. These powerful figures, often kings and queens, seem to have had a similar effect not just upon the sisters but also upon Mackintosh and MacNair who were to incorporate such figures into other large-scale paintings probably made in 1893 – or were they simply following Frances's example? Or were all of these pictures, produced in 1893, each artist's

24. Frances Macdonald, *Ill Omen* or *Girl in the East Wind with Ravens Passing the Moon*, 1894, pencil and watercolour, 51.7 x 42.7 cm, The Hunterian, University of Glasgow

personal response to an assignment set for members of the Club as a summer project? *Ill Omen* is by no means as assured or sophisticated in its composition or handling as *The Harvest Moon* – but Mackintosh had had the benefit of a visit to Italy and ten years at art school when he painted it, as opposed to barely three years of study for Frances. In some ways *Ill Omen* can be seen as a classic student work (which it was) but it has a vitality and self-belief that counter any notion that it might derive from other sources.

Ill Omen, alongside *The Harvest Moon,* was not the only portent of things to come later in 1893. One painting, in particular, stands out as comparable to it – *The Creation of Eve* (26). At various times this picture has been attributed to the Macdonald sisters or jointly to Mackintosh and MacNair.[8] I now believe, however, that it is solely the work of Mackintosh and that it was made in 1893. It was possibly intended for incorporation in some church project connected to Honeyman & Keppie as, at over 2.5 metres high, it seems unlikely that it was a personal or exhibition work. Alternatively, it could have been Mackintosh's response to a set piece of coursework or even one of Newbery's projects for the summer vacation. Mackintosh's hand is undeniable in the handling of the angels, which dominate the overall design, in the drawing of the naked figures that appear in various cartouches incorporated into the design, and in the decorative flourishes at its top. There are obvious links to *The Harvest Moon*, but the symbolism in *The Creation of Eve* is straightforwardly religious with the angels here being set against a panel of celestial blue. These angels are similar in concept to the lone figure in *Ill Omen* and probably share the same source – the plaster casts of the sculptures at Chartres Cathedral. MacNair's hand has been attributed to the figures within two circular panels, one at the bottom and the other at the centre of the composition, but he was not skilled in life drawing and the quality of these two figures points firmly to Mackintosh (with apologies to Michelangelo, as in the School of Art Club invitation of 1892).

Three years later Mackintosh was to work on a larger scale in the stencil decorations for the luncheon room at Miss Cranston's Tea Rooms in Buchanan Street (98). Several elements of that design can be seen in almost prototype form in *The Creation of Eve*, but the latter is by no means as assured in its composition. The height of this watercolour, with its relatively narrow width (possibly dictated by the dimensions of paper available to Mackintosh), imposes an awkward arrangement on the various elements within it.

Without knowing its intended use and location one can say that it fails as a harmonious composition; it is more of an assemblage of individual motifs than a unified painting. These individual motifs, however, were over the next few years to be adapted by all of The Four into an immediately recognisable style. They appear here in a painting for the first time in Mackintosh's work, and his use of them is hesitant as he struggles to incorporate each of them coherently into the overall design. One might say that this is for Mackintosh as much a student work – or at least a learning work – as *Ill Omen* was for Frances Macdonald.

The future importance to the Glasgow Style of these particular motifs means that it is useful to identify them in some detail. The whole design is based on a linear stylisation of organic forms that originates at the very bottom of the painting and rises through it to the very top. Out of two heart-shaped corms rise stems that flank a central thicker trunk of a tree. This latter soon branches to encircle the first of the cartouches that each contain an episode from the story of the Creation of Eve and the Expulsion. The two stems multiply above this cartouche to form a stylised garden (of Eden, perhaps) between the two rows of angels. Above the garden is another cartouche, encircled by a tracery of stems tipped by seedpods, where Eve seems to be evolving from Adam's rib. A similar tracery extends on each side through the upper rank of angels to end in elaborate finials that in turn support flowers with decorative *putti* heads above them. Over the upper cartouche is an amorphous figure above which hovers a crown, presumably Jehovah. The heads of the angels and the figures within the two cartouches are unmistakably drawn by Mackintosh, as are the two figures of naked women at the foot of the painting, again owing much to Michelangelo. The flowing hair of each of these women is absorbed into the composition much as the wings of the angel are in *The Harvest Moon*, a motif to be developed further by the Macdonald sisters in later work.

Did Newbery see this picture? If, as I suspect, Mackintosh painted it in the middle of 1893, did Newbery see parallels between its acidic colours – blues, greens and purples – and those in Frances Macdonald's *Ill Omen*? He might also have seen another painting by MacNair that is dated 1893 and uses a similar palette. *The Lovers* (27) is one of the most extreme works by The Four for that year, or any other. The subject, of a man and woman, seemingly in coitus, is more daring than anything that Mackintosh or the sisters were ever to produce,

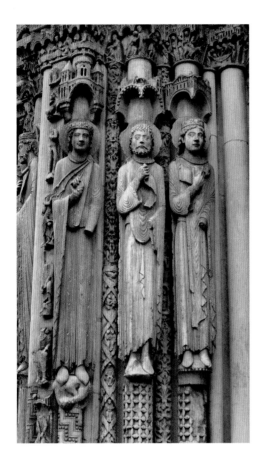

where such erotic themes, though present, are less overt. A congregation of winged angels, surrounding the two figures and painted in a purple wash, is accompanied by hags rising from vapid pools – symbolic perhaps of hell – and other gaunt women silhouetted against a purple sun or moon. Intertwined with all of these figures is the green shape of a malevolent plant, harking back to the organic shapes in Mackintosh's work at the Glasgow Art Club or the strange plants in *The Creation of Eve*. The composition is relatively naturalistic, as was that of *Ill Omen*. *The Lovers* has more figures than *Ill Omen*, but MacNair does not present them in quite the stylised or graphic forms that Frances and Margaret were to use in the School of Art Club invitation cards of November 1893 or in the bookplate for Lucy Raeburn included in *The Magazine* for the same month.

The Magazine was the name given to a handwritten album circulated among a small coterie of students at the School of Art, most of whom were contributors, including Mackintosh and the Macdonald sisters but not MacNair. It contained handwritten essays and was illustrated with a combination of original watercolours and photographs. It was compiled by Lucy Raeburn, who did not become a student at the School until the year after the first issue appeared (dated November 1893). The only work by The Four included in it is a bookplate for Lucy Raeburn designed by Frances Macdonald (30). This occupies a place of honour, as a frontispiece, and is technically and aesthetically far in advance of most of the other work included in this issue. It was probably made specifically for *The Magazine* just before its appearance as it closely resembles the invitation cards produced by the sisters for the School of Art Club for its exhibition opening on Saturday 25 November 1893. At its centre is a tree of knowledge (a common bookplate motif and one which appeared repeatedly in much of Mackintosh's later work, either architectural or decorative), but the trunk of the tree is replaced by the figure of a naked woman whose source, as we shall see, is quite specific and crucial to the development of the Glasgow Style. Frances had, in fact, recently used this design (with subtle differences) in a bookplate for her own use. That version has the date 1763 (in Roman numerals) and had been inserted into a copy of Ossianic poems published that year. Ossian connects the sisters immediately with the fashionable interest in Celtic art, myth and poetry. The tree of knowledge was a Celtic image (that also appeared in many other cultures), and decorative ribbons were used

in Celtic imagery and metalwork. Howarth was the first to make a link between The Four and the Celtic Revival,[9] but there are actually few other references to Celtic imagery in the work of The Four. Admittedly, the young Mackintosh had plundered Celtic symbolism in his design for a gravestone for Andrew McCall in 1888, but The Four never adopted the Celtic strapwork that characterised the later phase of the Glasgow Style at the hands of a younger generation of School of Art graduates after 1900 such as Margaret Gilmour and De Courcy Lewthwaite Dewar. It is impossible to rule out a Celtic influence on The Four but, in my opinion, it is to be found only in a certain crudeness of handling in their later metalwork rather than as an academic study or awareness of the artistic output of the Celts. As we shall see, The Four were in fact reacting to new ideas and images from a more accessible source – *The Studio,* a new magazine devoted to contemporary fine and applied arts.

Although the autumn 1893 issue of *The Magazine* contained no more artwork or photographs of paintings by the sisters (and nothing by Mackintosh or MacNair), they themselves featured prominently in a short essay by Lucy Raeburn entitled 'Round the Studios'. In it she considers the paintings and other works to be submitted to the imminent School of Art Club exhibition and starts:

> To begin with, the brilliant sisters Macdonald have some work which ravished my artistic 'Soule', by its originality of idea, tho' perhaps in execution something is to be desired.
>
> The younger's colour schemes made me ask myself tenderly, 'Is it possible your eye for harmony is out of tune?' I never could abide crude blues, they always make me think of the wash tub. A very much woe-stricken soul would no doubt feel its grief embodied in her clever stained-glass window design, 'Despair', representing two figures who sorrow has worn them to shadows, and whose tears have watered their eyelashes, & made them grow to rather an alarming extent. Her 'Children blowing dandelions' was very charming, the bright effects made me dry my eyes, while 'Reflections' – well on reflection I will not say anything about it; too original for me to get the hang of.

This critique suggests that Frances Macdonald's exhibits for the School of Art Club show were similar in style to the bookplate

27. James Herbert
MacNair, *The Lovers*, 1893,
pencil and watercolour,
23.5 x 14.6 cm, untraced

and the invitation cards for the exhibition, although these three works could not be described as having anything wanting in their execution. *Ill Omen* may share the 'crude blues' mentioned by Lucy Raeburn, but it does not feature the stylised figures of the November graphics; also, it may be fair to say that the execution of the painting leaves something to be desired. It would seem, therefore, to predate the graphic works.

Raeburn next turned to Margaret's exhibits:

> The elder sister trotted out her productions next. 'Soldier, Sailor, Tinker, etc' is very charming in its unfinished condition, and to me is the nicest thing she has ever done showing great improvement and promise of better to come. Go on and prosper my Young Friends, I expect to hear of you in wider circles soon.

There is no real indication here of the style that Margaret was developing, or of whether her painting was similar to that of her sister. We can, however, infer that Frances was already somewhat more advanced than Margaret. It is clear from further comments made by Raeburn that the sisters already had a growing reputation among their contemporaries, but that their fellow students were not necessarily at ease with them artistically:

> I had hoped to do two visits that same day, but 'Tempus Fugited' so quickly in the company of the 'sweet girl artists with golden hair' as Tennyson has it, that the conclusion was — late for dinner again. I hope these remarks will be taken for what they are worth.

Raeburn continued:

> The nut-brown, who rejoices in the famous name 'Raeburn' [Agnes Raeburn, Lucy's younger sister] claimed my attention next afternoon. She is a very business-like young person, no afternoon tea to moisten my malicious tongue.

Had the Macdonald sisters expected a malicious tongue and prepared tea to sweeten it? Were they perhaps already seen as somewhat precocious – perhaps a little pretentious – by their fellow students?

The paintings discussed by Raeburn in her article have not survived; all that remains that is firmly datable to the end of 1893 are the Raeburn bookplate (30, and the variant for Frances herself) and two graphic designs, one by each of the sisters, announcing the School of Art Club exhibition (29, 31). All three of these images build on elements to be found in Mackintosh's work over the previous year: the attenuated figures, which surely show an awareness of the finger plates on the doors in the Glasgow Art Club gallery; the central image of a woman with wings or a tree with encircling branches; the use of long tendrils of plants or ribbons. All of those motifs seem to have appeared first in drawings, designs and paintings that Mackintosh made between September 1892 and the summer of 1893. Subsequently the women, however, took these various elements and developed from them a complete language, turning away from painterly motifs, from the narrative imagery of *The Harvest Moon* and *Ill Omen*, towards a linear and more decorative style. Although the new imagery is mixed – traditional forms such as the central tree of knowledge, the artist's palettes and musician's lyres, are combined with a novel decorative tracery of organic shapes and emaciated female figures with exaggerated limbs and hair – a new vocabulary is plainly discernible.

While one can identify individual motifs derived from Mackintosh within the School of Art Club invitations, his work does not seem to be the immediate source of the radical composition of the invitation cards. George Rawson[10] has pointed out the similarity in pose of these pairs of seated women to figures in an illustration in the September 1893 issue of *The Studio*[11] of a wallpaper design by C.F.A. Voysey, an architect and designer who was of considerable interest to Mackintosh, and obviously to Margaret and Frances Macdonald. Voysey's women sit in pairs, their backs against a tree, their heads bent forwards over their knees which are encircled by their clasped hands (28). His naturalistic rendering of these women, however, was not adopted by the sisters. Instead, they found inspiration fifteen pages further on in the same issue of *The Studio* in a reproduction of *The Three Brides*, a painting by a young Dutch artist, Jan Toorop (32).

In her foreword to the catalogue of the Memorial Exhibition in 1933 Jessie Newbery recalled the impact of these early editions of *The Studio* on The Four. She identified Toorop, Aubrey Beardsley, and Carlos Schwabe as giving 'an impetus and direction to the work of The Four'. Certainly, the women on the invitation cards produced by Margaret and Frances Macdonald for the School of Art Club take their poses from

28. C.F.A. Voysey, Design for a wallpaper frieze in *The Studio*, *c*1892–93

29. Margaret Macdonald, Invitation for a Glasgow School of Art Club 'At Home', 1893, lineblock, 13.1 x 15.6 cm, The Hunterian, University of Glasgow

30. Frances Macdonald, Design for a bookplate for Lucy Raeburn, 1893, pencil on tracing paper, 13.5 x 12.1 cm, Glasgow School of Art

31. Frances Macdonald, Programme of music for the Glasgow School of Art Club 'At Home', 1893, line block, 13.2 x 11.8 cm, The Hunterian, University of Glasgow

Voysey but their style from Toorop. The illustration of *The Three Brides* in *The Studio* was a line engraving rather than a half-tone reproduction and it emphasised the graphic qualities to which the sisters so readily responded.[12] The commentary on the painting, by Walter Shaw Sparrow, would also have appealed to the young Glasgow artists. He identified the sources of the painting as 'old Vedas and Eastern dramas – those ritualistic masterpieces of which we English know so little.' Sparrow continued:

[*The Three Brides*] illustrates what I will term the ever-lasting and universal antithesis of grace and disgrace of the pure and impure. To explain the allegory tellingly is out of the question because it is imperatively necessary, by our singular British conventions, scrupulously to respect the feelings of 'the Young Person' in all our magazines, though not by any means in all our newspapers. Yet I think I may venture so far as to say that Herr Toorop's idea was to contrast the Bride of Christ – i.e., the Church – with that Egyptian-featured person with the necklace of human skulls, whose position in life I will leave you to guess; while the third bride, the maid who seems to triumph is the type of guilelessness, innocence, loneliness, humility; in a word, she is the Bride of what is most divine in human hopes and thoughts and inspirations. The big ringing lily-bells, being emblems of purity, need no comment; and as for those whirling figures, some of whom (or is it *which?*) carry lilies, while others shriek, they are meant to typify the worldly influences of good and evil; but I cannot but wish that the artist had been less inspired by the queer puppets which used to amuse him as a child in Java. But yet, after all, his fancy may certainly have imagined those whirling figures thus, and we ought really to allow every man his nature, as Goethe once said aptly enough after finding fault with Schiller, his dearest friend. In the fantastic spirit of the design, one fancies there is much to interest even those critics and those artists who object to ideas in painting, while the unconscious and refreshing ingenuousness of the whole conception should appeal especially, one thinks, to the imaginative and simple students of 'Borderland'.

These are words that could be said to form the manifesto of The Four – particularly the emphasis upon ideas – giving them almost *carte blanche* as to their sources, their vocabulary (with its regular personification of good and evil) and their resistance to providing an explanation for their imagery.

For many writers on Mackintosh and on The Four, the impact of *The Three Brides* has become a given, and it demands more than a passing acknowledgement as it contains so many images and themes that explain much of the iconography of The Four over the next two years, removing the need to resort to conjectural accounts of convoluted interpersonal relationships. The three women at its centre – the brides – are attended by a dozen or so bridesmaids. The latter are stylised in their draughtsmanship, with elongated and scrawny arms, faces reminiscent of Egyptian carvings and sarcophagus paintings, and hair rendered in tightly grouped lines that describe its voluptuous waves. The same decorative motif is used to symbolise the waves of sound emanating from the bells at either side of the painting and in the hands of the two foreground bridesmaids; these waves course around the painting becoming interchangeable with, and indistinguishable from, the bridesmaids' hair. It is an archetypal vision of good and evil, a young woman presented with the choices between a spiritual life and one of earthly sensuality and evil. At the centre stands a naked figure of a slender young woman. Her attributes are roses, a full-length veil held in place with what seems like mistletoe, and butterflies at her feet – a figure that was to appear in several works by the Macdonald sisters and MacNair over the next ten years. Her handmaids ring bells to celebrate or announce her or proffer lilies, which are also offered to her innocent companion, on her right, who wears the garb and apprehensive countenance of a religious. To her left a sensual figure, with a knowing facial expression of malevolence and sexual experience, holds a charger into which is being poured an unappetising liquid from a vessel held aloft by the hands of the dead. The whole composition is enveloped in a vortex of stylised sounds – the sound of the bells and of the speech or breath that escapes from the rank of androgynous figures behind the three brides. The bridesmaids in the foreground float with arms outstretched, their legs – if they exist – sheathed in tubes of decorated cloth; one hand holds a bell, the other touches the petals of a chrysanthemum-like flower at the very centre of the composition which seems to be the source of the virgin's host of roses. Despite the complexities and many layers of the composition, the overall impression is of a flat decorative tapestry, where pattern and movement

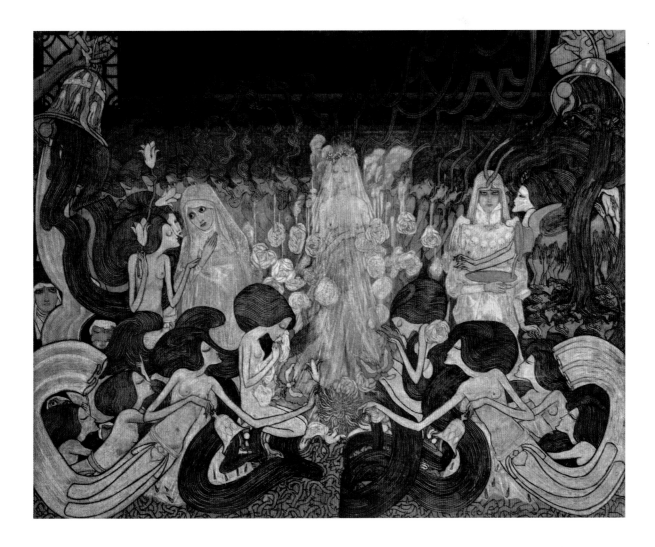

conceal, or enhance, the underlying subject; the viewer is aware, above all, of the strength of the design that holds the picture together.

This description of Toorop's painting could be applied to much of the work of The Four over the next three or four years. Roses, butterflies, naked women, evil wraiths, whirling tracery, a sense of good and evil, of innocence and sexual knowledge, the repetition of graphic motifs for decorative and emotional effect are all shared. The rose and the butterfly, in particular, appear in the work of Frances almost to the end

32. Jan Toorop, *The Three Brides*, 1893, black chalk, tinted, 78 x 98 cm, Rijksmuseum Kröller-Müller, Otterlo, Netherlands

of her life. These florid roses have even acquired a sobriquet – the Glasgow Rose. Each of The Four was to incorporate in their designs figures sheathed in tubular tunics that concealed legs and, often, arms; each encircled their figures with stylised frameworks as part of an overall decorative structure. Single women, often naked as in several of the sisters' later paintings, are juxtaposed with their opposites – youth and age, life and death, sorrow and joy, summer and winter. The Macdonalds' women, however, have little or none of the open sexuality of Toorop's brides, even when shown naked; they are de-eroticised, New Women like their makers. These are the real subjects of their work, fundamental truths about the human condition, not an account of a supposed struggle between two young women for the marital hand of

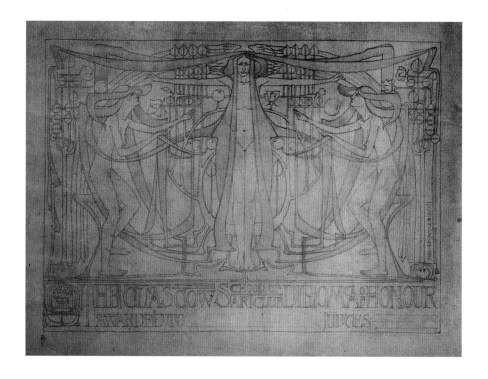

33. Charles Rennie Mackintosh, Glasgow School of Art Club Diploma of Honour, c1893, photogravure, 23.2 x 29.3 cm, The Hunterian, University of Glasgow

Mackintosh. Underlying all of this new work is the stylisation of the human form, begun by Mackintosh in the finger plates at the Glasgow Art Club, and taken to new extremes inspired by Toorop's wraiths and maidens.

Both Mackintosh and MacNair doubtless saw these articles and illustrations in *The Studio*, but only Mackintosh seems to have reacted to Toorop as quickly as the Macdonald sisters. He designed for the Glasgow School of Art Club a diploma that would be awarded to prizewinners in the annual exhibition (33). Although signed, it is undated and is usually ascribed to 1894 because it was shown at the Glasgow Institute in 1895, and the submission day for exhibits had been in early January of the same year. The style of lettering at the foot of the design, which has much in common with Mackintosh's lettering on his architectural drawings at the time, would suggest a more likely date of 1893. If this is so, it would mean that Mackintosh and the Macdonald sisters would have played central roles in the organisation of that year's exhibition, designing both its advance publicity and its prizewinners' certificate. Certainly, in these exhibition graphics The Four were presenting a novel and unified front. The diploma shares several characteristics with the invitation cards produced by Margaret and Frances, depicting three naked female figures bearing leaves and

apples set against a stylised framework of tree trunks and tendrils. The women's hair extends to the ground and then flows around the design linking all of the discrete elements. Although there are references here to Beardsley and the bride and bridesmaids by Toorop, the women share the pose of the supplicant Eve in the large painting made earlier in 1893, and still show the Renaissance influences which can be found in all Mackintosh's figure drawings of this date; it is possible that, as an architect, Mackintosh did not have access to the life-drawing classes at the Art School, hence his reliance on the powerful human forms to be found in reproductions of both the painting and sculpture of Michelangelo. Underlying the arrangement of the three figures here is a schematic arrangement of natural forms that seems to have its source in a large watercolour (34) that has been largely overlooked in any discussion of the development of The Four's iconography. Viewed in isolation it could be attributed to any of them, as its handling is uncertain and several of its motifs appeared in each artist's work over the next few years — seedpods, intertwined stems and tendrils, dandelion heads, feathered leaves, all set against a sun or nimbus of gold. The Diploma, however, also contains most of these individual elements — a tracery of stems, flower stalks bent

at right-angles, root structures contained within a square box – but presents them in a much more coherent, integrated and sophisticated manner. This watercolour is contained within the original collection of work by Mackintosh and Margaret Macdonald that formed part of their estate in 1933. I believe, therefore, that this 'strange plant form' was probably painted by Mackintosh at some point in 1893, perhaps inspired in its colouring and unusual symbolism by Frances Macdonald's *Ill Omen,* or, alternatively, was Mackintosh's response to another summer project set by Newbery in 1893: the architectural nature of this strange plant is not dissimilar to the underlying structure of the vegetation in *The Creation of Eve.*

More evidence of the effect of Toorop's painting can be found in Mackintosh's design for a meeting of the Glasgow Architectural Association that was probably made in the closing months of 1893 (35). Although the lettering has some affinities with that on the diploma it shows Mackintosh beginning to explore the potential of typography and fonts. The rest of the design is purely schematic: against a full circular sun rises a tree of knowledge and around it a flight of birds, probably swallows, circle in formation; from the same seed that the tree sprouts, a host of stalks and stems spread along the bottom of the design and then rise up each side to terminate in spiky flower heads. In its simple two tone colour, the design is as radical a statement as the invitation cards produced by the sisters a couple of months earlier.

So, by the end of 1893 The Four were beginning to work in a style that shared a common vocabulary. Their imagery was starting to extend beyond the usual range of that used by students, clearly distinguishing their work from that of their peers and at the same time making them a focal point for visitors to the Club exhibitions and the local critics. Surprisingly, the local press seems to have made no comment about the exhibits in the 1893 exhibition, but that omission was to be dramatically corrected the following year.

ABOVE
34. Charles Rennie Mackintosh, *Strange Plant Form*, c1893, pencil and watercolour, 56.8 x 37.2 cm, The Hunterian, University of Glasgow

BELOW
35. Charles Rennie Mackintosh, Glasgow Architectural Association: Conversazione Programme 1894, lithograph, 13.3 x 19 cm, Glasgow School of Art

36. Frances Macdonald, *The Crucifixion and the Ascension*, 1894,
pencil and watercolour, 122 x 105.8 cm, The Hunterian, University of Glasgow

3 GHOULS AND GASPIPES

A T THE NEXT ANNUAL EXHIBITION of the Glasgow School of Art Club, in November 1894, the Macdonald sisters were very much to the fore. They do not seem to have been involved in the publicity for the show as they had been in 1893, but their exhibits were of sufficient number to be allocated a room of their own, joined by work from Mackintosh and MacNair. Unfortunately, no catalogue for the exhibition survives and the plentiful press commentary does not provide enough detail to allow identification of particular paintings, although it does indicate that three-dimensional work was included in the exhibition. The sisters' exhibits provoked a press furore, and this, combined with the appearance of a group of posters designed by them around the same time resulted in their work becoming instantly recognisable to the exhibition-going public of Glasgow. The Glasgow Style was now firmly established.

Although we cannot identify the specific exhibits that aroused such attention – even animosity and certainly hilarity – in the press notices, we can gain a good idea of how they would have looked by tracing the development of The Four from the first appearance of the new style at the end of 1893. Almost all of the sisters' known or surviving work from 1894 is contained in two editions of *The Magazine*. These issues also include work by Mackintosh, but there is nothing from Herbert MacNair (nor in a subsequent issue in 1896). Mackintosh's adoption, as an artist, of the Macdonald sisters' new imagery was relatively gradual, even hesitant, as we can see from his (now lost) design for a cover, or perhaps a frontispiece (37), for the spring 1894 issue of *The Magazine*.[1] His naked women are much more fleshy than those of the sisters and are derived from the figure that appeared in the clouds of *The Harvest Moon* and from his study of the work of Michelangelo; while the Cabanel figure seems to be asleep, the two women here are stretching awake. They are awakening from the deep slumber of winter, and the stylised plants that surround them echo their movements. Stalks and shoots sprout from bulbs and corms to make a tracery around the women, terminating in flower buds. The figures and tendrils are silhouetted against a pale background above which is glimpsed a narrow segment of the rising sun. The imagery of the Spook School is thus confirmed as being rooted in organic shapes, stylised to create decorative patterns, combined with naked figures, usually female.

The work of the sisters in the spring 1894 issue of *The Magazine* consists only of photographs. The paintings depicted were each quite large, the product of several months' work, and they presumably had no small watercolours available to paste

into this issue. Frances's submission is similar in scale and complexity to Mackintosh's *The Creation of Eve;* the scale of Margaret's painting, *The Path of Life,* is unknown as it has not survived and is known only from the contemporary photograph. It is possible, given the content of all three paintings, that they were the result of a summer assignment, more likely emanating from Newbery to members of the School of Art Club rather than as part of the curriculum as the sisters and Mackintosh were not following the same courses. It seems improbable that either the sisters or Mackintosh would have been commissioned to produce such large-scale works for churches, given their youth and inexperience in such work. They all may have a religious or spiritual content but that is where the similarities end. Frances Macdonald's painting (36) was a large mural decoration perhaps intended for the chancel of a church. Its religious subject has obvious affinities with Mackintosh's *The Creation of Eve,* but that is where the similarity ends. This is a much more schematic composition, almost like a wallpaper design with repeating and reversed panels. The figures from the Gothic portals at Chartres reappear linking the various parts of the design, but other figures are much more stylised, closer in feeling to the bridesmaids in Toorop's *The Three Brides* (32). These angels, with their formalised wings and supplicant stance, are used as a repeated motif transposed in adjacent panels. Each group is enclosed inside an oval above which is another oval containing a rather more decorative design. The figurative elements compete with abstract geometric or organic patterns within these ovals, and schematised organic forms are placed above and below the paired sculptural figures of women. Mackintosh's celestial blue has been replaced by a funereal Roman purple, the colour of mourning. The photograph of Margaret's work (38) shows another religious – or at least philosophical – subject, designed as a leaded glass panel; it is recorded that she received a prize in 1894 at the School of Art for the design of a stained-glass window, though it is not clear for which one.[2] The composition is much more conventional than that of *The Crucifixion and the Ascension,* with the five figures arranged across the design in a symmetrical pattern, Toorop-like. Two angels, derived from the Chartres casts, flank a naked female figure, and two outer figures seem to be offering homage to the central three. Although the design is interrupted by the arrangement of the leading, elements of the 1893 invitations are still discernible in the extension of the hair of the two side figures, the stylisation of the angels' wings, and the absorption of all of these into

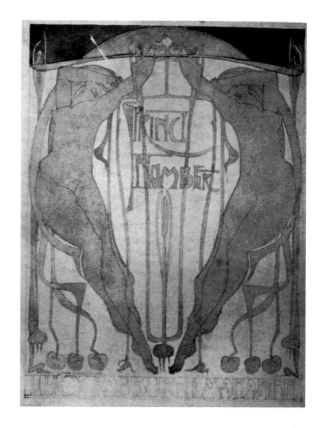

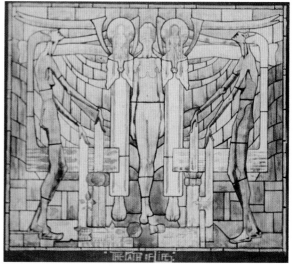

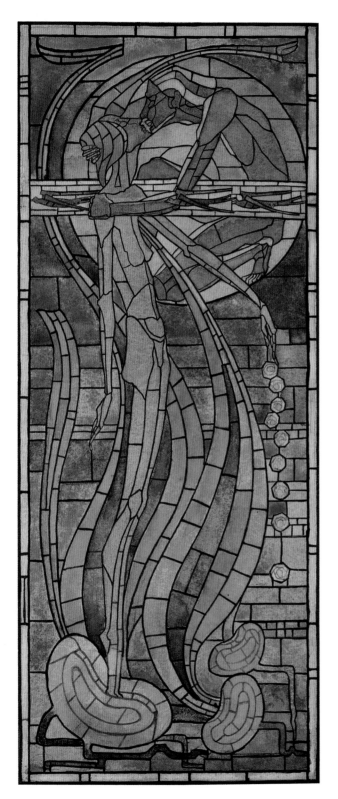

the overall surface pattern. These figures continued to appear in Margaret's work in various media over the next few years, gradually becoming less naturalistic and more decorative.

The second of Margaret's illustrations for *The Magazine* was a photograph of another watercolour that seems to have been made as a design for a leaded glass window – *Summer* (39). This is a markedly different painting from *The Path of Life*, less of a formal student exercise. It contains references to earlier works by both MacNair and Frances Macdonald, combining motifs such as the birds flying across a background moon from *Ill Omen* and the two embracing naked figures from MacNair's *The Lovers*. These figures assume the attenuated, even emaciated, forms of the women in the Glasgow School of Art Club invitations. Although the contact between the two figures is not as explicit as that in MacNair's painting, it introduces a sexual aspect to the sisters' work. The fecundity of summer is the subject of this painting, expressed in the vigorous plant forms and the sexual contact between the figures. It is another painting where stylised plant forms are used as decorative motifs – the kidney-shaped seeds at the bottom with fronds emanating from them that describe arabesques across the whole design. Margaret repeats the use of roses that had appeared in *The Path of Life*; here they tumble from the woman's left hand.

Sexual imagery can frequently be found in the work of The Four, either in a human or in a botanical context. Imagery with underlying sexual connotations would not be uncommon in the work of male students at the School of Art. It may have been subdued in straightforward life studies of the female nude but such paintings always contained hidden references for a Victorian audience. Many of the women in Pre-Raphaelite paintings have a sexually charged or provocative aura – and The Four are known to have been admirers of the Pre-Raphaelites.[3] The nude figure in paintings by Frederic

LEFT
39. Margaret Macdonald, *Summer*, *c*1894, pen and ink, pencil and watercolour, 51.7 x 21.8 cm, The Hunterian, University of Glasgow

OPPOSITE, ABOVE
37. Charles Rennie Mackintosh, *Spring*, by 1894, probably pencil and watercolour, untraced

OPPOSITE, BELOW
38. Margaret Macdonald, *The Path of Life*, by 1894, pencil and watercolour, untraced (photograph The Hunterian, University of Glasgow)

Leighton, Lawrence Alma-Tadema, Albert Moore and others popular with middle-class exhibition-goers in Glasgow were deemed 'respectable', but nobody was fooled. MacNair's *The Lovers*, however, would have been seen as shocking and the absence of contemporary comment on it suggests that he did not exhibit it in Scotland.[4] It was, however, very rare for such explicit sexual imagery to appear in the work of female artists, especially one so young as Frances Macdonald, but until about 1896 The Four can be identified with the use of naked female figures that are more than merely decorative. Janice Helland considers these naked women to be unerotic,[5] which may well be true, but they appear in so many situations within the work of the sisters at this time, and in contexts which do not demand the shedding of clothes, that we have to consider whether the Macdonalds were simply wishing to shock their audience for the sake of it. Contemporary press comment about these naked women held back from identifying an openly sexual content but reviewers and commentators readily drew comparisons with the work of Aubrey Beardsley – a sophisticated Glasgow audience would have recognised this coded reference and would have been prepared for the Macdonalds' imagery. (Toorop, who was an even more likely source, was not mentioned by the press due, undoubtedly, to their unfamiliarity with his work.) This openness about sexuality is what differentiates the Macdonald sisters from their friends Jessie Keppie, Agnes and Lucy Raeburn, Katherine Cameron and Janet Aitken, whose rather more douce work was regularly included in *The Magazine*. More overt sexual imagery is not uncommon in Mackintosh's work either. After all, the nude figure in *The Harvest Moon*, and other later watercolours, may have its source in Cabanel's *The Birth of Venus*, and Cabanel's eroticism was well known to a late nineteenth-century audience. The false modesty of Venus in this painting, her eyes open although she seems to be sleeping, the languid pose, all speak a language that Cabanel's, and Mackintosh's, audience would have understood. There is, however, a clear difference in the vocabulary of Mackintosh and the sisters at this date. The sisters were in the process of creating a new visual vocabulary, in which their androgynous women played a crucial part (representing, perhaps, the 'New Woman'), while Mackintosh still referred to a traditional, classical rendering of the naked female figure.

Two small watercolours by Mackintosh were included in the spring issue of *The Magazine* that show changes in his work, some reflecting the stylised patternmaking of the sisters and others Mackintosh's feeling for pictorial composition. *The Descent of Night* (40) is Mackintosh's entry into the imaginary world of the Macdonald sisters. The central figure, a naked female angel, or winged spirit, still betrays its classical sources but the pose is similar to that of the central figure in Margaret's *The Path of Life* – even down to the toe-less feet. If the figure has arms they are hidden in its outstretched wings or flowing hair. Her hair is transformed into decorative ribbons that fall down either side of the drawing to touch a band of purple paint that may represent the ground. Behind this band the sun is setting, pushed down by the figure – or is it a pale green moon rising that is, in fact, supporting the winged figure? She represents night and her supporters, a rank of abstracted flying birds, advance out of the painting towards us. We shall encounter these birds several times in Mackintosh's (and particularly MacNair's) later work, in furniture, watercolours and even sculptural decoration in his buildings (when he entered the competition to design a House for an Art Lover in 1901 his pseudonym was Der Vogel, the bird). The pale purples and eerie greens of twilight are from the same palette that MacNair, Frances and Margaret were using, and similar colours appear in Mackintosh's other contribution to this issue of *The Magazine*: *Cabbages in an Orchard* (41). This can be viewed as a relatively straightforward piece of landscape painting, inspired perhaps by the cabbage gardens of the Glasgow Boys. It is by no means as robustly painted as work by the Boys, having a strong design but an ethereal, unearthly quality emphasised by its transparent washes and ambiguous perspective. Individual elements from it would re-appear in Mackintosh's watercolours over the next decade. Unusually, Mackintosh wrote a short descriptive essay to accompany it in which he attempts to pre-empt anticipated criticism. As by the spring of 1894 there had been no public comment on the new style adopted by The Four, it seems likely that Mackintosh was reacting against criticism from his tutors, or more likely his peers, specifically the other contributors to and readers of *The Magazine*. A certain antipathy can be inferred from Lucy Raeburn's interview with the Macdonald sisters in 1893; perhaps this broadened to include Mackintosh

40. Charles Rennie Mackintosh, *The Descent of Night*, by 1894, pencil and watercolour, 24 x 17 cm, Glasgow School of Art

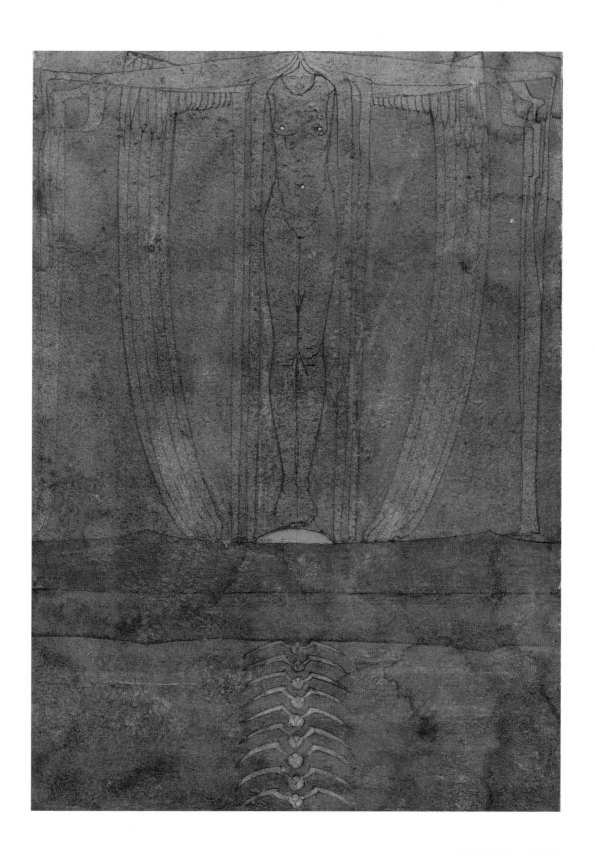

and, presumably, MacNair. Mackintosh's polemic is light-hearted and sometimes humorous in its rebuttal of potential criticism, but it is evidence of his concern, and what he writes is as much a defence of the work of the sisters as his own:

Cabbages in an orchard
The above title explains the picture on the opposite page but to satisfy the ordinary reader I am forced to give the following explanation.

The before mentioned kind of reader may imagine that the cabbages here shewn are the usual kind of everyday cabbage, or as some people call it 'common or garden cabbage', but that is just because they never see cabbages unless when they are not growing. The cabbages in this orchard are different – they have stood through a severe winter of snow, and hail, and frost, and thunder: they have stood through a spring lasting three months, and raining all the time, before they had time to dry in an ordinary way the sun came out with frizzling ferocity – yet still they stand.

A glance at the sketch will convince anyone – (although it conveys but a poor render of the rich variety of colour, the beautiful subtlety of proportion and infinity of exquisite form) – that the cabbages here shewn are a particularly hardy and the long-suffering kind.

Neither is the orchard a common kind of orchard. I explained this because some people may not distinguish between cabbage and orchard, and will grumble accordingly. They may be right, the trees are old trees, very old trees, they are far away from any other trees, and I think they have forgotten what trees should be like.

You see they have lived alone for a long time with nothing to look at but cabbages and bricks, and I think they are trying to become like these things. That at least is what their present appearance would suggest, (and the sketch suggests the same thing in a less perfect way). I know this much, I have watched them every day this winter and I have never once seen an apple, or an orange, or a pear on one of them, and I have seen clothes – and what is more I have seen mud – and a brick maker once told me that bricks were made of mud. The mud I saw must have been the beginning of bricks.

I will explain before concluding, that anything in the sketch you cannot call a tree or a cabbage – call a gooseberry bush. And also that this confusing and indefinite state of affairs is caused by the artist – who is no common landscape painter, but is one who paints so much above the comprehension of the ordinary ignorant public, that his pictures need an accompanying descriptive explanation such as the above.

C.R. Mackintosh

Why cabbages? Is this, as already suggested, an oblique reference to the frequent subject matter of the Glasgow Boys – and many lesser painters who followed them in the so-called Kailyard School? Or is the imagery referencing

41. Charles Rennie Mackintosh, *Cabbages in an Orchard*, 1894, pencil and watercolour, 8.6 x 23.6 cm, Glasgow School of Art

something closer to home? Does Mackintosh see the School of Art as the orchard; are his critics the trees – the staff and other students from whom Mackintosh has discerned no fruit for some time, indicative perhaps of their lack of imagination. After all, 'they have forgotten what trees [artists] should be like'. Are the cabbages The Four? They are 'different' and have withstood the winter, they are particularly hardy and long-suffering. They also have a 'beautiful subtlety [...] and infinity of exquisite form'. *Cabbages in an Orchard* is perhaps a declaration of the independence of The Four.

Mackintosh contributed three more drawings to the November issue of *The Magazine* in 1894 and the sisters each showed one watercolour. Apart from these submissions to *The Magazine*, few of his drawings or watercolours (other than those that Mackintosh made in his architectural sketchbooks) survive from this year. Two of the drawings in *The Magazine* show his growing fascination with trees, developing the shapes used in *Cabbages in an Orchard* and moving towards even more stylised forms. *Landscape with a Stylised Tree* (42) is painted with thin, liquid washes over a pencil drawing of the tree trunk and branches, stylised here into the kind of tracery to be found in other watercolours by The Four in *The Magazine*. The palette is similar to that of *Cabbages in an Orchard*, muted greens and blues, but with occasional splashes of colour – red and lilac depicting flowers in the foreground – and the bright blue kite-like shape in the canopy of the tree. *A Tree* (43), with its deliberate use of the grain of the paper to enhance the effect of the colour, suggests that Mackintosh has been looking at the blottesque watercolours of Arthur Melville (1855–1904). Watercolour artists often use the surface grain of their paper to enhance the effect of their washes. Melville was the contemporary master of this technique and his watercolours were regularly exhibited in Glasgow. Again, Mackintosh overlaid simple washes on a pencil drawing, with the structure of the tree becoming ever more stylised, the overlapping branches forming rhythmic abstract patterns which were to become a common motif in Mackintosh's work over the next few years. Another tree, this time a pencil drawing, appears in the November issue of *The Magazine* (44). It is a relatively straightforward drawing, probably taken from one of the sketchbooks that Mackintosh filled on his holiday trips around England and Scotland drawing examples of vernacular architecture. What has obviously caught Mackintosh's eye here is the way the tree trunk suddenly breaks into several stunted limbs each rubbing against another. The tree appears to be dead, but Mackintosh celebrates the vitality of its previous

years of growth. By emphasising the haphazard arrangement of the branches with very little modelling to suggest three dimensions, he has deliberately created a flat pattern.

Autumn (45) was used as a frontispiece to this issue of *The Magazine*, perhaps correcting the omission of *Spring* from the earlier issue. The figure that we see here is entirely stylised; only her face is recognisable as human, and her arms and legs are hidden within her flowing cloak. She is posed against a dusky red sun, another repetition of the arrangement first used by Mackintosh in *The Harvest Moon* in 1892. The figure is overlaid with a leafless tree form, its trunk rising out of an underground corm and splitting into boughs and limbs as it rises through the drawing. Two branches support cartouches that appear to contain stylised versions of the Glasgow coat of arms. This is the most abstract pictorial design that Mackintosh had produced by this date. It owes something, in the design of the vegetation, to the elaborate arrangement of linear shapes at the centre of Frances Macdonald's *The Creation and Crucifixion*, illustrated in the spring 1894 issue of *The Magazine*. In his choice of a coarse rag paper as a support for his drawing and the way that it, in turn, is mounted on a similar sheet of blue paper – different from all the other pages of *The Magazine* – Mackintosh shows that he is aware of the power of presentation and the continuity of ideas beyond the simple marks on the page. A similar attention to design is obvious in his final contribution to this issue of *The Magazine* – an untitled drawing of a strange-looking plant,[6] today known simply as *Stylised Plant Form* (46). The arabesques, horizontal and vertical lines of its thin stems are countered by heart-shaped leaves and the delicate petals of flowers. Washes of a bluish purple and green reinforce the eeriness of the subject.

Margaret and Frances were as adventurous as Mackintosh in their exploration of outlandish subjects. Their two water-colours, *A Pond* by Frances (47) and *The Fifth of November* by Margaret (48), would have perplexed their audience just as they have continued to provoke speculative discussion over the last fifty years. Frances produced a carefully controlled composition incorporating lettering within discrete boxes formed from different elements within the design. It seems an unusual subject for an autumn issue of *The Magazine* as, like Mackintosh's unused spring cover, it celebrates birth and new life. At its centre are two supplicant figures whose attached and diaphanous wings identify them as dragonflies emerging from the nymph stage. In nature, this transformation takes

42. Charles Rennie Mackintosh, *Landscape with a Stylised Tree*, *c*1894–95,
watercolour, chalk and pencil, 42 x 31.3 cm, untraced

43. Charles Rennie Mackintosh, *A Tree*, 1894, watercolour, 33.8 x 18.9 cm,
The Hunterian, University of Glasgow
44. Charles Rennie Mackintosh, *Tree*, 1894, pencil, 17.2 x 11 cm, Glasgow School of Art

45. Charles Rennie Mackintosh, *Autumn*, 1894,
pencil and watercolour, 28.2 x 13.2 cm, Glasgow School of Art

46. Charles Rennie Mackintosh, *Stylised Plant Form*, by 1894,
pencil and watercolour, 25.5 x 10.7 cm, Glasgow School of Art

place on a plant stem – here they have escaped the murky waters of the pond for their brief life on land and in the air. Behind them floats a group of eight tadpoles, each waiting for its opportunity to escape from the pond. The long tails of the tadpoles form the kind of tracery we have come to expect in such Glasgow Style designs, but here it is emphasised and enlarged by the figures' blossoming hair which joins the tadpole tails at the bottom of the pond. The subject is again fecundity and birth, even though the two human shapes within it are shown as asexual. While Toorop's influence is much in evidence here, the schematic design is suggestive of Mackintosh's *Autumn*, although Frances's composition is much more assured. Margaret's watercolour, *The Fifth of November*, shows a similar pair of attenuated figures, again with long expressive hair, but this time with full breasts. 5 November was Margaret's birthday and the watercolour is perhaps more personal than a simple celebration of Guy Fawkes Night. The ambiguity is maintained, however, in the rocket-like tears placed between each head and the ground below. If they are tears they are upside down, as the rounded droplet should be at the bottom and the tail above. So are they rockets, rising from the ground below and aimed at each head? If they are inverted tears, they and the adjacent tails of hair fall upon the ground, upon a hillock that conceals within it the rather sad face of a woman. Neat suggests a further ambiguity: the woman is presumably Margaret, but the exaggerated lips suggest the moustache of Mackintosh. Whatever the interpretation, the symbolism contained in *The Fifth of November* is undoubtedly personal but still elusive.

MacNair's work never appeared in *The Magazine* but he was certainly working in a similar manner in 1894. Although undated, one surviving watercolour from this period (49) shows how fully MacNair had adopted the new style – as with *The Lovers* he takes it to new extremes, pushing the boundaries of what Mackintosh and the sisters achieved in 1894. Very little of his early work in watercolour survives, but that which does supports the proposition that it may have been MacNair leading the move towards these exotic subjects and that his

OPPOSITE
47. Frances Macdonald, *A Pond*, 1894, pencil and watercolour on grey paper, 32 x 25.8 cm, Glasgow School of Art

RIGHT
48. Margaret Macdonald, *The Fifth of November*, 1894, pencil and watercolour on grey paper, 31.5 x 19 cm, Glasgow School of Art

three friends were following him. He is often overlooked, both because as a painter he is the weakest of The Four in terms of technique and draughtsmanship and because much of his early work was lost in a fire around 1895–96 and was thus hardly known until the recent emergence of a few surviving pieces from this period; his imagination, however, surpasses that of his colleagues. *The Fountain* (49) has been attributed in the past to the Macdonald sisters, but its handling and the ferocity of its imagery support more recent attributions to MacNair and a date of *c*1894. As in so many of these early Glasgow Style watercolours, the composition is divided in two vertically, each half overseen by a naked female figure with billowing hair. Water streams from the women's eyes appearing to form two columns falling into a pool below. On the left a naked female figure appears to be siphoning off some of the water, while on the right a naked and kneeling male figure looks up towards the top of the fountain. Behind each of these figures lies a malign landscape while at the bottom of the painting two vultures in flight attack each other. Is this a fountain of life or is it the source of a great flood?

Although *The Fountain* was not included in *The Magazine* at the end of 1894, it was probably shown in the annual exhibition of the Glasgow School of Art Club alongside work by the Macdonald sisters and Mackintosh. This was the exhibition that introduced them to a wider public beyond the confines of the school, but the response was by no means polite and respectful. Every year Newbery invited a well-known artist or craftsman to address the members of the Club at the opening of the exhibition; in 1894 the honour went to Alexander Roche. In what was probably meant as a light-hearted speech he paid special attention to the work in the room devoted to The Four. Having recently completed a very large allegorical painting called *Idyll*, Roche was not going to object to the exhibits at the Club because of their emphasis on spiritual ideas or unconventional imagery. His speech certainly does not deserve Ray McKenzie's dismissal of it as 'venomous' (in the publication, *Glasgow Girls*, that accompanied the 1990 exhibition of the work of women in the arts in Glasgow).[7] But Roche did wonder aloud whether some of the exhibits might be better suited to the graveyard and claimed that one of his fellow judges was now ill from nightmares;[8] he suggested to

49. James Herbert MacNair, *The Fountain*, *c*1894,
pencil and watercolour, 41.2 x 16.4 cm, The Hunterian,
University of Glasgow

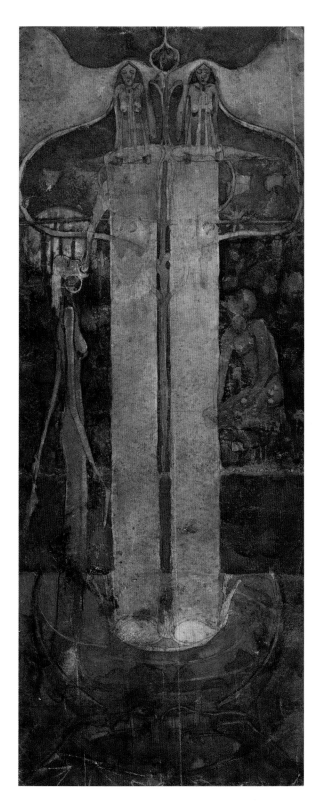

Newbery that future judges should be pressed to 'put down that ghoul-like sort of thing'. Newbery quickly defended his students, claiming that he actively encouraged them in their explorations. The press rarely paid attention to the School of Art Club exhibitions, although they were open to the public in the Glasgow Institute's galleries on Sauchiehall Street, but sensing something of a controversy two local journals – *Quiz* and *The Bailie* – immediately picked up on Roche's remarks. These two weekly magazines mixed political and social comment, cultural reviews and society gossip, and this new exhibition gave them plenty of scope on several levels. Both journals sensed a story that could be treated in a satirically humorous manner without fear of the kind of stinging comeback that might emanate from a more professional or celebrated target:

> As to the ghoul-like designs of the Misses Macdonald, they were simply hideous, and the less said about them the better. Decidedly the authorities should not halt till such offences are brought within the scope of the Further Powers.[9]

The 'Further Powers' referred to was a parliamentary bill intended to enlarge the power and remit of the police in dealing with social unrest in Glasgow. It was a frequent topic in these magazines, referred to more out of derision than for enlightenment, and by associating the art in this exhibition with such a hot topic the editors were sure of a ready audience. *The Glasgow Evening News* was quick to point out that giving publicity to Roche's remarks would generate more interest in the exhibition, and its editor provided his own poetic contribution:

> Would you witness a conception?
> Of the woman really New
> Without the least deception
> From the artist's point of view
> See the Art School Exhibition
> In the rue de Sauchiehall
> They don't charge you for admission
> (For they haven't got the gall)
>
> As painted by her sister
> Who affects the realm of Art
> The Woman New's a twister

> To give a nervous man a start
> She is calculated chiefly
> To make him really think
> That he's got 'em and that, briefly,
> It's the dire result of drink.
>
> For if Caliban was mated
> With a feminine gorilla
> Who her youth had dissipated
> O'er the book yclept the Yellow
> The daughters of the wedding
> Would be something such as these –
> Sadly scant of fleshly padding
> And ground-spavined at the knees.
>
> But the dodge is very easy
> If of conscience you're devoid
> Take a supper—if it please you—
> Of roast pork and liver fried
> From the nightmares that will follow
> Paint impressions in pale green
> Of the hags who sought your pillow
> Spectral, hideous and lean.
>
> Let them waltz across your paper
> In a weird Macabre dance
> Or perform some fiendish caper
> With the Beardsley leering glance
> Let their slim limbs sprawl erratic
> And eschew all kinds of dress
> If the whole thing's idiotic
> Then your picture's a success!
>
> If you're asked for explanations
> Talk vaguely of design
> Or adopt a few evasions
> About temperament and line
> But if nothing save confession
> Of your real intent will do
> Say the hags are your impression
> Of the Women who are New.[10]

There were targets aplenty in this doggerel that the readership of *The News* would immediately recognise. 'New Women' featured regularly in the satirical columns of newspapers and

magazines of the day, early feminists who adopted masculine clothes, habits and manners and were rejected and ridiculed for their simple claims for equality with men. It was easy to label the Macdonald sisters with this tag, after all they were students at the School of Art where many such women received a modern education and they adopted what *The Evening Times* was quick to deride as a 'most aesthetic' mode of dress.[11] The references to *The Yellow Book* and Beardsley, already notorious in most middle-class minds, would have further associated the sisters, and Mackintosh and MacNair, with subversive thinking.

The correspondence columns, the perennial home of those who 'know what they like', soon joined in. We can be grateful to one of them for giving us some insight (however uncomplimentary) into the content of the exhibition:

Imagine human-beings drawn on the gas-pipe system— arms, legs and bodies of the same skinny pattern with large lips and immense hands. The background of one of these masterpieces consisted of various parts of anatomy subjects, floating about in an objectless manner in a sea of green mud.[12]

Another targeted the exhibition's three-dimensional work by 'the architectural members of the school', presumably Mackintosh and MacNair, whose work is described as 'so alarmingly unique and bizarre that their adaptation for the furnishings of a room would surely create within the tenant thereof a species of disease bordering on "delirium tremens".'[13]

The four artists must have hoped that this fuss in the press would die down with the closure of the exhibition but they would already have been aware of other events that were likely to add fuel to the fire. The Glasgow Institute had commissioned from them a pair of posters to advertise the annual exhibition that would open at the beginning of February 1895. Why The Four were chosen is not known; perhaps it was because of the attention they had gained from their exhibits at the Glasgow School of Art Club exhibition, though it is just as likely that they were selected through Newbery's recommendation. *The Bailie* announced on 16 January 1895 that the Institute would host a display of modern posters of which two would advertise the Institute itself. It cannot have been a coincidence that Alexander Reid, a Glasgow art dealer (and former Paris room-mate of Vincent van Gogh), would also exhibit a group of modern posters in his Glasgow gallery that same month. His exhibition included not only the Glasgow Institute posters by The Four but also designs by Aubrey Beardsley, Dudley Hardy, Toulouse-Lautrec, Théophile Steinlen and Jules Chéret. But it was the exhibition of posters by The Four at the Institute that attracted most press comment – or rather, derision.

At least one other poster by the Macdonald sisters was included in the show, designed for an umbrella manufacturer, Joseph Wright, whose trademark was 'Drooko' (50). The weird plants which had often appeared in earlier Glasgow Style works are seen here in gigantic format, a visual pun on their taxonomic name, 'umbelliferous'; they also appeared, alongside a less stylised figure, in Mackintosh's poster for the Institute. The division of the Drooko poster into panels of lettering and images recalls the design of Frances's *A Pond* and it seems likely that, although both sisters signed the poster, Frances took the lead. Mackintosh's poster for the Institute (51) has a more naturalistic appearance, which did not stop the newspaper critics from comparing it to Beardsley – in their eyes certainly not a compliment. There were the by-now-usual calls for the involvement of the authorities in the suppression of this poster – in fact, it was reported that the magistrates would have removed the poster were it not for its designer's 'influential relatives in the police force'.[14] A second poster for the Institute was a joint production by the Macdonald sisters and MacNair, the first time that the three of them had publicly collaborated (52). In many ways this was a more successful design than Mackintosh's, incorporating the schematic division from *A Pond* with other motifs – an angel, roses, and the hovering falcons that became a favourite image of MacNair's – that can be found in earlier work by these three artists. This poster has a confidence and maturity in its design that is a major step forward; it was a portent of further collaboration between these three, in all of which work it becomes increasingly difficult to identify discrete hands. Together they were developing a homogenous style palpably different from their individual pieces of the period, and slowly growing away from Mackintosh who rarely collaborated with the others at this date.

The press was quick to recognise that these posters were a continuation of the themes seen at the School of Art Club exhibition the previous November, and *Quiz* magazine again resorted to doggerel to poke fun at the young artists:

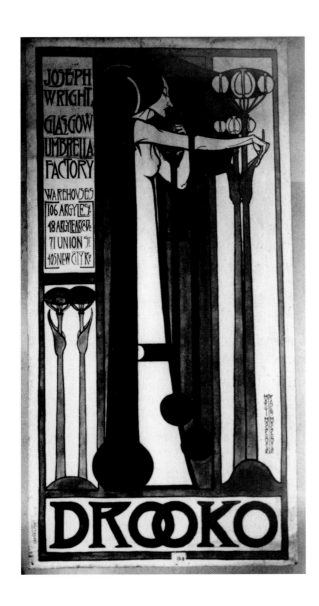

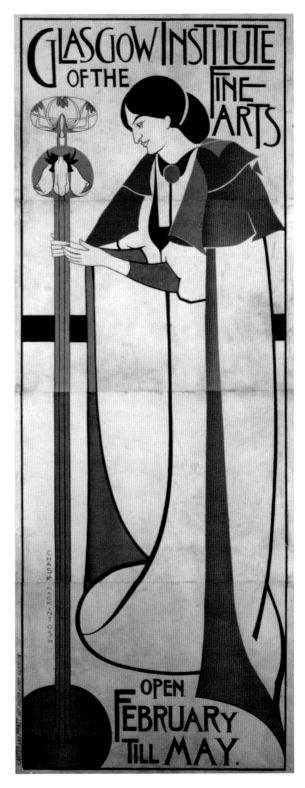

ABOVE
50. Frances and Margaret Macdonald, Poster for 'Drooko' umbrellas, 1894, ?colour lithograph, untraced (photograph The Hunterian, University of Glasgow)

RIGHT
51. Charles Rennie Mackintosh, Poster for the Glasgow Institute of the Fine Arts, 1895, colour lithograph, 223.8 x 89 cm, The Hunterian, University of Glasgow

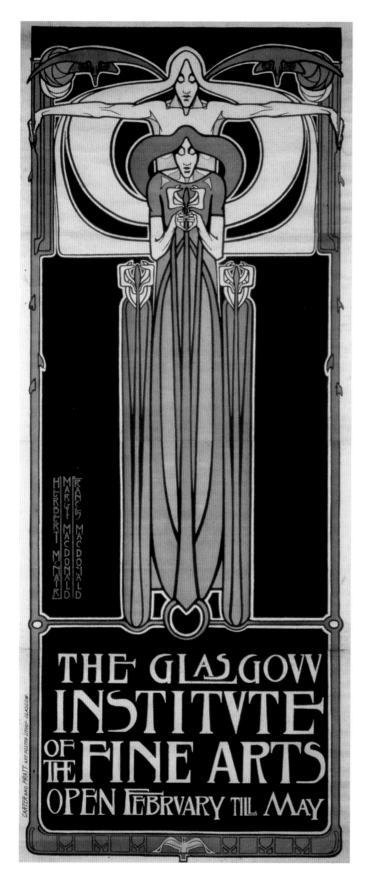

One day as I gazed at a hoarding
My soul was filled with dread
For I looked on an Art School Poster
A poster comprised of a head
With lines attached that seemed to fall
In somewhat aimless ways –
It was the crazy Aubrey Beardsley
No – the Aubrey Beardsley craze.

But no, I thought, 'tis no Woman
'Tis a map of the new subway
With the down lines red, and the up lines black
Made in a style to pay.
What I took for a head is the City
And the staff is the Mileage scale
Yet I felt my words were idle
For I feared 'twas no plan of the rail.

That night I returned from a concert
Of a scarcely clerical kind
And I gazed again at the hoarding
Great Whistler! What horrors I find –
A two-headed serpentine dancer
Most ghoulishly grins down at me
I've got 'em again cried I wildly,
So that's why I became T.T.[15]

On the basis that 'no publicity is bad publicity', The Four could only benefit from the attention the new graphic work attracted. It certainly seems not to have harmed their chances of future commissions as one of Mackintosh's most effective poster designs was ordered by *The Scottish Musical Review* in 1896 (53). This is a design that owes something in its layout to the MacNair and Macdonald Institute poster but even more to the watercolour – *Autumn* – that Mackintosh made for the November 1894 issue of *The Magazine*, showing how he was happy to translate ideas from one medium and scale to another, as were his companions. Newbery's public backing of his former students notwithstanding,[16] there were to be few other commissions for posters (despite their inclusion in poster exhibitions in London, Paris and Reims), or perhaps the artists were too busy to accept them.[17] Although a few large-scale drawings survive they do not seem to have been put into mass production.

The Four would have undoubtedly preferred a more congenial introduction to the public but at least they now had a public face that would be recognised in future exposure, and a reputation that might generate future sales as they embarked upon a career outside the School of Art. For in the summer of 1894 the Macdonald sisters completed their course at the School and a new phase of their lives began, culminating in them working from a shared workshop at 128 Hope Street, Glasgow; Mackintosh had stopped attending the School's classes the year before and had a growing role within Honeyman & Keppie; only MacNair retained a direct link with the School as a student until 1895, although he also had a studio near the sisters on West George Street. The new work of The Four would no longer be aimed at the School of Art Club audience but at a wider, more critical public who, through their patronage, put the new Glasgow Style, and its members, to the test.

RIGHT
53. Charles Rennie Mackintosh, Poster for *The Scottish Musical Review*, 1896, colour lithograph, 240 x 95 cm, The Hunterian, University of Glasgow

OPPOSITE
52. Frances Macdonald, Margaret Macdonald and Herbert MacNair, Poster for The Glasgow Institute of the Fine Arts, 1895, colour lithograph, 236 x 102 cm, The Hunterian, University of Glasgow

54. Frances Macdonald, Margaret Macdonald and James Herbert MacNair, *Vanity* mirror, 1895, beaten lead on wood frame, 109 x 109 cm, Glasgow School of Art

4 COLLABORATIONS

IN SEPTEMBER 1893 Fra Newbery achieved a long-held ambition – the opening of the Technical Art Studios at the Glasgow School of Art. He had been working on the project for nearly three years, negotiating funding from his governors and extra accommodation from the Corporation art gallery with which the School shared space in the McLellan Galleries on Sauchiehall Street. In 1889 Newbery presented a paper at the Edinburgh meeting of the National Association for the Advancement of Art – 'The Place of Art Schools in the Economy of Applied Art' – in which he mused on the purpose of schools of art. He identified many of the problems facing practitioners of painting and the shortcomings of the newly trained industrial designer:

> The picture producer objects that the country is being flooded with specimens of work executed by half-taught or wholly ignorant students, whose burning ambition is to be at one end of the brush, without the slightest knowledge of what is going on at the other end, and the market placed at a discount, as far as good work is concerned, by a crowd of dilettanti, chiefly of the young lady order, who can paint nothing, are quite willing to execute this nonentity for nothing, and who care for nothing except that their friends will accept of their productions at the cost of nothing. The manufacturer objects on the ground that the workman or designer comes to him crowded and crammed full with the crop of ready-made ideas which are not of the slightest value to him or his trade, and that, whilst in the full possession of these ideas, the very ABC of his profession has been left unlearnt; that he can design a carpet or a cathedral with equal facility, and yet cannot correctly draw a flower from nature or rightly set down the proportions of the classic order. All this may be, and probably is, true, but such a state of affairs has been brought about, not by the use but by the abuse of Schools of Art.

He believed that the solution to these continuing problems lay in introducing a different emphasis to the training of future students:

> Schools of Art should have nothing to do with the direct production of picture painters. Their function is to ensure that the student shall draw and paint to the best of their ability to teach him. That is, to draw and to paint not in and after some antiquated method, but with every care that his individuality and method should be nurtured and cultivated; and, should he care to become an artist, that should be his own affair.

But Art has other issues than picture painting. Certainly, says the manufacturer, there is the field of design and one of the uses of a School of Art is to supply me with designs for my particular manufacture; and although its existence is to meet the needs of the surrounding population, in this respect I find Schools of Art of no service to me. Neither of necessity should they be. Schools of Art exist, and in this respect exist rightly, not for the immediate production of designs, but of designers. They are not commercial but artistic institutions, with ideas and aims which should be ever of the best, and whose efforts should be directed, not to supplying the demands of the public taste, but of endeavouring to educate that taste by an acceptance of the fact that good art and public taste are not usually synonymous terms and in this really lies [*sic*] the true functions and place of a School of Art. Picture painting is for the few, but beauty in the common surroundings of our daily lives is, or should be, an absolute necessity to the many; and to educate alike the producer to send out, whether from loom, bench, lathe, or wheel, articles which shall possess an intrinsic value in the art they contain, and the consumer to appreciate such beauty as lies therein, is to teach the gospel which shall have for all men a like salvation.

Newbery's new workshops would provide courses in majolica, book illustration, glass staining, pottery, wood carving, bookbinding and mural decoration, under the direction of Aston Nicholas, the design master, in addition to the classes on repoussé metalwork taught by William Kellock Brown. The School of Art and its associated Haldane Academy already had a major commitment to the design training of workers in manufacturing industry, but Newbery wanted to extend such classes to the students in his diploma courses. He was a keen supporter of the English Arts and Crafts Movement and was committed to the professional training of his students in its disciplines; he regularly invited key figures in the Movement, among them William Morris, Walter Crane and Lewis Day, to lecture in Glasgow and meet his students and staff. Newbery was involved in various events and exhibitions supporting the Movement in Glasgow and in 1895, in one of these, he saw the first public success of his new project: an Arts and Crafts exhibition at the Queen's Rooms, Glasgow, from 6 to 11 April. It comprised a very large amateur section and a smaller section for professional designers and manufacturers, among whom The Four were to make their first public appearance.

As avid readers of *The Studio*, The Four would almost certainly have seen the article by Nelson Dawson in 1894 where he demonstrated the simple techniques of repoussé work.[1] The Macdonald sisters would have attended Kellock Brown's classes on repoussé metalwork, and Mackintosh certainly knew Kellock Brown, who made the finger plates designed by Mackintosh for the doors in the Glasgow Art Club, the earliest appearance of the attenuated or anorexic female figures from any of The Four. We do not know whether Mackintosh or MacNair attended any of Kellock Brown's or other classes in the Technical Art Studios, but they must have received some instruction as they each showed examples of beaten metalwork in the Queen's Rooms exhibition. Both men, and possibly the sisters, exhibited some three-dimensional work in the 1894 exhibition of the School of Art Club (and some of those pieces may have been re-exhibited at the Queen's Rooms the following year). So it comes as little surprise that most of the work submitted by The Four to the Queen's Rooms exhibition was in beaten metal.

The imagery in the metalwork exhibited in 1895 is firmly based on the watercolours that The Four had produced since 1892–93. In fact, so well did this imagery transfer to beaten metal that it might be fair to say that the most memorable (and publicly visible) works of the Glasgow Style were repoussé metal pieces rather than paintings. What these pieces also confirmed was the practice of collaboration between the individual artists. MacNair and the sisters had collaborated on the Glasgow Institute poster earlier in 1895, and the sisters had worked together on the 'Drooko' poster. In this new work the collaboration of MacNair and the Macdonald sisters went a step further. The posters bear no evidence of individual hands, and among these three-dimensional pieces there is only one item, the *Vanity* mirror, that is jointly attributed; other items contain metal panels attributable to each sister or MacNair. Mackintosh does not at this stage seem to have collaborated either with his fellow architect or with the Macdonald sisters. What his exhibits did include, however, were designs for wallpaper that seem to have been printed by Percy Heffer, a well-known London wallpaper manufacturer. This appears to have been the first (and possibly only) occasion on which one of The Four was involved with a collaborator from the national Arts and Crafts Movement – Heffer is known to have produced several wallpapers from designs by C.F.A. Voysey.

The *Vanity* mirror (54) is the most important exhibit by The Four in the 1895 exhibition. It is unequivocally attributed to the Macdonald sisters and MacNair, and it is not possible to identify individual hands in either the design or the execution of the piece. Given the medium here, the design must have been arrived at before work began on making it; a drawing or painting can be altered during execution, but it is much more difficult to do this while working on a metal panel. It is, therefore, a truly collaborative piece. The screen, *The Birth and Death of the Winds* (55), shows a different kind of collaboration. The catalogue attributes it again to MacNair and the Macdonald sisters, but MacNair is described as the designer of the woodwork and the panels are attributed to all three artists. Only one of the metal panels can be seen clearly in contemporary photographs, and it is consistent with earlier work by MacNair; a drawing (56) clearly shows the rank of emaciated women that can be found in MacNair's watercolour, *The Lovers* (27). Surviving drawings for other panels[2] are less clear but they do suggest two different hands – one, for instance, shows a panel attributable to Margaret Macdonald (57) – and it seems that the three artists made one panel each. Another screen, unidentified but probably the

LEFT
55. James Herbert MacNair, Frances Macdonald and Margaret Macdonald, *The Birth and Death of the Winds* screen, by 1895, wood with beaten metal panels, untraced

RIGHT, ABOVE
56. James Herbert MacNair, Design for central panel of *The Birth and Death of the Winds* screen, by 1895, pencil on tracing paper, 36.3 x 53.2 cm, The Hunterian, University of Glasgow

RIGHT, BELOW
57. Margaret Macdonald (attributed to), Design for right-hand panel of *The Birth and Death of the Winds* screen, 1895, pencil on tracing paper, 42.3 x 50.3 cm, The Hunterian, University of Glasgow

original version of the *Owl* screen (58), is similarly attributed in the catalogue; each of the owls in beaten metal is subtly different and, again, each was probably made by just one of the trio of artists. A cabinet, or dresser (59), is described as being by MacNair with a painted panel by Frances Macdonald; this was probably the one illustrated in *The Studio* in 1897,[3] but Frances's painting is unidentifiable from contemporary photographs. Two finger plates (60) are listed in the catalogue as designed by Margaret and Frances Macdonald, but contemporary illustrations suggest that, although the concept may have been a collaboration, each artist was responsible for a single plate. The remaining exhibits are catalogued as the work of one artist, either Mackintosh or MacNair (although the furniture is acknowledged as being made by professional cabinetmakers). I don't believe that this means that Mackintosh was against collaboration but simply that the time he had available for discussion and development of projects was limited by his employment as an architect,

while MacNair and the sisters were more free to meet and progress their ideas together.

The imagery in these pieces of metalwork is a development of earlier watercolours by each of the artists. The motifs have been modified – usually exaggerated – to suit the new medium. The personal symbolism remains but is much less impenetrable than the works we have seen in *The Magazine*, usually because it is linked to the function of each item. The screens are self-explanatory, with figures making blowing or inhaling gestures or being themselves blown by the winds; the owls perch, sagaciously, within their panels on the screen. The *Vanity* mirror, perhaps the first joint production in metal by the Macdonalds and MacNair, has a symbolism that can be interpreted on several levels. First, its main decorative motif is a peacock, a bird which is frequently associated – because of the plumage and behaviour of the male bird – with vanity and preening. Historically, it has been a common symbol of vanity or, in the case of a single 'eye'

feather from the tail, of evil or malice. Both the Hindu and Buddhist religions use peacock imagery and motifs and they appeared regularly in Egyptian and middle-eastern works. All of these interpretations would have been known to The Four, could have been easily researched and in any case peacock imagery appeared regularly in Aesthetic Movement and Arts and Crafts work around the same time. Peacocks appear in some of Mackintosh's metalwork (incorporated in his furniture) and other designs by him around this date, and the Macdonald sisters also included it in contemporary designs for a handkerchief (61). But does the mirror have a simpler, more personal, symbolism? In it, two peacocks contemplate each other below the glass, and their plumage extends up each side of it where one of the tail feathers terminates in the head of a woman.[4] Two peacocks, two women – is this an overt reference to the growing personal attachment of Herbert to Frances and Mackintosh to Margaret? Or is this too simple an analysis? Maybe, but the continuing use of the

CHARLES RENNIE MACKINTOSH AND THE ART OF THE FOUR

motif, particularly by Mackintosh, suggests a coded message rather than just the use of a fashionable image by a group of impressionable young artists.[5]

Mackintosh's metalwork exhibits at the Queen's Rooms are, unfortunately, unidentified by subject, but we can speculate as to what they were. The catalogue descriptions are rather vague, referring to wallpapers and friezes; posters both designed and executed by Mackintosh; a linen cupboard;[6] wall decoration and bracket; and 'lead and brass work'. The latter is the most intriguing, in the light of the other pieces exhibited by The Four. No free-standing beaten metal pieces made by Mackintosh – whether frames or mirrors or other wall hung objects – survive from this date. There were, however, three pieces of furniture that were probably made in 1895 or early 1896 and include panels of beaten lead or pewter, two of them enhanced by small spots of enamel; in addition, Mackintosh exhibited two other panels of beaten brass at the Arts and Crafts Exhibition Society in London, 1896. Surprisingly, the latter do not seem to have been previously commented on, but their appearance in London might suggest that Mackintosh had been working in a similar manner to the Macdonald sisters making beaten metal panels to be hung on walls. His first London exhibit (no. 504) is listed as a panel in beaten brass – *Art and Literature seeking Inspiration at the Tree of Knowledge and Beauty*. Without any accompanying illustration it is difficult to imagine the form it took, but it may well have owed something to the watercolours that Mackintosh showed in the spring 1896 edition of *The Magazine* (71, 72) – *see* pages 74, 75. The second brass panel, *Vanity* (no. 510), may well relate to the *Vanity* mirror that the Macdonalds and MacNair showed in Glasgow in 1895. What is surprising is that this panel is described as being designed by Mackintosh and executed by Jessie Keppie, the first and apparently only occasion that Mackintosh is recorded as collaborating with Jessie, or any artist other than Margaret Macdonald (although Peter Wylie Davidson made pieces to Mackintosh's design for Kate Cranston at Hous'hill in 1909). Apart from anything else, it would suggest that Mackintosh and Jessie Keppie had at least a working relationship as late as 1896, which undermines Neat's contention that by this date Jessie Keppie and Mackintosh had nothing to do with each other due to his romantic attachment to Margaret Macdonald.

Also at the London exhibition, Mackintosh showed a large settle (62), which was bought by Talwin Morris, a friend of The Four and art director of Blackie & Son, the Glasgow publisher.[7]

The Society's practice in its catalogue was to list the designer and maker, or makers; only Mackintosh and his cabinetmaker, Messrs Guthrie of Glasgow, are listed here so we must assume that Mackintosh himself made the panel. Certainly, in the manuscript of his article for *Dekorative Kunst* in 1898,[8] Talwin Morris states that Mackintosh designed and executed the two panels in a bookcase probably made by Guthrie that was bought by William Davidson for Gladsmuir (65). These panels had first appeared in a design for a fireplace of *c*1896[9] and were re-used in the wardrobe designed for Westdel in 1898. The stencilled linen panels on the back rests were possibly printed by Guthrie, but Mackintosh was certainly responsible for the design, a larger version of the stylised plant forms seen in his watercolours dating from around 1893–94. It would also seem likely that he made the similar panel (63) in a large cabinet, datable stylistically to 1895. Both of these panels incorporate peacocks, and it seems possible that these were the panels

ABOVE
63. Charles Rennie Mackintosh, Peacock panel from Croll cabinet, 1895, beaten pewter with enamel, private collection

OPPOSITE
62. Charles Rennie Mackintosh, Settle with peacock panel, 1895, oak, stained dark, with beaten metal and enamel, 181.5 x 142 x 65 cm, National Museums of Scotland

exhibited in the Queen's Rooms in 1895 alongside the *Vanity* mirror. As in the mirror, each panel shows two juxtaposed peacocks (such a contrapuntal arrangement of motifs is common in Celtic art), and Mackintosh has applied enamel to their crests and tail feathers. Two other lead or pewter panels, possibly also shown in this exhibition, are attached to a linen cabinet (64), perhaps that shown at the Glasgow Arts and Crafts Exhibition (although another linen cabinet which appears in a photograph of a bedroom at Gladsmuir (66) at that time is perhaps the more likely candidate[10]). The panels depict groups of two opposing naked figures in a style very similar to that seen in paintings by the sisters in 1894, but their poses seem to derive from Mackintosh's painting *The Creation of Eve* (26), or even from the flanking figures in the School of Art Club Diploma (33). And there is more than a hint of the screeching hags in MacNair's drawing for his panel in the *Winds* screen (56). This is the only time that Mackintosh seems to have followed the sisters and MacNair into the iconography of emaciated naked figures, in contrast to the more fleshy women seen in his earlier (and later) watercolours.

Any, or all, of these panels could have been exhibited in 1895 at the Queen's Rooms before being fitted into their respective pieces of furniture. Again, we can only speculate as to the identity of the other pieces exhibited by Mackintosh at the Queen's Rooms – designs for posters, wallpaper and friezes. The frieze could be the one that he designed, and possibly made and stencilled himself, for his bedroom at his parents' house at 27 Regent Park Square in Glasgow and then repeated at Gladsmuir for William Davidson (66). This contains a sphere, either a sun or a moon, against which images of cats are silhouetted – the cat was a symbol of the Mackintosh clan. A central figure with streaming hair dominates the composition. The wallpaper shown at the Arts and Crafts exhibition in

Glasgow is untraced; it is the only known occurrence of Mackintosh designing wallpaper and it is significant that it was taken up by a London manufacturer, Percy Heffer – but no record remains of it. The exhibit of posters is intriguing because they are listed as being not only designed by Mackintosh but also made by him. The Glasgow Institute poster (51) was commercially printed so perhaps what Mackintosh exhibited were either the small-scale originals or any of the larger hand-lettered posters that are known only from photographs in the Mackintosh estate. Although the printed poster for *The Scottish Musical Review* is dated 1896, perhaps Mackintosh exhibited a drawing that he showed to his client as the design developed (67) as it differs in some minor details from the final production. Another design that has much in common with Mackintosh's graphic work and watercolours from 1895 is a poster for 'A Magazine of Art, Literature and Science' (68). Elements of earlier watercolours, and the frieze from his bedroom, can be seen in the saplings with their twisted branches and the head of a woman with flowing hair at the top.[11]

Unlike the sisters or MacNair, Mackintosh produced more graphic work or watercolour paintings in 1895 than he did panels of beaten metal or furniture. The other three artists were, of course, working more or less full-time as freelance designers (MacNair's involvement with Honeyman & Keppie seems to have been winding down at this time and there is little evidence of his input in the office), but Mackintosh was rising up the ladder as an architect, taking on more responsibility for individual projects within the firm, which probably left

ABOVE
68. Charles Rennie Mackintosh, Design for a poster for the spring number of a magazine of art, literature and science (unknown), 1897, pencil, watercolour and grey wash, 155 x 77 cm, The Hunterian, University of Glasgow

LEFT
67. Charles Rennie Mackintosh, Design for a poster for *The Scottish Musical Review*, c1895–96, pencil and watercolour on tracing paper, 37.3 x 17.1 cm, The Hunterian, University of Glasgow

OPPOSITE
69. Charles Rennie Mackintosh, *Winter*, 1895, pencil and watercolour, 31.8 x 24 cm, Glasgow School of Art

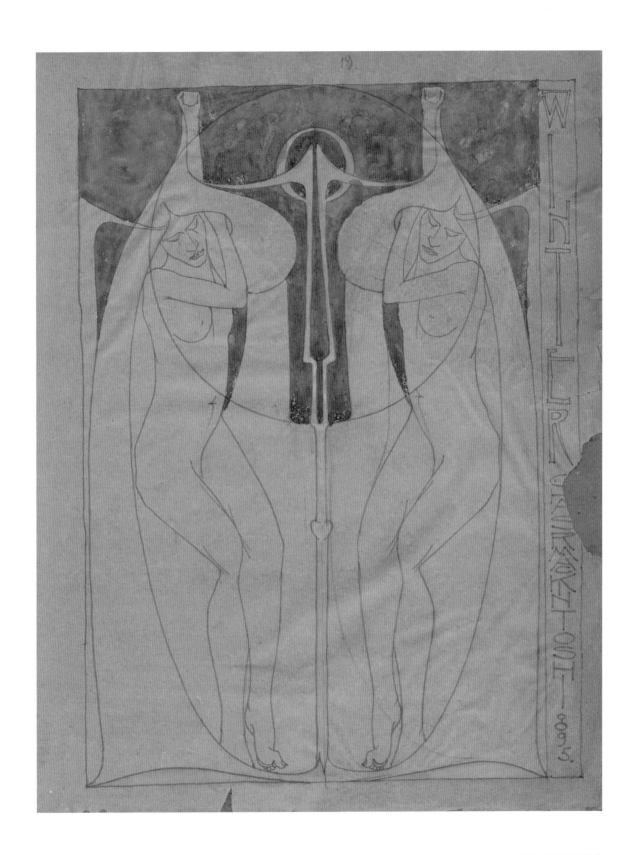

him less time for personal projects. At the beginning of 1895, however, he produced a small group of watercolours which seems not to have been publicly shown until they appeared in the spring 1896 issue of *The Magazine*. They are either signed and dated January 1895 or can be dated to the early part of that year. Conversely, Margaret and Frances Macdonald produced few, if any, watercolours at this time and concentrated their efforts on metalwork. These four watercolours by Mackintosh, however, are some of the most important of his early career, combining the emotive colour and by now expected imagery of the Glasgow Style with a more overtly contemplative content.

With the exception of *Winter* (69), these watercolours show Mackintosh approaching a more abstract manner. Although his usual references to natural forms still appear, his concern is with colour and pattern, as well as a more obvious philosophical content, than it was in the paintings of 1893–94. *Winter* contains two more of the Cabanelesque figures that appear in several of Mackintosh's earlier works. The drawing looks as if it was intended as a frontispiece for *The Magazine* but it was included in the main body of the journal. The two women, drawn carefully in pencil, break away from their classical archetypes in the treatment of their hair, which sweeps down the drawing to link at the bottom in the manner of some Macdonald sisters' drawings and even the hair of the women in the work of Toorop. Between the figures rises a totemic plant, almost a stylised cactus, which terminates in a graphic cartouche at the top of the drawing, silhouetted against a purple sun or moon – a motif clearly related to *Strange Plant Form* (34). The women are sleeping, representing dormant nature in the depths of winter. Down the right-hand side of the drawing Mackintosh titles, signs and dates it in an elaborate fashion. *The Shadow* (70), features another stylised plant form, this time more of a tree, which describes a decorative arrangement of trunk and branches, painted in pale green against a darker green background which is itself laid over a pale blue sugar paper. The shadow was created by leaving the pale blue paper exposed but, intriguingly, it is not a true shadow of the foreground tree. Alan Crawford has described Mackintosh's habit of playing games – as an architect and artist[12] – and perhaps this is one of those playful, provocative efforts. Neat, who is generally insightful in his analysis of these drawings from the 1896 *Magazine*, links the tree and shadow to images of life and death.[13] But it is just as likely that the artist was playing with shapes for the sake of it.

The final two watercolours from January 1895 (71, 72) are much more substantial and open to various interpretations.

They are, at the same time, the most abstract of Mackintosh's early watercolours but also, thanks to Mackintosh's inscription down the side of each drawing, the most clearly indicated of all his early work. The titles and inscriptions seem to be, as Neat has suggested,[14] Mackintosh's reflections on his personal and professional status at a time when his role within Honeyman & Keppie was becoming more significant but was yet to be acknowledged in terms of a partnership. In a letter to Hermann Muthesius,[15] Mackintosh insists that any illustrations to be published of the *Glasgow Herald* building – mainly his design – must be credited to the firm as he was only the assistant and not a partner. Mackintosh must have been realising that the hierarchical nature of architectural practice and the importance of social contacts in gaining new commissions (and his lack of them) were leaving him at a professional disadvantage. Glasgow was a close-knit business community where deals were done over coffee in the tea rooms or the drawing rooms of the many clubs (especially the Glasgow Art Club where John Keppie was held in high esteem, but where Mackintosh was never to become a member). Mackintosh does not seem to have been naturally gregarious and was never a successful canvasser for new work. His frustration, anger and disappointment are evident in the titles alongside each drawing:

THE TREE OF INFLUENCE. THE TREE OF IMPORTANCE. THE SUN OF COWARDICE.

THE TREE OF PERSONAL EFFORT. THE SUN OF INDIFFERENCE.

Without these inscriptions, however, would an observer arrive at the same conclusions about the content or purpose of these drawings? Yes, there are trees; there are circles that may represent suns or moons; there is a muted range of colour that may represent melancholy or angst. But there is much more – images, pattern and tracery that might conceal a different interpretation of these two watercolours. In January 1895 Mackintosh was working on the new building for the medical department of Queen Margaret College, a women's college at the University of Glasgow. His perspective drawing (73) of the college was exhibited at the Glasgow Institute in April; it had been preceded by a perspective of the *Glasgow Herald* building and was followed, in turn, by a perspective of Martyrs' School, all buildings for which Mackintosh acted as principal assistant, even designer, on the projects. Although all three

70. Charles Rennie Mackintosh, *The Shadow*, 1896, pencil and watercolour, 30 x 18 cm, Glasgow School of Art

OVERLEAF, LEFT
71. Charles Rennie Mackintosh, *The Tree of Personal Effort*, 1895, pencil and watercolour painted area 21.1 x 17.4 cm, sheet area 32.2 x 236 cm, Glasgow School of Art

OVERLEAF, RIGHT
72. Charles Rennie Mackintosh, *The Tree of Influence*, 1895, pencil and watercolour, painted area 21.4 x 17.2 cm, sheet area 31.8 x 23.2 cm, Glasgow School of Art

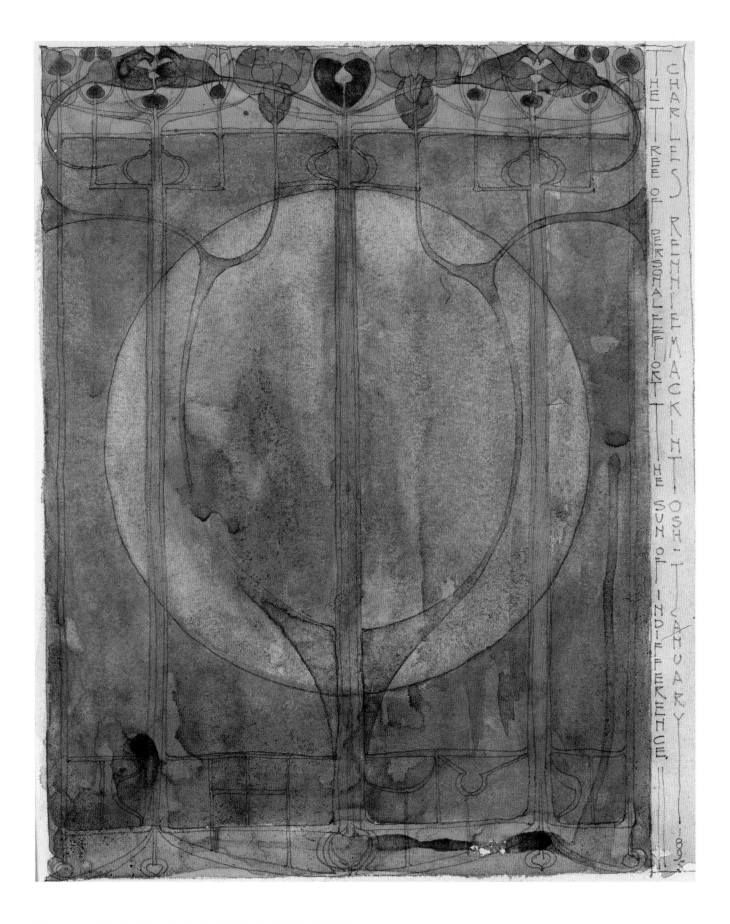

The text within the artwork (vertical, right side):

CHARLES RENNIE MACKINTOSH · JANUARY 1895

THE TREE OF PERSONAL EFFORT THE SUN OF INDIFFERENCE.

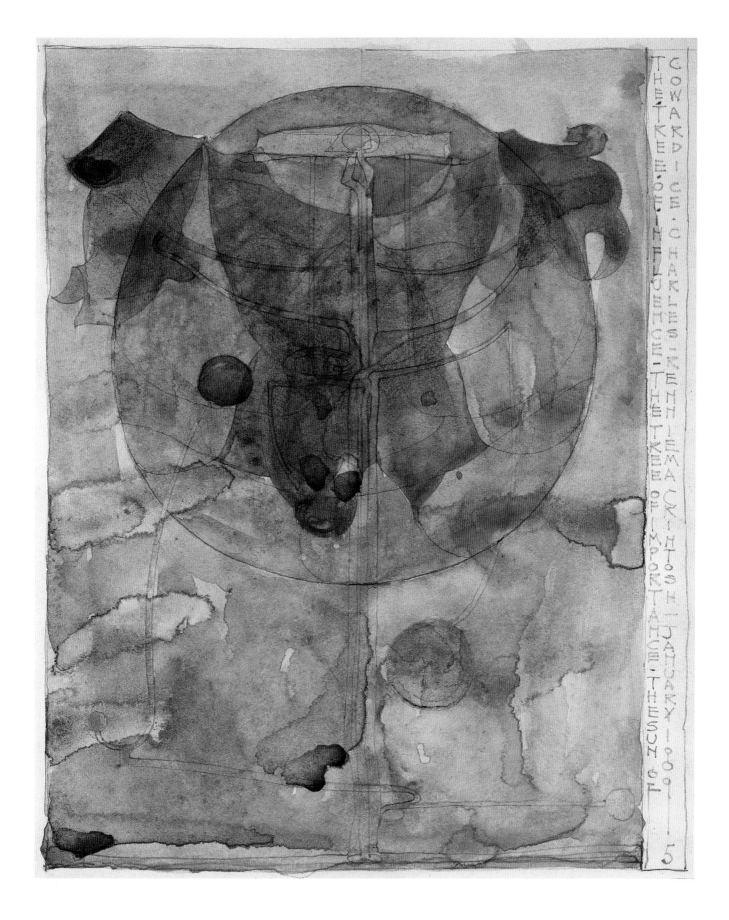

THE TREE OF INFLUENCE · THE TREE OF IMPORTANCE · THE SUN OF COWARDICE · CHARLES RENNIE MACKINTOSH · JANUARY 1901 · 5

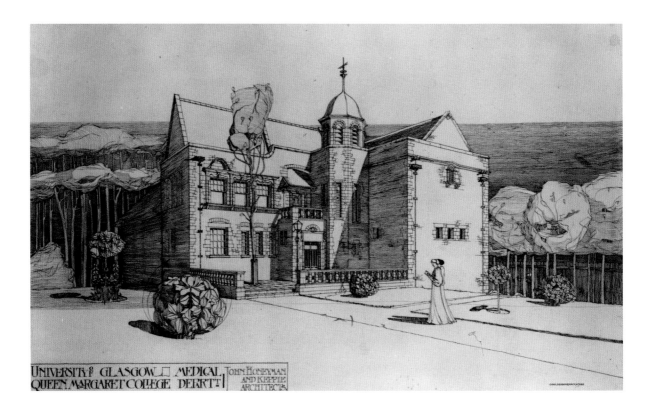

drawings share dramatic skies and bold draughtsmanship, the perspective for the medical college includes typical Glasgow Style elements, particularly in the depiction of the trees and shrubs surrounding the building. There are echoes here of *Cabbages in an Orchard* (41) and *Landscape with a Stylised Tree* (42) which provide clear pointers to Mackintosh's way of working and the importance of this building to him. A reviewer in the *Glasgow Herald* had a mixed reaction:

> This design is appropriately simple and severe, but it is not so remarkable as the drawing of it by Mr C.R. Mackintosh. Quite a delightful bit of conventionalisation is the shrubbery in the foreground, and the technique of the pen is skilful, but the limit of this sort of thing is surely reached when a tree is represented by an inflated sack, and a wood as a country washing hung out to dry. Even the extremely conventional girl graduates in the foreground have lost their conventional sweetness in Mr Mackintosh's hands.[16]

Construction on the banks of the river Kelvin had probably commenced in the autumn of 1894, and Mackintosh would no doubt have been considering the furnishing of the interiors at the beginning of 1895. This was the first medical building that Mackintosh had worked on and he was doubtless keen to immerse himself in the workings of an anatomy school to ensure that the building functioned properly for his clients. In 1933 the Professor of Anatomy at the University, Thomas Bryce, wrote to William Davidson about his encounters with Mackintosh during the design of the school:[17]

> I first met him about 40 years ago when the Anatomy building at Queen Margaret College was being built [...] A good deal of the detail of the decoration was by Macintosh [*sic*], and as it stands is perhaps among the earliest examples of his style, which after that first acquaintance, I followed with interest in its development and efflorescence [...] At that time even he was always on the outlook for new ideas of form for decoration, and I remember how, at one of his visits, he looked down my microscope under which was to be seen the developing eye of the fish. He at once sketched the general form of the object, which he translated into a decorative design.

On a later occasion he asked me if I could show him something else, for he had used what he had seen before in all sorts of permutations and combinations in many decorative schemes.

This is perhaps part of the key to understanding the iconography of these two drawings and others over the years to come, stretching as far as the designs for printed textiles that Mackintosh produced in London after 1915. Key to them is the stylisation of natural forms, whether visible to the naked eye or not. The schematised trees, growing from the foot of each drawing and terminating in a stylised canopy of foliage at the top, are perfectly clear. The circles in the centre of each drawing we know from the inscriptions to be suns, but their colour – a bluish purple or dark pink – is by no means natural. A tracery of more organic forms, even more stylised than usual, overlies these suns, and within these marks can be

glimpsed some of the forms that Mackintosh might perhaps have encountered through Professor Bryce's microscope, or in the specimen jars which lined the walls of the main Anatomy Museum at the University. Each drawing appears to contain a stylised diagram of the female reproductive system – ovaries, fallopian tubes, uterus and vagina. It is easy to attribute these shapes to Mackintosh's thoughts about Margaret Macdonald, but it seems to me much more likely that they simply refer to Woman – especially as represented by the students at the college (archetypal 'New Women') and the specimens stored on the shelves. At the centre of *The Tree of Influence* is a purple shape that has been described as a cuirass or a bodice – but it could almost be a butterfly mounted in a museum display. Whatever it is, it reappeared in Mackintosh's designs for the gates at the entrance to Queen Margaret College: a design which enlarges *The Tree of Influence* tenfold and translates it into three dimensions (74), just as Professor Bryce described.

These powerful paintings in *The Magazine* form a fitting finale to a finite phase of Mackintosh's career as an artist. His pictorial ideas, already translated to the larger scale of posters, wallpaper and a frieze, were superseded by the demands of his architectural work, although in many ways they underpin all of his output as a designer and architect. Over the next four or five years he made fewer paintings, which certainly changed in content. This paralleled changes in the work of the sisters and in the rapidly increasing output of MacNair as an artist. All four artists moved away, in their paintings, from the stylisations and elusive symbolism of the mid-1890s towards a more figurative subject matter and illustration. The Glasgow Style of *The Magazine* was not, however, dead; it lived on for two or three years in the graphics and metalwork of The Four. Their student years were behind them and they were ready to build on the fine beginnings that they had presented to the public at the Queen's Rooms in 1895.

LEFT
74. Charles Rennie Mackintosh, Gate at Queen Margaret College, Glasgow, 1895, wrought iron, *in situ*, photograph by Stuart Robertson

OPPOSITE
73. Charles Rennie Mackintosh, Perspective drawing of Queen Margaret College, Medical Department, 1894–95, pencil and ink, 49.8 x 80.6 cm, private collection

5 ART AND CRAFT

Following their emphasis on furniture and metalwork in the Arts and Crafts Exhibition in Glasgow in April 1895, The Four showed signs of diverging pursuits over the rest of that year and 1896. Frances Macdonald maintained her new interest in design and three-dimensional work and there are no surviving watercolours by her datable to 1895; MacNair seems to have concentrated on new paintings, as did Margaret Macdonald, although she continued to work jointly with her sister on metalwork projects; and Mackintosh found his time being consumed by his work as an architect, resulting in fewer paintings or pieces of metalwork, although he did produce several designs for furniture in 1895–96. Dated paintings by Margaret and MacNair from 1895 are rare, but Margaret produced one of the strangest – or at least unexpected – paintings of her career. *Mother and Child* (76) is – in comparison with her images for *The Magazine* – relatively naturalistic in its depiction of a woman holding a plump infant who reaches out towards a group of balloons. Dandelion clocks and balloons featured regularly in paintings and metalwork made by the sisters in the 1890s, as did images of children in their later pictures; but none of them approached the realism of the balloons and child seen here. The baby is taken straight from a Renaissance or Mannerist painting, plump and overlarge in relation to the female figure holding it. This mother is not, however, one of the anorexic women from *The Magazine*; her billowing dress and mannequin-like face speak of a different world. Although this painting may be surprising in its distance from Spook School wraiths, it would probably have found favour with Macdonald's contemporary critics in 1895 who had rejected her stylisation of the human form in previous years. It is the first of a series of moves towards a more naturalistic, even romantic, content in her paintings, a manner which, for a year at least, Margaret Macdonald developed alongside her by now expected imagery in designs for metal.

MacNair also produced a key watercolour this year, *Ysighlu* (75). Although not quite so radical a departure from the work of 1894, MacNair also incorporated a fuller figured woman and a group of cherubic children. Both are set within a typical Spook School framework of androgynous figures overshadowed by birds with outstretched wings. The identity of Ysighlu remains obscure, but when the painting had its first public showing it was accompanied by the verse: 'The very shadows in the cave worshipped her. The little waves threw themselves at her feet, and kissed them.'

75. James Herbert MacNair, *Ysighlu*, 1895, pencil, watercolour charcoal, gold and silver paint, 48 x 40.5 cm, National Museums, Liverpool (Walker Art Gallery)

If the iconography was abstruse, the same cannot be said about the draughtsmanship or colouring of the painting. Purples, blues, greens, overlaid with a gold tracery on the woman's veil, hark back to *The Lovers* and other works by MacNair's friends in *The Magazine*. MacNair's imagery is as obscure as that of the sisters and Mackintosh, but in later works it becomes even more impenetrable, based, as it is, on MacNair's own verse. There is still menace in this painting, in the eyes and beaks of the birds – perhaps owls – and in what appears to be a peacock feather laced into their swooping wings. No other work datable to 1895 has survived, but at the beginning of the year, in the Glasgow Institute annual exhibition, MacNair showed two watercolours with architectural or topographical titles (both untraced). They were submitted from his personal address, not that of Honeyman & Keppie, and must have been made towards the end of 1894 as handing-in days for this exhibition were in early January. As one of them is a design for a cottage it seems that MacNair might still have been harbouring ambitions to work as an architect. The second, however, seems to have been a watercolour of Linlithgow Palace. In this, MacNair may have been following Mackintosh's example, both in his Italian sketches and watercolours and in his personal habit of working in a sketchbook.

The use of the sketchbook is one of the major differences in artistic practice that separates Mackintosh from his three colleagues: none survives from the other three artists, and it seems doubtful that they ever used one while Mackintosh is known to have used sketchbooks up to around 1920. It was part of his training that he should commit architectural details to paper; as a draughtsman he developed an ability (or perhaps it was an innate talent) to capture what he saw in front of him, often for reuse in competition designs or commissioned buildings. Throughout the 1890s he regularly drew in sketchbooks, particularly on the summer vacations he spent in England visiting and recording churches and villages in the southern counties. In 1895 he also spent some days in Ayrshire, working near Maybole – probably while staying at the weekend with Keppie in Prestwick, but his summer holiday saw him in Dorset. Fra Newbery was a Dorset man, from Bridport, and it may have been his encouragement that sent Mackintosh so far south. Drawings from this Dorset trip are typical of the style and vocabulary that had evolved since his visit to Italy – church towers, old houses, village inns all fill the pages. Starting in the mid-1890s, Mackintosh began to incorporate drawings of flowers and trees, often extending the drawing over two facing pages. When, in 1889, Newbery chastised designers for their inability to draw a flower from nature correctly, he must have been hoping to encounter a student with the talent and ability that Mackintosh showed in his sketchbooks. One drawing from his tour in 1895, however, is very different – a watercolour view of the village green, bridge and church at Wareham in Dorset (77). This appears to be Mackintosh's first topographical watercolour since his visit to Italy. He had learned much in the interim –in the making of *The Harvest Moon* and *Cabbages in an Orchard* – and *Wareham* seems to have intrigued Mackintosh as he returned to the same kind of subject a year or so later in his painting, *Porlock Weir* (78). Both of these watercolours are observational, with washes overlaid on a pencil drawing, but they are more paintings than coloured sketches. There is no suggestion of the symbolism, overt or subliminal, to be found in the earlier

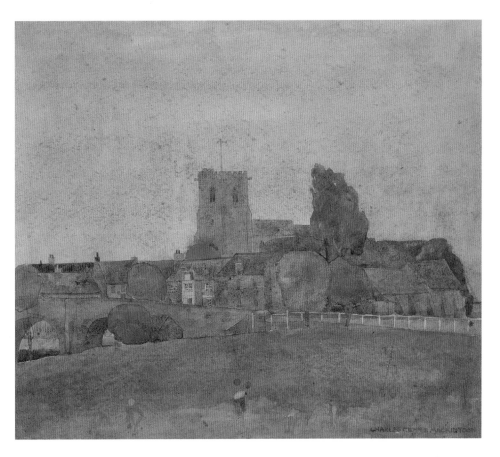

work of 1892–94. Mackintosh was the only one of The Four to produce such non-figurative watercolours and he seems to have been equally at ease making topographical paintings alongside his more imaginative subjects. Is there a hint here of Mackintosh's dissatisfaction or unease with the direction his painting had taken over the previous four or five years?

For whatever reason, in the mid-1890s Mackintosh put much of his creative, graphic energies into his sketchbooks. They became a visual lexicon, mainly serving as *aides-mémoire* for forms and motifs he was to draw on in his architecture and furniture design, but, as with all artists who maintain sketchbooks, they allowed Mackintosh to think on paper with a pencil, and occasionally a brush. Painterly ideas appear alongside straightforward elevational studies and plans. The frontal compositions that we see in *The Tree of Influence* (72) and *The Tree of Personal Effort* (71) are countered by the exaggerated perspective of *Porlock Weir* (78), although *Wareham* displays the flattened, two-dimensional view of landscape which later became more prevalent in his work. In later years Mackintosh was able to switch at will from elevation to perspective in his sketchbooks; and when he gave up using sketchbooks, after 1920, many of his drawings and paintings dealt with the illusion of perspective, although, as we shall see, the French watercolours contain a subliminal flattening of the landscape. The work Mackintosh did in his sketchbooks allowed him to make mistakes – and correct them – in private. When he came to work on paintings, posters, or the large-scale decorative

panels of the next decade, Mackintosh already had his vocabulary at his fingertips and he rarely put a foot, or finger, wrong compared with his friends who, by contrast, seemed to have worked *alla prima* on to paper or metal, sometimes with less-than-perfect results.

Frances retained her interest in working in beaten metal throughout the mid-1890s. Occasionally she collaborated with Margaret, sometimes indivisibly as on the *Vanity* mirror and sometimes alongside her sister, as in the panels of the *Winds* screen. There has always been confusion over the authorship, joint or individual, of several items made at this time, sometimes initiated by mistaken captions in the journals where work was illustrated, at other times caused by the absence of signatures on these pieces, exacerbated by the sisters' willingness to have their work jointly, or even alternately, attributed.[1] This vagueness also extends to the dating of their work, particularly the beaten metal pieces which are not always signed and even less often dated. Perhaps there was no genuine rivalry between the sisters, but there were growing differences between their two styles, although this has often been denied or ignored by recent commentators. At its most simple, Frances's metalwork can be seen to have developed the Spook School delineation of the female figure and the linearity of composition, while Margaret slowly moved towards a more realistic and rounded depiction of women. This can be seen even in 1895 in the two finger plates (60) that they exhibited at the Queen's Rooms: Margaret's figure has rounded breasts and identifiable hips, a

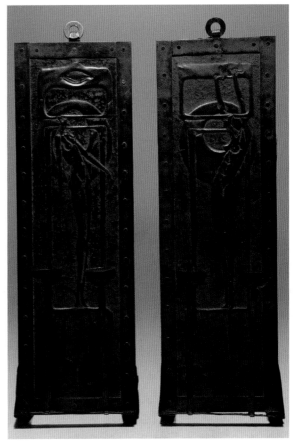

face with a benign expression, and an overall more feminine appearance; Frances's figure is more austerely androgynous and is contained within a tube-like robe, with flattened, pointed breasts, an angular face and hands which are bent in a Z shape to clasp and support the angular face. In addition, Frances's plate, *Future,* incorporates two of the peacock eyes which first appeared in the *Vanity* mirror and recur repeatedly in her work.

A figure with almost the same attributes is to be found in the remnants of a frieze (79), almost certainly made in 1895. One piece was acquired for the Hunterian collection, another by Thomas Howarth, both from Mrs Dunderdale, adopted daughter of Charles Macdonald (brother of Frances and Margaret) who had bought Dunglass Castle in 1899, and from whom she inherited the house and its contents. Among these contents was a group of works by The Four, mainly the work of Margaret and Frances, which they both seem to have left with Charles and their mother for safekeeping at various stages of their lives. Each of the repeated figures in this frieze is flanked by a tall tree bearing the silver discs of the honesty plant, and each of these discs is stylised into a square shape bearing three flowers and their stems. An almost identical motif was used on a mirror (80) first illustrated in 1897.[2] Here also are the anorexic women, bodies totally hidden in amorphous robes, with outstretched arms, and elongated and pointing fingers indicating the honesty petals. This was an *Honesty* mirror to accompany *Vanity,* and it surely dates from the same year, 1895,[3] as must, I believe, a pair of sconces now attributed jointly to Margaret and Frances (81). When an image of the sconces was first published in 1898,[4] however, they were attributed solely to Frances, although Talwin Morris, in the manuscript of his article for *Dekorative Kunst,* attributed *Night* specifically to Margaret.[5] The attenuated figures, with sharpened details of hands and face, combined with the linear design and the

use of the peacock eye, are more recognisably the work of Frances than of her sister, though this does not of course preclude the sisters having collaborated on this and other works at the time (1895–96). A clock with a square silver face is signed and dated by both of them (82); Morris describes its little putti as 'winged hours sporting with dandelion puffs', two of which threaten to carry away the uppermost figures;[6] the weights are decorated with stylised owls. These figures of children began to appear more often in the work of both artists and, as in the *Vanity* mirror, it is not possible to identify here an individual hand, although the piece seems to have little of the edginess of contemporary works by Frances.

Two other clocks are known from this period, both jointly attributed and both illustrated in *The Studio* in 1897. The first (84), a clock with a square face and simple wooden stand, is reminiscent of the finger plates where each sister made an individual piece; here similar figures flank the dial of the clock suggesting a very simple collaboration. The other clock (83) is altogether different, combining a Spook School tracery of plants and stems with cherubic heads blowing dandelion clocks. The dial was supported on an elaborate white painted stand; it was an awkward juxtaposition of a rectangular stand with quite conventional legs against the bold circular brass face of the clock. Gleeson White in his account of his visit to Glasgow in 1897 compares

LEFT AND RIGHT
84. Frances and Margaret Macdonald, Clock,
c1895, beaten brass, modern wood stand,
132 x 52 x 21.6 cm including stand,
Crab Tree Farm

the two clocks unfavourably, praising the simplicity of one stand while questioning whether 'a circular form is quite happy as the crown of the structure quadrangular in plan especially when it seems like a silhouette on an object otherwise modelled in the round'.[7] Whatever the relationship between the sisters and Mackintosh, it does not seem that his skills as a furniture designer were enlisted here. Other joint works followed including a pair of sconces (85), sadly lost, where the naturalistic tracery of other contemporary work is replaced by an abstract arrangement of discs and ellipses scribed into, or gouged out of, the flowing robes of the two figures. The theme again seems to be night and day: *Night* shows a crescent moon and was probably designed by Margaret, while *Day* includes a suckling child and sun disc overlaying a figure with the Z-shaped hands evident in previous work by Frances.

All of these works were figurative in their imagery with an emphasis on women. Not the garlanded and crinolined figures often found in the work of The Four's contemporaries but a stark presentation of the female form. Often naked, with closed eyes and open hand gestures, these women are presented as archetypes suggestive of the universal condition of women at the end of the nineteenth century.[8] At the same time, however, Frances was experimenting with the production of metalwork decorated with non-figurative patterns and produced, with Margaret, a pair of sconces

that hark back to the peacock theme of early 1895. Two pairs of candlesticks (86, 87) – one pair now at Glasgow Museums, the other pair now unfortunately lost – are reminiscent of medieval shapes, one with a deep dish base, the other flat with decoration in high relief. A photograph of the lost pair shows that it bore a symmetrical pattern of fluttering moths (according to Morris); on the other there is a more typical Glasgow style arrangement of lines and swelling forms incorporating Frances's regular use of the peacock eye. The peacock sconces (88) are different again; they have been likened by Timothy Neat to the Eye of Thoth in their symbolism,[9] with a cascade of peacock eyes at the top. This is a project where the overall design was probably agreed by the two sisters, and then each of them made one sconce, identical to the other except for the direction in which the central bird is facing. Talwin Morris, a friend of The Four and art director of the publisher Blackie & Son (in the mid-1890s living at Dunglass Castle), recognised in these two

sconces and a pair of Frances's candlesticks the summit of their achievement at this time. He bought all four pieces, and added to his growing collection two pieces exhibited by Mackintosh at the Arts and Crafts exhibition in London in 1896 (*see* below).

In all of these pieces dating from the mid-1890s there is a robustness of handling and at times a crudity in the hammering and forming of the shapes in the metal. It is this immediacy, this rusticity, which links the Macdonald sisters' metalwork to similar pieces of the 'Celtic' period. The sisters did not adopt the Celtic strapwork and tracery that was so common in items produced over the next decade by their followers in Glasgow. Their connections to Celtic design are more in the approach to the making of the pieces than in a shared iconography. But suddenly all of this changed, and Celtic connections were rejected, as Frances and Margaret produced their two largest metal panels, handled with a new delicacy and with fully worked out, more graphic, compositions – *The Annunciation* and *The Star of Bethlehem* (89 and 90). These two panels must have been completed by the beginning of September 1896 as they were submitted, along with the clock (82), to the fifth exhibition of the Arts and Crafts Exhibition Society in London which opened at the beginning of October. Other work from Glasgow shown in this exhibition included pieces by Lucy Raeburn, Charles Rennie Mackintosh, Jessie Keppie, Jessie Newbery and Talwin Morris.

In 1895 The Four had taken part in an exhibition of work from Glasgow School of Art, 'L'Oeuvre Artistique', that was shown in the Casino Grétry in Liège, but there is no record of the actual exhibits. They had shown their posters in 1895 with Samuel Bing in Paris, at his first Salon de L'Art Nouveau,

in the early part of 1896 in London at the Royal Aquarium, and in Reims in 1896,[10] but the Arts and Crafts exhibition was the first appearance of their work outside Glasgow in a major exhibition of the decorative arts. Their exhibits attracted some press coverage, on the whole positive, although Howarth was to suggest that they were badly received and ridiculed.[11] As well as the two large metal panels and the clock (82) – illustrated in a review of the exhibition in *The Studio* – the sisters exhibited a muffin stand (now lost).[12] Mackintosh showed – in addition to the metal panels that were perhaps first seen at the exhibition at the Queen's Rooms, Glasgow (*see* pages 67–68) – his hall settle (62) and a small watercolour panel, *Part Seen, Imagined Part* (96), both of which were bought by Talwin Morris. The women's two metal panels and Mackintosh's small watercolour show the beginnings of a new style, or at least a new vocabulary, that The Four were to develop over the next four or five years concentrating, in both metalwork and watercolour painting, on a more realistic rendering of the human figure in a narrative context; the stark landscapes, anorexic women and malevolent plant forms that had characterised the Spook School were all to be left behind. The subject matter changed, too, towards religious subjects, Arthurian legend and traditional fairy tales usually derived from the Brothers Grimm. Janice Helland and Jude Burkhauser[13] have objected to suggestions that the sisters resorted to fairy-tale imagery because they feel that the term demeans the artists (but they raise no objection to the same description being applied to works by Mackintosh or MacNair produced at the same time). Where else, however, could paintings illustrating the story of the Sleeping Beauty and the

Frog Prince have come from? Fairy tales in the nineteenth century had an underlying morbidity that in twentieth-century North America was too often watered-down, if not obliterated, by the schmaltz of Disney and others that transformed them. To describe the subjects of the Macdonalds' new painting from 1897 as fairy tales does not diminish their achievements or belittle their standing as inventive artists. Mackintosh included in his later titles 'fairyland', 'fairies', 'princess', and so on, adapting as wholeheartedly as did the Macdonald sisters new content for his paintings that would be accessible to a much wider audience than his work from the first half of the decade. It is a change that is impossible to deny, a change also seized on enthusiastically by MacNair who created his own fantasy word populated by cherubs and women in ethereal skirts, surrounded by briar roses and love-in-a-mist. The message is not very different from the works of 1893–95; the subjects are still joy and sadness, love and rejection, life and death, dark and light, evil and good – only the language delivering the message had changed.

The Annunciation and The Star of Bethlehem are now lost, having entered an Italian private collection after being shown in Venice in 1899. They were, at 1.3 metres high, perhaps the biggest works in metal that the sisters ever produced. The subject matter is overtly religious (Talwin Morris described them as 'altar panels'[14]) and the women in them are transformed from the stylised forms in the earlier sconces and mirrors into more delicate figures, both in their expressions and in the way that they are drawn. There is still a linear framework based on stylised plant forms but otherwise almost all traces of the Spook School have been erased, except for the swooping bird seen in the top left corner of Frances's panel that appeared in so many other works by MacNair and Mackintosh at this date. The superimposing of one figure over another recalls the Glasgow Institute poster of 1895 but here is much more naturalistic and, in fact, became a favoured arrangement in later works by the sisters. These panels were aluminium, not the brass or copper or tin of earlier pieces; there also appears to have been some colour in the halos of the angels and Mary and in the sun, or nimbus, which supports the Christ child in The Annunciation. The catalogue of the exhibition, normally very detailed in its descriptions of the exhibits, does not mention colour so it is unlikely that it was enamel; although each panel seems to have had some attached beads or jewels as decoration, these also go unmentioned in the catalogue.[15] The panels were illustrated in The Studio in an anonymous review of the exhibition (probably written by Gleeson White, the editor) and were praised for their originality and also for the distance between them and earlier Spook School works, of which the reviewer was aware. This review is undoubtedly what provoked later suggestions that the work of the Four at the exhibition had been derided by contemporary critics. In fact, there were very few printed reviews of their work and those that appeared were reasonably positive; it was only in the review in The Studio that an element of doubt was introduced.

For that these decorators already proved themselves able to make beautiful patterns, of good colour and decoration that is really decorative, may be granted. Probably nothing in the gallery has provoked more decided censure than these various exhibits; and that fact alone should cause a thoughtful observer of art to pause before he joins the opponents. If the said artists do not come very prominently forward as leaders of the School of design peculiarly their own, we shall be much mistaken. The probability would seem to be, that those who laugh at them today will be eager to eulogise them a few years hence.[16]

If this review was, indeed, written by Gleeson White, then his article about the Glasgow designers in 1897 was probably worded to prove his prophecy. White noticed a distinct change in the work of the sisters in these two panels, drawing particular attention to the fact that the modelling of the figures made them much more discernible within the linear decoration of the rest of the panel. All the same, he hoped that a 'Rosetta Stone' would be discovered that would help make clear 'the tangled meaning of these designs […] it would be hazardous for the average person to suggest that interpretation. One thing however is clear, that in their own way the Glasgow students have sought out a very fascinating scheme to puzzle, surprise, and please.'

It is surprising that the reviewer should refer to these artists as students; this, together with references to earlier work, suggests that White knew something of their background and recent training at the Glasgow School of Art. He must have known of them, at least, through the posters that were exhibited in London and from the literary periodical The Yellow Book, which published five watercolours and a pastel. Sadly, both of Margaret's paintings – Mother and Child (76)

FAR LEFT
89. Margaret Macdonald (perhaps with Frances Macdonald), *The Annunciation*, 1896, beaten aluminium and beads, approx. 113 cm high, untraced

LEFT
90. Frances Macdonald, *The Star of Bethlehem*, by 1896, beaten aluminium and beads, approx. 113 cm high, untraced

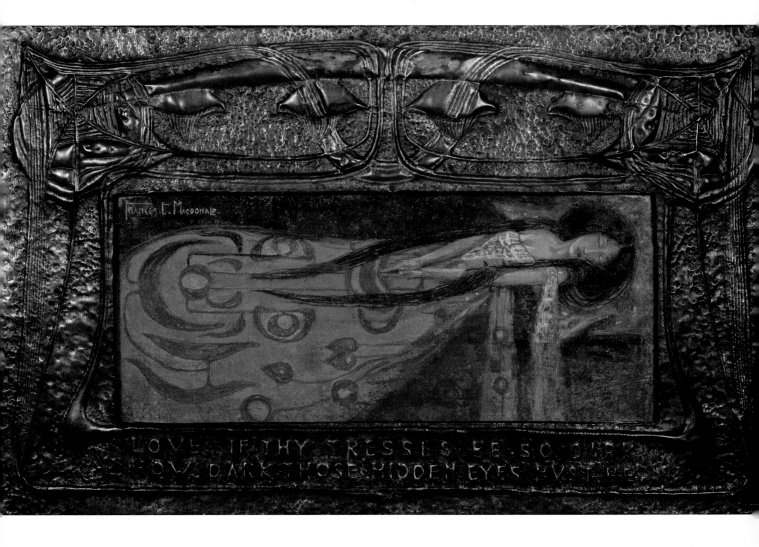

and *A Dream* — are lost and we have no idea of their colour or size. Frances was represented by *Ill Omen* (24) and by a new work, *The Sleeping Princess*, which was illustrated without its beaten metal frame (91) — although Gleeson White included the frame when it was illustrated in *The Studio* in July 1897. MacNair's two watercolours *Ysighlu* (75) and an even more ominous design, *The Dew*, confirmed his new interest in subjects just as impenetrable as the Macdonalds' work had been two years earlier. Of this group *The Sleeping Princess* is the most interesting. The reclining woman is shown in a pose not

91. Frances Macdonald, *The Sleeping Princess*, framed, 1896, pastel on tracing paper, beaten copper frame, 19.3 x 46.6 cm (sight); frame, 48 x 67.3 x 2.7 cm, Glasgow Museums

unlike the standing figure in *Ill Omen*, with hands clasped over her pelvic area. Her long black hair flanks her hands recalling the linear patterns of various beaten metal pieces. The woman's dress, however, has a much more graphic pattern of black lines and shapes against a blue background. Peacock eyes, leaves and tendrils dominate but the dress has a much more hieroglyphic feel than anything we have seen before. Nothing about the figure differentiates her from Ophelia or other similar reclining female figures popular with artists, but the frame, with its spiders' webs stretched between the branches and leaves of a tree, links it to the fairy-tale story of the princess condemned to sleep until she is woken by the kiss of a prince. It is the earliest of the fairy-tale subjects painted by The Four at this time, any possible sweetness of content

firmly denied by the morbidity of the metal frame. This frame contains an inscription, a verse from Tennyson's *A Day Dream,* where the fairy tale of the Sleeping Beauty is retold for a modern audience:

Love if thy tresses be so dark
How dark those hidden eyes must be.

It is not known why the Macdonald sisters and MacNair were chosen for *The Yellow Book*; occasionally, Glasgow painters had also been illustrated in it, but there are no specific links known that would associate the artists with John Lane at the Bodley Head, its publisher. Perhaps Talwin Morris was working on their behalf, exploring his contacts with the London publishing trade. Whatever the connection, the sisters were certainly in touch with John Lane about another project some time in 1896, sending him photographs of a new series of watercolours on which they were working, presumably with in the hope of publication (though this never materialised).[17] The photographs show various pages of a manuscript entitled *The Christmas Story* which are clearly related to the two large metal panels shown in the 1896 Arts and Crafts exhibition. Other watercolours associated with this project were included in the spring 1896 edition of *The Magazine*, so it would seem that the project went through various iterations. According to Talwin Morris,[18] the two separate watercolours in *The Magazine* – *The Annunciation* (89) and *The Star of Bethlehem* (90) – were the sources of the much larger metal panels shown in London; it seems likely that the watercolours preceded the other versions that appear in a handmade illustrated missal, bound between covers of beaten metal.[19] Of all of the images associated with this project, the panels demonstrate a superior draughtsmanship and command of the design, required by their much larger scale and their intended purpose and location (Talwin Morris referred to them as altar panels).

Over the next few months the sisters expanded the story, working on vellum and lacing the pages with gold thread, eventually placing them between two metal panels with a beaten and incised design. It is not easy to determine the chronology of the different watercolours – the two in *The Magazine* are probably the first and may have been produced before there was any thought of a series. There is a new simplicity about all of these watercolours, partly dictated by the format – that of a mediaeval illuminated manuscript.

The linear complexity of the design is simplified and the relationship between two or more figures in the pictures is naturalistic. The colour is fresh and clean and carefully applied to the drawings. The album's other contents, however, were not a total break from the past. The title page for *The Christmas Story* (92) is a sanitised version of the once-malevolent plants to be found in Spook School paintings (*see*, for instance, Mackintosh's *Strange Plant Form* (34); and *The Crucifixion* (95), known only from a contemporary photograph) and contains an almost direct reference to Frances Macdonald's *The Crucifixion and the Ascension* (36) of 1894. The drawings are signed individually by either Frances or Margaret (and in one instance, *Suffer Little Children...*, by both of them), but there is no real indication of which of them took the lead. In later years, however, Frances and Herbert MacNair were to make several watercolours and banners with religious themes, while few, if any, such subjects appear in Margaret's work.

The narrative sense of this group of drawings and their collection together as an album is a new departure, one that Margaret and Frances were to develop further in 1897. They had left behind the Spook School, replete with personal imagery, and replaced it with more accessible references to literary subjects. Mackintosh, too, soon abandoned 'ghouls and gas pipes' in favour of more pictorial compositions. MacNair's commitment to painting would manifest itself in the form of a solo exhibition in London in 1898 – none of the other artists were to produce their own equivalent displays, although Frances collaborated with her husband on a joint show in 1911, and Mackintosh's last project was designed to be a solo exhibition. The Four were maturing and exhibiting a natural talent for illustration that was to become the basis for much of their work over the next decade.

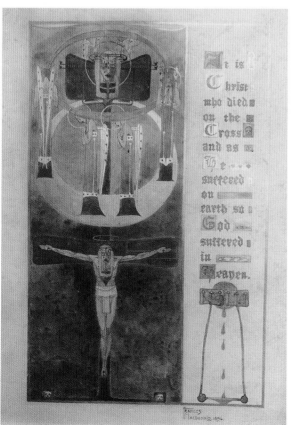

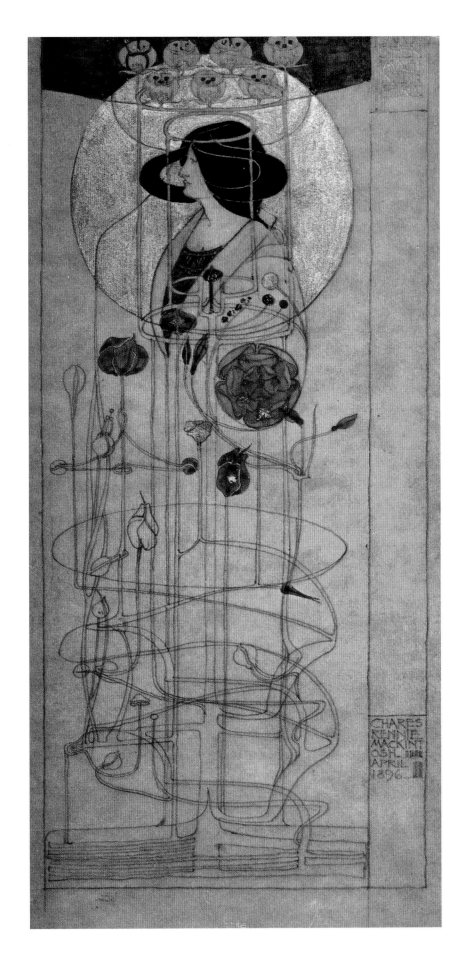

96. Charles Rennie Mackintosh,
Part Seen, Imagined Part, 1896,
pencil and watercolour, 39 x 19.5 cm,
Glasgow Museums

6 RECOGNITION

THE SMALLEST ITEM that Mackintosh showed in the 1896 Arts and Crafts
exhibition in London was a watercolour with the enigmatic title *Part Seen,
Imagined Part* (96). It is signed and dated April 1896 suggesting that it was
painted before Mackintosh became involved with the decorative schemes
at Miss Cranston's Buchanan Street Tea Rooms which opened in May 1897. This
appears to be the first (and certainly the only surviving) imaginative watercolour
that Mackintosh had made since the paintings of January 1895 (71, 72, *see* pages
74 and 75), and it makes for an interesting comparison with similar works by the
sisters, particularly Frances. Her stylised honesty petals appear above the head
of the figure[1]; the nimbus recalls those around the figures in *The Annunciation* and
The Star of Bethlehem (93, 94) included in the spring 1896 issue of *The Magazine*; and
Margaret had incorporated roses in her early watercolour *Summer* (39). Those roses,
however, were probably inspired by the flowers in Toorop's *The Three Brides* and were
nothing like the impressive bloom placed by Mackintosh at the centre of his design,
that looks for all the world like a heraldic Lancastrian rose. It became the archetype
for all the Glasgow Roses in later works by The Four and in pieces by the younger
designers who followed them. This drawing is also interesting for Mackintosh's use
of an elaborate pencil line, honed through his many sketchbook drawings of flowers,
trees and architectural details (97), that describes the briar tendrils snaking around
the figure (96). The golden nimbus around the figure's head is more likely to be a
sun than a halo – there is no other indication of a religious context in this design.
Apart from the plant forms taken from his sketchbooks, this drawing has its origins
in *Autumn* (45) and the posters that followed it, although it echoes the new and more
naturalistic style that the sisters had begun to adopt in their watercolours of 1896.
It is a powerful image, despite its small scale, and it obviously made an impression
on Gleeson White who, in his article in *The Studio* in July 1897 about The Four,
remembered it from the London exhibition and made the link between it and the
later Buchanan Street tea room murals.

White had probably been the author of the anonymous review of the Arts and
Crafts exhibition of 1896 in *The Studio* that had drawn attention to the exhibits of
The Four.[2] Six months later he came to Glasgow to satisfy his curiosity about these
young designers who were beginning to make a name for themselves, and his articles,
published in July 1897 and two subsequent issues, contain some of the most incisive
and illuminating observations on The Four. Recent commentators have tended to
take for granted White's account of his visit to Glasgow, and it has entered into

the subliminal folklore that pervades the story of The Four. It is, however, the only detailed contemporary account of their work and relationships that has survived, other than Talwin Morris's memoir[3] (which was probably written after White's articles were published), and is worth recounting in some detail. White wrote as a neutral, but enthusiastic, observer, rather than as a friend as was the case, in the months and years to come, for Morris, Hermann Muthesius and Fernando Agnoletti;[4] he was also commenting with the benefit of a wide knowledge of fine art and design movements in Britain at the time. His opening words encapsulate the essential character of the group:

In studying the history of decorative art, it becomes evident that the most original and lasting work has been more often than not the outcome of a well-defined local movement. Sometimes a single artist initiated the whole school; at others a few working in familiar intercourse acted and reacted on each other, so that at last a distinct character was imparted to their work and that of their successors. No matter how much each of these differed from his neighbour, the characteristics which distinguished his work from that produced in other localities, are still more evident to an unprejudiced observer than any family likeness among members of his group.[5]

He identified the Glasgow group's connections to the Arts and Crafts Movement and the freedom and encouragement that they had enjoyed under Newbery while students at the School of Art. He also remarked upon the widespread confusion among critics as to the inspiration and sources of English designers exhibiting at the same time, many of whom professed to identify an Egyptian influence. White continued:

One eminent French critic thinks that the Egyptian Court at the British Museum is responsible for most of the so-called novelty in design at the late Arts and Crafts Exhibition. Had he seen the products of Young Glasgow the statement would have seemed far more plausible. Yet those sons and daughters of Scotland, who appear to be most strongly influenced by Egypt, affect to be surprised at the bare suggestion of such influence, and disclaim any intentional reference to 'allegories on the banks of the Nile'; nor in their studios do you see any casts, photographs, or other reproductions of Egyptian art.

He happily recounted the, perhaps apocryphal, story of a foreign critic's earlier visit to Glasgow:

There is a legend of a critic from foreign parts who was amusing himself by deducing the personality of the Misses Macdonald from their works, and describing them, as he imagined them, 'middle-aged sisters, flat-footed, with projecting teeth and long past the hope (which in them was always forlorn) of matrimony, gaunt, unlovely females.' At this moment two laughing, comely

girls, scarce out of their teens [although Margaret was by this time 33 years old], entered and were formally presented to him as the true and only begetters of the works that had provoked him. It was a truly awful moment for the unfortunate visitor, whose evolution of the artists from his inner consciousness had for once proved so treacherous.

Perhaps this particular critic had been White himself. The sisters answered questions openly and laid out their artistic creed, such as it was:

> With a delightfully innocent air these two sisters disclaim any attempt to set precedent at defiance, and decline to acknowledge that Egyptian decoration has interested them specially. Therefore, he is driven to believe that the very individual manner in which they have elected to express their sense of beauty is really the outcome of the feeling they have towards the arrangement of lines and masses. 'Why conventionalise the human figure?' said one critic. 'Why not?' replied another of the group. 'Certain conventional distortions, harpies, mermaids, caryatides [sic], and the rest are accepted, why should not a worker today make patterns out of people if he pleases?' This is a query easier propounded than demolished. If you once throw over precedent there need be no limit to experiment; except that to be accepted it must justify itself.

Could there have been a little mischief, a certain disingenuousness, in the sisters' replies to their visitor from London? Are we to believe that their designs have no deeper meaning than their simple fascination for colour, line and mass? White may or may not have been convinced by their protests but he was certainly prepared to acknowledge their particular talents:

> Without claiming that the method of new Glasgow is the best, or that it is impeccable its very audacity and novelty deserve to be encouraged. After seeing much of it one must needs admit that there is method in its madness; that in spite of some exaggeration that has provoked the nickname of 'the spook school', yet underneath there is a distinct effort to decorate objects with certain harmonious lines, and to strive for certain 'jewelled' effects of colour, which may quite possibly evolve a style of its own, owing scarce anything to precedent [...] Surely it is but decent civility to treat any serious experiment with some show of tolerance; and the work of all Glasgow school of designers is singularly free from vulgarity of idea, redundance of ornament, and misapplication of material. It may controvert established precedent, but it does so in an accomplished manner, and with a sincere effort to obtain new and pleasing combinations of mass and line.

White seems to have been genuinely moved and impressed by his encounter with the Macdonald sisters; their informality and sisterly humour even infused his editorial prose:

It is with some relief that one finds the Misses Macdonald are quite willing to have their work jointly attributed – for actuated by the same spirit, it would be difficult, if not impossible, for an outsider to distinguish the hand of each on the evidence of the finished work alone. Perhaps the most striking fact that confronts one at first is to find that some comparatively large and heavy pieces of wrought metal were not only designed, but worked entirely by the two sisters. Indeed, with the exception of certain assistance in joinery, all the objects here illustrated are their sole handiwork.

He defended them against the attacks on them in the local press, stressing that their intention was not to shock but to experiment in a valid way. He concluded his account of the sisters' work (illustrated almost wholly with beaten metal pieces) with words that were to hold considerable sway with other writers in European journals over the coming months and years:

It is just because the naïveté and daring of these designs controvert all well-established ideas that it is very hard to be quite just in criticising them. Either they offend without extenuating circumstances, or, having become attracted towards them, one is inclined perhaps to defend their weakness as well as their strength. Seen with many others from the same hands, it is impossible not to recognise a distinct method in their apparent extravagance. Today, when almost everything in decoration can be traced to an established style, it is so unusual to find original endeavour, that one tries to hark back to some precedent. Because of its use of vertical lines, and its archaic treatment of the figure, many people prefer to say that all the Glasgow work is based upon Egypt. Yet a visit to the corridor devoted to Egyptian art in the British Museum, undertaken specially by way of comparison to see, proves the debt to be but slight, for even if the spirit of the early art is in these, its motives are not.

Turning to Mackintosh, White remarked that his decorative work might be expected to take second place to his architectural work, but his description and analysis of the new stencilled murals at Miss Cranston's Buchanan Street Tea Rooms reveal that this was very definitely not the case. Mackintosh was not a man to make such distinctions:

To him has fallen an opportunity rare at the present time; and that he has fully grasped the possibilities it offered we shall endeavour to show, so far as black-and-white illustrations can convey an idea of a scheme depending to a great extent upon its colour. A large building to be known, I believe, as 'Miss Cranstoun's Tea Rooms', has been lately erected from designs by an eminent Edinburgh architect [George Washington Browne]. As several interior features are open to somewhat severe criticism, it will be best not to give the architect's name. But if parts of the structure are extremely irritating, in common justice one must allow that others reveal knowledge, good taste, and a capacity for planning spaces that entitle him to very high praise. Of this building the mural decoration of the two lower storeys has been entrusted

to Mr. George Walton and those above to Mr. Charles R. Mackintosh [...] Mr Mackintosh's portion has been executed by Messrs. Guthrie [...] The extremely intelligent handiwork bestowed upon Mr. Mackintosh's designs, and the quality of its execution, must be recognised as no small factor in the success of the work. Indeed, it is rare to find a 'firm' carrying out work with the same 'feeling' that is manifest here. As a rule, the battle between a designer – and those who carry out his schemes is long, and the victory is not always with the artist. Here it would seem that both parties have worked so loyally to secure the desired effect, that praise bestowed on either one is equally, if indirectly, credited to the other at the same time.

Mr. Mackintosh has planned the decoration for the several floors [...] with a certain unity of effect. The ground colour of the walls on the first of the floors which Mr. Mackintosh has decorated is green, the second a greyish greenish yellow, and the upper blue, the colour in each intruding as a frieze on the adjoining storey, so that the idea of earth to sky is preserved. The plaster has been prepared in flat colours of singular quality; whether owing to the surface or to some clever manipulation, the effect is of flat but not even colour with a fine texture in it that imparts a surface not unlike that upon the 'self-colour' bottles of Chinese porcelain. The whole of the applied decoration is in stencil, with a large range of colour in the various details. In the Ladies' Room are figures disposed in groups of varying sizes. These figures have white robes, and the head of each is set against a disc of gold, by way of nimbus. An unbroken procession round the walls might have been monotonous, but grouped as they are, a very decorative result is obtained. If memory is trustworthy, a sketch of one of these figures was shown in the balcony of the 1896 Arts and Crafts Exhibition. Interspersed among these are conventionalised trees, and a suggestion of a flower-studded meadow is preserved in the low dado which runs round the base above the actual panelled wainscot of the room in which they appear [...] In the Luncheon Room decoration, peacocks appear as the chief feature of the design, and applied to the projecting portions of the walls between these is a formal row of trees. These same trees [...] although they occupy much the same space, are not absolutely replicas. Some half-dozen varieties lend interest to the detail and yet conform generally to the symmetry which a repeated pattern demands. The ingenious variations of detail, secured with no restless sense of change, is a feature of Mr. Mackintosh's work. Thus it gains no little of the interest which is usually limited to painted decoration, inasmuch as it avoids the formal repetition of the ordinary stencil designs, in very few of them, if any, is 'graduated wash'; the various portions of the stencil are painted with different colours, but each, if memory serves, is put on in a flat ungraduated coat. But here, as in the background, the texture of the plaster breaks the colour into a sparkling living surface, in place of dull paint, which on smooth plaster is so uninteresting.

It is just because the means employed for these decorations are so simple compared with the result that it is essential to regard it as a very important enterprise.

RIGHT
98. Charles Rennie Mackintosh, Design for wall
stencils, Buchanan Street Tea Rooms, 1896,
pencil and watercolour, 35.6 x 76.2 cm, The
Hunterian, University of Glasgow

BELOW
99. Charles Rennie Mackintosh, Ladies Room,
Buchanan Street Tea Rooms, 1896–97

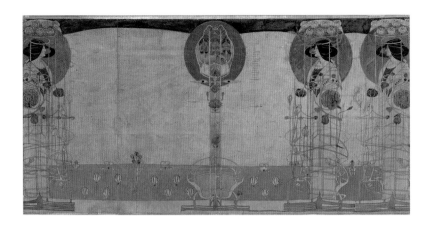

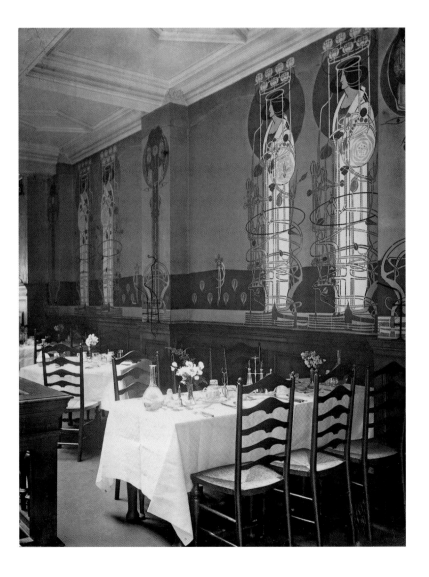

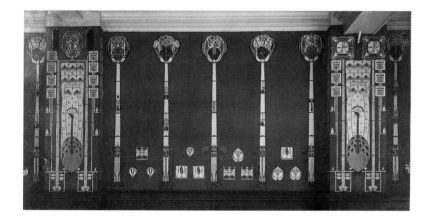

100. Charles Rennie Mackintosh,
Trees and peacocks stencil, Luncheon Room,
Buchanan Street Tea Rooms, 1896–97

White was correct in his identification of *Part Seen, Imagined Part* as the source of the statuesque figures in the Ladies Room, albeit enlarged by a factor of twelve making them almost three metres high. What he didn't grasp, however, was the way that The Four continually shared motifs – peacocks for instance – despite illustrating examples in Mackintosh's Buchanan Street murals (100) and the Macdonald sisters' sconces (85). White did, however, acknowledge Mackintosh's ability to avoid monotony in a repetitive design such as the trees in the Luncheon Room (100). The variations in canopy and trunk are probably the first of such schemes and are a good example of the games Mackintosh played in such decorative schemes, as in the repetitive patterns seen in the Library at the Glasgow School of Art. The relationship of several of these motifs to Mackintosh's posters was also recognised by White: he believed that they were the first example of a new decorative style of mural painting derived from an earlier poster design, a format that he felt would become more and more popular. He was no doubt right in his prediction but what he seems to have been unaware of was an existing interchangeability of motif and genre in Mackintosh's work, and in that of the Macdonalds. The Ladies Room murals (98, 99) had their original source in *Autumn* (45), translated through the poster for the Glasgow Institute (51), then reinvented in *Part Seen, Imagined Part* (96): watercolour-poster-watercolour-mural. Throughout their careers, all of The Four adopted the practice of working up and adapting subjects first used in small watercolours for large-scale graphic work; Mackintosh, as an architect, had more opportunities than the others to do so.

After describing, and very much approving of, Mackintosh's designs for posters (particularly that for *The Scottish Musical Review*, (53), White turned to Herbert MacNair. But he was able to say very little about MacNair's work: much of it, he relates, had been destroyed in a fire at his studio (our appreciation of MacNair's work has been confounded by at least two such fires, one of them, after the death of his wife in 1921, being deliberate). White may well have accepted the Macdonald sisters' denials of historic and literary sources, but he discerns them in MacNair who did not contradict him.

In his work there is more conscious symbolism, more of the symbolism which modern critics love to trace to Celtic blood, than is apparent in the work of his neighbour. This tendency, however, is far more pronounced in his water-colours and pastels than in anything here illustrated; naturally it is absent from the furniture, or if, indeed, it be present there it is too subtly indicated to lie apparent to a mere matter of fact Southerner. All the same it is impossible to ignore the motive influencing many of Mr. McNair's conceptions. To realise his intention one must understand his point of view. To delight in parables and fancies, in symbolism and imagination, which find expression in subjects that are certainly not easily interpreted by the careless spectator may be only the inevitable reaction from a period of realism and naturalistic impressions. The fact remains that in Scotland as in England, in Germany no less than in Belgium, and in many other places, there is a return to mysticism, and to superstition and legendary fancies which at first sight seem out of touch with the 'actuality of modernity,' as modern journalese phrases it [...] A delightful jewel casket owes no little of its beauty

to the metal work, executed by the artist himself, who is a skilful worker of jewellery and fine pieces of bric-a-brac in costly metals, as a vinaigrette and two brooches may be left to prove […] A tea-caddy, tea-shovel, and table are other pieces of Mr. McNair's design, all distinguished by admirable simplicity, and a certain dignity rare in such things […] His bookplates will convey a hint of the symbolic manner Mr. McNair adopts in his paintings. Not a line in them is without intention, and the poetry of the idea (as their author explains it in a singularly modest way, which betrays how very really he feels this method of expressing himself) it were best, perhaps, not to vulgarise by any attempt to supply an explanation which, in the cold daylight of the printed page, might read too like the fantastic explanations of the music-programme, wherein the analytical critic discovers such marvellous intentions on the part of the composer. Yet a very brief summary of their author's meaning may be given. In one for *John Turnbull Knox* you see a falcon – the Knox crest [101], not heraldically displayed, but hovering over the tree of knowledge which enfolds with its branches the spirits of art and poetry. These hold in their hands rosebuds (conventionalised into baby heads) and lilies, emblematical of painting and sculpture. The little heads above represent the dew breathing on the tree inspiration which comes from above. In another for *George Stanser McNair* [102] occurs a reference to the family crest – a mermaid.[6] The three figures represent a fountain, while conventional drops falling from their hands burst into mer-babies. That these bookplates do not convey all this to every chance spectator is quite true; but those familiar with the works of many modern painters will readily own that to interpret a design by Khnopff, a play by Maeterlinck, or a painting by Gustave Moreau, demands almost as much idealism as their creators themselves have incorporated with the work. To own so much is not to convey a hidden sneer at these dark sayings upon a harp, nor to declare oneself too fond of common-sense to tolerate other modes of expression. As the puzzle of a poet's meaning seems an open riddle to some, and a sealed book to others, so designs of the ultra-symbolical order appeal only to those in close sympathy, and are in themselves neither better nor worse because they choose to do so. To me, I confess, it seems that whatever charm these designs possess, is not in any ways dependent on their allegory, but that is merely the view of one unsympathetic realist.

White here identifies MacNair as the poet, philosopher and mystic of the group. He admits to MacNair's assistance in the unravelling of his acutely personal symbolism; if the imagery of any of The Four required a Rosetta Stone for interpretation, it was that of MacNair. It is interesting that White mentions Maurice Maeterlinck, Gustave Moreau and Fernand Khnopff in his analysis of MacNair's work, while the Macdonalds and Mackintosh seem not to have confessed to such links, and White did not feel confident to suggest them himself. To some extent this may have been ingenuousness on their part because Maeterlinck has often been cited by commentators as a source for their symbolism; alternatively, perhaps Mackintosh and the sisters were unresponsive to his work before Margaret Macdonald's involvement with it at the

Waerndorfer Music Room in 1902. White illustrated few of MacNair's paintings; we do not know whether this was because they had been destroyed in the fire or because White deemed them too difficult to reproduce.[7] Certainly the black-and-white illustrations of MacNair's watercolours in *The Yellow Book* were muddy and barely legible. However his paintings and pastels of the late 1890s, despite both being his preferred medium, are often unattractively executed. Perhaps White was aware of this and realising that they would weaken his arguments and possibly embarrass their creator he stepped obliquely around them.

The White article was certainly not illustrated with the most up-to-date work – recent watercolours by both the sisters and by MacNair were omitted – and he admitted his concerns about reproducing them properly:

Space forbids description of an elaborately illuminated manuscript the Misses Macdonald have just completed. Nor would it do justice to the work to illustrate a sample page in mere black-and-white. It is conceived in the same spirit as many of the designs illustrated, but has also a splendid harmony of colour

which sets it fairly in competition with an ancient missal, although at the same time it has not a trace of mediaeval feeling, but is of the Macdonald school absolutely.

White was probably referring to *The Christmas Story* or possibly a group of twenty-one watercolour illustrations for William Morris's *The Defence of Guenevere and Other Poems* that the sisters painted in 1897. Had White illustrated either of these series, contemporary perceptions of The Four might well have been different. These drawings confirm an important milestone in the development of the Macdonald sisters, the transition from purely personal imagery to a more universal content, as well as a transition from the joint recognition of the sisters' talents to an acknowledgement that one of them was moving towards a different plane of achievement. Comparisons may have been odious to the sisters themselves, but at this distance in time it is obvious that there were growing differences between their respective approaches and capabilities. Each of the Morrisian watercolours is roughly the same size (about 18 x 12 cm), but Frances better mastered the challenges that this format presented. Her compositions are stronger, her draughtsmanship more taut, her sense of colour impeccable, and her design far more assured than that of her sister. As with *The Christmas Story*, each sister worked individually, although there was no doubt collaboration in the initial selection of the text and the division of subjects between them. The quality of Frances Macdonald's watercolours in this series is such that it confirms for me the suspicion that it was she who was the driving force in the sisters' enrolment at Glasgow School of Art and who took most away from the experience.

Illustrating Arthurian legend was by no means uncommon in the 1890s. The Pre-Raphaelites and their followers were the best-known interpreters of these tales of courtly love, but none of them had presented the stories quite so clearly from the point of view of the women portrayed in them. Margaret and Frances Macdonald were well aware of the work of the Pre-Raphaelites but in their own watercolours they selected those elements of the Arthurian story that were of most interest to them and to female viewers; the knights who appear here are incidental – the focus of these watercolours is the role of the women. Melancholy is the overriding theme – the plight of women left behind through death, desertion or acts of war predominates. Several of these drawings include imagery found in the sisters' earlier work, such as the opposing ranks of knights and maidens in *A Ship with*

ABOVE
103. Frances Macdonald, *A Ship with Shields Before the Sun*, from 'Near Avalon' in *The Defence of Guenevere and Other Poems* by William Morris, 1897, pencil, watercolour and gold paint, 18.5 x 12.4 cm, Thomas B. Lockwood Collection, University Libraries, The State University of New York at Buffalo

OPPOSITE, ABOVE, LEFT AND RIGHT
104. Margaret Macdonald, *A Great God's Angel* in *The Defence of Guenevere and Other Poems* by William Morris, 1896, pencil, watercolour, gold and silver paint on vellum, 19.3 x 7 cm, Thomas B. Lockwood Collection, University Libraries, The State University of New York at Buffalo
105. Frances Macdonald, Design for front cover of *The Christmas Story*, 1896, pencil, 35.4 x 25.3 cm, The Hunterian, University of Glasgow

OPPOSITE, BELOW
106. Margaret Macdonald, *The Wind* in *The Defence of Guenevere and Other Poems* by William Morris, 1897, pencil, watercolour, gold and silver paint on vellum, 11.5 x 17.4 cm, Thomas B. Lockwood Collection, University Libraries, The State University of New York at Buffalo

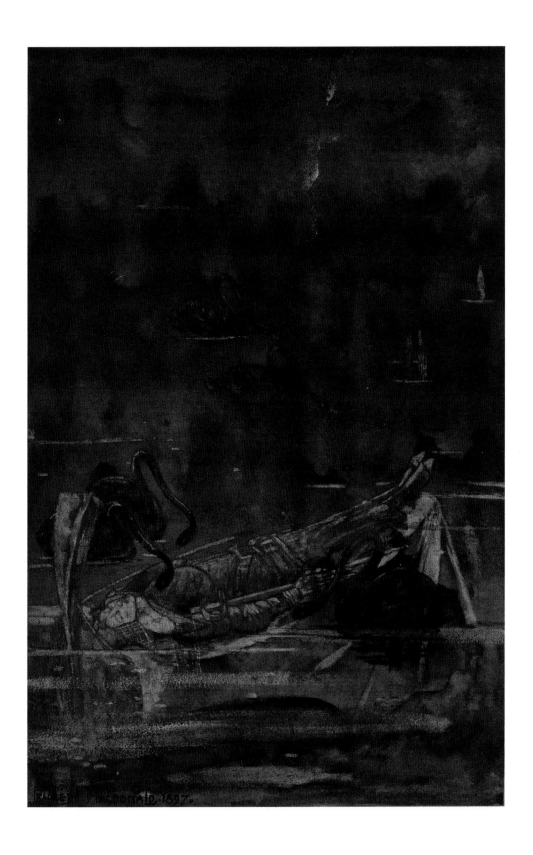

109. Margaret Macdonald, *Yet Am I Very Sorry for My Sin*, from 'King Arthur's Tomb' in *The Defence of Guenevere and Other Poems* by William Morris, 1897, pencil, watercolour, gold and silver paint on vellum, 18.0 x 11.7 cm, Thomas B. Lockwood Collection, University Libraries, The State University of New York at Buffalo

OPPOSITE
110. Margaret Macdonald, *Two Red Roses Across the Moon* in *The Defence of Guenevere and Other Poems* by William Morris, 1897, pencil, watercolour, gold and silver paint on vellum, 18.2 x 7.2 cm, Thomas B. Lockwood Collection, University Libraries, The State University of New York at Buffalo

Shields before the Sun from 'Near Avalon' (103); Margaret's *A Great God's Angel* (104) owes much to Frances's design for the metal cover of *The Christmas Story* (105); her *The Wind* (106) is a reprise of Frances's *The Sleeping Princess* (91). There is much that is new, however, as in *Shameful Death* (107) and *The Death of Jehane* from 'Golden Wings' (108) both by Frances, where the handling of the medium breaks new ground for The Four. Here, Frances Macdonald's experiments in design and colour come to fruition. There is a melancholy achieved, for instance, by the repetition of the curves of the swans' necks, by the muted colour and the pose of the main figure, that puts the artist on a new course. Margaret, too, was to set herself new standards with *Yet Am I Very Sorry for My Sin* (109) and *Two Red Roses Across the Moon* (110), where she introduces an image that she was to reuse several times over the next twenty years. That these paintings were never published during their lives, either by Gleeson White in his 1897 article or in any form by John Lane, meant that they were condemned until recently to being known only through fading sepia photographs in the Mackintosh estate.[8] These are not images that responded well to contemporary photography, and it is not surprising that the Bodley Head did not take them up or that *The Studio* was unable to illustrate them. But they are images that would have put an end to repetitive references to the 'Spook School' and 'ghouls' and the widely held belief that the sisters were capable of working only in such a restricted manner.

Not discouraged, the sisters started work on another project, this time not illustrations of a literary piece but a series of four watercolours devoted to the seasons, for which they made special frames of beaten metal. Each sister made two watercolours – Frances chose spring and autumn, while Margaret worked summer and winter. Each of the seasons is depicted as a single female figure attended by motifs which identify or confirm the mood and season. Again, the sisters are making a subliminal comment on the changing and challenging position of women in contemporary life. Youth, maturity, fecundity, decline and death are seen through the four figures presented to us – Margaret's women are robed like the mediaeval characters in *The Defence of Guenevere* while Frances's figures are presented naked. In *Spring* (111) Frances uses the device of one figure standing directly in front of another (perhaps the spirit of winter past) who hovers in the background. In *Autumn* (113) the naked figure is shown in a pose that seems to represent resignation or humility, attended

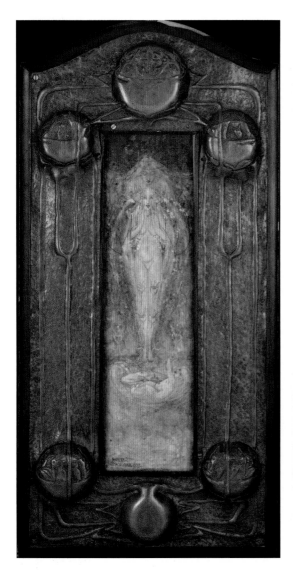

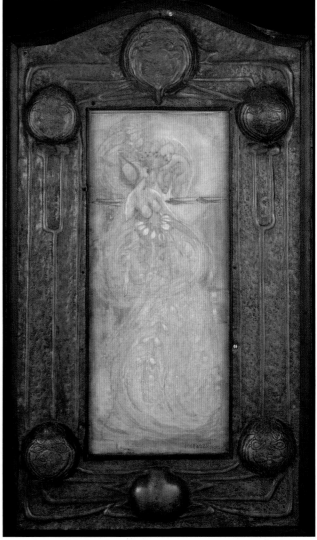

LEFT
111. Frances Macdonald, *Spring*, framed, 1897, pencil and gouache on vellum, 43.8 x 12.3 cm (sight), frame 73 x 35.9 cm, Glasgow Museums

RIGHT
112. Margaret Macdonald, *Summer*, framed, 1897, pencil, gouache and gold paint on vellum, 45 x 19 cm (sight), frame 71.7 x 41.5 cm, Glasgow Museums

by skulls on stalks and a ghostlike figure that may represent the winter to come. Margaret remodels one of her Guenevere figures as the bounty of *Summer* (112) with the ranks of floating cherubs echoing the woman in *Two Red Roses Across the Moon*, while *Winter* (114) follows the established pattern of a single figure placed beneath the cherubs.

With their contemporary beaten metal frames, these four paintings can be interpreted as a landmark in the lives of the two women. The watercolours are delicately handled with a conscious emphasis on design; the frames provide a contrast, a deliberate spontaneity with their rough shapes of six bosses connected by a tracery of tendrils and stems, very different from the precision of the metal panels, *The Annunciation* or *The Star of Bethlehem* (89, 90). The bosses bear imagery

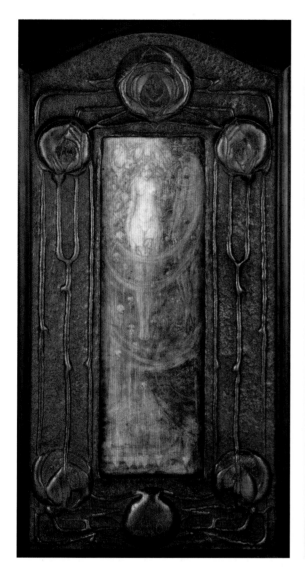

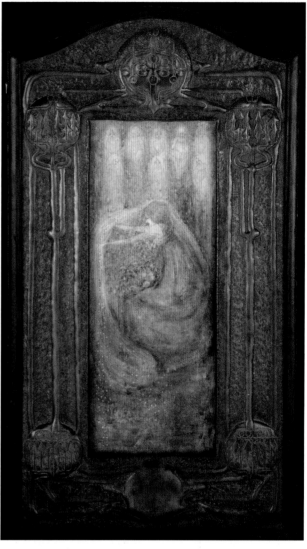

appropriate to the season – a nest of fledglings for spring, posies of flowerheads for summer, fading roses with hidden human faces for autumn, prickly holly leaves and berries for winter. There is a robustness, and urgency, even crudity, about these frames, a feeling reinforced by the choice of lead as the medium. Here, if anywhere, the sisters make their closest contact with Celtic design, execution, and content. The differences between the two sisters that became apparent in *The Defence of Guenevere* are also to be found here: Margaret's figures are carefree, confident in themselves and unstressed without any of the emotional charge of the two naked women in Frances's paintings. These four watercolours were painted over the winter of 1897–98, possibly at a time when Frances became engaged to Bertie MacNair. Can we read into her paintings thoughts on marriage, possible motherhood and a major change

LEFT
113. Frances Macdonald, *Autumn*, framed, 1898, pencil, gouache and gold paint, 43.5 x 13.8 cm (sight), frame 70 x 36 cm, Glasgow Museums

RIGHT
114. Margaret Macdonald, *Winter*, framed, 1898, pencil and gouache on vellum, 45.2 x 17.9 cm (sight), frame 72.5 x 48 cm, Glasgow Museums

in her life? Margaret, on the other hand, seems unwilling to delve more deeply into these matters. Had she and Mackintosh become engaged by this time and if so did she view the future with less apprehension than did her sister? Certainly, unlike Frances who seemed driven to change her work continually, Margaret resorted to repeating the figures she had used in her two seasons panels in several future works with an almost inevitable lessening of emotional input.

The frames that the sisters made for *The Seasons* are the most powerful and emotive of any of the pieces of metalwork they produced between 1897 and 1900. The Celtic motifs that can be seen in them reappear in an unusual frame that, despite its references to organic forms, seems almost abstract in its design (115). Probably made in 1897–98, it came from the Macdonald family collection, and is likely to have been in the family home, Dunglass Castle, and left there after both daughters married and moved away. It has no signature and could have been worked by either of the sisters, but the air of experimentation and boldness in its handling supports an attribution to Frances Macdonald. If there ever was a Celtic influence on the sisters, then the evidence for it lies here. A picture frame of 1897 (116) seems, by comparison, positively frivolous with its delicate arrangement of daisy heads and butterflies. Two other panels, illustrating episodes from the Odyssey have the crisp, incisive handling of the two altar panels shown at the Arts and Crafts exhibition in 1896. It was a style that in 1898 Mackintosh adopted for two metal panels that he designed and made for a smoker's cabinet commissioned by Hugo Brückmann in Munich (117). In each of these four panels we can see a culmination of the earlier designs that included similar layers of decorative figures, enclosed in flowing robes and dresses that envelop them in an extension of the space around them. The robes add an ethereal quality to the figures which appear to float in space, unconnected with the ground, unlike the totem-like women of the Buchanan Street Tea Rooms frieze. The picture frame and these four panels thus mark the end of a phase in the Glasgow Style, just as the illustrative watercolours do. The inventive compositions – with their own vocabulary and a very personal sense of design and colour that The Four produced from 1892 to 1896 – have passed.

It is tempting to describe that phase as student work – the four artists were, after all, still in training at the Glasgow School of Art. Perhaps, as students, they felt the need to shock their contemporaries and teachers, or at least to challenge

LEFT
117. Charles Rennie Mackintosh, Two panels from a smoker's cabinet for Hugo Brückmann, Munich, by 1898, beaten copper, private collection

OPPOSITE, ABOVE
115. Frances Macdonald (attributed to), Frame, c1897–98, beaten lead over a wooden frame, 80 x 62.2 x 5.8 cm, National Museums of Scotland

OPPOSITE, BELOW
116. Frances and Margaret Macdonald, Frame, 1897, beaten aluminium over wood, 69 x 60.5 cm, Carnegie Museum of Art, Pittsburgh

them, with a heady mix of sexual imagery and fantasy. They had nothing to lose; each of them had some security – the Macdonalds and MacNair the financial security of family, Mackintosh his career with one of Glasgow's leading architectural firms. As they each neared the end of their art school years, a certain sense of reality entered their lives; the changes in their work, the move from personal imagery to a more accessible one, surely reflected a need to succeed in their chosen careers as independent artists and designers. Or had they become tired of, or uncomfortable with, their invented world, populated with miserable creatures so unhappy with their lot? The move from the enclosed world of

the School of Art where the Macdonalds, particularly, lived and worked within a tight coterie of fellow students may well have freed them from the constant need to be different and the continual striving to live up to their reputation of being so. It is perhaps telling that The Four do not seem to have associated with their student contemporaries after 1895; admittedly, Herbert and Frances would be in Liverpool from 1899, but Margaret and Mackintosh, very much in Glasgow, seem to have socialised very little with their contemporaries at the School of Art.

In terms of quantity of output in the late 1890s, it is clear that The Four saw themselves as painters rather than decorative

118. James Herbert MacNair, *The Lily's Confession*, 1897, pencil, pastel, chalk and gold paint, 24.9 x 8.6 cm, Glasgow Museums

artists. Much of their new work was to be exhibited outside Glasgow, both in London and abroad, and brought them to the attention of a rather different audience than that which visited the Arts and Crafts exhibition in London in 1896. Their subject matter also changed – the exhibits of the next few years contained not only the paintings of the seasons but new watercolours inspired by more fairy tales. MacNair was by far the most prolific and his imagery more personal than that of the sisters and Mackintosh. In 1898 he was given a solo show at the Gutekunst Gallery in London, devoted to a collection of twenty-one pastels; he also brought his architectural and design talents to the installation of the show, apparently modelled on Whistler's earlier arrangements in an exhibition at The Fine Art Society in London in 1883. Many of these pastels are on wood, an unusual technique which allowed for some surprising results. Gold and silver paint lightened the darknesses but probably did little to offer an explanation of the work on show. MacNair was confirming Gleeson White's description of his romantic, dreamy character through an array of impenetrable lilies, cherubs or babies, and fairy-tale damsels (118).

> They are the work of a dreamer in love with the land of faery, who has the truly northern delight in symbolism. These dainty fancies are drawn in pastel in very few soft tones on paper, or in many cases on wood, where the colour and grain of the wood are made dexterous use of and here and there gold and silver are employed to heighten effects of hair or of sunlight with great effect. Mr McNair is at present at work illustrating a book of Fairies; or to be more correct he is drawing a series of designs of Fairyland for which he intends to write interpretative verse, thus reversing the usual order of verse and illustration.[9]

Mackintosh, too, produced a group of fairy-tale subjects. Sadly, the more substantial of these are now lost (119), presumably because they were all sold rather than remaining with Mackintosh, but *In Fairyland* (120) and *Fairies* (121) are representative of the group. Mackintosh does not seem fully committed to the subject, however, and a number of pictures are more repetitive in theme and weaker in handling then we have come to expect of him.

The same could not be said of Frances Macdonald. In *The Frog Prince* (122) she selects the moment in the Brothers

119. Charles Rennie Mackintosh, *A Fairy Figure*, c1897–98, ?pencil and watercolour, untraced (contemporary photograph, Hunterian Museum)

120. Charles Rennie Mackintosh,
In Fairyland, 1897, pencil and watercolour,
37 x 17.6 cm, private collection

121. Charles Rennie Mackintosh,
Fairies, 1898, pencil and watercolour,
52.7 x 25.6 cm, Glasgow School of Art

Grimm story where the princess persuades the frog to retrieve her golden ball by promising him her constant companionship, only to renege on her promise afterwards. The prince is a ghostly presence behind his alter ego; both figures are coloured pale blue or grey in contrast to the delicate brighter colours of the princess. Frances is perhaps hinting at the character of the young woman in her depiction of her deformed hands, one set of talons grasping at the ball, the other distractedly plucking at her dress to reveal the rose-covered petticoat beneath. There is nothing vaguely sentimental or maudlin about this painting. In *Girl with Blue Butterflies* (124), one of the largest of her watercolours, Frances transforms her *The Sleeping Princess* (91) into a healthy girl lying in a meadow surrounded by daisies and blue lily-of-the-valley, around which butterflies flutter. If we are to read anything into the imagery here, the traditional meaning associated with lily-of-the-valley is 'the return of happiness'; its flowers and leaves, however, contain a well-known poison. Images from past work abound – the daisies and butterflies from the picture frame, the patterns of the dress worn by the sleeping princess, the stylised flowers and bracken. But there is no sense of malice here, no hidden premonition of the future or menace from the past; one could interpret this as the work of a young woman on the verge of marriage and happy with her lot. In *The Rose Child* (123) Frances produces another painting that seems to point towards a happy future. The babies that appeared in earlier work are replaced here by a rather indeterminate figure with the face of a woman but the chubby body of a two-year-old. The handling and tonal range recall *The Frog Prince*, but despite the slightly quizzical look in the face of the child there is no real sense of menace.

Menace is certainly absent too from Margaret Macdonald's *June Roses* (125) or *The Rose Garden* (126). Both paintings are developments, or rather simple enlargements, of earlier works – *Summer* and *Two Red Roses Across the Moon*. This was a practice that Margaret maintained for some years, and both images can be seen in slight variations, usually of size or colour, that she made over the next ten years. There is an overt sense of romance about these pictures, perhaps inspired by the engagement of Frances and Bertie or their wedding in 1899, or even an anticipation of her own marriage to Mackintosh. The handling is accomplished, the design fully developed, with *June Roses* easily accommodating the increase in size from the small image in *The Seasons* series to one over a metre in height. One might

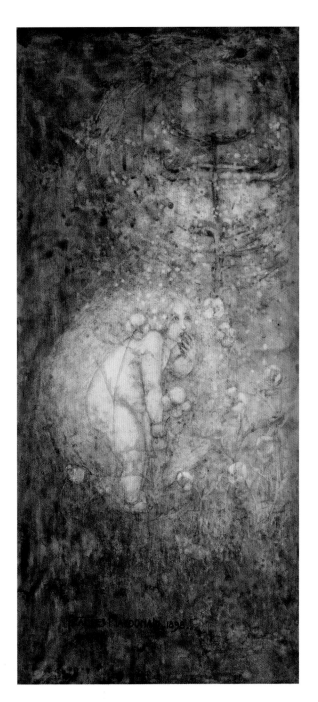

ABOVE
123. Frances Macdonald, *The Rose Child*, 1898,
pencil, watercolour and gouache, 45.7 x 20 cm, untraced

OPPOSITE
122. Frances Macdonald, *The Frog Prince*, 1898,
pencil, watercolour and gold paint, 48.9 x 36.8 cm, private collection

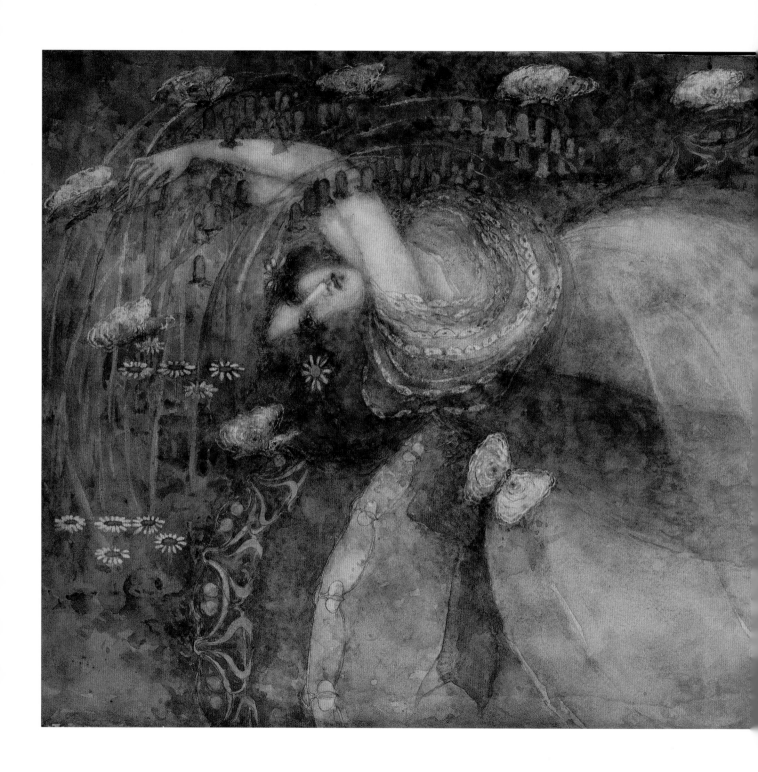

124. Frances Macdonald, *Girl with Blue Butterflies*, 1898,
pencil and watercolour, 45.3 x 101.8 cm, untraced

125. Margaret Macdonald, *June Roses*, 1898, watercolour and pencil, 103 x 45 cm, Belvedere, Vienna

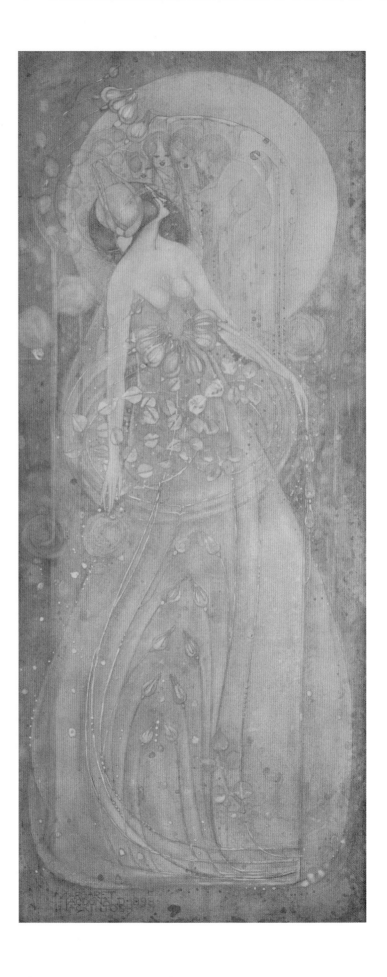

say that if a particular solution is as successful as this there is nothing wrong in its repetition, but perhaps it also reflects a lack of imagination, invention or confidence on the part of the artist. Of all the members of The Four, Margaret Macdonald had the fewest distractions – emotional or domestic – over the next few years and yet, in some ways, she often appears the least inventive. Perhaps she missed the spur of her sister's companionship – Frances had married MacNair in 1899 and moved with him to Liverpool; Mackintosh took Frances's place as a sometime collaborator, but this would probably not have replaced the bond between sisters.

Several of these paintings were sent to the 1899 exhibition of the International Society of Sculptors, Painters and Gravers (ISSPG) in London. Encouragement almost certainly came from Fra Newbery who was a guarantor for the exhibition but there were several other Scottish connections with the society. James McNeill Whistler was its president and he was supported by several of the Glasgow Boys who had moved to London in the 1890s. James Guthrie, E.A. Walton and John Lavery were all Whistler's neighbours in Chelsea at some point and their support of his new venture was undoubtedly substantial. The chairman was the sculptor Alfred Gilbert, which confirmed its links to the London *avant garde*, and exhibitors from abroad in 1899 included Gustav Klimt, possibly offering The Four their first glimpse of contemporary art from Vienna. Exhibits by The Four included *Summer* and *The Rose Garden* by Margaret Macdonald; *Spring* and *Lover's Land* by Frances; *The Black Thorn* and *The Moss Rose* by Mackintosh; and *Hope and Love* by MacNair. Of these, only *Summer* and *Spring* have survived; no photographs survive of Mackintosh's exhibits and it is not known whether they were simple flower drawings or more complete paintings in the style of the fairy pictures of recent years.

At the end of the decade, then, The Four were committed to exhibiting as artists not designers – not just at the Glasgow Institute and the RSW but also at a national level. Only Margaret returned to the ISSPG, however, despite the growing influence of Scottish artists in its council (Lavery was to become vice-president). The attention of The Four over the next decade was to be focused on Europe. But suddenly they were no longer working side by side. MacNair accepted a teaching post in Liverpool in 1898, and Frances went with him as his wife the following year; Mackintosh and Margaret Macdonald married in 1900 and remained in Glasgow until 1914. Although their careers ran in parallel for a few years, The

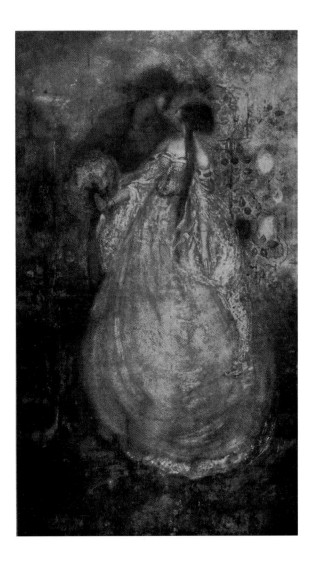

126. Margaret Macdonald, *The Rose Garden*, by 1898, watercolour, destroyed

Four were now really two sets of *Künstlerpaare* [artist-couples] as the Viennese dubbed them. Slowly they diverged, with different interests, different goals, and different pressures. It was the beginning of a gentle process of the creation of four quite individual artists.

7 PARTNERSHIPS

THE CHANGE in the circumstances of The Four generated different kinds of artwork after 1899 as new phases of their lives opened up. From the summer of 1898 MacNair had a full-time job as Instructor in Decorative Design at the School of Architecture and Applied Art within University College, Liverpool. Frances Macdonald married MacNair in June 1899 and moved to Liverpool with him, giving birth the following year to their only child, Sylvan. In 1899 the first phase of the new building for the Glasgow School of Art, designed by Mackintosh, was opened and his promotion to partner within the practice must have been under consideration. Margaret Macdonald and Mackintosh married in the summer of 1900. All of these events would have limited the amount of time that the MacNairs and the Mackintoshes would have had for their independent careers as artists; although Margaret would now have responsibility for her own domestic affairs, as opposed to living with her mother, she would probably have been the least affected by these changes, other than missing the artistic bond she had had with her sister. Domestic demands commanded considerable attention from The Four, however, as both couples faced the challenge of creating a suitable home. The MacNairs found a house near the college in Liverpool, in Oxford Street, and presumably spent much of 1899 and 1900 modifying it to their own tastes and needs. Charles and Margaret, who married in August 1900, faced similar challenges, moving into a tenement flat at the corner of Bath Street and Mains Street (now Blythswood Street) in Glasgow. The two couples, however, found themselves with very different canvases on which to work: the MacNairs' house in Liverpool had small rooms, not particularly well-lit and ranged on three floors; the Mackintoshes' first floor flat had almost full-height windows to the large drawing room, ranged on two sides, giving so much light that Mackintosh chose to filter it through gauze curtains.

Photographs of the interiors of the two houses were published together by *The Studio* in 1901 and the captions gave equal credit to Margaret and Frances as designers with their husbands.[1] Much of the furniture in the rooms was undoubtedly designed by Mackintosh or MacNair. Frances made her own contribution to this furniture in the form of beaten metal panels, as well as embroidering curtains and cushions and hanging her paintings on the walls of the house. There is,

127. Charles Rennie Mackintosh and Margaret Macdonald Mackintosh, *Two views of the drawing room, 120 Mains Street, Glasgow, 1900–01*

LEFT
128. James Herbert MacNair, c1901–03

RIGHT
129. Frances Macdonald MacNair and her son Sylvan, 1900

OPPOSITE, ABOVE
130. James Herbert MacNair and Frances Macdonald MacNair, Studio, 54 Oxford Street, Liverpool, 1899–1900

OPPOSITE, BELOW
131. James Herbert MacNair and Frances Macdonald MacNair, Dining room, 54 Oxford Street, Liverpool, 1899–1900

however, a distinct feeling about the Oxford Street house that it is the work of two minds acting as one to create a home; the painter, Augustus John, who was a colleague of Herbert, wrote of the MacNairs working 'in perfect harmony'.[2] In Glasgow Margaret must have worked similarly with her husband on the layout and decoration of their apartment and her paintings and metal panels appear on the walls, although not in the same numbers as Frances's did on hers. But here there seems to have been less of a visible integration between two supposedly equal partners; the large and sparsely furnished drawing room, for example, appears as more of a set-piece by Mackintosh than a comfortably usable space.

The joint attributions to the two couples, however, were to re-appear in relation to later rooms, exhibited in Vienna and Turin (*see* pages 130–138 and 155–165). This was a different and new kind of collaboration for The Four, based on less tangible material than a metal panel or poster. It had to be more a meeting of minds over such generalities as colour schemes and arrangement of furniture and paintings, although the latter, whether watercolours or larger gesso panels, were generally but not always the province of the sisters at this time. More traditional forms of collaboration were not abandoned: Margaret and Charles worked together on a chair they sent to the

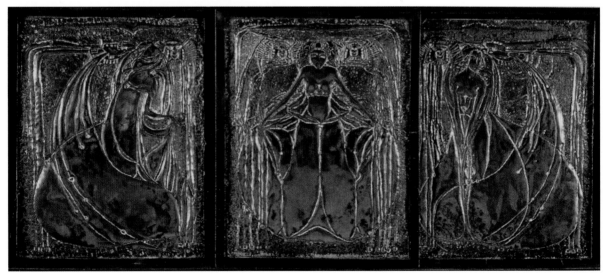

CLOCKWISE FROM TOP LEFT
132. Margaret Macdonald Mackintosh, *Night* (left) and
Day (right), panels for a smoker's cabinet designed by
C.R. Mackintosh, 1899 and 1903, silvered beaten copper,
60 x 10.9 cm, Glasgow School of Art

133. Margaret Macdonald, Panel, 1898, silvered beaten
brass, 56.8 x 53 cm, The Hunterian, University of Glasgow
134. James Herbert MacNair and Frances Macdonald
MacNair, Panels for a wardrobe, by 1900, National
Museums, Liverpool (Walker Art Gallery)

sixth exhibition of the Arts and Crafts Exhibition Society in 1899 where a lacquer panel was designed and made by Margaret for a chair that Mackintosh exhibited. Surprisingly the panel was attributed in the catalogue (a year before their marriage) to 'Margaret Mackintosh'. In another collaborative piece, also made in 1899, Margaret signed her two metal panels as 'Margaret Macdonald'. These were *Night* and *Day* (132; the original cabinet was sold in Vienna in 1900, and is now lost, and the panels illustrated here are from a later replica made by the Mackintoshes) and were made for a smoker's cabinet designed by Mackintosh, probably for his own use; all of Macdonald's metal panels dating from 1899 were made for other pieces of Mackintosh furniture or room settings. The smoker's cabinet panels demonstrate her undoubted skill as a metalworker, developing ideas seen in earlier watercolours and incorporating imagery more usually associated with Frances Macdonald (the floating eyes above the two figures in *Day*) or with Mackintosh himself (the swooping birds seen at the foot of *Night*). This was a substantial piece of furniture, important enough for it to be given a prominent position in the room that The Four were to exhibit at the eighth exhibition of the Vienna Secession in 1900.

The smoker's cabinet was echoed by the wardrobe at the Liverpool house, designed by MacNair but containing three beaten metal panels, the outer two of which were probably by Frances (134). Challenged by her relocation to Liverpool

and the birth of her son, Frances possibly found little energy for new work at this time (despite the assistance of a nanny and live-in maid). Unlike Margaret, she had already produced large-scale designs for unlocated friezes (79) as well as a stencilled back panel for a settle at Dunglass (135), where the Macdonald family had moved in 1899; but for her own house she concentrated on embroidered hangings, curtains and cushions, several being used in MacNair's innovative settles, of which three were made for 54 Oxford Street — although I feel the guiding hand, a more sure hand, of Frances in much of the furniture. Although all of the embroidered pieces made for the Liverpool flat in 1899–1900 are now lost, from contemporary photographs they appear very similar to the Turin cushion of 1902 (186). MacNair turned to birds as the main motif in his large (139 x 40 cm) watercolour *The Legend of the Birds* (137), a companion piece to Frances's *The Legend of the Snowdrops* (136). Both of these repeat the by now traditional Glasgow Style imagery of single figures flanked by or superimposed on others. The contrast between the draughtsmanship of these two artists is most clearly seen here with Frances's design carefully delineated and coloured while that of MacNair is over-complicated in its composition and muddy in colour. The overt religious symbolism is most likely to have been the input of Bertie MacNair, as are the verses beneath each painting. These panels were obviously important to the MacNairs and they exhibited them in Vienna,

135. Frances Macdonald, Design for settle cover, Dunglass Castle, Bowling, *c*1898, pencil and pigment on linen, 92 x 297.5 cm, The Hunterian, University of Glasgow

Dresden, Turin and London. They never sold, however; the mystical or religious symbolism that fascinated Herbert MacNair was slow to find a ready market.

The publicity given to The Four by *The Studio* in 1897, and later by *Dekorative Kunst*, had come to the attention of the group of young architects, artists and designers who were the driving force behind the Secession Movement in Vienna (the Wiener Secession). One of its backers, a textile manufacturer and financier called Fritz Waerndorfer, visited Charles and Margaret in Glasgow in the early part of 1900 at the suggestion of Josef Hoffman. He was to become their most important continental client and was open in his appreciation of their work. Out of his visit came an invitation for The Four to exhibit with the Secession in Josef Olbrich's new gallery at the end of the year. The design of their room, ostensibly by Mackintosh, was an amalgam of the Mains Street drawing room and the new tea room that he had designed for Catherine Cranston at her Ingram Street premises. Two large gesso panels intended for the Ingram Street Tea Rooms, one by Charles and one by Margaret, dominated the space in Vienna, while the mirror from the Mains Street bedroom and the smoker's cabinet formed centrepieces below them; another cabinet by Mackintosh was placed against the third wall. The MacNairs showed several earlier pieces, including *The Frog Prince*, as well as the two large watercolours, *The Legend of the Snowdrops* and *The Legend of the Birds*. Margaret exhibited, among others, a large embroidered panel, a silvered metal panel like that in the Brückmann apartment (133), which had been one of the earliest appearances of a design by Macdonald in a Mackintosh room setting, and the clock (83) that she had designed and made with Frances (like Margaret's embroidery, this was sold at the exhibition). The entire exhibit firmly established the reputation of The Four in German-speaking Europe and had a considerable effect on the design and layout of spaces in future exhibitions of the Vienna Secession. Inevitably, given the impact of his furniture and the placing of the two gesso panels, Mackintosh received the most coverage and credit, but the room acts as a manifesto for the new directions that The Four were beginning to take.

Charles and Margaret travelled to Vienna in late October 1900 to unpack and arrange their exhibits in their allotted exhibition space. They stayed for six weeks, forming friendships and making contacts that were to be of particular importance for both themselves and the MacNairs over the next few years. Mackintosh had the opportunity to discuss their exhibit with both artists and critics; not all of the latter were convinced of the validity of the new work. Echoes of the Glasgow criticism regarding 'spooks' and impenetrable symbolism appeared in some reviews, but others, obviously guided by Mackintosh, were more perceptive. Berta Zuckerkandl, an Austrian writer and critic who was a consistent supporter of the Secession, recalled Mackintosh's remark that a room should be a picture and continued in her review:

. . . the white room in the exhibition, with its subtle flecks of colour, the peculiar jewel-like embroidery, the serious motionless lines of the friezes, truly is a picture, perhaps puzzling to many of us but nonetheless effusing the authenticity of a distinct vision of beauty.[3]

In the same article Zuckerkandl pondered the genesis of the Glasgow Style, wondering whether it grew out of the guidance of one powerful leader who had 'announced a new doctrine, and the others became his proselytes …' We know that that is not what happened in Glasgow, but because of Mackintosh's supervision of the installation and his interviews with the press, that was the presumption in Vienna. What impressed the Viennese designers most about the Glasgow exhibit in 1900 was the way that each item in the display had been carefully considered as part of the whole. All the exhibits were arranged along the walls, and each wall was composed to complement the others. Only one item – a flower stand – stood away from the walls; this was the same clear emphasis on composition and spatial manipulation that had been reflected in the Mackintoshes' drawing room in Glasgow. The large gesso panels that floated above opposite walls were to have a continuing influence on future rooms at the Vienna Secession – in particular the fourteenth exhibition in 1902 when Josef Hoffmann designed the installation for the Beethoven Room. This was centred on Max Klinger's sculpture of the composer, and included a series of frieze panels by Gustav Klimt (*The Beethoven Frieze*) which was fixed at high level around the

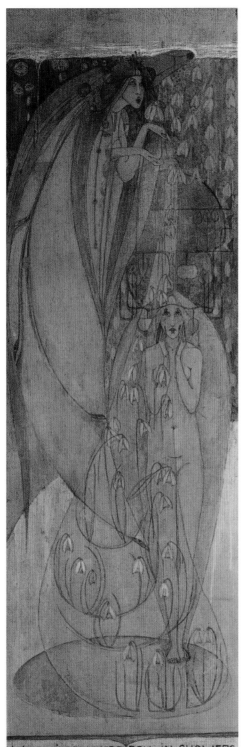

WHEN ICE-FLAKES FELL IN SHOWERS
VPON THAT WORLD OF DEATH ■ ■ ■
SOME PITYING ONES ■ DISTILLED
BY ANGEL-BREATH ■ FELL LOV-
ING FLOWERS ■ ■ ■ ■
AND SNOW-DROPS THVS WERE BORN
TO COMFORT EVE ■ WHO SORROWFVL
THE LAND OF LIFE DID LEAVE ■ ■ ■

FRANCES McNAIR

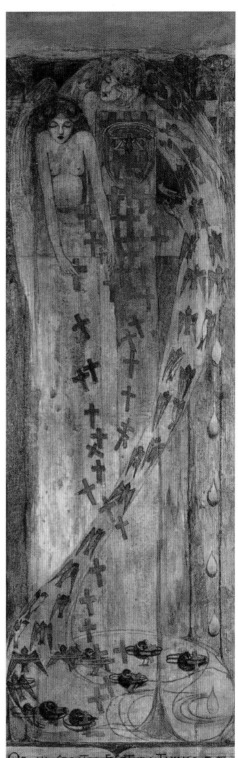

OF ALL CREATED EARTHLY THINGS ■ ■
THE ONLY ONES HAVE GOT TEN WINGS
CHRIST'S CROSS VPON THEIR SHOVL-
-DERS BARE ■ ■ ■ ■
AND IN ITS STEAD ■ RECEIVED
THERE ■ ■ ■ ■ ■ ■
THIS BLESSING FROM THE KING
OF KINGS ■ ■ ■ ■

1900 HERBERT McNAIR

LEFT AND BELOW
140. The Four at the Eighth exhibition of the Vienna Secession, 1900, including a smoker's cabinet by Charles Rennie Mackintosh, with silvered panels, *Night* and *Day*, by Margaret Macdonald Mackintosh
141. The Four at the Eighth exhibition of the Vienna Secession, 1900, including *The Frog Prince* by Frances Macdonald, and a cabinet by Charles Rennie Mackintosh, with a silvered panel by Margaret Macdonald

OPPOSITE, ABOVE AND BELOW
138. The Four at the Eighth exhibition of the Vienna Secession, 1900, including clock by Frances and Margaret Macdonald and *The May Queen* by Margaret Macdonald Mackintosh
139. The Four at the Eighth exhibition of the Vienna Secession, 1900, including candlestick by Frances Macdonald and metal panel by Margaret Macdonald

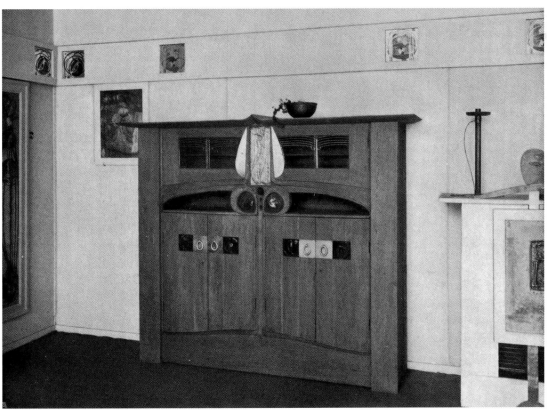

TOP
142. Margaret Macdonald Mackintosh,
The May Queen, 1900, painted gesso set with
twine, glass beads and tin inlay, three panels,
each 158.7 x 152.4 cm, Glasgow Museums

ABOVE
143. Charles Rennie Mackintosh, *The Wassail*,
1900, painted gesso set with twine, glass
beads and tin inlay, three panels,
each 158.7 x 152.4 cm, Glasgow Museums

galleries. Some of the imagery from the Glasgow gessos – the floating figures enveloped in filmy robes and dresses, and the decorative patterns linking them – also found their way into Klimt's work from 1901.

The two gessos had been made for similar positions in the White Room at Miss Cranston's Ingram Street premises. Designed by Mackintosh outside his employment by Honeyman & Keppie, this is the first room where Margaret Macdonald played a significant role in the decoration of a room designed by her husband. In recent years Macdonald has been credited as co-designer of the tea room, but I think it more likely that its concept was entirely Mackintosh's and that Macdonald's participation was limited to the (albeit substantial) gesso panel and the beaten metal panel that hung nearby. There is no doubt that Mackintosh and Macdonald designed and worked on their two panels together[4] – her *The May Queen* (142) and his *The Wassail* (143) – but their purpose and positioning (removing the negative distraction of a large empty

space in the upper walls of both the tea room and the exhibition stand) was surely Mackintosh's idea alone. It recalls his proposal in 1897 to install a painted frieze of promenading figures at a high level in the museum at Glasgow School of Art, which was never executed.[5] Although it contains a large number of chairs and tables, the overall impression given by Mackintosh's dining room is of a simple affair of white and silver painted walls and screens and contrasting darker furniture; the elaborately worked gesso panels form a strikingly tactile foil to the plainer walls below.

The iconography of the panels is a development of the images in both artists' earlier work. The 'Drooko' (50) poster (by the sisters) and the poster (by the sisters and MacNair) for The Glasgow Institute of the Fine Arts (52), the School of Art Club Diploma (33) and Buchanan Street murals (98, 99) by Mackintosh have all been developed here into something softer and more pictorial. Elements of Spook School tracery link all of the figures, and the roses from Buchanan Street play a major part,

TOP

144. Charles Rennie Mackintosh, after Margaret Macdonald Mackintosh, *The May Queen*, 1900, pencil and watercolour, body colour and silver paint on brown tracing paper, 33 x 69.2 cm, private collection

ABOVE

145. Charles Rennie Mackintosh, *The Wassail*, 1900, pencil and watercolour, 32 x 68 cm (sight),Toyota Municipal Museum of Art, Japan

146. Walter Crane, Illustration of a gesso panel in *The Studio*, c1893

particularly in Mackintosh's panel. The figures have no visible legs or feet and usually no hands, and even their bodies seem indeterminate under their formless robes whose colours are indistinguishable from the background of the panels into which they blend, although in later watercolours depicting the panels (144, 145) Mackintosh did make the distinction between robe and setting. The themes are a mixture of quasi-religious and traditional folklore, extending the fairy-tale imagery of the late 1890s watercolours by The Four, but the medium and handling are entirely new in their work. Neither artist seems likely to have had any formal training in the use of gesso, but in the second issue of *The Studio* Walter Crane contributed an article praising its versatility and its historical pedigree. Given Charles and Margaret's acknowledged familiarity with the journal it seems likely that they had seen this article, particularly as their compositions show distinct affinities with one of Crane's illustrations (146).[6]

Given Margaret's evident skill in future gesso panels, it seems likely that the choice of medium here was hers. Compared with the subtlety and delicacy of execution of these later panels, the Ingram Street gessos are bold, almost crude, perhaps because of their intended distance from any viewer. The support is a heavy canvas which is often visible through a thick layer of gesso, except where faces appear and are carefully painted on smooth plaster. The linear decoration has been achieved by immersing twine in gesso and stretching it across the panels; the individual compartments thus created are usually painted and sometimes filled with gessoed buttons or pieces of coloured glass to create more relief and a varied surface texture. The

compositions, however, are almost interchangeable between Mackintosh and Macdonald although we can detect historical motifs peculiar to each in their own panels. The same can be said for the two adjacent metal panels that Mackintosh and Macdonald also made for the tea room (148, 147).[7] Individual hands were unimportant at Ingram Street; a unity of design was required to give the space its necessary coherence. Mackintosh, however, had other areas at the tea room where his own graphic ideas could be achieved on a large scale in either two or three dimensions: the leaded-glass panels in the entrance screen (149), stencilling in the mezzanine balcony, and the leaded-glass windows concealing an internal duct (150).[8] Similar motifs can be found in the Vienna Secession room, many of which were repeated in a special edition of the Secession journal, *Ver Sacrum*, in 1901 (151, 152, 153).[9] This was the first issue of the journal to contain work by non-Secession members and was entirely devoted to The Four. It contained colour reproductions of the stencils designed by Mackintosh for the panelling in the Secession room, photographs of his posters and other graphic work such as vignettes and colophons as well as a group of watercolours and graphic designs by MacNair and the Macdonald sisters. Here, almost more than in any publication that appeared before 1900, one can observe the interchangeability of ideas and imagery between each of the four artists. Just as much as the Secession exhibition, *Ver Sacrum* confirmed the originality and integrity of these four Glasgow artists both individually and as a group.

The demands of creating their new homes, followed so quickly by the work needed for the Vienna Secession room,

147. Margaret Macdonald, *The Dew*, 1900, silvered lead, 122.5 x 29.8 cm, Glasgow Museums

148. Charles Rennie Mackintosh, Panel for the Ingram Street Tea Rooms, 1900–01, silvered lead, aluminium, 122.5 x 29.8 cm, Glasgow Museums

TOP LEFT
149. Charles Rennie Mackintosh, Leaded-glass panel from entrance screen at the Ingram Street Tea Rooms, 1900, lead with clear and coloured glass, Glasgow Museums

TOP RIGHT
150. Charles Rennie Mackintosh, Window panel for Ingram Street Tea Rooms, 1900, lead with clear and coloured glass, Glasgow Museums

CENTRE LEFT
151. Margaret Macdonald Mackintosh, Cartouche published in *Ver Sacrum*, by 1900, line art, untraced

CENTRE RIGHT
152. Charles Rennie Mackintosh, Cartouche published in *Ver Sacrum*, by 1900, line art, untraced

BELOW, LEFT AND RIGHT
153. Charles Rennie Mackintosh, Stencil patterns for room at Eighth Exhibition, Vienna Secession, 1900, untraced

had a noticeable impact on the output of The Four in 1900 and 1901, although the MacNairs were perhaps less affected as they continued to produce watercolours and graphic works – bookplates, greetings cards and so on. Herbert became more and more involved with the artistic life of Liverpool and the University College, where he lectured in the School of Architecture and Applied Arts, producing book plates (155), certificates (154) and scientific illustrations for his academic friends and a notable poster for the Liverpool Academy of Arts (156). This was a public declaration that the Glasgow Style had come to Liverpool, combining lettering and Spook School imagery in a design that would not have been out of place in Glasgow in 1895 – the Academy never had a more effective or beautiful poster.[10] His bookplates for John Turner similarly depend markedly on 'traditional' Glasgow ideas (157) and his Kanthack medal is distinctly backward-looking (159). Frances continued to make watercolours in which the imagery is often related to her new role as a mother. *The Sleeping Princess* (158) was possibly inspired – or provoked – by her pregnancy; the baby in a rose ball sits on the woman's abdomen like an external pregnancy while her full breasts are openly exposed, which was rare for The Four at this date. *Child in a Rose Bowl* (160) was probably painted in 1901 and presumably depicts the young Sylvan, the only child of The Four. The colours and compositions in these and other paintings from the early 1900s still have a strong flavour of the Glasgow years, but Frances was to move away from them, closer to MacNair, and began to turn her attention to the design and making of jewellery.

The Mackintoshes faced a different situation with mounting pressures as new and grander opportunities presented themselves. While they were staying in Vienna

LEFT
154. James Herbert MacNair, Certificate of Tropical Veterinary Medicine, 1904, lithograph, 34.6 x 40.5 cm, National Museums, Liverpool (Walker Art Gallery)

RIGHT
155. James Herbert MacNair, Bookplate for Albert Grünbaum, 1903, collotype, 9.9 x 3.5 cm, private collection

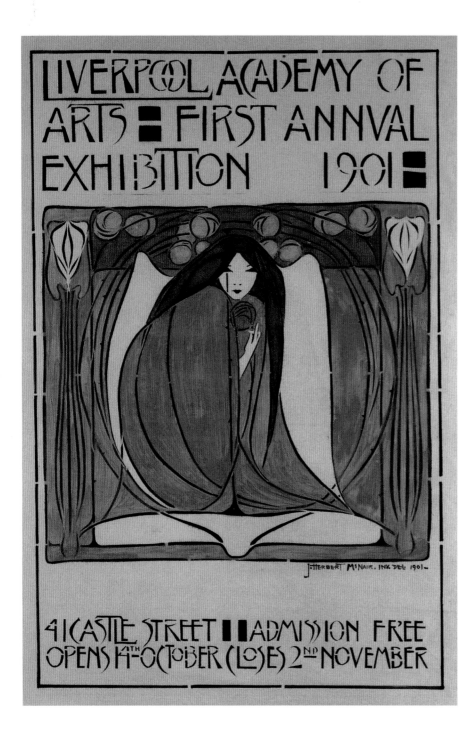

LIVERPOOL ACADEMY OF ARTS ▪ FIRST ANNUAL EXHIBITION 1901 ▪

41 CASTLE STREET ▪▪ ADMISSION FREE OPENS 14TH OCTOBER CLOSES 2ND NOVEMBER

ABOVE
156. James Herbert MacNair, Design for a poster for the Liverpool Academy of Arts, 1901, gouache, ink and chalk, 89 x 57 cm, National Museums, Liverpool (Walker Art Gallery)

RIGHT
157. James Herbert MacNair, Bookplate for John Turner, 1901, collotype, 15.3 x 3.0 cm, The Hunterian, University of Glasgow

ABOVE
158. Frances Macdonald MacNair, *The Sleeping Princess*, c1900–01,
pencil, watercolour and gold paint, 14.7 x 47.8 cm, private collection

BELOW, LEFT AND RIGHT
159. James Herbert MacNair, Kanthack medal, 1900,
bronze, 9.5 x 6.4 cm, National Museums, Liverpool (Walker Art Gallery)
160. Frances Macdonald MacNair, *Child in a Rose Bowl*, c1900,
pencil and watercolour, 12 x 12 cm, University of Liverpool, Art and
Heritage Collections

GALLERIE.

DIE DIELE ::　　　DIE THÜR DES EMPFANGS-RAUMS:　　　DER KAMIN:

EMPFANGS---RAUM UND MUSIK---ZIMMER PANELS VON MARGARET MACDONALD MACKINTOSH

CHARLES RENNIE MACKINTOSH

IDEEN-WETTBEWERB FÜR EIN HERRSCHAFTLICHES WOHNHAUS EINES KUNST-FREUNDES. 10.

DER SPIEL---RAUM DER KINDER PANEL VON MARGARET MACDONALD MACKINTOSH.

they probably learned of the competition to design a *Haus eines Kunstfreundes* [House for an Art Lover].[11] Mackintosh had become friendly with Josef Olbrich, who was to be one of the judges, and it was possibly at Olbrich's suggestion that he submitted designs to the competition. Unfortunately, his (or probably Margaret's) command of German led him to submit an incorrect number and mixture of drawings and he was disqualified. The judges, however, considered his drawings to be amongst the best received and awarded him a special prize, *hors concours*, and he was asked to provide extra perspectives; these were published in 1902 in a series of folios relating to the project. The overall design need not concern us here, however it is worth noting that many of the decorative details are an extension of Mackintosh's artistic and graphic vocabulary of the period, showing how seamlessly he could

translate imagery from one medium to another. For instance, in the hall he decorated the piers with inlaid panels similar to the metal panel he had produced for Ingram Street and the greetings cards illustrated in *Ver Sacrum;* leaded-glass panels in the doors and mantel cupboard are an amalgam of the

163. Charles Rennie Mackintosh, Design for playroom with a panel by Margaret Macdonald Mackintosh, Haus eines Kunstfreundes, 1901

OPPOSITE, ABOVE
161. Charles Rennie Mackintosh, Design for hall, Haus eines Kunstfreundes, 1901

OPPOSITE, BELOW
162. Charles Rennie Mackintosh, Design for music room, Haus eines Kunstfreundes, 1901

glazed window and entrance screen panels at Ingram Street; a decorative frieze running around the hall seems to be either stencilled or painted gesso and includes the sort of stylised plant forms he drew in the mid-1890s.

In his original submission Mackintosh does not seem to have realised that the organisers were looking for a collaboration between an architect and an art-worker; in the four extra perspectives that he produced this misapprehension has been corrected and Margaret's contribution is clearly acknowledged. In the music room (162), long stencilled panels designed by Margaret were hung at the side of windows and on either side of the piano; these extend the imagery of the curtain that she exhibited at the Vienna Secession. In the children's playroom Mackintosh introduced over the fireplace a gesso panel designed by Macdonald (163); other decorative panels in the room might also be by her. His elevation of the main bedroom (164) is a repetition of that at Windyhill (he was obviously very short of time), but the stencilled roses were perfectly apt here. There is no acknowledgement to Margaret in the perspective of the dining room (165), and it seems likely that the decorative panels around the walls were designed by Mackintosh and probably intended to be made in gesso. Over the fireplace (itself a variant of another design used at the School of Art) is another decorative panel, possibly gesso inlaid with glass, that combines elements of similar designs (but in different materials) seen later that year in work at 14 Kingsborough Gardens, Glasgow, and St Serf's Church at Dysart. The competition brief called for the use of sandstone in the detailing of the exterior elevations, and Mackintosh concentrated its use on a series of sculptural features, often

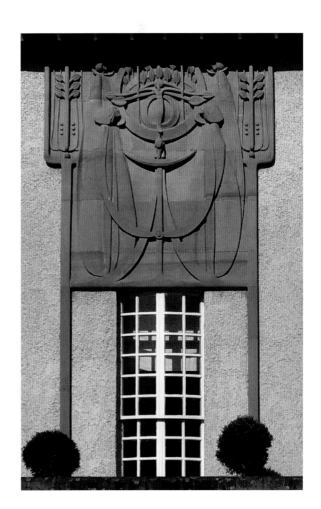

RIGHT, ABOVE
166. Charles Rennie Mackintosh, Relief carving on south elevation, modern reconstruction at the House for an Art Lover, Glasgow, 1992

RIGHT, BELOW
167. Charles Rennie Mackintosh, Maquette for sculpture over entrance door, Glasgow School of Art, 1899, clay, untraced

OPPOSITE, ABOVE
164. Charles Rennie Mackintosh, Design for bedroom, Haus eines Kunstfreundes, 1901

OPPOSITE, BELOW
165. Charles Rennie Mackintosh, Design for dining room, Haus eines Kunstfreundes, 1901

incorporating or developing motifs from the interior of the house. He articulated the wide south elevation of the design with a series of sandstone piers that rise between the music-room windows and culminate in relief panels between the windows of the second floor. Between two of these piers he placed a large sculptural panel incorporating several figures that appear in the music-room decorations with a more abstract central form based on organic motifs (166). I am sure, following his practice at the Glasgow School of Art in 1899 where he modelled the entrance door sculpture in clay (167), that Mackintosh would have developed this design into one of his most impressive works had the occasion arisen.

All of this decorative work in 1901, produced outside Mackintosh's normal architectural practice, shows how a simple motif, emphatically repeated, can be transformed through its execution in different media – gesso, watercolour, wall stencils and stencilled upholstery fabrics. This is, of course, true of the work of all of The Four, but Mackintosh had more opportunity than his friends to translate ideas from one format, or one medium, to another. This practice underpinned much of his decorative work of the next two or three years; ultimately, much of it was to be drawn from his study of wild flowers which became the major subject of his paintings between 1900 and 1905.

Mackintosh's output as an artist, throughout his career, was in inverse proportion to his output as an architect. From 1900 to 1910, when his career as an architect and exhibition designer was at its busiest, his painting was generally limited to small watercolour studies of wild flowers, usually made on holiday. Throughout the 1890s on his sketching trips in the south of England and Scotland he had regularly made pencil drawings (rarely including colour) of plants and flowers in his sketchbooks. In some of these sketches Mackintosh went further than a simple pictorial record, making some attempt to analyse the botanical structure of the flowers, separating individual parts and overlaying these drawings onto the main subject, as in the 1896 drawing *Clematis Flower, Bud, Leaf* (168). This is the most elaborate of several similar drawings, some made at West Kilbride near Keppie's house; Mackintosh has added the initial K for Keppie here. After 1900 his holidays were spent with Margaret and seem to have been rather more static than the peripatetic journeys of his bachelor days. In 1901 they spent part of July on Holy Island where he was clearly fascinated by the castle on top of the rocks, making several drawings of it – it had obvious affinities with his design for Glasgow School of Art. These drawings sometimes included clumps of sea pinks bursting out of crevices in the cliff side; at first they are usually seen in context (169), with the rocks forming the main part of the design, but by the end of the holiday Mackintosh had moved towards the format he would use to paint wild flowers for the rest of his life (170). The drawings often contain a small cartouche that usually includes a title, location and the signature – almost always CRM. It is, in fact, rare for this cartouche to include only Mackintosh's initials; MMM, for Margaret Macdonald Mackintosh, usually also appears. Explanations for the use of both sets of initials often attribute the colour to Margaret and the pencil sketch to Charles, but this does not account for extra initials on some of these drawings. For instance, in 1901 these include F, B and C, standing for Frances and Bertie MacNair and Charles Macdonald, brother of the two sisters, who had

CLEMATIS. FLOWER. BUD. LEAF,
K. JULY 189 6.

CHARLES RENNIE MACKINTOSH AND THE ART OF THE FOUR

SEED FLOWER

BUD

SEA PINK
HOLY ISLAND
JULY 1901
M T

joined the Mackintoshes on Holy Island. This was a practice that Mackintosh had followed in his student days where two or three single initials might appear, recording friends who were present when the drawings were made, and he seems to have done the same on later flower drawings. Mary Sturrock, daughter of Fra and Jessie Newbery, saw Mackintosh at work on his flower studies in Walberswick in 1914 (*see* Chapter 10) and later firmly stated that Mackintosh would never allow anybody, including Margaret, to work on his drawings. Living in a city apartment, with no garden, these drawings of flowers became even more important to an artist who emphatically believed that the source of all artistic beauty was to be found in nature.

Any respite from the previous hectic six months that the Mackintoshes might have enjoyed on Holy Island soon disappeared once they were home and Mackintosh once again became immersed in both office and private projects, several of which involved Margaret. All of them were essentially decorative in content, allowing Mackintosh to develop his growing interest in naturalistic painted decoration. A cousin of Jessie Newbery, Robert James Rowat, commissioned the redecoration of the hall and drawing room at his house in Kingsborough Gardens, Glasgow. Mackintosh designed several new pieces of furniture for the drawing room, where the walls were stencilled with a repeat pattern based on roses and briars (171). More elaborate

ABOVE AND BELOW
171. Charles Rennie Mackintosh, Stencils at 34 Kingsborough Gardens, Glasgow, 1901–02, *in situ*, now overpainted

OPPOSITE, ABOVE
172. Charles Rennie Mackintosh, Stencilled settle cover, 34 Kingsborough Gardens, by 1901, pigment on linen, untraced

OPPOSITE, BELOW
173. Charles Rennie Mackintosh, Door of display cabinet for 14 Kingsborough Gardens, 1902, glass, inlaid on silver-painted wood, private collection

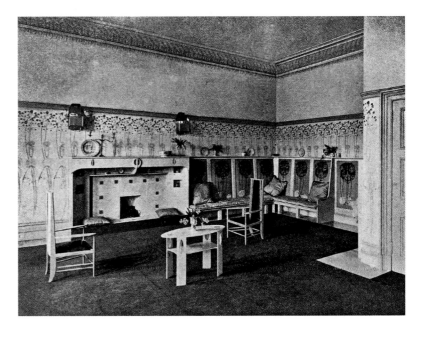

patterns were stencilled on the backs of the fitted settles adjacent to the fireplace and on a companion settle designed for the hall. The roses extended to a pair of display cabinets also designed for the drawing room where the interiors of the doors were painted silver and inlaid with coloured glass in the form of a woman holding a giant rose. There is a simplification in this design that borders on abstraction (173). Margaret seems to have had no direct involvement in this project, but a commission from another member of Jessie Newbery's family (the Rowats) put Margaret at its heart. Mackintosh designed a mantelpiece and fender for the house at 3 Lilybank Terrace, Glasgow, which was effectively an elaborate frame for a gesso panel made by Margaret Macdonald Mackintosh. *The Heart of the Rose* (174) is its subject, extending Mackintosh's rose theme seen at Kingsborough Gardens into a more pictorial format. The heart of the rose is, in fact, a baby enveloped by the rose's petals. One female figure holds the baby while another looks on; is this another reference to Sylvan MacNair? Margaret Macdonald never had any children, but according to Mary Sturrock she and Mackintosh were very keen to have a family,[12] and infants appear regularly in Margaret's work over the next four or five years. This gesso panel is rather different in technique from those made for the Ingram Street Tea Rooms

174. Margaret Macdonald Mackintosh,
The Heart of the Rose, 1901/02, painted
gesso set with string, glass beads and shell,
96.9 x 94 cm, Glasgow School of Art

which were intended to be viewed from a distance. This panel was designed and made
to suggest a painting, and its composition and execution are much more subtle and
delicate than those of *The May Queen* (142). A second panel exists, *The White Rose and the
Red Rose* (175), which appears to have been installed at the Mackintoshes' apartment at
120 Mains Street, Glasgow. Here, two female figures are surrounded by roses, which
are quite definitely divided into two colours. Only the faces of the women are treated
in a naturalistic manner; their gowns intermingle even more than those of the women

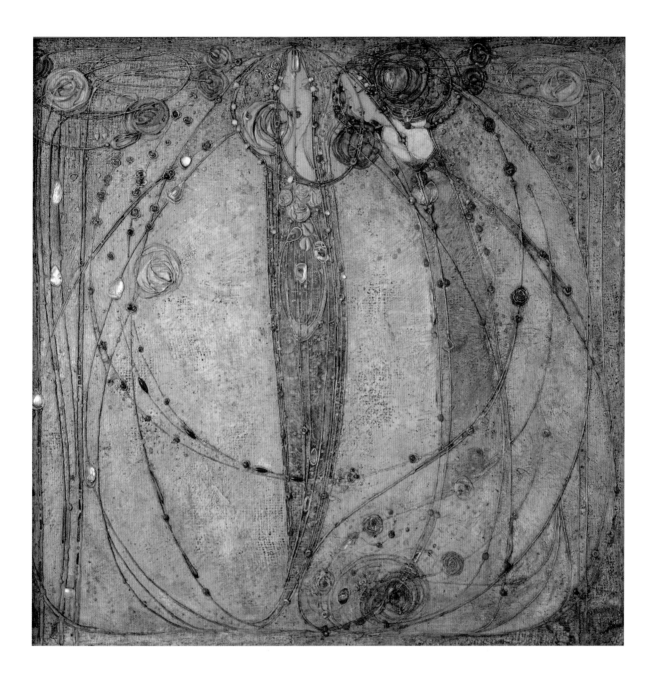

in *The Heart of the Rose*, creating an almost abstract pattern – there is no attempt here, in either panel, to suggest the form of bodies beneath the voluminous dresses, and hands and feet are, again, totally absent. One face looks directly to the viewer while the second, perceptibly smaller, seems to hover in the background possibly trying to speak to the other. If they were conceived as a pair we have to ask why they should have been separated so soon; however the following year replicas were exhibited together at an exhibition in Turin.

175. Margaret Macdonald Mackintosh, *The White Rose and the Red Rose*, 1902, painted gesso set with string, glass beads and shell, 99 x 101.5 cm, The Hunterian, University of Glasgow

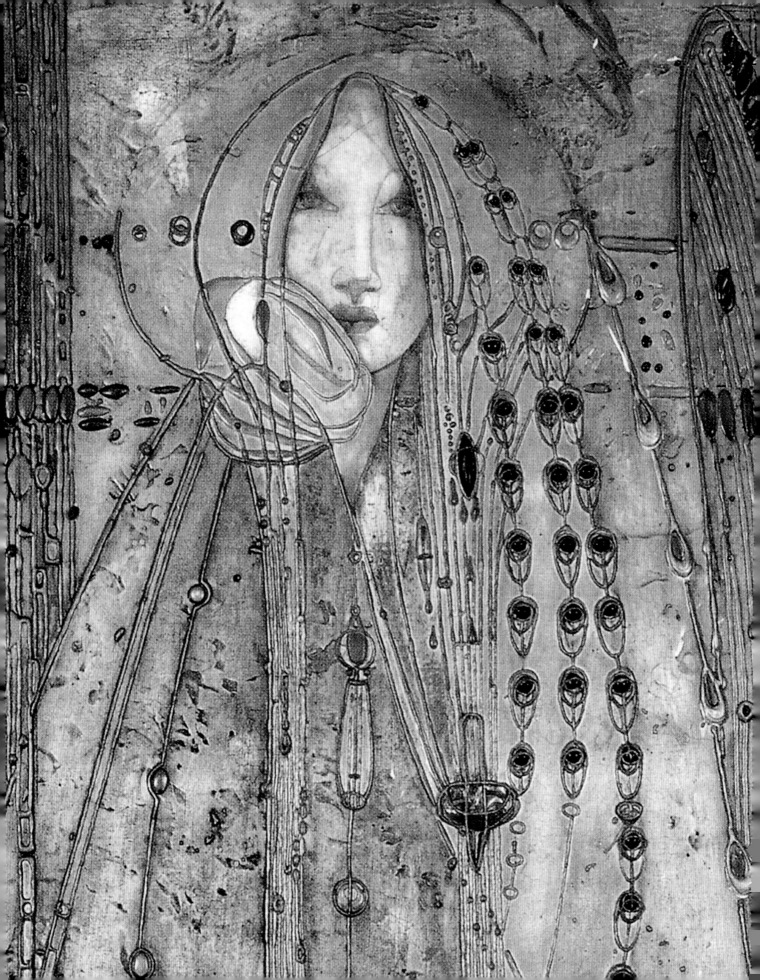

8 TURIN AND BEYOND

IN 1901 preparations were being made in Turin for an international exhibition of contemporary decorative arts, which was to open in the spring of 1902, and the organising committee approached Fra Newbery, asking him to prepare a group of exhibits to represent Scotland. Newbery chose to restrict his exhibitors, on the whole, to graduates of the Glasgow School of Art. He appointed Mackintosh as overall designer of the Scottish section and enlisted the help, as administrator and translator, of a young lecturer in Italian at Glasgow University, Fernando Agnoletti.[1] The allotted gallery space was divided into various sections: two room settings, one by the Mackintoshes and a second by the MacNairs; a small room showing mainly framed work and a collection of vases by the Mackintoshes; and a third larger space devoted to other Glasgow designers. The two room settings were an idealised elaboration and development of rooms in their homes by the MacNairs and Mackintoshes that had been included in the 1901 *Studio Special Number*. As the Turin rooms were purely exhibition spaces, as opposed to living spaces, The Four were able to mature the ideas first seen in their display in Vienna in 1900 without the restrictions of practicality. Their designs were arguably the most perfect exposition of the Glasgow Style that was to be seen in Europe. Mackintosh developed his Secession scheme of a room as an exhibit in itself. His was not the only such offering at Turin but it was the only one in which the quality of the exhibits matched, complemented and enhanced the room itself.

The Scottish Section was well publicised in the German and French magazines that had followed Mackintosh's career so far and in *The Studio* (no longer edited by Gleeson White who had died in 1898), it was praised as the most outstanding exhibit of the whole exhibition.[2] The anonymous reviewer immediately grasped Mackintosh's intentions, comparing them favourably with the less successful efforts in the German and Belgian stands. The writer had recently seen at the Vienna Secession Josef Hoffmann's Beethoven Room with Klimt's frieze panels hung high on the walls, but he did not register Mackintosh's influence on the design of that room (*see* Chapter 7, pages 130–136). He compared the control of such displays with the arrangements made by Whistler for his exhibitions at The Fine Art Society in Bond Street: 'Artist and architect were one, and nothing was left to chance or accident.' Acknowledging that the best such installations require a single guiding hand he continued:

Detail from 196. *The Seven Princesses* by Margaret Macdonald Mackintosh, 1906 (*see* page 171)

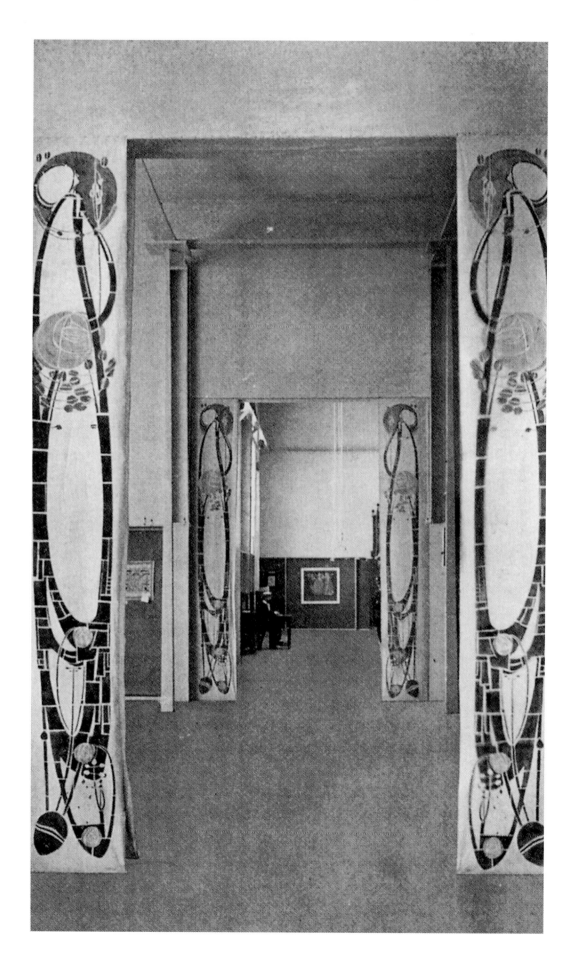

And in the Turin International Exhibition [...] the idea that a composition can be made 1000 miles away from the building that is to contain it as an exhibition occurred to more than one body of artists. Germany, notably, came with a distinct scheme, but it was a scheme whose units were not cohesive [...] Belgium also appears with a motif, but it is the agglomeration of the work of several brains and accordingly there is the absence of a central thought running from end to end. If a piece of work is to be done well give its control into the hands of one man.

[...] it is upon this principle that the design and decoration of that part of the Turin Exhibition called the Scottish Section has been worked [...] and the Architect is Mr Charles R. Mackintosh of Glasgow. Mr Mackintosh has had some experience in work of this nature, notably the design and decoration of the room which, two years ago, Mr Mackintosh and Margaret Macdonald Mackintosh were invited by the artists of the Vienna Secession to deal with. And the experience there has been turned to account in Turin. Large, lofty, and barn like galleries, designed and carried out by the architect of the Exhibition, Signor D'Aronco, entirely on the lines of the ordinary picture saloon, with windows whose light glared into every corner, have been ordered into a sequence of studied and interdependent proportions; and the veiled daylight looks into rooms whose simple tones and harmonies afford a welcome relief to an eye tired with the glare of an Italian sun.

Rarely has such unpromising material been more happily or successfully dealt with and it is not a matter of wonder that the section is receiving much interested attention, nor that the verdict passed upon the work is one that adds solidly to the already rapidly growing reputation of Mr Mackintosh.

This artistic creed of the room as a work of art was one that Mackintosh was to follow for the rest of his career; the Turin exhibition spaces, however, were among the last that were viewable by the general public as most of his future such rooms were in private houses. Mackintosh was being praised in *The Studio* for his overall handling of the Scottish section, particularly the way that he concealed the vulgarity of D'Aronco's galleries, veiling windows which were unnecessary for the Scottish displays and designing full height banners (176) that broke up irrelevant vistas and served as punctuation between the individual rooms in the Scottish section. But it was in the two rooms devoted to the Mackintoshes and the MacNairs that the design philosophy was seen at its best. Charles and Margaret presented The Rose Boudoir (177), a room meticulously arranged for a coherent group of wall-hung framed pieces and free-standing furniture with the unifying link of a rose. Replicas of Margaret's two gesso panels with a rose theme (174, 175) were centred on each of the shorter walls, facing each other. For the short stub walls at the entrance to the room Mackintosh designed two leaded glass panels, *The Spirit of the Rose* and

OPPOSITE AND RIGHT
176. Charles Rennie Mackintosh, Banners in the Scottish Section, International Exhibition of Modern Decorative Art, Turin, 1902, stencilled linen, 384 x 55.3, The Hunterian, University of Glasgow

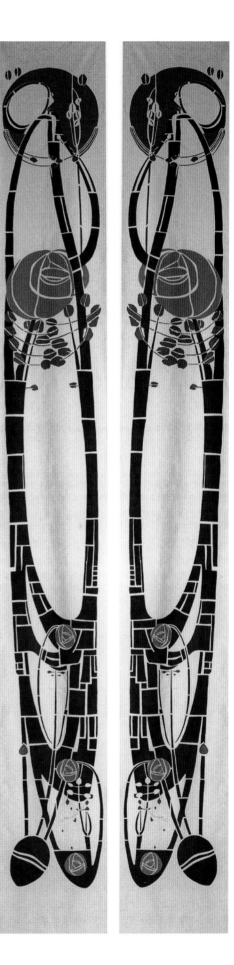

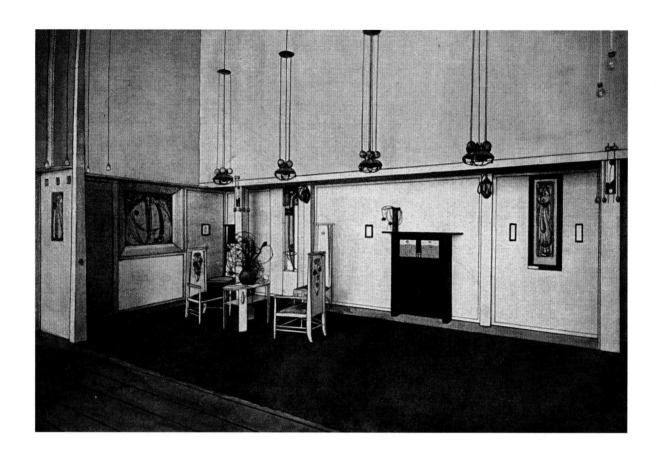

177. Charles Rennie Mackintosh and Margaret
Macdonald Mackintosh, The Rose Boudoir,
International Exhibition of Modern Decorative
Art, Turin, 1902

The Secret of the Rose (178, 179). On the upholstered backs of the chairs, and even inlaid in ivory on the tea table, more roses appeared. In an elegant black writing cabinet (180), Mackintosh incorporated five small panels by his wife, one in silvered metal and four others in gesso, all involving roses. It is the subtle and successful interconnection of all of these separate images by both artists that gives the room its coherent identity. In his glass panels Mackintosh has adopted Margaret's ethereal female figures, indicated simply by a head in profile. In Margaret's two gesso panels inside the desk, the voluminous dress of the central figure, surrounded by a tracery of briar roses fills each panel. In *The Awakened Rose* (181) the woman is flanked by two babies, while her companion in *The Dreaming Rose* (182) turns to kiss a female face behind her. Interestingly, when Margaret reworked this image for the cover of the May 1902 issue of *Deutsche Kunst und Dekoration* (183), the female head was changed into a peacock, perhaps Margaret's abiding symbol of her husband, Mackintosh. Margaret also exhibited the embroidered panel first seen – and sold – in Vienna in 1900 and the metal panel, *The Dew* (147) from the Ingram Street Tea Rooms. The Turin room was an apotheosis of collaboration between these two artists. They spoke as one voice, and the room was hailed as a triumph. But to some extent, I feel, its overarching elegance is somewhat self-defeating; it is a work of art and as such is intended to be looked at – there is a feeling that this is a room that may not be used without being disturbed or even destroyed.

178. Charles Rennie Mackintosh, *The Spirit of the Rose*, 1902,
lead with clear and coloured glass, 69.6 x 34.5 cm, The Hunterian,
University of Glasgow

179. Charles Rennie Mackintosh, *The Secret of the Rose*, 1902,
lead with clear and coloured glass, 70 x 34 cm, Museum für Kunst und
Gewerbe, Hamburg

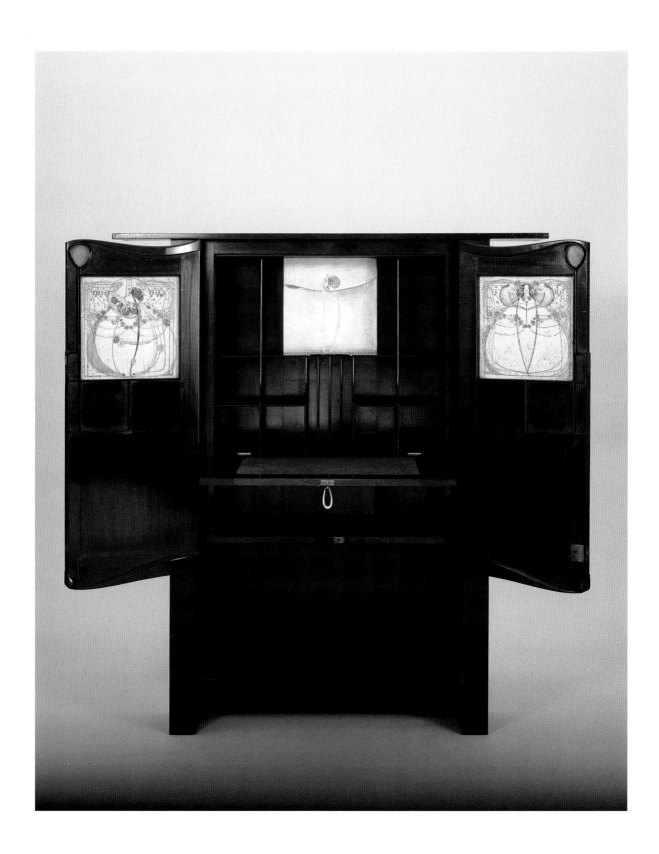

184. James Herbert MacNair and Frances Macdonald MacNair, A Lady's Writing Room, International Exhibition of Modern Decorative Art, Turin, 1902

The MacNairs' room (184), however, despite its similar unity of design and purpose and being furnished in a similar way, has a much more comfortable feel to it; it seems designed to be used. Perhaps this is because much of its furniture had been proven to work in daily use in the MacNairs' own house in Liverpool, while some of the furniture in the Rose Boudoir had been designed for a more formal room, Fritz Waerndorfer's Music Room in Vienna. Frances and Herbert chose as their theme A Lady's Writing Room, creating an intimate space with handmade rugs on the floor, embroidered tablecloths, a unifying stencilled and leaded glass frieze around the room, and paintings and metalwork by both artists hanging on the walls. MacNair added metal panels to his furniture, as Mackintosh had done (185), but the simple, almost crude, workmanship of the near abstract panel on the writing desk suggests his hand rather than that of Frances. He also seems to have been responsible for the stencilled frieze and leaded glass windows above the wall plate, which were based on the Liverpool Academy poster (156). Frances's immediate contribution would have been the design of the rugs, and the embroidered curtains, cushions (186) and tablecloths; she probably also made them. Around the wall were several of the MacNairs' paintings and pastels, all from an earlier period and including *The Frog Prince* (122) and the two *Legend* watercolours (136, 137). Two new pieces of repoussé metalwork (187, 188) complete the ensemble. Sadly, these elegant panels

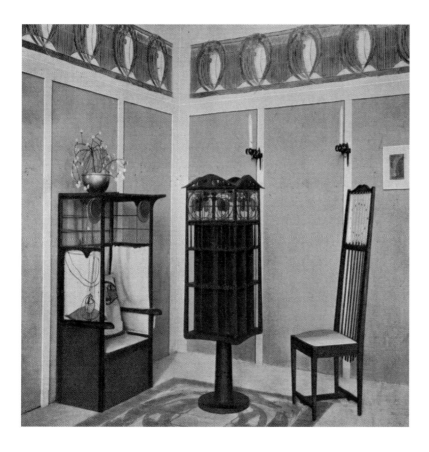

BELOW LEFT
185. James Herbert MacNair, Metal panel for a writing desk, 1901–02, incised brass and glass, National Museums, Liverpool (Walker Art Gallery)

BELOW RIGHT
186. Frances Macdonald MacNair, Design for a Cushion for A Lady's Writing Room, International Exhibition of Modern Decorative Art, Turin, 1902, pencil and watercolour, 57.8 x 61.5 cm, The Hunterian, University of Glasgow

RIGHT
187. James Herbert MacNair,
Panel, 1901, repousséd silver,
silver wire and beads, untraced

FAR RIGHT
188. Frances Macdonald MacNair,
Panel, by 1902, repousséd silver,
silver wire and beads, untraced

OPPOSITE
189. Margaret Macdonald
Mackintosh, *The Flowery Path*,
1901, watercolour, untraced
(contemporary photograph, The
Hunterian, University of Glasgow)

– one by each of the artists – are lost; the reviewer in *The Studio* was fascinated by them:

[...] the silver panels, each treatments of a single figure, contain much novel matter. On the broad plain of the silver sheet the figures are repousséd in low relief, and these are traced with silver wire designed in curved forms strung with beads and coloured stones, through which the figures are seen. It is a delightful piece of playful fancy, quite novel in treatment and rich in possibilities.

In an adjacent room separate works by The Four were displayed; Frances was represented solely by a Christmas card

that she and Margaret had produced together, and there were no works by Herbert. There were, however, several pieces by Charles and Margaret, the latter showing another large panel, *The Flowery Path* (189) first seen at the RSW in 1901. The exhibition catalogue and Mackintosh's list of exhibits (both in the collection of the Glasgow School of Art) describe this item as a 'panel'; when it was illustrated in *Dekorative Kunst*, it was referred to as a 'coloured panel',[3] but the RSW catalogue does not suggest that it is anything other than a watercolour – although at 30 guineas it must have been exceptional. It is one of those pieces which falls outside the mainstream of Margaret's work but which shows how different her designs are when she is working outside her collaborative manner with Mackintosh. The young couple, walking up the hill towards a castle that obviously has its roots in Mackintosh's drawings of Holy Island, make a straightforwardly romantic image with none of the tensions or compositional complexities of the two rose gessos. Over the next few years, in independent work produced by Macdonald outside her collaborations with Mackintosh, similar uncomplicated themes and motifs are repeated which, for me at least, begs the question of the degree of involvement by Mackintosh in the complex compositions of the gesso panels made by Macdonald for the Rose Boudoir or the Waerndorfer Music Room and Willow Tea Rooms. Collaboration is of course a two-way street, but too often in recent years proposers of collaborative theories have asserted that it was Mackintosh's work that changed under Macdonald's input while ignoring any such reverse influences.

The Turin exhibition focused new attention on The Four. The Mackintoshes already had a commission from Fritz Waerndorfer to furnish and decorate a new music room in his house in Vienna. This was separated by a curtained opening from an adjacent dining room designed by Josef Hoffmann, and Frances Macdonald was commissioned to provide embroidered panels for the curtain, perhaps a result of Waerndorfer having seen her embroideries in Turin. She also received a commission to design the cover of a new book (to be published in 1903) by Anna Muthesius – *Das Eigenkleid der Frau*, a commentary on contemporary women's fashions (190), but neither she nor Bertie received any further commissions from European sources. For the Mackintoshes, however, the pace of life and their growing success did not slacken. While in Turin Mackintosh had provided Waerndorfer with new drawings for the Music Room that he was designing for him.[4]

and stems of flowers. This more structural arrangement of the gesso tracery appears in all the later gesso panels that Margaret made for other Mackintosh commissions – the Willow Tea Rooms and The Hill House – as well as in the large panel, *The Seven Princesses* (196) that she produced for the Music Room. This structure appears to a lesser extent on the large gesso panel, *Summer* (191), which is a repetition of the more pictorial image in the 1897 watercolour, *Summer* (112) and *June Roses* (125). But in watercolours produced at about the same period this architectonic structure is not apparent and the paintings are correspondingly weakened. After about 1910 Macdonald introduced a new rigour in her compositions as they became less dependent on earlier arrangements. Are these changes in the large gessos evidence of Mackintosh's input? If collaboration has any meaning – and it has become the cornerstone of much recent analysis of the artistic relationship between Charles and Margaret – then we could expect to see changes in Margaret's work that reflected Mackintosh's influence, just as Mackintosh's interior designs of the period 1900 to 1903 are deemed to show Macdonald's influence.

Among the largest decorative works by either of the Mackintoshes were the two frieze panels proposed for the Music Room, 1.5 metres high by 6 metres wide; these were the key to the whole design, linking the symbols incorporated in the furniture and giving it a unity and intensity unparalleled in any of their other collaborations. They were designed to face each other across the Music Room, a layout based on that at the Vienna Secession (and originally designed for the Ingram Street Tea Rooms) in 1900. It was unusual for Mackintosh to repeat such a compositional motif and it is my belief that the arrangement of the panels at Waerndorfer's house was made at the client's request, impressed as he was by *The May Queen* and *The Wassail* in 1900. In a letter dated 6 August 1902 to Muthesius, Mackintosh wrote that he and Margaret were then at work on the panels, and that work in the room was expected to be finished in September.[5] A month later he wrote to say that much of that work had to be redone and that Josef Hoffman's room was not as advanced as his.[6] If work was started on the panels in 1902 then it was much interrupted and delayed as Margaret's panel was not installed until 1906, the date inscribed on it. Comparing Margaret's finished panels with her *The May Queen* (142) at Ingram Street, it is not difficult to see why such delays occurred. The earlier panels, which could be viewed only from a distance, were broadly handled, with large areas

This was not a big space and it was dominated by a large grand piano at its centre with, on the walls, two new, six-metre-wide, gesso panels. The tall chairs shown at Turin were re-used in the Music Room, arranged around its perimeter in pairs separated by tiny tables for glasses and coffee cups. The grand piano was encased by a square structure of swooping birds, a favourite motif that Mackintosh used in many different media, from sketchbook drawings to chairs and friezes (194). Over the keyboard Mackintosh placed two small gesso panels, *The Opera of the Winds* and *The Opera of the Sea* (192, 193) made by Margaret Macdonald. There is a marked difference between these two panels and the panels made for the writing desk that was shown in Turin, and bought there by Waerndorfer. The tracery in the panels for the piano is much more rectilinear, featuring strings of piped gesso usually following horizontal and vertical paths with repeated lines emphasising hair

190. Frances Macdonald MacNair, Design for a cover for *Das Eigenkleid der Frau* by Anna Muthesius, 1903, pencil on tracing paper, 32 x 25 cm, untraced

of unpainted gesso at each side of the compositions. The linear tracery on those panels was, as previously described, achieved by simply dipping twine into gesso and applying it to the surface, detailed painting was on the whole confined to faces and flowers, and the panels, in general, show evidence in their unsophisticated and robust handling of speedy execution. The Waerndorfer panels, however, were made using a completely different and more painstaking technique where the surface was much smoother, prepared for paint, and the tracery was a far more delicate application of piped liquid gesso. An intricate design covers the full six-metre width of the butted panels and incorporates over a dozen figures in an ethereal setting. Margaret's panels are undoubtedly her masterpiece, unrivalled by anything by her sister or MacNair; their foil would have been Mackintosh's panels, which would presumably have been similar in handling and technique – although there is some doubt that Mackintosh ever finished them and no trace of them appears either in contemporary photographs or in reviews.

The theme was based on Maurice Maeterlinck's play, *The Seven Princesses*. Its subject is a variation on the traditional Sleeping Beauty story, dramatized into an almost silent narrative with the stage set reflecting the monumental simplicity and symbolism of the story. Maeterlinck is often cited as a source for The Four but there is, in fact, very little direct evidence of his influence. Certainly, in the 1890s and first decade of the new century, culminating in his receipt of a Nobel prize, his work was to be found everywhere in Europe, including Britain, and it is possible that The Four were caught up in the general enthusiasm for his writing. Although Jessie Newbery did not refer to Maeterlinck as an influence on The Four in her introduction to the catalogue for the 1933 Memorial Exhibition, an extract from a book published in 1905,[7] quoted in the same catalogue, describes Margaret's studio as being 'strewn with the novels of Maeterlinck'. What is certain is that Waerndorfer was well aware of Maeterlinck; Waerndorfer's favourite sculptor, several of whose works were to be displayed in Hoffmann's dining room, was Georges Minne (1866–1941), a Belgian who was closely associated with Maeterlinck. Perhaps the

191. Margaret Macdonald Mackintosh, *Summer*, 1904, painted gesso over hessian and twine, set with glass beads, 100.7 x 43.2 cm, National Museums of Scotland

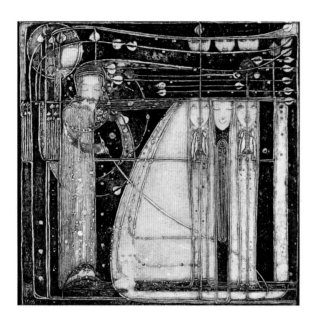

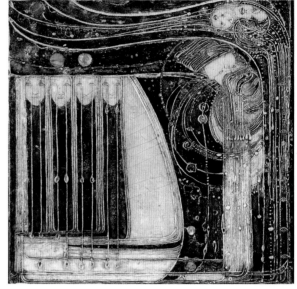

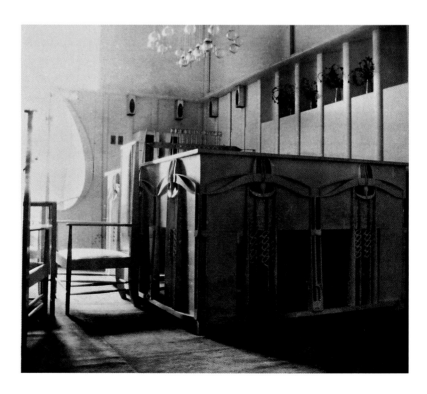

ABOVE LEFT
192. Margaret Macdonald Mackintosh, *The Opera of the Winds*, 1903, painted gesso on panel, set with string and glass beads, 20 x 20 cm, private collection

ABOVE RIGHT
193. Margaret Macdonald Mackintosh, *The Opera of the Sea*, 1903, painted gesso on panel, set with string and glass beads, 20 x 20 cm, private collection

RIGHT
194. Charles Rennie Mackintosh, Piano for the Waerndorfer Music Room, Vienna, 1902

OPPOSITE
195. Charles Rennie Mackintosh, *The Return of Prince Marcellus*, c1904–06, pencil and watercolour on tracing paper, 36 x 90.6 cm, The Hunterian, University of Glasgow

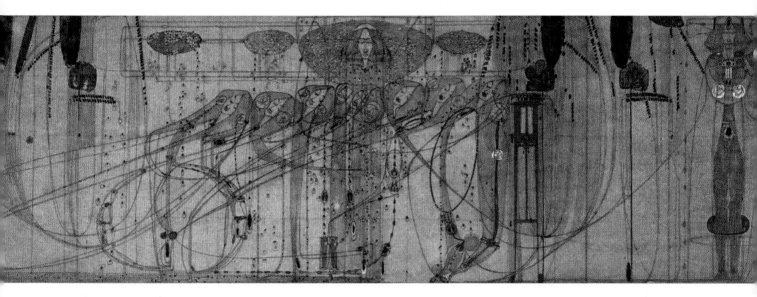

choice of subject matter for the gessos was Waerndorfer's. In 1905 when E.B. Kalas visited Glasgow, Margaret would have been in the midst of the commission and would naturally have been immersed in Maeterlinck's work. Kalas, however, makes no mention of Mackintosh's companion panels. The essential story of *The Seven Princesses* was uncomplicated: Prince Marcellus returns to the Palace after a journey to discover the death of Princess Ursula, one of his seven cousins. Pamela Robertson[8] has described in detail the story's opposing themes and imagery explored by Macdonald in her composition. The central panel depicts Marcellus, shown only by his head, mourning Ursula; Marcellus appears to be kissing a large rose that hovers over the prone form of the Princess. Ursula's body is the only horizontal element in a composition dominated by the upright figures of the other six princesses. An elaborate skein of piped gesso tracery weaves its way around the figures, incorporating roses and the architecture of the minimal stage set proposed by Maeterlinck. The repeated vertical lines that first appeared in the two gesso panels on the piano (192, 193) are much in evidence, reinforcing the verticality of the flanking princesses. Black swans glide below the dead Princess – perhaps a reference to the swans in Frances's paintings of Jehane in the illustrations for William Morris's *The Defence of Guenevere and Other Poems* (1897–98) (108) – and Robertson identifies the trees as willows, probably inspired by the Willow Tea Rooms in Glasgow designed by Mackintosh in 1903.

In his letter to Muthesius in August 1902, Mackintosh specifically mentions that he and his wife were at work together on two panels for the Music Room. If his own panel was ever made, it has disappeared without record, other than in an incomplete drawing (195) for what appears to be the companion panel to *The Seven Princesses*. Two men and a woman appear alongside seven reclining female figures; the proportions of this remnant match those of the space left for Mackintosh's panel. The figure at the centre of the seven reclining women must be Prince Marcellus, seen with the king and queen, parents of the dead princess, on the right. Mackintosh shows the overlying pattern of gesso tracery and has incorporated the roses and trees seen in Margaret's panel, the canopies of his trees bearing a distinct resemblance to

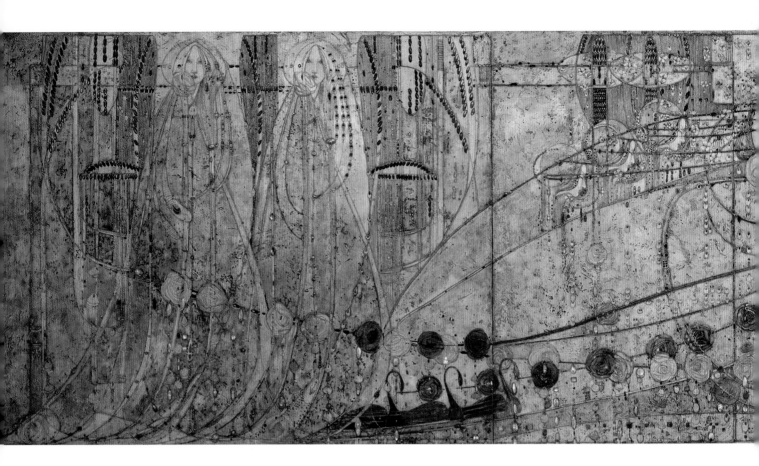

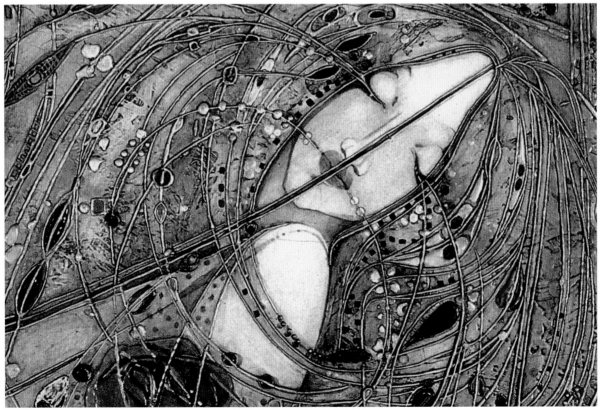

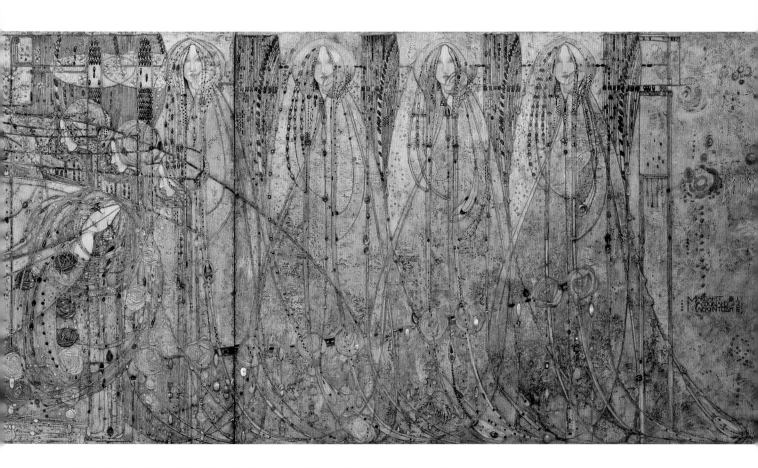

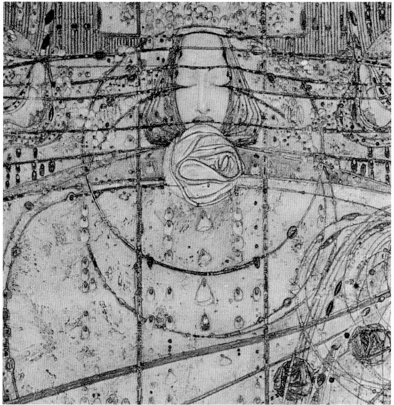

ABOVE
196. Margaret Macdonald Mackintosh,
The Seven Princesses, 1906,
painted gesso on hessian and scrim with
twine, set with thread, glass beads, mother
of pearl and tin leaf, 152 x 594 cm,
Museum für angewandte Kunst, Vienna

LEFT
Detail showing the head of Prince Marcellus
from *The Seven Princesses*

OPPOSITE
Detail showing the head of Princess Ursula
from *The Seven Princesses*

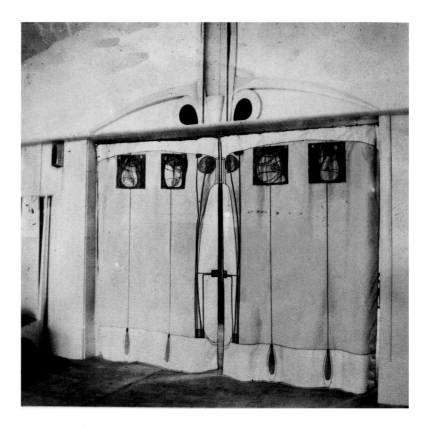

197. Frances Macdonald MacNair, Embroidered curtain for the Waerndorfer Music Room, Vienna, 1903, silk with appliqué, braid and glass beads, untraced

the top rail of the high-back chairs that he designed in 1898. No similar preparatory drawings survive for the Macdonald panel. There is no hesitancy in Mackintosh's drawing – the handling is fluid, the command of the composition in all its complexities is clear, perhaps evidence of Mackintosh's involvement in the conception of the design of both panels. None of the contemporary commentators on the Music Room describe Mackintosh's panel or confirm its eventual installation. It would not be surprising if Mackintosh had been unable to complete it; the years between 1902 and 1906, when the Macdonald panel was completed and installed, were among his busiest as an architect in Glasgow; Margaret also was drawn in to some of his projects which no doubt further delayed her completion of *The Seven Princesses*. The critic A.S. Levetus wrote in an article in the *Glasgow Herald* in 1909 that the spaces for Mackintosh's panels 'remain empty and we are eagerly looking forward to the time when Mr. Mackintosh – these are to emanate from him – will find the necessary leisure to create them.'[9] By this date Waerndorfer was in serious financial difficulties. He had invested much

of his fortune in the Wiener Werkstätten, and the enterprise was making serious losses; perhaps it was agreed between Mackintosh and Waerndorfer that the panels could wait for more propitious times.

Charles and Margaret were not the only Glasgow artists involved in the Waerndorfer Music Room – Frances was commissioned to provide four appliqué panels for curtains to divide it from the adjoining dining room designed by Josef Hoffmann (197, 198); these curtains contained a full-height panel at their meeting edges which may also have been designed and made by Frances. The curtains are lost, but black-and-white photographs of the finished panels and two watercolour designs have survived revealing that they echoed the two large gesso panels shown by Margaret in Turin; the watercolours are inscribed *L'Esprit de Rose* (189, 190). These show Frances as the equal of her sister in terms of design; furthermore, the quality of the embroidery seen in the photographs is more accomplished than surviving pieces by Margaret. The compositions are similar to the gessos that Margaret exhibited in Turin. This

198. Frances Macdonald MacNair, Four appliqué panels for the Waerndorfer
Music Room, Vienna, 1903, silk with appliqué, braid and glass beads
(contemporary photographs, The Hunterian, University of Glasgow)

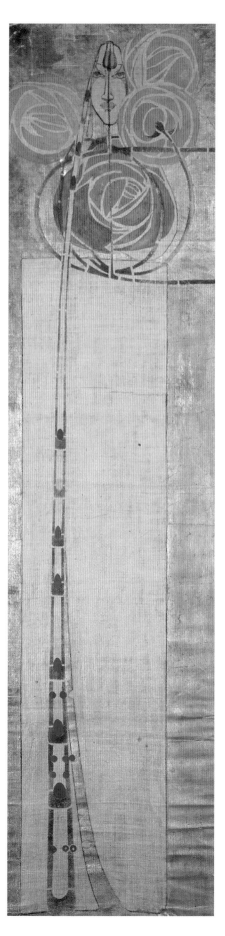

was a prestigious project and no doubt Frances was keen to present the best workmanship possible. Sadly, no further commissions were forthcoming, although Frances exhibited the two watercolours in Moscow in 1902–03.[10]

Mackintosh's work in continental Europe continued in 1902–03 with an exhibition room in Moscow, as part of *Architecture and Artistic Crafts of the New Style* organised by Feodor Shekhtel, who had been responsible for the Russian village at the Glasgow International Exhibition in 1901. Mackintosh retained the theme of the rose, using the small armchairs designed for Turin, the display cabinets with the silvered doors (173) and an array of stencilled wall hangings, each 1.5 metres high (201). Although the dominant element here is Mackintosh's typical rose, there is an indication of a change towards a more geometric style in the pattern of squares in the carpet.

This duality was to continue in Mackintosh's designs for the Willow Tea Rooms in Glasgow which opened in October 1903. The carpets and furniture were rigorously geometric, but he re-used the tall stencil panels from Moscow in the rear saloon on the ground floor, which had little daylight, and their touches of silver and pink would have done much to brighten the room. In the Room de Luxe the leaded-glass doors contained stylised roses (214), but the patterns in the lead recall the straight lines of piped gesso in the two *Opera* panels in Vienna, further evidence of Mackintosh's likely influence on their design – or at the very least a continuing collaboration between husband and wife. Similar patterns

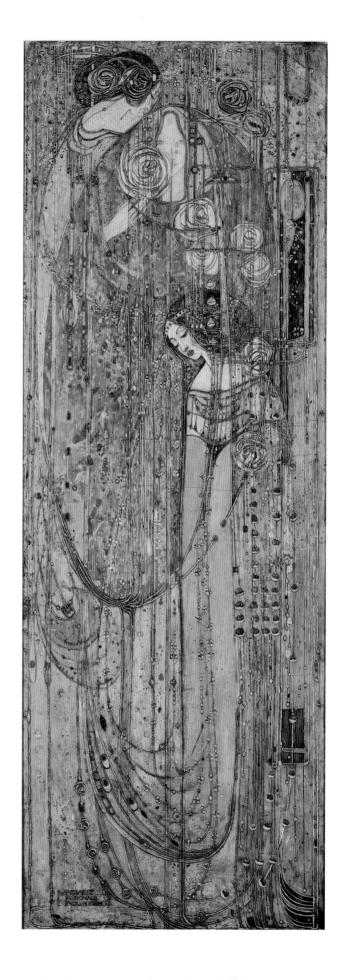

RIGHT
202. Margaret Macdonald Mackintosh, *O Ye, All Ye That Walk in Willowwood*, 1903, painted gesso on hessian and twine, set with glass beads, 164.5 x 58.4 cm, Glasgow Museums

OPPOSITE LEFT, ABOVE
199. Frances Macdonald MacNair, Design for appliqué panel for the Waerndorfer Music Room, Vienna, 1903, pencil and watercolour, private collection

OPPOSITE LEFT, BELOW
200. Frances Macdonald MacNair, Design for an appliqué panel, for the Waerndorfer Music Room, Vienna, 1903, pencil and watercolour, 30.5 x 30.5 cm, private collection

OPPOSITE, RIGHT
201. Charles Rennie Mackintosh, Stencilled wall hanging, 1902, stencilled linen, 150 x 40 cm, The Hunterian, University of Glasgow

CHARLES RENNIE MACKINTOSH AND THE ART OF THE FOUR

appeared in the gesso panel that Margaret Macdonald made for this elegant room (202). Its melancholy subject, which undermines the elegant hedonism of the room, is taken from Dante Gabriel Rossetti's *Four Willowwood Sonnets*, its title quoting the first line of one of them: 'O ye, all ye that walk in Willowwood'. It is one of Macdonald's most accomplished pieces, melding a typical Glasgow Style arrangement of the three women with an elaborate web of piped gesso, beads and pieces of glass.

At his next major architectural project, The Hill House in Helensburgh, Mackintosh continued with his amalgam of geometric and organic decorations, the latter being most clearly seen in stencilled decoration on the walls and upholstery. Roses predominated, contained within geometric arbours and patterns of briars (203); a rose was also incorporated in an inlaid glass panel in a bedroom fireplace. Margaret's contributions to the house remain within her established canon: they include two embroidered panels placed behind the main bed (206) and a later gesso panel for the mantelpiece of the drawing-room fireplace (205). One of the most striking pieces of decoration, however, was a design that Mackintosh made to be stencilled around the entrance hall. Its pattern of squares and curving lines is one of his most abstract compositions (207) and dominates a room that is devoid of organic shapes. His

204. Charles Rennie Mackintosh,
Design for bedroom, The Hill House, 1903,
pencil, watercolour and gold paint,
31.5 x 45.3 cm, The Hunterian, University
of Glasgow

OPPOSITE
203. Charles Rennie Mackintosh, Doors to
the Room de Luxe, Willow Tea Rooms, 1903,
wood, lead, clear and coloured glass, white
metal, each leaf 195.5 x 68.5 cm, Willow Tea
Rooms Trust

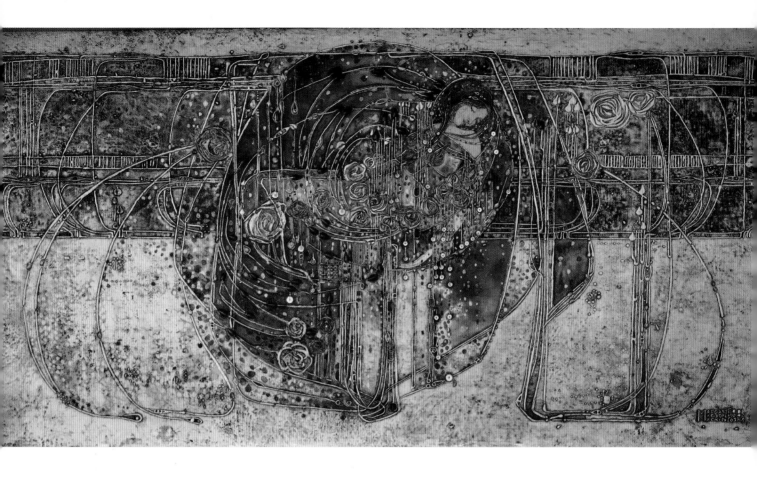

205. Margaret Macdonald Mackintosh,
The Sleeping Princess, 1908, painted gesso
on board, 54 x 105 cm, The Hill House,
National Trust for Scotland

OPPOSITE
206. Margaret Macdonald Mackintosh,
Embroidered panels, 1903–04,
embroidery and appliqué on linen,
182.2. x 40.6 cm [each], Glasgow School of Art

versatility in pattern-making is particularly evident in the stylised tree that forms a splashback on a washstand, made entirely from squares and oblongs of coloured glass and pewter (208). Although ingenious, this deliberate abstraction of organic shapes was perhaps not comfortable for Mackintosh. Nature had always been the source of Mackintosh's art and even in his most advanced furniture designed for The Hill House he was loath to lose touch with it completely. In the elegant and severe desk designed for his client, Walter Blackie, Mackintosh inserted a leaded glass and metal panel (209) – a heavily stylised version of the figures in the Rose Boudoir gesso panels.[11] In the version of the desk that he made for himself, however, this panel was replaced by a classic weeping-rose motif (210).

In projects that followed The Hill House, these geometric shapes of furniture predominated, occasionally leavened by a rose stencilled on the wall or inserted into a leaded glass panel on a light fitting. Organic shapes became more and more stylised and abstract, as in the Tree of Knowledge form used on a revolving bookcase for Miss Cranston at Hous'hill, but all the time that Mackintosh was concentrating on geometric ornament in his architecture he was also spending more time making flower studies while on holidays and tours around Britain. As has already been noted, when Mackintosh's architectural career blossomed

CHARLES RENNIE MACKINTOSH AND THE ART OF THE FOUR

his output as a painter diminished (and vice versa). When his time was mainly taken up by the architectural practice, his artistic creativity was diverted into pattern-making and pictorial decoration for interiors. I doubt that Mackintosh was content with this situation. While on Holy Island in 1901, he had started to make watercolour drawings in his sketchbooks of wildflowers. In 1902 his vacations were dedicated to visits to Turin and possibly Vienna with little opportunity to search out suitable subjects for painting. In 1904 his sketchbooks record a visit to the Isles of Scilly, probably a holiday, where he produced about half a dozen drawings of flowers (211). The following year he was at Blakeney, but only one drawing there is recorded. From 1906, however, a year rarely went past without him working assiduously in his sketchbook, often making studies of wildflowers. As early as 1893 Mackintosh was writing that architecture was a summation of all the arts and should directly involve architect, painter, sculptor and craftsman.[12] He would not have expected his audience to have practised all four disciplines as he himself did – as an artist he made stencils; as a craftsman he made metal panels for his furniture; and even as a sculptor he produced the full-size maquette for the carving over the entrance to Glasgow School of Art (167). He believed that such skills were inborn – that they could be cultivated but not learned – and that it was the role of the architect to encourage and incorporate all of the arts within his buildings. These beliefs were outlined in a lecture given in Glasgow before Mackintosh had proved himself as an architect.[13] Ten years later, in a similar lecture but this time to a group of craftsmen and artworkers, he made his famous pronouncement:

Art is the flower – Life is the green leaf – Let every artist strive to make his flower a beautiful living thing – something that will convince the world that there may be – there are things more precious – more beautiful more lasting than life. But to do this you must offer real living – beautifully coloured flowers – flowers that grow from but above the green leaf – flowers that are not dead – are not dying – not artificial – real flowers springing from your own soul [...] You must offer the flowers of the art that is in you – the symbols of all that is noble – and beautiful – and inspiring – flowers that will often change a colourful fearless life – into an animated thoughtful thing.[14]

It is important to note that Mackintosh was not painting flowers as a literal expression of the statements in his lecture – he was using them, rather, to recharge his batteries, his visual and emotional memory at a time when the pressures of professional life were especially heavy. These flower drawings of the first decade of the century were made to remind him of the power of nature. A few years later similar flower drawings rescued him from deep depression and helped to give him the strength to embark upon a new career. A period of intense and very successful collaboration with Margaret Macdonald effectively came to an end around 1905. Although, a decade later, the two artists would occasionally work together, their future years would be largely spent in more typical artistic solitude, each working alone but aware of the other. Margaret's career faltered as she moved away from joint productions towards individual watercolours, but these slowly increased in power to end in a burst of new intensity and artistic success. Although in 1906 he was preparing to start work on the second phase of Glasgow School of Art, Mackintosh's career as an architect was about to enter a steep decline. During these years painting assumed for him a new aesthetic and intellectual importance, insulating him from the problems of economic failure and the depression that went with this.

211. Charles Rennie Mackintosh, *Ivy Geranium, St Mary's, Scilly*, 1904, pencil and watercolour, 25.8 x 20.2 cm, private collection

212. Frances Macdonald MacNair, *The Choice*, 1911, pencil, watercolour, gouache and gold paint, 34.2 x 30.3 cm, The Hunterian, University of Glasgow

9 HARDSHIPS

ETWEEN 1905 and the outbreak of war in 1914 there was something of a
hiatus in the output of The Four. For much of the time Mackintosh was
preoccupied – initially by the second phase of the Glasgow School of Art
building in Renfrew Street and then by the economic slowdown in Glasgow
which curtailed new building. The School of Art was not a project which required
new artwork – gesso panels or leaded glass – from Margaret Mackintosh, and her
output slowly declined: after the Waerndorfer panel was completed in 1906 there
were only a dozen or so watercolours and small gessos before she and Mackintosh
left Glasgow in 1914. Mackintosh made the most of his time away from the office
on vacations, producing a number of flower drawings, but there is no surviving
evidence of similar work by Margaret.

The MacNairs, however, were more active as artists during this period, despite,
or perhaps because of, growing personal and financial difficulties. For a few years
after the Turin exhibition, they devoted themselves to their lives in Liverpool
where MacNair continued to work in the School of Architecture and Applied Art,
and Frances developed new skills in designing and making jewellery. Watercolours
continued to be the mainstay of their production and they exhibited regularly in
Liverpool. They gathered around them a coterie of students and academics who
delighted in their company and their artistic prowess. MacNair extended his
contacts within the University through designs for both the university authorities
and his colleagues. Frances began to make jewellery, as Herbert had done earlier
in their Glasgow years, and her work was recognised nationally through its
illustration in contemporary journals. Despite this apparently settled existence as
a gregarious artistic couple, troubles loomed in the background. Neither of them
was commercially successful as an artist, which probably did not matter while
MacNair had a salary and each of them had family money. But MacNair's family
was encountering hard times and by 1909 had been declared bankrupt; Herbert had
borrowed heavily against a future inheritance which was now no more. Worse, the
University and the city council of Liverpool decided to revisit their joint funding of
the School of Architecture and Applied Arts where MacNair had been employed
since 1898. A combination of a different curriculum devised by the new professor of
architecture at the University, Charles Reilly, and changes to educational provision
within the city brought about the closure of the School and its transfer to the
municipal School of Art and Design. MacNair and his colleagues were offered posts
there, but MacNair was uncomfortable in his new environment and soon left to work

with a former colleague, Gerard Chowne, in a new venture, a private art school named the Sandon Society – an atelier on the French model. There was no regular salary attached to the post, however, and life became a hand-to-mouth existence.

MacNair seemed unable to cope with these new stresses and began to drink heavily; in 1909 he withdrew from the Sandon (where his drinking had caused problems with the members) and, with Frances and Sylvan, returned to Glasgow. During their happier times in Liverpool they produced a series of joyful watercolours, peopled with happy couples surrounded by cherubic babies (214, 216). There was little of the edge of the Glasgow Style watercolours of the 1890s, and in some of her later works produced in Liverpool Frances gradually adopted a more decorative manner (215). After the return to Glasgow both artists continued to send watercolours south for exhibitions at the Sandon and also at the Allied Artists Association in London. They first of all stayed briefly with the Mackintoshes in Hillhead and then moved 400 yards away to a family-owned flat at 50 Gibson Street. Frances took on some teaching in embroidery and metalwork at the School of Art, but after 1909 Newbery was unable to offer any permanent position to either artist. Around 1912 MacNair left Scotland for Canada, possibly at the behest of the Macdonald family. His brother-in-law, Charles Macdonald, had managed to extract some money from the MacNair family estate[1] and although MacNair may have decided to use this to finance his journey to Canada, it seems odd that he should want to leave his wife and child. In the 1970s, a descendant, Mrs Charlotte Armstrong, told me that according to MacNair family history the Macdonald family had paid his passage to get him out of Glasgow. In Canada he worked in a chocolate factory as well as on the railways, but his drinking became worse and he returned to Glasgow before the outbreak of war in 1914. By this date he had probably given up painting altogether (he worked in the Post Office during the war), although just a few years earlier in 1911 he and Frances had had a joint exhibition at the Baillie Gallery in London, where they showed both recent and earlier work. Pictures by Frances such as *A Paradox* (216) and *Bows, Beads and Birds* (217) have a conscious elegance about them, carefully drawn and coloured and incorporating new motifs alongside by now traditional Macdonald figures. Many of MacNair's contributions to this exhibition are now lost, but the catalogue suggests that most would have been similar to *'Tamlaine'*, painted in 1906 (213). The exhibition cannot have been a financial success, and MacNair's 'banishment' to Canada followed; Frances returned briefly to Liverpool in 1912 to seek work (unsuccessfully) by setting up classes in embroidery. Frances now had a small private income following the death of her uncle, but her family ensured that neither she nor Herbert could access the capital.

The miserable situation in which Frances and her son, Sylvan, found themselves seems to have been the spur for a group of watercolours which could not be further from the

OPPOSITE
213. James Herbert MacNair, *'Tamlaine' – A Border ballad*, 1905, pencil, watercolour, gold and silver paint, 24.8 x 16.1 cm (sheet), 25.6 x 16.1 cm (panel), Dublin City Gallery The Hugh Lane

RIGHT
214. Frances Macdonald MacNair, *Golden Heart*, 1904, watercolour and wash with silver and gold paint, 28.5 x 19.9 cm, National Museums, Liverpool (Walker Art Gallery)

princesses and butterflies painted just a few years before (215). Only one of them, *Sleep* (218), may have been exhibited in Frances's lifetime. A picture of this title was shown at the Sandon and the Allied Artists Association in 1908 and then again at the Baillie Gallery in 1911, but the surviving picture is so far removed from other work of 1908 that one must conclude that there were at least two paintings with this title. None of the other pictures in this group seems to have been publicly exhibited. This is odd given that Frances would have welcomed sales at this distressing time of her life. None of the paintings is dated and the titles by which they are now known seem to have come about through family usage; perhaps they are titles given to them by Frances and passed down through the generations but as, on the whole, they reflect the content in a descriptive manner, at times vague, they were possibly added after her death. In general, the compositions of these seven paintings contain a counterpoint between groups of different figures. They have been described as a reflection on the universal condition or plight of women, the choices that face them in their lives, a comment on the status of the New Woman as she confronted the travails of life in the twentieth century. Their poignancy, their choice of events in a woman's life — and the conflicts that seem to underlie several of them — point to an autobiographical input. Frances's mother died in 1912 and I believe that these paintings reflect Frances's relationships with her family and MacNair following that death.

216. Frances Macdonald MacNair, *A Paradox*, 1911,
pencil, watercolour and gouache, 35 x 44 cm, private collection

OPPOSITE
215. Frances Macdonald MacNair, *Girl with White Butterflies*, 1907,
pencil and watercolour, 21.1 x 25 cm, The Hunterian, University
of Glasgow

Frances's family tried to guard her from the worst effects of Herbert's apparently dissolute life, ensuring that her finances were kept safe. A legacy from her mother was placed in trust, and Frances had access only to the income which was carefully protected from Herbert and his debts; on her death this income was to pass to any living children, not Herbert, and any residual capital would pass to her sister Margaret.[2] Despite the family's good intentions Frances's life in Glasgow after 1912 was unhappy. The subjects depicted in this small group of watercolours are surely inspired by the hardships facing the MacNairs. *The Choice* (212) shows a handsome couple surrounded by a briar rose contemplating two other wraith-like figures standing in the shadows, one

of whom leaves a trail of gold coins or petals. Is this an allegory of The Four, the lovers being the MacNairs and the distant figures the Mackintoshes, or are we looking at the Macdonald family withdrawing their funds from Herbert and Frances, or even the dissolute throwing away of money by the MacNairs themselves? *Man Makes the Beads of Life but Woman Must Thread Them* (219) almost returns to the Spook School iconography of the 1890s, with its naked woman holding a child against a rose ball while her hair trails around the composition. A man, whose pose is uncannily similar to figures in both MacNair's and Mackintosh's drawings of the 1890s, proffers another child – perhaps just a seed; he

forms part of the grey landscape while the woman is painted naturally and is surrounded by strings of beads, huge necklaces almost, that share this brighter palette. *Prudence and Desire* (220) again contrasts a young naked woman with two rather more severe figures standing behind her and to one side. The young woman's hair is filled with apples and her hands are outstretched in mild protest, perhaps another account of the Macdonald family's hostility towards MacNair and disapproval of Frances's relationship with him. In *Woman Standing Behind the Sun* (221), a dead woman and mourners overlook a young girl dancing among roses. *Sleep* (218) is divided into two quite distinct parts. On the left a

OPPOSITE
217. Frances Macdonald MacNair, *Bows, Beads and Birds*, 1911,
pencil, watercolour and gouache, 30 x 35 cm, private collection

ABOVE
218. Frances Macdonald MacNair, *Sleep*, 1911, pencil and watercolour,
34.2 x 29.2 cm, Scottish National Gallery of Modern Art, Edinburgh

HARDSHIPS 191

ABOVE
219. Frances Macdonald MacNair, *Man Makes the Beads of Life but Woman Must Thread Them*, 1911, pencil and watercolour, 35.2 x 29.8 cm, The Hunterian, University of Glasgow

BELOW
220. Frances Macdonald MacNair, *Prudence and Desire*, 1911, pencil and watercolour, 35.2 x 29.9 cm, The Hunterian, University of Glasgow

OPPOSITE
221. Frances Macdonald MacNair, *Woman Standing Behind the Sun*, 1911, pencil, watercolour and gold paint, 35.2 x 30.3 cm, The Hunterian, University of Glasgow

young woman with flowing hair covers her eyes while on the right a series of couples progresses along the path out of the picture: the first pair cast roses in front of the girl; the second pair seem to be carrying a child between them; in the third pair the male figure leading his bride away has turned into something quite evil. Is this Frances's reflection upon the slow disintegration of her life and marriage after 1905?

Although none of these watercolours is dated there is one final work that bears the year of Frances's death, 1921. *The Dreamboat* mirror (222) harks back to the *Vanity* and *Honesty* mirrors; the medium is lead over a wooden frame and the design recalls several Spook School motifs. Robertson believes the sleeping figure at the foot of the mirror to be Arachne, who challenged Athena to a weaving contest.[3] If so, it is a particularly apposite image. In one version of the story Arachne hangs herself and then Athena turns her into a spider so that she can carry on weaving for eternity. Mary Newbery Sturrock told the author that, despite the cause of death having been recorded as 'cerebral haemorrhage', she had been told by her

mother, Jessie Newbery, that Frances had hung herself from a coat hook on the back of a door in the flat at 50 Gibson Street, Glasgow. If this mirror is a deliberate prediction by Frances of her own death, then in all its aspects – the use of lead, the spiders' webs, the briar rose, and the sleeping 'princess' in a bower of web and briar stems – it is a poignant end to a latterly sad life. After her death MacNair gathered together much of their surviving work and burned it. With his son he ran a number of businesses, usually connected with the motor trade, until Sylvan emigrated in the 1930s. MacNair survived all of The Four, living in obscurity in Argyll with his sisters, where Mackintosh's biographer, Thomas Howarth, wrote to him in 1945. Howarth's single-minded pursuit of Mackintosh's life seems to have prevented him from enquiring into the lives and art of Herbert and Frances, and MacNair was able to talk only in generalities about his friend Charles with whom he had lost contact after 1912. MacNair died at Inellan in 1955.

While by no means as dire as that of the MacNairs, life for the Mackintoshes was not as happy and straightforward, or as busy, as it had been in the first part of the decade. After 1905 Mackintosh had only one substantial architectural commission – the completion of the Glasgow School of Art building. Miss Cranston continued to give him work at the Ingram Street Tea Rooms and at the 1911 Exhibition in Kelvingrove Park; she also commissioned a new card room at her house, Hous'hill, where there was an opportunity for Margaret to make a contribution. On the whole, however, there were no new projects that would require Margaret's talents. Outside his professional life, Mackintosh had since 1901 been making studies of wildflowers in his sketchbooks while on holiday. After he had become a partner in his firm in 1901 and until he settled in London in 1915, these flower drawings were his personal artistic mainstay. Gradually, they increased in number, from the half dozen that survive from a visit to the Isles of Scilly to about twenty made on a holiday at Chiddingstone, Kent, in 1910. Occasionally he would produce something more finished such as *Faded Roses* (223) or *At the Edge of the Wood* (224). Neither of these conforms to the canon of the sketchbook flower drawings and may well represent the record of some special occasion or visit. *Faded Roses* presages a format of painting cut flowers that Mackintosh developed in London from the latter part of 1915; in fact, were the date 1905 not so clearly inscribed on this watercolour it would be easy to attribute it to 1915. The flowers are painted in a naturalistic manner very different from the drawings in the sketchbook

that are laid out as botanical studies; the colour is fluid and the background totally abstract. This is a picture that was obviously precious to the Mackintoshes as they kept it until 1923 when it was given as a present to Sybil Sheringham, a close friend in London. *At the Edge of the Wood* owes something to *Cabbages in an Orchard* (41) and other studies of trees made in the mid-1890s. It is a dense, claustrophobic composition, seemingly as much concerned with the creation of an abstract pattern as the naturalistic recording of a clump of saplings. No other similar watercolours survive, and these two must have been painted wholly in the studio. Mackintosh otherwise limited himself to sketchbook studies of wild flowers (themselves also probably completed in the calm of a hotel room), culminating in a spectacular group painted in Walberswick in 1914 and 1915.

The genesis of the Chiddingstone and Walberswick flower studies can be seen in the drawing that Mackintosh made on holiday in Sintra, Portugal, in 1908 (225). This is a drawing that is as far from the naturalistic studies on Holy Island in 1901 as could be. The *Tacsonia* flower – spread out across

the sheet of paper, and shown in various stages of its life – is similar to the drawing of clematis of 1896 (168). There is even a section showing its inner structure, and outlines of its leaves are drawn over the whole design. It is simultaneously an imaginative watercolour and a botanical description of the plant. Mackintosh would occasionally, in his sketchbooks, overlay elevations, sections and plans of the buildings he was looking at; although the result would be a fascinating drawing it would not necessarily be a formal artistic rendering of the subject (227). At Chiddingstone in Kent, in 1910, Mackintosh produced more flower drawings but on the whole these were less analytical than *Tacsonia*. *Cuckoo Flower* (226) is laid out on the paper to display its constituent parts – stem, leaves, flower buds, open flowers – and is a conscious attempt to produce a decorative image rather than a botanically descriptive one. I'm sure that Mackintosh pressed these flowers before drawing them which undoubtedly added to the schematic form of some of the drawings. For instance, *Japonica, Chiddingstone* (228) is a beautiful assembly on the paper, in a Japanese fashion, of these delicate flowers, hinting at structure but being more concerned

LEFT
228. Charles Rennie Mackintosh, *Japonica, Chiddingstone*, 1910, pencil and watercolour, 25.8 x 20 cm, The Hunterian, University of Glasgow

RIGHT
229. Charles Rennie Mackintosh, *Blackthorn, Chiddingstone*, 1910, pencil and watercolour, 25.8 x 20.2 cm, The Hunterian, University of Glasgow

OPPOSITE, CLOCKWISE FROM LEFT
225. Charles Rennie Mackintosh, *Tacsonia, Cintra, Portugal*, 1908, pencil and watercolour, 25.8 x 20.2 cm, untraced
226. Charles Rennie Mackintosh, *Cuckoo Flower, Chiddingstone*, 1910, pencil and watercolour, 25.8 x 20.3 cm, The Hunterian, University of Glasgow
227. Charles Rennie Mackintosh, *Well, Cintra, Portugal*, 1908, pencil and watercolour, 25.8 x 20.1 cm, The Hunterian, University of Glasgow

with artistic effect. The cartouche, which identifies the flower and its location and includes the Mackintoshes' initials, here begins to be more carefully integrated with the design. *Blackthorn* (229) summarises Mackintosh's future practice in these simple, yet memorable, drawings with the careful disposition of two pieces of the shrub, the fastidious delineation of the flowers and the clear exposition of the plant's structure.

With the exception of a small gesso panel for The Hill House and a set of decorative gessos for the card room at Miss Cranston's Hous'hill, Margaret became less involved with Mackintosh's architectural practice after completing the gesso panel for the Room de Luxe at the Willow in 1903. Undoubtedly, the six-metre-long panel for Waerndorfer's Music Room, commissioned in 1903 but not finished or installed until 1906, took up much of Macdonald's time and creative energy in the middle of the decade. She also produced one large, one-metre-high, gesso panel (191) in 1904 which was based on the earlier watercolours *Summer* (112) and *June Roses* (125). The panel seems only ever to have been exhibited in 1909, at the ISSPG as a loan from Charles Macdonald, Margaret's brother. It features many of the techniques and stylistic motifs that she also used in

The Seven Princesses (196) and the panel may have been a conscious trial for the processes used in the Waerndorfer panel as, indeed, the panel *O Ye, All Ye That Walk in Willowwood* may also have been (202). The exhibition at the ISSPG was entitled *Fair Women* and Margaret submitted three substantial gesso panels: *Summer*, *In Willow Wood* and *The White Rose and the Red Rose*. Before this exhibition, the first of a series with the same title and theme, the ISSPG had originally been welcomed by women artists because of its more open policy of accepting and displaying their work on the same terms as works by male artists. As Helland has shown,[4] in left-wing quarters this exhibition was seen as perpetuating contemporary perceptions of women as having little importance beyond their physical beauty: while *The Daily Telegraph*, *Glasgow Herald* and other journals concentrated on the exhibition as a collection of 'beauty and grace', *The Daily Mirror* actively questioned the validity of the themes of the exhibition in the context of growing social unrest over the roles of women in contemporary society. Surprisingly, Helland does not relate these panels (particularly *Summer* and *The White Rose and the Red Rose*) to the *Mirror*'s charge that the exhibition contained too many images of women who had 'nothing to do but dream'.

The inhabitants of Macdonald's gesso panels certainly did not fit the *Mirror*'s demand for portraits 'of the women of today – the woman who is going to have the vote tomorrow'; Helland agrees that Macdonald was not challenging the status quo, but mitigates this criticism by suggesting that she was making 'woman into a purely decorative object, thereby effectively removing any pretence that she operates independently'. I am not sure that the New Women who were the Macdonald sisters in the mid-1890s would find this a valid or flattering description of their early promise. Nor do I think either of them would have submitted work at that date to an exhibition that paid homage to 'Fair Women'.

Several watercolours of the period develop different themes, some of them related to the Vienna frieze. A watercolour known as *The Sleeper* (230) echoes its central section, with a reclining figure overlooked by a male head enveloped in a web of briar tracery. A similar figure, more decorative and less ominous in its iconography, appeared in a small watercolour made for an album presented in 1905 by fellow members of the RSW to Francis Powell, its first and retiring president – *The Sleeping Garden* (231). A linear framework with encircling tendrils links each of these works and clearly relates them to the Waerndorfer project. Not surprisingly, given the demands for completion of the Waerndorfer room, there are few

231. Margaret Macdonald Mackintosh, *The Sleeping Garden*, 1905, watercolour on vellum, dimensions unknown, private collection

OPPOSITE
230. Margaret Macdonald Mackintosh, *The Sleeper*, by 1903,?watercolour, untraced (contemporary photograph, The Hunterian, University of Glasgow)

ABOVE
232. Margaret Macdonald Mackintosh, *St Dorothy*, 1905,
pencil and watercolour, 76.2 x 45.2 cm, The Hunterian, University
of Glasgow

RIGHT
233. Margaret Macdonald Mackintosh, *Cinderella*, 1906,
pencil and watercolour, untraced

OPPOSITE
234. Margaret Macdonald Mackintosh, *The Dead Princess*, 1908,
watercolour on vellum, dimensions unknown, private collection

other works from this period. Two strange pictures survive, however – both paintings of St Dorothy, both dated 1905. They are each substantial in size, 75 cm high, but never seem to have been exhibited, which is perhaps not surprising given their weakness in both composition and execution; they seem totally unrelated to the complex designs Macdonald was producing for Waerndorfer at the same time. Perhaps they were influenced by the work that her sister and MacNair were producing in Liverpool – a more romantic, and slightly vacuous, make-believe world, reflected in this crinolined figure floating in front of a 'Mackintosh' building (232). Despite their size these are two pictures that do not earn a mention in feminist accounts of Margaret's work; perhaps their frivolity does not conform with the accepted profile of Margaret as the begetter of *The Seven Princesses;* on the other hand, perhaps they betray the level of her work when she was not collaborating with Mackintosh. They could be read as an isolated aberration but there are parallels with some of the watercolours from the later 1890s when Margaret was working on her own and not in a collaborative partnership with others of The Four. It confirms her, I think, as an artist who often works best as a collaborator; certainly there are only half a dozen later watercolours that have the power of her collaborative works, several of which were provoked by the deaths of her mother and sister.

Cinderella (233), however, is a more accomplished drawing than *St Dorothy*, taking a conventional Macdonald composition of one figure superimposed on another and wrapping it within a tendril framework. One new element here is the repeated chequered panels, reminiscent of motifs in some of Mackintosh's furniture and even some architectural details. It failed to sell in London at the RSW exhibition in 1911 and was eventually acquired by the Glasgow artist Jessie M. King. Macdonald's gesso panel, *The Sleeping Princess* (205), c1908–09, incorporates techniques and motifs from several earlier watercolours; despite its compositional similarity to the melancholy Waerndorfer frieze, Macdonald chose to adopt a happier note as it was intended for the Blackies' drawing room at The Hill House. This was not the case with *The Dead Princess* (234), a watercolour of 1908 exhibited at the Kunstschau in Vienna in 1909, where a solemn figure, lying in a meadow or possibly floating in a pool, is overlooked by a rank of sad-looking cherubs. A curious trio of watercolours, which appeared on the market in the 1980s, shows a move in a totally different direction. These watercolours (235) were discovered in the 1980s fitted into a crude screen that was probably not contemporary with them – they each bear the date 1909. A variation on the Japanese pictorial maxim of three wise monkeys – 'see no evil, speak no evil, hear no evil' – these watercolours portray a woman whose face is flanked by her outspread hands and on whose head appears to sit a

pair of dragonfly wings; she is seen either weeping, or with eyes open, or with eyes closed. She remains a mystery, totally outside the canon of Margaret's contemporary work.

In 1909 Kate Cranston came to Mackintosh's rescue with the commission for a new Card Room at her house outside Glasgow, Hous'hill, and again in 1911 when she asked him to design a temporary tea room, The White Cockade, for yet another major exhibition in Kelvingrove Park – the third in fewer than twenty-five years. Margaret became involved with both of these commissions, producing a striking quartet

235. Margaret Macdonald Mackintosh, *Woman with Eyes Open*, 1909, pencil, body colour and watercolour on vellum, 29.5 x 42.5 cm, Crab Tree Farm

of playing-card queens for the first and an eye-catching menu for the second. *The Four Queens* (236–239) were made in gesso, each figure reduced to and surrounded by her attributes. The romantic imagery of the recent watercolours has gone, replaced by a hard linear scheme that so much anticipates what Mackintosh was to do in the hall parlour at 78 Derngate in 1916 that one has to wonder whether he had a hand in the design of these four panels. Collaboration, after all, means just that, and, given that the design of the furniture in this Card Room is so radically different from much of the furniture Mackintosh had produced before 1906, he would surely have wanted the decorations in the room to complement the card tables and chairs. Nothing else in Macdonald's contemporary production compares with

these four gessos which suggests that Mackintosh may well have had a hand in their design, aiming for a specific and non-typical effect. Even the dramatic menu for The White Cockade (240) has a hint in its design of the decorations Mackintosh had recently finished for Kate Cranston at the Ingram Street Tea Rooms – the Cloister Room and Chinese Room – but its execution is undeniably that of Margaret Macdonald. Miss Cranston even extended her helping hand to Frances Macdonald in a commission for another menu, this time for The Red Lion café (241), which draws on the iconography of the Card Room gessos by her sister.

In the next few years, however, Margaret concentrated on watercolours, producing a group of images that rank among her most skilful and moving designs. *The Mysterious Garden* (242) is often cited as being inspired by a Maeterlinck play, *The Blue Bird* (performed in Glasgow in the autumn of 1910), but the iconography seems more related to that of *The Seven Princesses*. Eight heads float above a ninth figure which seems to be sleeping, rather than dead. Her hair blends with a diaphanous dress, rendered in transparent washes in front of a row of architectural panels. This watercolour is larger than recent examples and was the first of a substantial group that Margaret submitted to the annual exhibitions of the RSW from 1910. It was shown along with *Cinderella* in 1911, and in 1912 she submitted it again (this time for sale at £25), accompanied by *The Three Perfumes* (243) and *The Silver Apples of the Moon* (244). The first is a less accomplished piece that marks a return to the simpler compositions of the 1890s, with a central forward-facing figure flanked by two others in profile. Hands and faces are painted in some detail while voluminous and ethereal dresses conceal the bodies beneath, as in some Glasgow Style figurative works from the late 1890s. These dresses are boldly detailed with patterns of roses and other organic shapes, having a translucent quality which extends over the whole painting. The source is unknown, perhaps it is again Maeterlinck, perhaps it is more personal as with the 1890s paintings, but it has the feel of an illustration. The second watercolour has a readily identifiable and rather unexpected source, the poem by W.B. Yeats, 'The Song of Wandering Aengus' (1899). Macdonald was an able illustrator of such works, as her later 1890s drawings showed. Aengus, while roaming through a hazel wood, drops a berry into a stream and catches a silver trout that metamorphoses into '... a glimmering girl/With apple blossom in her hair/Who called

me by my name and ran/And faded through the brightening air'. Macdonald chose the moment when he wanders in search of his lost love saying, 'I will find out where she has gone,/And kiss her lips and take her hands;/And walk among long dappled grass,/And pluck till time and times are done,/The silver apples of the moon,/The golden apples of the sun.'[5] This is one of the most elaborate of Macdonald's watercolours of this date with its overall and almost monochrome pattern of apple blossom and apples on a rather sinister tree. Macdonald makes obvious allusions to Eve and the apple, and in the juxtaposition of the beautiful girl with the handsome man behind her there seems to be a hint of Frances Macdonald's *The Frog Prince* (122). This comparison does not diminish Margaret's achievement here – at the RSW in 1912 the paintings she presented bore little hint of the Spook School reputation for otherworldly decorations that she and The Four had acquired in the 1890s. Like her sister she appeared in 1912 as an independent artist at the height of her powers with a blossoming career as a watercolour artist ahead of her. Subsequent events, however, were to cause her to withdraw from such a course, beginning in 1912 with the death of her mother.

The Pool of Silence (245) is probably the last picture that Margaret Macdonald painted before she and her husband left Glasgow in the summer of 1914. Her mother, Frances Grove Hardeman Macdonald, died on 16 June 1912. *The Pool of Silence* is a daughter's powerful grieving homage and one of Margaret Macdonald's most accomplished paintings. As with *Silver Apples of the Moon*, she adopted a very restricted palette; the lunar silvers of that painting are replaced here, however, with shades of grey and black relieved only by touches of red in the tears and raindrops that fall upon the prone figure floating in her simple craft in a grey pool. The upper figure touches her lips in a gesture of silence, a silence of melancholy that pervades the painting. It is likely that this melancholy, provoked by the death of her mother, was intensified by the situation in which Margaret and Charles found themselves in 1913. Their circumstances, both creative and financial, were to provoke depression in both artists and lead to a decision that would unexpectedly change their lives for ever.

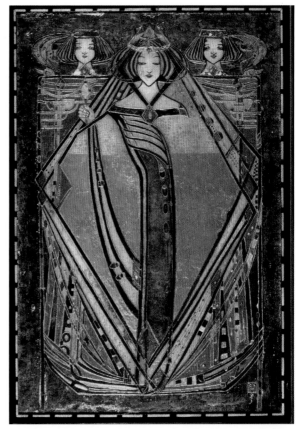
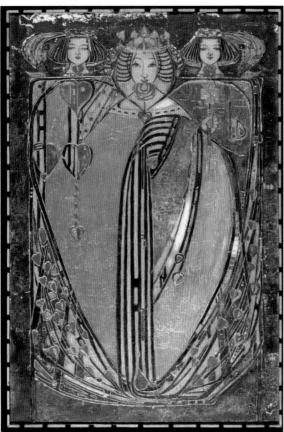
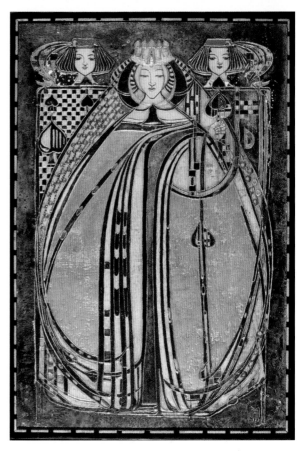

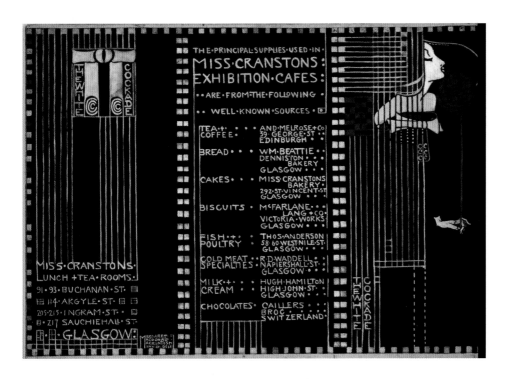

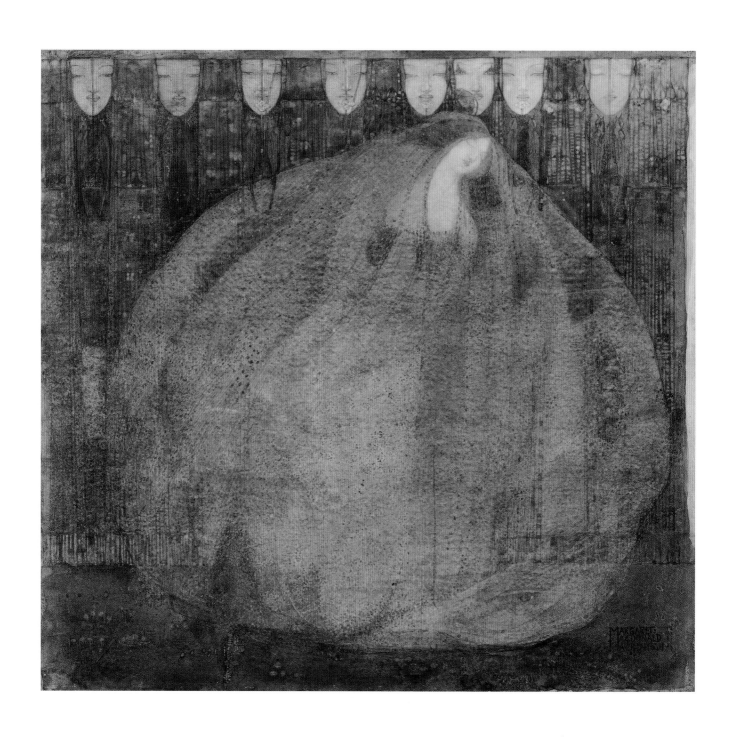

242. Margaret Macdonald Mackintosh, *The Mysterious Garden*, 1911,
watercolour and ink over pencil on vellum, 45.1 x 47.7 cm,
Scottish National Gallery of Modern Art, Edinburgh

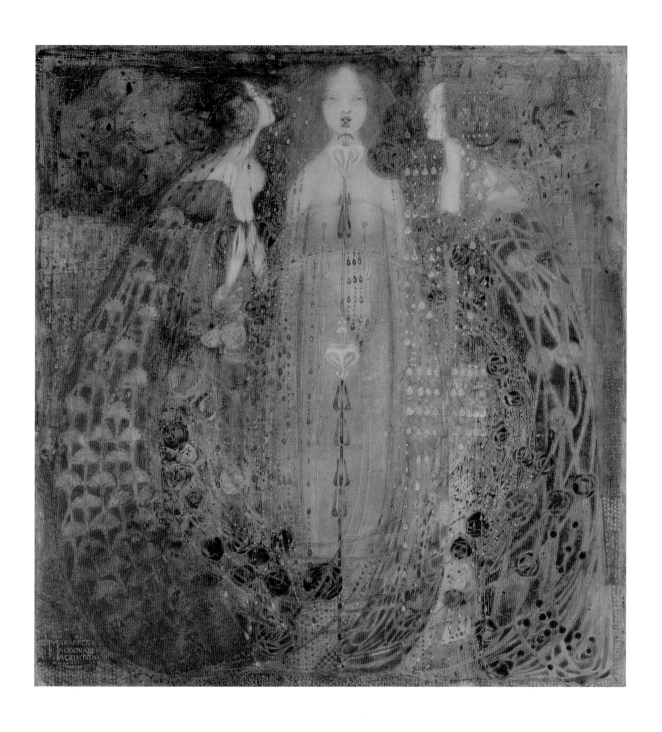

243. Margaret Macdonald Mackintosh, *The Three Perfumes*, 1912
pencil and watercolour on vellum, 50.2 x 47.6 cm,
Cranbrook Art Museum, Michigan, USA

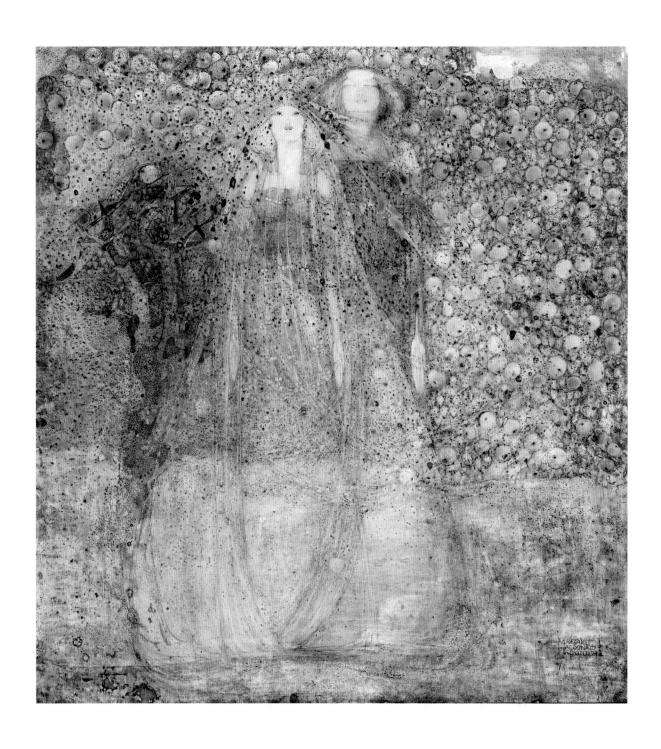

244. Margaret Macdonald Mackintosh, *The Silver Apples of the Moon*, by 1912, pencil and watercolour, with highlights of gilt paint and gum arabic, on gesso-prepared paper, laid on cardboard, 68.2 x 72.5 cm, untraced

OPPOSITE
245. Margaret Macdonald Mackintosh, *The Pool of Silence*, 1913, pencil and watercolour on vellum, 75.8 x 63.5 cm, National Gallery of Canada, Ottawa

246. Charles Rennie Mackintosh, *Yellow Tulips*, c1922–24,
watercolour, 49.5 x 49.5 cm, private collection

10 SOLACE

I N JULY 1914 the Mackintoshes moved to Suffolk: Walberswick, at the eastern edge of England. Flat fields with a tracery of rivers and meres. Huge skies and, on a sunny summer's day, the endless waters of the North Sea filling the horizon and beyond. In winter, a different picture: there are not many trees here, the winds are no doubt too strong for young saplings, and the rivers Blyth and Dunwich seem bleak and unwelcoming, the isolated black wooden huts along their banks leaning into the wind, or with it. Or were they built off the perpendicular to begin with? The winter sea is very grey and at some point in the distance may merge with an equally grey sky without forming a horizon.

Walberswick in 1914 was home to a fishing and boatyard community; here working boats were built that plied their trades up and down the coast or scoured the sea for herring. Like a number of such coastal villages in Britain – Newlyn, St Ives, Staithes, Whitby, and Cove and Eyemouth in Berwickshire – it attracted artists. The unshaded light was what brought them to Walberswick and its bigger neighbour across the Blyth – Southwold. The English impressionist, Philip Wilson Steer, created some of his most important paintings in the village of Walberswick and on its pier. It even attracted the Glasgow Boys – E. A. Walton worked here for many summers – and Fra Newbery and his family kept a house, Rooftree, in the village for twenty years. It was here in the summer of 1914 that the Mackintoshes came to escape the rigours of Glasgow so that Mackintosh could have a much needed holiday; it was a place to rest and recuperate and consider the future, perhaps a place to paint, too.

A century later, Mackintosh would have struggled to recognise his haven. The dunes are still there, of course, and the rivers Dunwich and Blyth, but the Blyth's banks – where once there were fishing boats – are now clogged with moored pleasure craft, sometimes two or three deep. I suppose it is not alone in suffering this fate. The village has grown too, in both physical size and wealth. On a fine summer's day its car parks by the harbour and on the dunes hold more than five hundred cars and as many as two to three thousand holiday makers pour into the tiny village. For children it continues to be a paradise where catching crabs and exploring the miles of dunes easily outdo building sand castles and haunting amusement arcades. But the fishermen have gone, and their tiny cottages have been smartened up to rent to holidaymakers. The Newberys' semi-detached house near the Anchor Inn on The Street, however, is still recognisable; its partner, Millside, was the house rented by Mackintosh in 1914. Walberswick in summer would no longer offer Mackintosh the solace and, seclusion he enjoyed there. But in winter he might not notice much of a

247. Charles Rennie Mackintosh, *Framlingham Castle*, 1897, pencil on paper, 37.2 x 13.4 cm, The Hunterian, University of Glasgow

change – the weather and the village would still be quiet, with few attractions for the typical summer visitor other than solitude.

It was not the first time that Mackintosh had visited the area. In 1897 he had toured Suffolk and East Anglia – perhaps at Newbery's suggestion – and had made several drawings in his sketchbook at the nearby village of Blythburgh, just a couple of miles from Walberswick. Most were typical sketches of architectural details, but at Framlingham Castle (247), about fifteen miles away, Mackintosh had made one of his rare (at this date), more pictorial sketches of the powerful and majestic gateway tower and bridge. He introduced a sense of place here, choosing a viewpoint in the now dry moat and looking up at the soaring towers and walls of this once great castle. The majority of his other drawings on this tour had been made head-on to their subject, with little indication of context and none of perspective. But at Framlingham he revealed his eye for a painterly composition, setting his subject, as he had done with *Glasgow Cathedral at Sunset*, 1890 (2), in a more naturalistic setting. He would repeat this in his Holy Island sketches of 1901, where the castle is seen more in perspective than in frontal elevational views; but he rarely used this format again until twenty years later at Worth Matravers in Dorset. At Walberswick, in the first works of his new career as an artist, Mackintosh usually adopted a frontal approach to his subjects.

The Mackintoshes moved to Walberswick because life in Glasgow seems to have become unbearably oppressive for Charles. Margaret wrote to her friend Anna Geddes that the couple had planned to go there 'just for a holiday & then war broke out & I induced Toshie to just stop on & get the real rest-cure that he so badly needed for quite two years.'[1] After completing the School of Art in 1909 his firm attracted little work, in common with most other Glasgow architects, for the city was in the grip of a recession. What was built in the years before the outbreak of war in 1914 tended to reflect a growing fashion for Beaux Arts swagger and grandeur, inimical to Mackintosh. Architecture students at the School of Art mocked his Arts and Crafts manner,[2] swayed no doubt by their tutor, Eugene Bourdon, Paris-trained at the École des Beaux Arts and never an admirer of what some referred to as the 'new art'. Honeyman Keppie & Mackintosh saw fee income fall, despite the best efforts of John Keppie, always the firm's agent for new work. Kate Cranston's commissions for extensions to her tea rooms at Ingram Street and for a temporary tea room at the 1911 exhibition in Kelvingrove Park constituted the bulk of his work at this time (*see* pages 202–205, Chapter 9). In 1898 Mackintosh had produced an exciting scheme for the vital 1901 Glasgow International Exhibition, but the firm failed to win; had his design succeeded, the story of his later career might have been very different. Some hope, however, came in 1912 in the commission for a new demonstration (teacher-training) school at Jordanhill, Glasgow, that Mackintosh seems to have taken charge of, although his heart does not appear to have been in the job. Apparently, deadlines were missed, the brief not complied with and Mackintosh seemed to be unable to pull the scheme together. The economic climate, and perhaps the looming prospect of war, caused it to be shelved. Mackintosh's assistant, Graham Henderson, who in later years was keen to take credit for some of the work at the Ingram Street Tea Rooms and rarely passed up an opportunity to denigrate Mackintosh, took up the

plans in 1916 when work started on site and was finished at the end of the war. It was this job that led to his promotion as partner within the firm and its change of name to Keppie Henderson.

On the 31 December 1913 Mackintosh resigned as a partner (and the partnership of Honeyman Keppie & Mackintosh was formally dissolved in June 1914), apparently with the intention of setting up on his own in Glasgow. Nothing seems to have come of the venture, however, although Mary Sturrock believed that he had been involved in a design for the 'Dough School', Glasgow's College of Domestic Science. There is no record of this, however, and she may have been confusing it with the Jordanhill project.[3] She remembered Mackintosh complaining that the client 'wouldn't take his designs because the washbasins were the wrong side of the corridor'. After this, I believe that Mackintosh suffered some form of nervous breakdown or was simply exhausted and depressed by the dramatic change in his fortunes. His future detractors in Glasgow, led by Henderson, would later attribute his decline to excessive drinking. Glasgow undoubtedly had a serious drinking culture, and none was a more hearty participant than John Keppie, a stalwart of the Glasgow Art Club for fifty years; but Mackintosh's later relationship with alcohol, particularly in France, suggests that if he did drink to excess in 1912–13 it was because of a failure to attract work and not vice versa. Certainly, in Port Vendres in 1927 Mackintosh was capable of limiting his consumption of wine with his dinner to just a couple of glasses – not the behaviour of an alcoholic, even a recovering one. The Mackintoshes travelled to Walberswick in mid to late July and rented the house adjacent to the Newberys;[4] it does not seem, from contemporary letters and memories, that they intended this to be a permanent break with Glasgow. Even if Mackintosh had been capable, work as an architect was unlikely in this predominantly agricultural county and, in any case, the outbreak of war in August that year led to a prohibition on new building.

Mackintosh seems to have turned quite quickly to painting, no doubt encouraged by Margaret and their good friends the Newberys (and even by Newbery's daughter, Mary Sturrock, who was also at Walberswick that year and by her own account busy with her own watercolours). Most of Mackintosh's output there was paintings of flowers, more botanical in their handling than earlier studies, and the choice of plant suggests they were painted from late summer onwards. He also painted at least three landscapes, or 'villagescapes', which were his first watercolours of this kind since his Italian tour or the occasional work from the 1890s, such as *Porlock Weir* (78). Had he already realised that his immediate hope of earning a living lay in the sale of paintings rather than architecture? Newbery had a studio on the banks of the Blyth, perhaps the large black wooden structure that was the subject of a painting around 1910 (257),[5] and the Mackintoshes rented a small hut close by. Every day they would leave the house in The Street and walk down to their studio by the river, with Mackintosh perhaps collecting a couple of specimens of flowers from gardens that they passed. Over the next ten months he made over forty watercolour paintings of flowers. The Walberswick flower studies were not just of wild plants, like the sea pinks that he found on Holy Island in 1901. He included fuchsia, petunia (248), borage, larkspur (249), gaillardia (250), aubrieta and salvia – cottage garden favourites – alongside flowers that grew naturally in the local hedgerows and fields,

such as sorrel and chicory (251). But in 1915, there was more of an emphasis on wild species such as willow catkins, field pea, daisies (252), kingcups and mullein – a selection perhaps forced upon him by the later flowering of many garden species, which he missed owing to his early departure from the village at the end of June 1915. Cultivated flowers were not ignored, however, and beautiful drawings of cactus flower (253), snake's head fritillary (254), honeysuckle and anemone (255) also appear in 1915. It has been said that Mackintosh was commissioned by a German or Austrian publisher to prepare enough drawings to illustrate a book;[6] firm evidence for this claim is not available and it is perhaps strange, if such a commission existed, that Mackintosh did not work with a scientifically trained botanist. There must, however, have been some reason for him to have concentrated on these delicate studies rather than on larger, and more easily saleable, watercolours of the village. Perhaps he felt that studies of this sort would sell quickly at reasonable prices, but there are no records of successful sales of anything at this date other than to William Davidson in Glasgow. Nor does Mackintosh seem to have made any concerted effort to submit his flower drawings for public exhibition, either during his months in Walberswick or later. Perhaps in 1914, when he started work on the series, money was not such a pressing problem as it was to become in the summer of 1915 when he wrote urgently to Davidson asking for the loan of £1, by return, if Davidson was not interested

in buying any of the drawings that had been offered to him only the day before.[7] Financial difficulties seem to have troubled the Mackintoshes until at least 1916, when Mackintosh received a payment of £250 from John Keppie in Glasgow of fees due to him under his partnership agreement, and when he began to receive some fees from Bassett-Lowke in Northampton.

Mackintosh had, of course, painted a similar series of flowers at Chiddingstone during a holiday there in 1910. The major difference was that the Chiddingstone flowers were mainly wild and not garden cultivars, but the format was the same: each flower was placed squarely on the page and drawn with connected stems and foliage. A rectangular cartouche contained the place, year and initials CRM and, usually, MMM, following the practice he had established at Holy Island in 1901 (*see* Chapter 7, pages 146–149). If, as Mary Sturrock asserted, the presence of Margaret's initials indicated that she was with him when the paintings were made, it shows that she was a constant presence in their studio hut in Walberswick in 1914 and 1915.

There is a further degree of stylisation in many of these watercolours, a more deliberate or decorative placing of the plant within the page, a definite attempt at pictorial delicacy. Was this driven by the supposed commission for a volume of botanical illustrations or was it simply that Mackintosh recognised in these

LEFT
250. Charles Rennie Mackintosh, *Gaillardia, Walberswick*, 1914, pencil and watercolour, 24.5 x 18.2 cm, Glasgow School of Art

RIGHT
251. Charles Rennie Mackintosh, *Chicory, Walberswick*, 1914, pencil and watercolour, private collection

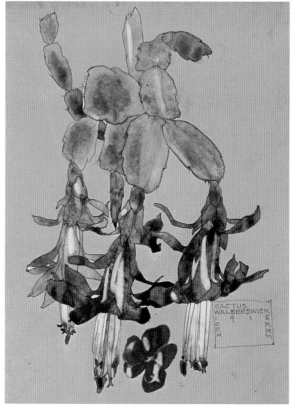

drawings a possible source of income as decorative paintings? There is rarely any modelling in these drawings, no hint of depth or perspective within the compositions (Mackintosh almost certainly worked from pressed specimens which would have provided him with an already flattened image). The plants sit in isolation on the white paper, floating in space. Is this a deliberate stylistic device or could it possibly be an indication of an eye problem that can be traced through all of Mackintosh's graphic work? A later friend of the Mackintoshes, Randolph Schwabe, who was a professor at the Royal College of Art and a distinguished topographical artist, once told his son-in-law, Harry Jefferson Barnes (Director of the Glasgow School of Art, 1964–80), that when Mackintosh was working and concentrating hard his left eyelid drooped so that his eye was almost closed. The drooping eyelid was apparently the result of rheumatic fever from which Mackintosh had suffered as a child. This can lead to a condition known as amblyopia (or, more colloquially, lazy eye) where, because the brain – in its first crucial six to seven years – has received consistent information from only one eye, it renders the sufferer monocular and with concomitant difficulties in perceiving perspective and depth.[8] This neurological defect, this inability to see stereoscopically, may well account for Mackintosh's propensity to draw his subjects in a purely frontal view or, when viewing from a three-quarter angle, to

flatten the drawn image so that there is little sense of perspective or depth. Until 1914 Mackintosh had made very few landscape watercolours and his incipient problem with spatial depth is detectable in these flower drawings only with the benefit of hindsight. But at Walberswick, he started to work more seriously as a landscape painter, and the effect of his condition in the paintings done there is apparent. It reappeared in the later London flower paintings and landscapes at Worth Matravers in Dorset, painted alongside Randolph Schwabe when the two families were on holiday there together. In the watercolours painted in France after 1923, as Mackintosh grew older, this lack of stereoscopy is more obvious and is combined with a peculiar ability to discern detail in the far distance with the same acuity as in the foreground.

Mackintosh painted three watercolours at Walberswick – *A Palace of Timber* (256), *Venetian Palace, Blackshore on the Blyth* (258) and *Walberswick* (259) –although others may have been lost. In the first two paintings Mackintosh adopts a frontal view point, obviously fascinated by the area's vernacular buildings, recording them as he would in a pencil drawing in a sketchbook. The colour is applied in a loose wash with very little description of the details of the buildings or the surrounding landscape. *A Palace of Timber* shows one of the waterside structures similar to that used by Newbery as a studio, which he painted (253) and which survives to this day.

LEFT
254. Charles Rennie Mackintosh, *Fritillaria, Walberswick*, 1915, pencil and watercolour, 25.3 x 20.2 cm, The Hunterian, University of Glasgow

RIGHT
255. Charles Rennie Mackintosh, *Anemone and Pasque, Walberswick*, 1915, pencil and watercolour, 26.3 x 20.8 cm, British Museum, London

256. Charles Rennie Mackintosh, *A Palace of Timber*, 1914/15, watercolour, dimensions unknown, formerly Glasgow School of Art, destroyed

The Mackintoshes rented a smaller building on the banks of the Blyth, more of a hut, in which Mackintosh painted his flower studies and maybe the larger watercolours (although the latter were probably painted *en plein air*). His study of the mouth of the Blyth at the North Sea, *Walberswick* (259), is rather different, with the river describing a strong diagonal across the paper. There is only an indication of a horizon over the river between the two harbour lights; at either side of the lights the sky descends to meet the dunes. This is a rare viewpoint for Mackintosh to adopt, later repeated in an early study at Port Vendres (293). Both paintings share disparate vanishing points, one for each side of their subject, separated by a stretch of water. In Walberswick there is a discrepancy in the perspective of each riverbank, with differing sizes of structures on each bank for a given distance from Mackintosh's viewpoint. The French watercolour shows a similar problem, where the buildings on the right-hand side of the harbour are drawn at a different scale. A stretch of water appears in the centre of each of these pictures, possibly confusing his spatial grasp of the scene before him. Perhaps this is all a result of Mackintosh's lack of stereoscopic vision which in turn may account for his subsequent practice of viewing his subjects head-on and concentrating on subjects with more palpable volume, such as rocks and buildings.

On Friday 18 June 1915, Mackintosh wrote to his old friend and client William Davidson.[9] He began his letter with general comments about the war saying that it had 'nearly finished me off completely'. But the main point of the letter was to ask Davidson if he would buy one of his watercolours. He appears to have included a group of the more recent landscapes, saying that they had been much appreciated by other artists at Walberswick, and citing E.A. Walton and Bertram Priestman. Mackintosh wrote that he would expect ten guineas for each of them but would be prepared to accept seven guineas. In the letter he also states that he has much larger work available, but that it is obviously more expensive; no larger pictures than the above three are now known from Mackintosh's Walberswick year. He excuses his haste and urgency with the news that he has to leave Walberswick on Thursday (24 June 1915). The following day, Saturday, 19 June, he wrote again saying, 'I find I am in a much worse plight than I imagined. If you cannot buy one of my pictures will you please lend me 1 pound and send it so that I can get it on Wednesday.'[10]

Mackintosh wrote again to Davidson on 21 July giving the address of a University of London hall of residence in Chelsea. Davidson had obviously responded to the earlier letters, telling Mackintosh of the death of his oldest son in

the war and enclosing a postal order for £10 for *Walberswick*. Mackintosh thanked Davidson, offered sincere condolences and proceeded to tell him what had happened to cause him to leave Walberswick so suddenly.[11] 'Somehow the natives of Walberswick got to know that I had done some work in Germany and Austria – at any rate some of the special constables informed the military against me and they made a search in our cottage here and among other things discovered some German and Austrian letters – all some years old and all relating entirely to artistic and social affairs.' All remonstrations had failed and the Mackintoshes were served with an order to leave the district. Only Charles seems to have left Walberswick immediately as the stress of the investigation had made Margaret ill and on doctor's advice she had remained in the village until she was well enough to join her husband in London. After making personal visits to various army stations in East Anglia and Salisbury to protest at his treatment, Mackintosh was continuing to fight his case from London where '[I am] playing around with prof Geddes at his summer meeting here. The lectures are full of interest and enthusiasm and of course they seem far away from reality – but they really are not.' With his letter he enclosed two further watercolours saying that Davidson could have them at 'your own price'; failing that he asked for a loan of five or ten pounds for a month or two. 'I am simply on the rocks just now but I have some money coming in soon and will be all right then. I am sorry to ask you to do this – if you can you will be helping me more than you know. As a matter of fact if

257. Francis H. Newbery, *Waterfront Building, Walberswick*, c1910, oil on canvas, 51 x 43.2 cm, formerly Glasgow School of Art, destroyed

you had not sent me £10 for the picture I don't know how I could have got our case forward at all.' Davidson did not buy the pictures but sent Mackintosh some funds and commissioned him to redo the stencils in his bedroom at Windyhill. On 5 August 1915 Mackintosh wrote again to say that Margaret had joined him in London, at 43 Paultons Square, and that his case against the military was progressing.[12] He also asked Davidson's opinion about an offer he had received to go to India for six months to work on the reconstruction schemes that Geddes was involved with. Despite the offer of £5 per day Mackintosh seems to have declined the opportunity although he did produce some architectural schemes for an Indian city for Geddes.[13]

This was obviously a traumatic time for the Mackintoshes – homeless (or, at least, very far from home in Glasgow), very short of money, and now with no work. The approval of his artist friends in Walberswick and the sale to Davidson of one of the new watercolours probably encouraged Mackintosh to consider an artistic career as his mainstay. The Walberswick interlude, with the many flower drawings, was precisely that – an interlude. Mackintosh had left Glasgow on a recuperative holiday, probably expecting to return to the city to try again to establish an

258. Charles Rennie Mackintosh, *Venetian Palace, Blackshore on the Blyth*, 1914, watercolour, 41 x 56.4 cm, The Hunterian, University of Glasgow

architectural practice. The war put paid to all of that, however, as new building was quickly prohibited to protect the war effort; anyway, having settled in London he certainly did not have the contacts there that an architect would need to establish a new practice. Life in London proved to be very different from their lives in Glasgow, or even in Walberswick where they had rented a semi-detached house next to the Newberys and had a separate 'studio' in a hut at the side of the river. Now they were forced to take lodgings, in Chelsea, as their house in Glasgow was unsold and they had no capital (and insufficient income) to buy in London. They took adjacent small studios nearby in Glebe Place, but they had no cooking facilities and took their meals in nearby restaurants. Eventually, they found a small restaurant – The Blue Cockatoo on Cheyne Walk – and a theatrical club, The Plough, which suited them perfectly; in both they found an atmosphere that offered companionship, friendship, an introduction to the artistic life of the capital and even the possibility of new commissions for Mackintosh. Mackintosh (and to a lesser extent Margaret) needed to find work both to provide an income and to restore some of their lost confidence.

259. Charles Rennie Mackintosh, *Walberswick*, 1914, watercolour, 28 x 38.2 cm, private collection

Walberswick had suggested the possibility of a new career as an artist, although it must have seemed unlikely to Mackintosh that painting wild flowers could be its basis. He put away the Walberswick drawings – none seems to have been exhibited – and turned instead to painting larger exhibition-style studies of cut flowers and producing designs for printed textiles. The first of the flower paintings to be exhibited, *Anemones* (264), appeared at the ISSPG in May 1916 and in its background appears a piece of fabric made from one of Mackintosh's designs. This would suggest that he began working for the textile roller printers, William Foxton Ltd and William Sefton & Co., before he began to paint his series of larger flower watercolours. Mary Sturrock believed that Mackintosh had been introduced to these manufacturers by Claude Lovat Fraser,[14] presumably in late 1915 or 1916, but recent research suggests that Fraser was not himself introduced to Foxton until April 1918, by which time Mackintosh had produced various designs for the company.[15] His designs for printed textiles (260, 261, 262) grew out of several of the decorative motifs that he had latterly explored in Glasgow. In the Cloister Room at the Ingram Street Tea Rooms, around 1910–11, he had introduced long strings of painted lozenges making a repetitive pattern around the panelling of the room. Similar motifs appeared in the Library at Glasgow School of Art, introducing colour to an otherwise monochrome room. In London Mackintosh transformed these ideas into a body of work that established him as one of the leading designers of textiles in Britain at that date. Some of Mackintosh's designs were published and credited to him in magazines and journals such as *The Studio,* but the fabrics themselves did not contain printed acknowledgement of their designer. There is at the beginning, not surprisingly, some

ABOVE
260. Charles Rennie Mackintosh, Textile design – ochre, black and white, *c*1920, pencil and watercolour, 17.2 x 16 cm, The Hunterian, University of Glasgow

BELOW
261. Charles Rennie Mackintosh, Textile design with blue garlands, by 1916, pencil and watercolour, 24 x 19 cm, British Museum, London

OPPOSITE
262. Charles Rennie Mackintosh, Textile design with sweet peas, by 1916, pencil and watercolour, 24.2 x 20.2 cm, The Hunterian, University of Glasgow

influence from the Viennese designers that he had admired before the war, and whose work had been reproduced in various *Studio Yearbooks* before 1914. Increasingly, however, as his ideas developed, Mackintosh's designs showed his ability to produce abstract patterns from his knowledge of nature and an awareness of how this could be combined with more geometric shapes to create an entirely new vocabulary. Over one hundred of his drawings survive and many more must have been retained by the manufacturers, most of whose records were destroyed in the Blitz. In 1920, his diary records an income of over £200 from his sales of such designs – for voiles, chintzes and handkerchiefs, among others.[16]

In the summer of 1916 Mackintosh received a commission which would allow him to put some of these new decorative ideas into three-dimensional form. A Northampton manufacturer of engineering models, and famous for toy trains, was recommended to use Mackintosh as the designer of the interiors of his newly acquired house in the centre of Northampton, into which he planned to move with his new wife in the summer of 1917. W.J. Bassett-Lowke had a passionate interest in modern design, particularly that emanating from Germany and Austria – an unfortunate passion in 1916 – and was an early member of the Design and Industries Association, modelled on the Deutscher Werkbund. He may have been told of Mackintosh's history with the Vienna Secession; if not, Mackintosh would surely have invoked his knowledge of recent Austrian design to confirm his appointment. In the hall-parlour at 78 Derngate (263), Mackintosh created an installation that evoked several of his new designs for fabrics. He covered a draught screen with a bright geometric pattern and for the walls developed a powerful scheme based on the form of a tree; its canopy was created from overlapping inverted triangles stencilled (as Mackintosh wrote) 'in rich golden yellow and outlined in silver grey and enriched at regular intervals by subsidiary V-shaped leaves stencilled in rich bright colours – emerald green, vermilion, cobalt blue and petunia purple. This with the black background showing gives an effect that is at once rich and gay and yet quiet and peaceful.'[17] Mackintosh designed various pieces of furniture for Bassett-Lowke, mainly for 78 Derngate but also for his parents' home where he lived before his marriage. For the latter Mackintosh designed a suite of bedroom furniture that was so admired by his friends that at least three other versions of it were commissioned by them. Contemporary photographs for one of these projects show that Mackintosh incorporated in the splashback of a washstand a piece of fabric designed by him, demonstrating the kind of furniture and room where he hoped his textiles would be used.

Although he had some obvious success with these new designs for fabrics it was not a career that placed him in the public eye or that might generate new commissions or bring general recognition for him as an artist. Such architectural commissions that he received, apart from those from or through Bassett-Lowke, either came to nothing or were so diluted in execution that they presented no recognisable Mackintosh style. Painting remained his alternative career and steadily, from 1916 to 1923, he built up a group of substantial works in watercolour and oil. Sadly, few of them sold despite being exhibited in London at the ISSPG or abroad in various exhibitions of contemporary British painting. They were not paintings at the cutting edge of contemporary British art but they form an intriguing group, modern in their approach if traditional in their handling. Alongside the watercolours of flowers are two or three landscapes and a small group of larger scale oil paintings – the latter often worked in collaboration with Margaret Macdonald – that were prepared for public exhibition with, for example, the Arts and Crafts Exhibition Society, or for architectural projects such as The Dug Out, a new tea room for Miss Cranston in Glasgow. Over the eight years that he lived in London, however, Mackintosh's total output as a painter was about sixteen watercolours and three large oils, two of the latter being collaborative pieces with Margaret. Admittedly, he would have been distracted by the commissions for Bassett-Lowke and the various projects that failed to come to fruition, as well as the textile designs for Foxton and Sefton, but it is still a surprisingly small number of paintings to have achieved in the time. He may have worked very slowly, but whatever the case, an output of this size could not support the life of a professional artist in London. Given that he was producing only two pictures a year with a total value, before commission to the vendor, of £80, it could be said that his commitment to an artistic career was somewhat lacking.

His first paintings in London set a pattern for future work: cut flowers arranged in a vase on a table and viewed frontally with little indication of the surrounding setting. These paintings rarely had any sense of depth as Mackintosh often arranged a length of one of his fabrics as a close backcloth to the main subject. *Anemones* (264) was probably his first such painting. As in *Walberswick* (259) and his first study at Port Vendres

(283), Mackintosh had some difficulty with perspective. The relationship between the vase and the table is ambiguous, and Mackintosh seems to have found the expanse of white wall in the background distracting. In later pictures he introduced a backdrop of fabric but here he tried to resolve his difficulty by introducing a mirror. A mirror, of course, would reveal the artist in front of his vase of flowers and so the reflection has been altered to avoid his image. In so doing, Mackintosh introduced a necessarily different view of the arrangement of anemones with a different perspective, not a true reflection of what we see in front of us. Behind this reflected bouquet hangs a piece of fabric that must be one of the first lengths made by Foxton or Sefton. Also, because the vase sits on the bottom of his sheet of paper the flowers are projected beyond the picture plane towards the viewer. This unintended *trompe-l'oeil* effect does not disturb our appreciation of the painting, however, because Mackintosh has painted each of the flowers with the same acuity, diminishing any sense of depth or projection in the arrangement of the flowers. On the whole he avoided such problems in future by setting the vase further back on its table, but both of his paintings of tulips have a similar composition. The charm of *Anemones* lies in Mackintosh's capturing of the delicate blooms with their almost transparent leaves and intense colour. One can see here, and in *Begonias* (266), the pure colour that Mackintosh was choosing for his decorations in the hall at 78 Derngate. *Begonias* again has a piece of fabric as a backdrop, with a design very similar to that in a surviving drawing (261). Another study from 1916, *Petunias* (267), shows further use of fabric as a background which is this time based on a design for silk that bears the inscription 'No 16', perhaps indicating that it came from one of the first batches of drawings made by Mackintosh in 1915–16 (262). This lovely watercolour was sent to the ISSPG in 1917 with a price of £40; it did not sell until Mackintosh exhibited it again at the Detroit Society of Arts and Crafts in 1920 (one of only two public sales of these large watercolours).

The format continued with minor variations – *White Tulips* shows the flowers splayed across a white wall (268); *White Roses* (269) and *Peonies* (270) have their flowers set against other contemporary Mackintosh fabrics. *Cyclamen* (271) again uses a fabric backdrop but here the markings on the leaves and the silhouettes of the white flowers create their own contrapuntal pattern against the fabric, based on another Mackintosh design (260). Occasionally Mackintosh used no physical background at all, as in the dark void behind

The Grey Iris (265) and the toned background of *Pinks* (272). Once, in *Yellow Tulips* (246), Mackintosh arranged his flowers against the book shelves and curtain screen in his studio; the arcs of tulip stems cut through the perspective of the room. Occasionally there is a crossover between a textile design and one of Mackintosh's paintings of bunches of flowers, as in a small group of pictures of stylised bouquets on dark backgrounds, for example *A Basket of Flowers* (273). There is no record of Mackintosh exhibiting these latter paintings so perhaps they were made for his textile printers as designs for cushion covers or fire screens. Some of the patterns seen in these little watercolours are encountered again in a group of much larger paintings, usually in oil, and usually created in collaboration with Margaret Macdonald.

263. Charles Rennie Mackintosh, Hall-parlour at 78 Derngate, Northampton, 1916

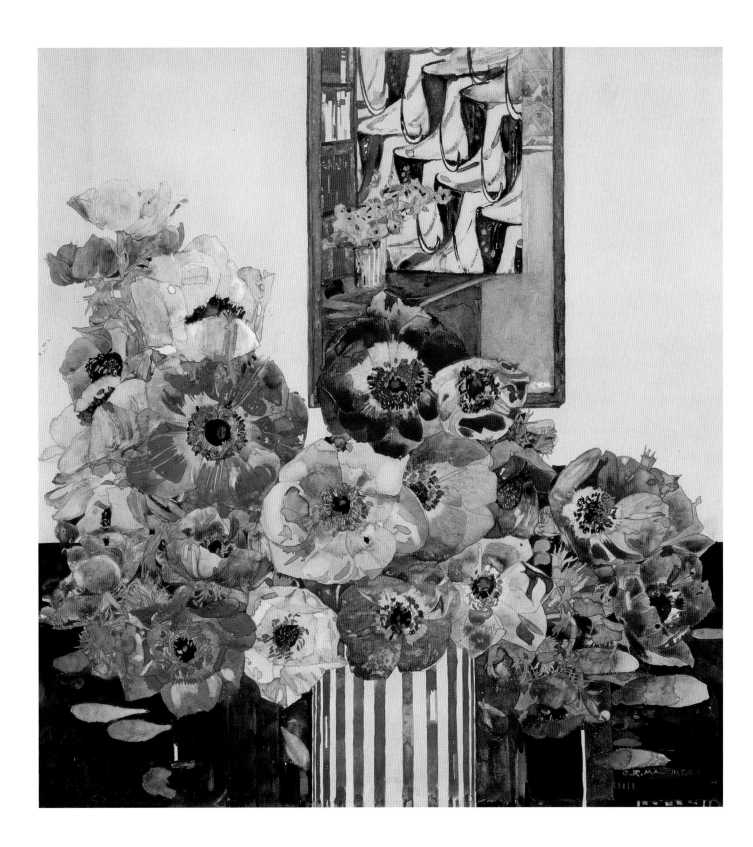

OPPOSITE
264. Charles Rennie Mackintosh, *Anemones*, 1916,
pencil and watercolour, 50.5 x 49.5 cm, private collection

BELOW
265. Charles Rennie Mackintosh, *The Grey Iris*, *c*1922–24,
watercolour, 43.1 x 37.4 cm, Glasgow Museums

OPPOSITE
266. Charles Rennie Mackintosh, *Begonias*, 1916,
pencil and watercolour, 42.5 x 37.3 cm, private collection

ABOVE
267. Charles Rennie Mackintosh, *Petunias*, 1916,
watercolour and gouache, 52.7 x 54 cm, Detroit Institute of Arts, U.S.A.

268. Charles Rennie Mackintosh, *White Tulips*, *c*1918–20,
pencil and watercolour, 40.5 x 35.2 cm, private collection

269. Charles Rennie Mackintosh, *White Roses*, 1920,
pencil and watercolour, 50.2 x 47.2 cm, Glasgow School of Art

270. Charles Rennie Mackintosh, *Peonies*, c1919–20,
pencil and watercolour, 42.8 x 42.6 cm, private collection

271. Charles Rennie Mackintosh, *Cyclamen*, c1920–22,
watercolour, 37 x 42 cm, private collection

OPPOSITE
272. Charles Rennie Mackintosh, *Pinks*, c1922–23,
watercolour, 50.1 x 50.1 cm, Glasgow Museums

ABOVE
273. Charles Rennie Mackintosh, *A Basket of Flowers*, c1918–20,
watercolour, 31.7 x 30 cm, The Hunterian, University of Glasgow

SOLACE 235

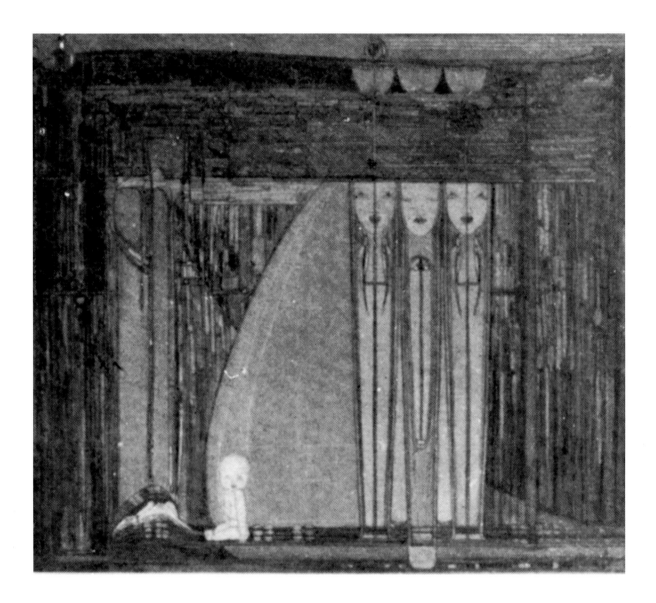

Margaret may not have painted at all at Walberswick. She suffered from what was then called cardiac asthma and is now recognised as left ventricular heart failure. It left her, although not a bedridden invalid, without energy and with a susceptibility to bronchial infections. Although the couple produced a few joint works in London after 1915, and Margaret painted a further small group of autograph watercolours around 1920, there is no doubt that her output declined. Almost none of these paintings sold, but she continued to make an important contribution to their income from legacies and trust funds originating from her family. This was doubly important because few of Mackintosh's paintings sold either. His income in 1915 and for much of 1916 (and particularly after the final payment from his Glasgow partnership) derived from the small number of jobs he did for Bassett-Lowke and from his textile designs. Without the sale of their house in Glasgow in 1920 their financial plight would have been even worse.

Margaret's return to painting began with a submission to the Arts and Crafts Exhibition Society for a show to be held at the Royal Academy in October 1916. This was an exhibition that was fraught with difficulties for the Society, which wished to place an emphasis on wall-hung pieces –

perhaps an acknowledgement of the exhibition's location at the Royal Academy. Exhibitors were given only two months' notice and the allocation of spaces was chaotic, complicated by wartime shortages of materials and manpower to install the show. Indicative of its problems is the existence of two versions of the catalogue: in the first, exhibit number 181 is attributed to both Margaret and Charles, consisting of a 'Wall Decoration of Panel and Candlesticks: "The Voices of the Wood"' (no price); a revised edition lists exhibit number 181 as 'Charles R Mackintosh, Wall Decoration and Candlesticks', (no price) and exhibit number 181A as 'Margaret Macdonald

275. Margaret Macdonald Mackintosh and Charles Rennie Mackintosh, *The Voices of the Wood* (right panel), 1916, oil and tempera on canvas with *papier collé* faces, 144 x 160 cm, Hessiches Landesmuseum, Darmstadt, Germany

OPPOSITE
274. Margaret Macdonald Mackintosh and Charles Rennie Mackintosh, *The Voices of the Wood* (left panel), 1916, ?oil and tempera on canvas with *papier collé* faces, probably 144 x 160 cm, untraced

Mackintosh and Charles R Mackintosh, Panel: "The Voices of the Wood" ' (priced at £105). Mackintosh's 'Wall Decoration' is not known and although *The Voices of the Wood* cannot be indisputably identified from its title or from the various reviews of the exhibition, it was almost certainly a pair of canvases (274, 275) painted in oil and tempera, based on the earlier painted gessos of 1902-03, *The Opera of the Winds* and *The Opera of the Sea* (192, 193). These earlier gessos were signed by Margaret but I have argued for the likely involvement of Mackintosh in their design (*see* Chapter 8, page 166); the joint attribution of the two paintings called *The Voices of the Wood* confirms, for me at least, that the earlier gessos were also jointly conceived and executed.

Further support for the identification of these two panels comes via Pamela Robertson's suggestion that the episodes described in the Arts and Crafts Exhibition catalogue can be identified in the two panels. [18] The left panel, now lost, contained *The Song of the Lovers*, *The Dirge of the Dead Mother* and *The Lament of the Little Child*; the right panel showed *The Song of Peace as She Covers the Child with her Cloak of Comfort*, *The Songs of Joy*, *The Cries of the Lost Souls* and *The Great Silences*. These titles were never associated with the original Waerndorfer gessos. Given the shortage of time available to produce new designs for this exhibition it is not surprising that the Mackintoshes reverted to an earlier idea that could be quickly enlarged (and we know that the couple owned contemporary photographs

as these survived in their estate), albeit executed in a different medium and in a totally different decorative fashion. I am sure that the titles, too, were invented to suit the existing iconography. The surviving right-hand panel has been wrongly attributed solely to Margaret Macdonald Mackintosh (with the occasional acknowledgement of Mackintosh's involvement) since its discovery in the early 1960s. It was then in the collection of the Macdonald family at Dunglass Castle, a repository for several larger items by Margaret and Frances, and probably sent there during their lifetimes. (In the Memorial Exhibition, 1933, the painting was credited as lent by Charles Macdonald, Margaret's brother and owner of the family home at Dunglass Castle.) The unequivocal description

277. Charles Rennie Mackintosh, *Figures and Foliage* [right panel], 1916, oil on canvas, 700 x 1370 cm, formerly Glasgow School of Art, destroyed

OPPOSITE
276. Charles Rennie Mackintosh, *Figures and Foliage* [left panel], c1916, oil on canvas, 700 x 1370 cm, formerly Glasgow School of Art, destroyed

in the 1916 exhibition catalogue of the two paintings (or diptych) as a joint work is supported by a number of motifs regularly found in Mackintosh's textile designs. The cascade of flowers, for instance, in the hair of the female figure on the right can be found not just in Mackintosh's preparatory study for this part of the painting[19] but also in several other designs for textiles. The repeated wavy lines in parts of the composition are to be found in other textile designs, as is the heightened colour of individual elements standing out against the black background, just like the decorations in the Derngate hall. Speed was obviously vital in the preparation of these two panels, hence the likelihood of joint execution and the reliance on earlier designs and more recent projects such as the textiles.

There are also two other diptychs – one probably by Mackintosh alone and the second another collaboration – which are more considered and more original ventures. Both of these have been associated with a commission that Mackintosh received from Kate Cranston in 1916 for a new tea room to be called The Dug Out in the basement of the building immediately to the west of the Willow Tea Rooms on Sauchiehall Street – customers entered it via a new staircase in the Front Saloon of the Willow. Permission to build was granted on 21 December 1916,[20] and work progressed throughout 1917, with a final inspection from the authorities on 5 September 1917. The tea room was painted overall in dark colours, relieved in places by brighter linear decorations and the occasional piece of yellow-painted furniture; its ceiling was painted black with a finish close to the appearance of traditional black-leading.[21] On the south wall and the east wall adjacent to it, according to surviving plans, Mackintosh left an unencumbered space that could have accommodated either of these two large painted panels (other walls in the north and west sides of the room had no such large expanses, being broken up by doors, seating and other decorative features).

The first of these paintings is, like *The Voices of the Wood,* in two parts, together 3.4 metres wide, now having the descriptive title *Figures and Foliage* (276, 277). The handling and design seem to be entirely autograph Mackintosh as there are many similarities with the designs for textiles that Mackintosh was making from 1915–16, and none of the motifs have identifiable sources in Margaret Macdonald's work. Obviously intended to be butted together as a pair, the design on these two panels is almost abstract in its concatenation of decorative patterns merging into the two large central figures. At each side of the design is a vertical panel of black-and-white checks, perhaps intended as an alternative to a frame or a link to a similar feature in the room where they were intended to be hung. These paintings were discovered, rolled up, in Glasgow School of Art in 1981 (they were destroyed in the fire at the School of Art in May 2014); they had no provenance and there is no known record of their previous ownership. Glasgow School of Art, before the fire, was in possession of several items of furniture from the Willow, most of which found their way into its collection via the Grosvenor Restaurant, whose owners bought in 1927–28 a lot of the Willow's furnishings, including furniture from The Dug Out after its closure (the Willow was then known as the Kensington). This may have been the route for the School's acquisition of these two painted panels; their colouring and sombre mood seem an ideal fit for The Dug Out.

Both Mary Newbery Sturrock and her mother believed that the Mackintoshes (or by their account just Margaret) produced large decorative panels for The Dug Out,[22] and Howarth believed that these panels were those known as *The Little Hills* (279, 280).[23] They are another two-panel project, painted in oil on canvas, that has long been attributed solely to Margaret Macdonald but which contains many references to Mackintosh's contemporary designs for textiles – too many for his contribution to the overall design (if not execution) to be ignored. In addition, a small preparatory study is certainly in Mackintosh's hand (278).[24] The title is taken from Psalm 65: 'Thou Crownest the year with Thy goodness [...] and the little hills shall rejoice', and the painting is the first occurrence of a religious subject for the Mackintoshes (apart from Christmas cards) since Margaret and Frances produced *The Christmas Story* in 1896. In its arrangement it has links to the composition of *The Voices of the Wood,* but this time it involves singing cherubs or *putti* garlanded with images of stylised daisies. These and the patterns in the platform that supports the upper rank of cherubs are taken directly from textile designs made by Mackintosh, as are many of the garlands which link the figures together. The execution, however, suggests only one hand (although the stylised handling cannot rule out the involvement of two artists), which, given the time the painting would have taken, must be Margaret's – a *tour de force* much more successful as a composition than the reworking of the Waerndorfer *Opera* panels for *The Voices of the Wood.*

Mary Sturrock recalled seeing *The Little Hills*, and Margaret working on it, in Margaret's studio in Walberswick in 1914 or 1915 and believed that it was intended for The Dug Out.

278. Charles Rennie Mackintosh, Design for *The Little Hills*, *c*1916–17, pen, pencil and watercolour on tracing paper, 27.8 x 20.1 cm, The Hunterian, University of Glasgow

This could be one occasion where Sturrock's memory was confused. Margaret does not seem to have had a separate studio at Walberswick and no work made by her at Walberswick is recorded, other than this suggestion that she painted *The Little Hills* there. Nor did Mackintosh produce in 1915 the kind of patterns for textiles that form such an important part of the design here. Nor, while he was living in Walberswick, is it likely that Mackintosh received from Kate Cranston a commission for The Dug Out – if he had he would surely have mentioned it in his letters to Davidson as a source of income that would help justify his ability to repay any loans that Davidson might make. However, Margaret did have, from late 1915 or early 1916, a separate studio in Glebe Place in Chelsea that Mary Sturrock visited when in London and where Margaret would have worked on the paintings. The subject matter and the bright colours used in *The Little Hills* seem disconcertingly at odds with a tea room whose name

was inspired by the fighting in the trenches in France and Belgium and I feel it much more likely that the two paintings once in the School of Art collection (known as *Figures and Foliage*) are much better candidates for such a location (if, indeed, any panels at all were actually installed).

Stylistically, *The Little Hills* can be dated after *The Voices of the Wood*. There is no record of it (nor of *Figures and Foliage*) before its appearance in the Memorial Exhibition in 1933 and no reference to any such commission other than Mary Sturrock's statement that two large panels were painted for The Dug Out. However, if *The Little Hills* was installed in the tea room, how did it come to be in the collection of Charles Macdonald at Dunglass Castle, lent by him to the Memorial Exhibition, and later recorded by Howarth as at Dunglass in the 1940s?[25] It seems unlikely the painting would have passed there from the new proprietors of the Willow, who would have acquired it in 1920, or that Charles Macdonald

279. Margaret Macdonald Mackintosh and Charles Rennie Mackintosh, *The Little Hills* (left panel), *c*1916–17, oil on canvas, 153.5 x 151 cm, The Hunterian, University of Glasgow

280. Margaret Macdonald Mackintosh and Charles Rennie Mackintosh, *The Little Hills* (right panel), *c*1916–17, oil on canvas, 153.5 x 151 cm, The Hunterian, University of Glasgow

281. Margaret Macdonald Mackintosh, *La Mort Parfumée*, 1921, pencil, watercolour, gouache and gold paint on paper, 63 x 71.2 cm, The Hunterian, University of Glasgow

OPPOSITE
282. Margaret Macdonald Mackintosh, *The Legend of the Blackthorns*, c1921-22, pencil, watercolour and gouache on paper, 40 x 30 cm, The Hunterian, University of Glasgow

(or Margaret) purchased the panels when the Willow closed in 1927, hence my belief that if either of these pairs of paintings was installed in The Dug Out, then the likelihood is that it was *Figures and Foliage*, which has a more traceable link to the tea room. It seems likely that when the Mackintoshes left London for France at the end of 1923, they sent *The Little Hills*, and the unsold right-hand panel of *The Voices of the Wood*, to Margaret's brother Charles at Dunglass Castle for safekeeping, which also explains why none of these panels was listed in the estate of either artist in 1928 or 1933.

Working on these large oil panels seems to have encouraged Margaret Macdonald to return to painting, albeit on a smaller scale in watercolour. In the Memorial Exhibition in 1933 two watercolours by her were shown that owed much to Mackintosh's textile designs (*Spring* and *Fantasy*). They are known only from tiny

black-and-white images in the installation photographs of the exhibition, but two other late paintings confirm Margaret's talent as a watercolourist. *La Mort Parfumée*, dated 1921 (281), seems to be a premonition of the death of her sister, Frances. A totemic or Egyptian figure, perhaps representing Death, watches as an eruption of roses cascades across the picture; there are links here to some of Margaret's own contemporary designs for textiles which reinforce the abstraction of the design. The source of the roses is a recumbent figure, towards whom five stylised women, their heads concealed, outstretch their arms. It was exhibited with the RSW in February 1921 and provoked much press comment, usually very complimentary, with frequent remarks as to its apparent Egyptian antecedents. It was followed in 1922 by *The Legend of the Blackthorns* (282) which perhaps commemorated the death of Margaret's sister, Frances, at the age of forty-nine in December 1921. The two figures – perhaps the two sisters – are surrounded by a blizzard of white blossom, the flowers of the blackthorn or sloe, a traditional symbol of death.[26] These paintings show Margaret returning to the freely imaginative style that dominated so much of the work of the early and mid-1890s. Much of her output in the intervening years, including the large panel for Waerndorfer's Music Room had been broadly illustrative, relying on other sources for its content. These two emotionally driven late paintings alone claim a place for Margaret in any assessment of British art of the first quarter of the twentieth century. Following these two poignant works, Margaret Macdonald Mackintosh produced only a tiny watercolour for Queen Mary's Doll's House in 1922 and submitted a work entitled *Sea-Music* to the 1923 winter exhibition at the Royal Academy (although this may possibly have been the right-hand, and unsold, panel of *The Voices of the Wood*, based on *The Opera of the Sea*; the left-hand panel seems to have been bought by a member of the Rowat family). For whatever reason she produced no work while in France with Mackintosh from 1923 to 1927 and nothing survives from after Mackintosh's death at the end of 1928 and before her own in January 1933.[27]

Life for Margaret in London had, naturally, both its high and low points. The unhappiness surrounding the MacNairs in Glasgow and problems over first the letting of the Mackintoshes' house in Hillhead and then its eventual sale, caused Margaret to return to the city several times. The death of Frances would also have caused another short return to Glasgow, presumably with Charles, and must have been the

nadir of her new life. But in between the Mackintoshes settled well into life in Chelsea. Evenings at the Blue Cockatoo were enjoyable – its meals cheap and the company invigorating. They met many artists, performers, composers and musicians, among them Augustus John, J.D. Fergusson and his partner, the dancer, Margaret Morris, E. McKnight Kauffer, Frank Dobson, Allan Walton, W.O. Hutchison (later Director of Glasgow School of Art), George and Sybil Sheringham, Wyndham Lewis and many more. Charles and Margaret became particularly close to Fergusson and Margaret Morris and to a painter from the Royal College of Art and his wife, Randolph and 'Birdie' Schwabe. 1920 brought some solace to the Mackintoshes. Mackintosh became involved with various artistic societies, designing new ventures for them, usually encouraged by Fergusson, but often the schemes came to nothing, almost always for want of the capital needed to fund them.[28] William Davidson bought their house in Glasgow, which would have eased their financial plight; the end of the wartime restrictions brought the possibility of some architectural work; and there was time (and money) for a holiday. With the Schwabes and their daughter Alice, the Mackintoshes made a month-long expedition to Dorset, visiting, among other places, Abbotsbury and Worth Matravers – at the latter Mackintosh made two important watercolours (and apparently a third, now lost, at Abbotsbury). There was a friend to visit, too. The Newberys had settled in Corfe Castle after Fra retired from the School of Art in 1917. He was a Dorset man, from Bridport – where he later painted a series of murals in the town hall – and was happy to return to his roots. The ruins of the castle, that preside over the village like a gigantic fairy ring, inspired Newbery to paint several views of them; Mackintosh, however, was more attracted to the nearby village of Worth Matravers.

As with Walberswick, it was not Mackintosh's first visit to the area. In 1895 he had toured Dorset on a sketching holiday and made his watercolour of Wareham (77). What interested Mackintosh in 1920, however, was the organic growth of Worth Matravers on the hillside beneath its protective church – a view which has all but disappeared today. Like Walberswick, the village was then a working community, home to the people who tended the pastures and animals on the surrounding hills. With its views out over fields to the sea and the comforting relationships of tiny lanes and houses, all in stone, and their gardens, Mackintosh probably saw here the ideal accumulation of all the little houses, village halls, inns,

ABOVE
283. Charles Rennie Mackintosh, photograph by E.O. Hoppé, c1919–20

BELOW
284. Margaret Macdonald Mackintosh, photograph from her passport, 1929

roofs and walls, creating privacy but destroying the cascade of stone shaped by generations of masons that once flowed down the hill. This is what Mackintosh saw and drew and then painted. From the field where he sat to paint his picture the view now is of modern houses, too large for their sites, too regular in the coursing of their stonework, while behind them sixty-year-old trees all but hide the gem at the heart of his composition. From his viewpoint, one has to struggle through the canopies of village trees for a glimpse of the church, the highest and tallest building in the village, sited at the top of the hill, and which in 1920 dominated the parish. The village, and his painting of it, must have sown a seed in his imagination that bore fruit in Roussillon when he and Margaret settled there at the end of 1923.

The Village, Worth Matravers (285) is an almost monochrome rendering of a perfect example of a community and its housing that have grown organically. Its charm would have been potent in 1920 – even today it attracts many tourists to its narrow lanes and wynds. Mackintosh drew it first in a sketchbook and then started work on his watercolour; whether it was all painted *en plein air* or partly indoors is not known, although he did stay for a month in Dorset with the Schwabes. What is apparent here, once again, is Mackintosh's flattening of the picture plane, and his rendering of detail in both near and distant buildings at almost the same level of scrutiny. Mackintosh records the houses and lanes making as clear a pattern as the shapes in his textile designs – but with less colour. The village, and much of 1920s Dorset, would have called up memories of the vernacular elements of his own architecture in distant Scotland. Turning his back on the village, Mackintosh looked out to sea, making another painting that concentrated on the landscape that had provided the natural shelter for the early inhabitants of the village. In this slightly more colourful painting, *The Downs, Worth Matravers* (286), Mackintosh sought out patterns in the landscape – the stepped fields, the stone walls that snaked across them – and then inserted the tall telegraph pole that crosses the composition from middle-ground to the horizon. Many, if not

alms houses and churches that he had drawn twenty-five years earlier. Margaret later wrote to Jessie Newbery saying that in France they had found nothing more satisfying.[29] What Mackintosh saw and drew is no longer visible. The village's working community is all but gone; instead there is gentrification and cottages are let to holidaymakers. The little houses may well be there but they are all but invisible from the fields surrounding the village because their tidy (and tiny) gardens, once planted with vegetables and carefully managed for self-sufficiency, have been filled with trees and now-huge shrubs. Foliage and canopies hide its plan, disrupt the careful and instinctive visual relationships between

285. Charles Rennie Mackintosh, *The Village,
Worth Matravers*, 1920, watercolour,
46 x 56.9 cm, Glasgow School of Art

most, artists would have omitted it from their painting – Mackintosh retained it, perhaps as a reminder of man's interaction with his environment, including not just charming stone cottages but also the paraphernalia of modern technology.

Two years later, at the 1923 winter exhibition at the Royal Academy, Mackintosh exhibited *A Design for a Landscape Panel* (as yet unidentified), hung in the same room as Margaret Macdonald's *Sea-Music*. The exhibition was entitled *An Exhibition of Decorative Art*, which has led to suggestions that Mackintosh's panel might have been a large composition similar in size to Margaret's *Sea-Music* (probably the right-hand panel of *The Voices of the Wood*),[30] but it was the frequent practice of both Margaret and Charles to refer to their watercolour paintings, when exhibited, as 'panels' – many of the watercolours Margaret sent to the RSW were described as such. I think it at least possible, therefore, that Mackintosh was showing one of his Worth Matravers paintings (or even an unidentified watercolour – *The Road from the*

Ferry — that he showed in Chicago in May 1922).[31] He would have been hoping that it would fare better than his paintings of cut flowers, which had mainly failed to sell. Sadly, he was probably proved wrong again, but the encouragement of Schwabe and Fergusson may have caused him to persevere with painting such subjects. Fergusson would certainly have recommended to Mackintosh the suitability of the south of France for an artist — for its light, its climate, its landscape as a never-ending source of painterly ideas and, perhaps even more importantly, for its low cost of living. Scotland, England, London, and even America where both of the Mackintoshes latterly sent work to exhibitions, had serially failed them; there was nothing to be lost, and perhaps much to be gained, in following in many artistic footsteps to Le Midi.

286. Charles Rennie Mackintosh, *The Downs, Worth Matravers*, 1920, watercolour, 45.2 x 53.7 cm, Glasgow School of Art

287. Charles Rennie Mackintosh, Fetges, c1926,
watercolour, 46.5 x 45.8 cm, Tate Gallery, London

11 FRANCE

BY THE END OF 1923 the Mackintoshes were living in the Pyrénées-Orientales, at Amélie-les-Bains, having recently arrived from London.[1] They could not, at this time, have realised that they would spend the next four years in the area. Howarth records Mackintosh telling J.D. Fergusson, around 1920, that if any more of his architectural schemes failed to be built he would give up architecture and concentrate on painting.[2] The month he spent in Dorset that year must have confirmed for him that his talent as a watercolourist could sustain this change in direction: even though sales were few, the quality of the work must have convinced him that such a career was worth pursuing. The Mackintoshes would have discussed the virtues and drawbacks of moving to France with many of their London friends. Fergusson, of course, had the most direct experience having worked in Provence for almost two years before the outbreak of war in 1914. Like many before him he had been drawn by the light and the landscape and discovered that it was also remarkably cheap to live there – Fergusson, who always lived hand to mouth, was forever attracted by a low cost of living. He would undoubtedly have played a large part in directing the Mackintoshes to France, although the area they chose, in the south-west, was not one that he or Margaret Morris knew at all. Acquaintances of both Mackintosh and the Fergussons, however, had spent some time in Collioure in 1923, a then little-known village on the Mediterranean coast near the Spanish border. Rudolph Ihlee and Edgar Hereford, fellow members with Charles and Margaret of the Margaret Morris Club, were following in the footsteps of other members Cedric Morris and Lett Haines, who had settled in May 1923 at Céret, about 20 miles from Collioure.[3]

Fergusson and Morris had returned to France at least twice before the Mackintoshes moved there. Since the end of the war Margaret Morris had arranged summer schools for her dance community in northern France but, after a visit to Juan-les-Pins in December 1922, she set her eyes on Cap d'Antibes for her 1923 summer school. Richard Emerson has argued that Charles and Margaret worked at the summer school in Antibes as lecturers in late August that year, but although his research has been extensive there is, as he has said, 'no smoking gun' that absolutely confirms their presence.[4] While acknowledging that his theory is tempting and plausible, for me some doubts remain. In none of their later correspondence do Fergusson and Morris or Charles and Margaret refer to the 1923 summer school, or to that of 1924 that Emerson also suggests included Mackintosh as a lecturer. To me that seems odd, given that such events must have been important to both couples.

In the 1940s Thomas Howarth interviewed both Fergusson and Morris when they were living in Glasgow and when their memories of these summer schools would have been relatively fresh, but they do not seem to have mentioned the Mackintoshes' attendance at any of them. In the 1950s and 1960s Margaret Morris and Fergusson were good friends in Glasgow of Andrew McLaren Young, who organised the Fergusson Memorial Exhibition after Fergusson's death in 1961 and also the exhibition marking the centenary in 1968 of Mackintosh's birth. I find it difficult to believe that they would not have mentioned in their many meetings Mackintosh's attendance at either of the summer schools. In 1973 I spent a considerable amount of time with Morris selecting and cataloguing the exhibition in 1974 that marked the centenary of Fergusson's birth. I was much interested in her recollections of Mackintosh and we talked at length about his and his wife's time in London, but at no point did she volunteer information

288. Charles Rennie Mackintosh, *Palm Grove Shadows*, c1921, watercolour, 50.2 x 40.3 cm, The Hunterian, University of Glasgow

about Mackintosh's attendance at the summer schools. By this date there was growing publicity about and interest in Mackintosh and his work, and Margaret Morris, a devourer and seeker of any publicity that would enhance Fergusson's reputation or that of her Margaret Morris Movement, would, I know, not have missed an opportunity to further link herself and Fergusson to Mackintosh's rising star. She was close to Mackintosh in the early 1920s and later helped nurse him in 1927 and 1928 after his debilitating operation for cancer of the tongue. Had Mackintosh attended her summer schools, I am sure she would have mentioned this.

Richard Emerson, however, presents an intriguing theory about an unusual watercolour by Mackintosh, *Palm Grove Shadows* (288). He has discovered that it appeared in Detroit at an exhibition of British Arts and Crafts which opened on 1 December 1923, meaning that it must have been painted before Mackintosh moved to Amélie-les-Bains at the end of 1923. He believes that the picture was painted in the south of France, according to him at the Margaret Morris summer school in Antibes, in the grounds of the Villa Gotte in nearby Juan-les-Pins. There are distinct similarities between contemporary photographs of the garden and the painting and I acknowledge the possibility that this painting was made in the south of France, especially if the sloping line across it is interpreted as a horizon formed by the meeting of the sea and sky. But it does not have to have been painted there in 1923 – it could be from an earlier, similarly unrecorded visit, unconnected with Morris. McLaren Young's suggestion that the picture was made at Kew Gardens about 1920 or 1921 remains viable but is certainly challenged by Emerson's theory, although the light in the painting is more that of a London glasshouse than the intense sunlight of the Riviera. Does the line across the picture mark the junction of ground and wall – it does not seem to be a horizon as the blue sky appears at the very top-right corner? If one chooses to identify the line as a distant horizon, why are the Mediterranean and the sky above not blue? Wherever it was painted, *Palm Grove Shadows* confirms, at least, the direction that Mackintosh's future painting was to take.

Following the paintings made at Worth Matravers, Mackintosh concentrated on landscape with a particular fascination for man's intervention in it through buildings. His emphasis was to be on the vernacular rather than the grand buildings of the state or of rich men; he seems to have been searching for a French version of the village of Worth Matravers but according to a letter from Margaret to Jessie

Newbery their early searches had revealed nothing 'quite so perfect'.[5] The imaginative subjects of the 1890s and the early 1900s, however, are now gone; Mackintosh concentrated on more factual images after completing the panel for Waerndorfer's Music Room (if he ever did). Townscapes are, of course, quite natural material for an architect, and Mackintosh was following in the footsteps of many colleagues and topographical artists in paying attention to picturesque villages. Unlike his friend Randolph Schwabe, however, he did not gravitate towards grander town and village architecture, churches and town halls and more monumental buildings, but looked for the kind of gradual development of more modest dwellings on a site that was typified by Worth Matravers.

For the first time in his working life Mackintosh now had no distractions from painting. There were to be no commissions for textile designs to divert him, no demands from clients and planning authorities over changes to his architectural designs, no searching for new work with the time-consuming socialising and travelling that that involved. Although France, and particularly this corner of it on the Mediterranean border with Spain, might be a cheap place to live, the couple must have had the financial stability and reserves to allow Mackintosh the time to assemble enough watercolours for an exhibition in London, presumably at the Leicester Galleries where he exhibited occasionally before his death. His target seems to have been fifty watercolours, not an onerous task at a rate of ten to fifteen pictures a year. But it must have meant that Mackintosh's perfectionism had to be controlled, that compromises had to be reached. In letters to Margaret he mentions having to abandon some paintings and start them again, and it may be that he destroyed several pieces. Even so, the occasional rogue picture was allowed to survive. We know little of how Mackintosh worked, or for how long he worked at a time, or even what he thought of his work, except for a few comments in his last letters from Port Vendres to Margaret who was in London in May and June 1927. In these, ever hard on himself, he occasionally mentioned a painting that he judged less than perfect as well as what he considered his best work. Although there are signs of development – or at least easily identifiable earlier pictures and later pictures

– it is difficult to establish a chronology on style alone; but by tracing where the Mackintoshes lived during their four years in Roussillon it is possible to suggest a tentative chronology for these very important paintings.[6]

The couple arrived in Amélie-les-Bains in November or December 1923 – certainly before Christmas when Margaret wrote to Jessie Newbery. It seems odd now that they should have headed for one of the colder parts of the region in winter, but perhaps its attraction was its reputation for various cures in the surrounding spas. Margaret wrote that the sun shone and that the air, with its winter chill, was exhilarating; they had already been down to the coast to see Collioure and expected to move there in March. They thought Collioure to be one of the most wonderful places they had seen – although not so 'perfect' as Worth Matravers. She had doubts that they would find accommodation in the village and I suspect that instead they settled in nearby Port Vendres, a half-hour walk from Collioure. The only painting that was definitely made at Amélie at this time was a flower painting, *Mimosa, Amélie-les-Bains*, reminiscent of those made

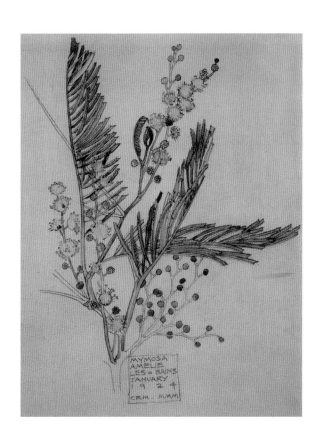

289. Charles Rennie Mackintosh, *Mimosa, Amélie-les-Bains*, 1924, pencil and watercolour, 25.7 x 21 cm, The Hunterian, University of Glasgow

ABOVE
290. Charles Rennie
Mackintosh, *Mont Alba*,
*c*1924–25, watercolour,
37 x 42 cm, Scottish
National Gallery of
Modern Art, Edinburgh

BELOW
291. Charles Rennie
Mackintosh, *Collioure,
Pyrénées-Orientales –
The Summer Palace of
the Queens of Aragon*,
*c*1924, watercolour,
38.1 x 43.2 cm, The Hill
House, National Trust
for Scotland

at Walberswick (289). There is rather more of the plant in this drawing than in those of 1914–15 and the design fills much of the page, although not so much as later flower drawings made up in the mountains at Mont Louis in the summer of 1925. The farmhouse at Mont Alba and the village of Palalda were both close to Amélie and Mackintosh probably reconnoitred the sites at the beginning of 1924 as possible subjects for paintings. *Mont Alba* (290) is probably the first and perhaps the only large watercolour made on this first visit to Amélie; its colours are those of winter and its handling is close to that of *Collioure, Pyrénées-Orientales* (291), painted, I believe, in the spring of 1924 when Mackintosh spent at least two months in the area. The palette of both pictures is very similar, as is the handling of rocks and fields. Mackintosh is beginning to come to terms with the unfamiliar landscapes in front of him, where the clarity of light laid bare the contours and details of distant fields, trees and roads, in turn flattening them. He was obviously pleased with his view of the Château Royal de Collioure (*Collioure, Pyrénées-Orientales – The Summer Palace of the Queens of Aragon*) as he sent the painting to the annual International Exhibition of Watercolours at the Art Institute of Chicago in 1926. Both of these paintings demonstrate Mackintosh's future approach to handling perspective and

distance in the French watercolours. There is a flattening of the various planes, in *Mont Alba* tilting the distant plane forward towards the viewer, and in the Collioure painting a way of handling the distant hills that turns them into a flat backcloth, rather like the textile designs that appeared behind the London still lifes. Perhaps this, too, was a sign of neurological problems affecting his vision (*see* pages 216–217) and thus the composition of many of the French paintings. Another early painting, *A Southern Town* (292), despite its complex arrangement of roofs and angular shadows – which was probably the point of attraction for Mackintosh – has a softness in its handling and draughtsmanship. Unusually, Mackintosh has included some of the life of this normally busy square in the group of drinkers sitting outside the café; such human presence rarely appears in later paintings.

Mackintosh was still feeling his way in these early paintings, in none more so than *A Southern Port* (293), which is probably the first study he made at Port Vendres in 1924. His viewpoint is from the quay outside the Hôtel du Commerce, which was to be the Mackintoshes' base in all later visits to Port Vendres (294, 295). The pale tonality and high key are evidence of an uncertain progress, but the right-hand side of the composition is distorted by a different perspective,

292. Charles Rennie Mackintosh,
A Southern Town, c1924, watercolour,
32.2 x 37.6 cm, The Hunterian, University
of Glasgow

changing the relative positions of the buildings on the opposite side of the harbour. Was this another symptom of the monocular vision that Mackintosh seems to have suffered? Whatever the case, he learned never to repeat this kind of composition again. Another painting that was possibly made in Port Vendres on this first visit is *The Road through the Rocks* (296), a distant view of Fort Mailly; here the handling of the sea and fields is conventional although the rocks have an almost Vorticist quality that appears again (but under more control) in Mackintosh's later paintings at Port Vendres, as in *The Rock* (341). This fort at the southern side of the entrance to the harbour was one of Mackintosh's favourite subjects at Port Vendres and he made several paintings of it in 1926 and 1927, but *The Road through the Rocks* has the look of an early exploratory study.

Contemporary letters suggest that the Mackintoshes intended to spend just a couple of months at Collioure or Port Vendres but they may well have stayed there for the whole summer before returning to London in September to re-let their studios in Chelsea – although Richard Emerson believes they probably broke the journey back to England with a visit to Margaret Morris's summer school in Provence. Margaret wrote, again from Amélie-les-Bains, to Jessie Newbery on 18 December

OPPOSITE, ABOVE
293. Charles Rennie Mackintosh, *A Southern Port*, c1924, watercolour, 36.2 x 44.5 cm, Glasgow Museums

OPPOSITE, BELOW LEFT
294. The quay and Hôtel du Commerce, Port Vendres, c1920

OPPOSITE, BELOW RIGHT
295. The harbour, Port Vendres, from the Hôtel du Commerce, c1915

BELOW
296. Charles Rennie Mackintosh, *The Road through the Rocks*, c1924–25, watercolour, 49.5 x 43 cm, private collection

ABOVE
297. Charles Rennie Mackintosh,
Palalda, Pyrénées-Orientales,
*c*1924–25, watercolour,
51.5 x 51.5 cm, private collection

BELOW
298. Palalda, Pyrénées
Orientales, 2015

299. Charles Rennie Mackintosh, *A Hill Town in Southern France*,
*c*1925–26,watercolour, 42 x 42 cm (sight), private collection

1924.[7] She describes Mackintosh as 'happy as a sand boy – tremendously interested in his painting + of course doing some remarkable work [...] He is absorbed in this landscape – since we got here on Nov. 22 he has been able to work outside everyday but 2 – from 9.30 till three – in brilliant sunshine.' This is almost certainly when he painted *Palalda, Pyrénées-Orientales* (297) and, possibly, the view of the farmhouse at Mont Alba. As at Worth Matravers, the village of Palalda cascaded down the hillside, and Mackintosh took a distant viewpoint from across the Tech, looking up towards the village. In fact, the painting is a combination of views from several separate points, and Mackintosh was obviously feeling confident enough, by now, to make these painterly decisions rather than produce a straightforward topographical view. He even went as far as carefully cutting out a piece of paper to stick over some of the houses to change or re-arrange aspects of the composition. The hillside behind the town is omitted completely – a view only possible from the riverside – and the red tile roofs of the houses (298) have been changed to grey and black, perhaps to suit the cold light of the winter's day when Mackintosh was working here. These are sophisticated decisions, actions of an artist, not those of an architect making notes in a sketchbook. In this painting Mackintosh crosses the divide between artist and tourist, immersing himself in his subject, taking control of it. In one unidentified subject, *A Hill Town in Southern France* (299), Mackintosh shows his further development as an artist. Stylistically this picture has much in common with *Mont Alba*, and the village is perhaps not far from Amélie; a snaking path in the foreground leads us towards the village and its graveyard populated with cypress trees whose blue shadows suggest an evening setting. The rock face behind the village is bathed in this evening light, turning it pink; at the same time this painting is both a record of a way of life in the Pyrenees and an evocation of the beauty of the hills.

A month later, on 23 January 1925, Margaret wrote again to the Newberys from the Hôtel du Midi at Ille-sur-Têt, a work-a-day town, rather different from the relative sophistication of Amélie-les-Bains. Mackintosh wrote to his friend Fergusson from Ille on 1 February 1925, describing the setting:

> We are now settled in our beloved Ille-Sur-Têt. There is nobody here but ourselves and we are as happy as sand boys. I wish you and Meg could come here for 3 or 4 months either to work or rest.
>
> This is a splendid little hotel [300] and we only pay 18 francs (four shillings) per day. The food is good and plentiful, the people are simple and kind and altogether it is an ideal place as I said for rest and work.
>
> The eating room is a delightful feature. At the end is a long table the full length of the room at which the workmen sit. There are usually 8, 10 or 12 splendid fellows sitting here having a gorgeous feast and discussing the affairs of the world. It always somehow reminds me of the Last Supper only there is no frugality here and the wine flows in a way that would have given life and gaiety to Leonardo's popular masterpiece.[8]

In her letter to Jessie Newbery, Margaret praised the weather, almost rainless, with little wind and blue skies – perfect for Mackintosh working outside. She wrote:

> You think, as we do – about Dorset – It is quite the best in every way – this comes very near it + the buildings here are perpetual joy to us. Toshie is going to paint some of the 'maas' as they call them – farmhouses really – so you will see what they are like some day – I hope.[9]

Robin Crichton has identified many of the *mas* painted in the five months that the Mackintoshes stayed in Ille-sur-Têt.[10] The glory of the town for Mackintosh, however, must have been the unusual stratified cliff known as Héré-de-Mallet. His painting of it (301) is one of the most unusual works from his French period – there are no houses, little vegetation, no lanes, hedges or stone walls, no sign at all of human intervention. The fascination for him is with the stripes of different stones and soil across this cliff face, now

ABOVE
301. Charles Rennie Mackintosh,
Héré-de-Mallet, Ille-sur-Têt, 1925,
watercolour, 46 x 46 cm, private collection

LEFT
302. Héré-de-Mallet, Ille-sur-Têt, 2015

OPPOSITE
300. Hôtel du Midi, Ille-sur-Têt, 2015

304. Bouleternère, 2015

OPPOSITE
303. Charles Rennie Mackintosh, *Bouleternère*, *c*1925, watercolour, 44.7 x 44.7 cm, private collection

virtually hidden down a track where wild vegetation has almost taken over (302). The rock formation at its summit must have recalled for him the castle at Holy Island. At least three other paintings are known from this date, the first half of 1925: *Bouleternère* (303), *A Southern Farm* (305) and *Blanc Antoine* (306). I doubt that Mackintosh would today find the village of Bouleternère (304) – now bisected by a new road – an attractive prospect. In 1925 he again played games in his painting of it, amalgamating two separate views, with his architect's hat on, to produce a perfect arrangement of these huddled buildings, but he did at least keep its red roofs, contrasting them with the whitewashed walls of the houses. A fourth watercolour, *Summer in the South* (307), was probably painted during this stay at Ille in 1925, presumably in May or June – certainly there were very few *mas* such as this around Port Vendres or Mont Louis, where he spent the summers of 1926 and 1927. It is one of the most colourful of these French watercolours, with an intensity of hue that Mackintosh does not seem to have repeated. The flattening of the house and the separate colour bands of the track and the grass below it are highly schematic, but the painting is very effective in its simple record of the heat and light of Roussillon.

With these paintings Mackintosh was developing and confirming his approach to painting in the open air. He is known to have worked on Whatman hot-pressed paper mounted on cardboard; according to Mary Sturrock[11] he chose white paper which, because it was 'really tough,' could be scrubbed with a toothbrush to correct mistakes and was perfectly suited to take 'the big washes that Mackintosh was so good at doing.' There is no evidence that he used an easel along with his three-legged stool, although he often preferred to find a seat on a wall or suitably situated rock. In later letters to Margaret, written in 1927, he talks about the difficulty he was having in holding his board steady on his knees – never mind the distraction of the local wildlife or curious children.[12] Some of the watercolours have traces of pencil and he almost certainly made a pencil drawing of the subject first, which was then either carefully erased or over-painted. He later recorded how some subjects took forever to get right, while some paintings seem to have been completed relatively quickly, in perhaps just three or four days. He brought a lifetime of office routine with him, working regular hours when the conditions were right, starting early in the morning and returning to the hotel for lunch and then perhaps moving in the afternoon to a different location and picture to keep the light consistent on different ongoing paintings. With his growing confidence he avoided the early inconsistencies of *A Southern Port* (293) and began to take even

305. Charles Rennie Mackintosh,
A Southern Farm, *c*1925, watercolour,
43.4 x 43.4 cm, private collection

OPPOSITE, ABOVE
306. Charles Rennie Mackintosh, *Blanc Antoine*, *c*1925,
watercolour, 39.2 x 51 cm, The Hunterian, University of
Glasgow

OPPOSITE, BELOW
307. Charles Rennie Mackintosh, *Summer in the South*,
*c*1925, watercolour, 28.3 x 38.5 cm, private collection

308. Charles Rennie Mackintosh,
Mixed Flowers, Mont Louis, 1925,
pencil and watercolour, 26.2 x 20.5 cm,
British Museum, London

greater liberties with the scene in front of him, particularly in areas that he came to know well such as the streets and harbour approaches of Port Vendres.

In his letter to Fergusson, Mackintosh said that they would be returning to Mont Louis for two months at the end of June 1925, then perhaps returning to Ille-sur-Têt or possibly visiting Professor Geddes at Montpellier for a month or so – Mackintosh had become friendly with Geddes shortly after he left Walberswick in 1915. There is no firm record of such a visit. Perhaps the Mackintoshes returned to Ille-sur-Têt at the end of summer before settling at Port Vendres in December 1925. At Mont Louis, Mackintosh was fascinated

by the wildflowers in the fields and painted several small studies, the size of the flower drawings made at Walberswick ten years earlier. As with the earlier flower study at Amélie, Mackintosh filled the sheet with his drawing and usually chose a small bunch of flowers rather than the single species that appeared in the Walberswick watercolours. These are more like finished paintings than earlier flower drawings, with complicated compositions of carefully selected blooms. Yet Mackintosh has chosen to flatten these arrangements on the paper, detailing overlaps where they occur but not giving an overall sense of depth (308). In one of them, *Dianthus, Mont Louis* (309), he has even incorporated a block of black,

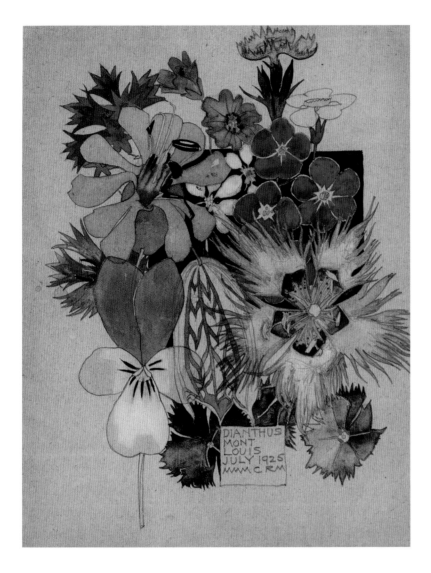

309. Charles Rennie Mackintosh,
Dianthus, Mont Louis, 1925,
pencil and watercolour, 25.3 x 19.9 cm,
National Gallery of Canada

which emphasises this flatness and against which the blue of the flower becomes more intense. It is almost as though Mackintosh was making a demonstration of his methods, disclosing to the viewer his sources for the earlier textile designs featuring organic shapes.

There were other attractions at Mont Louis, however, in the form of the neighbouring villages of Fetges and La Llagonne. In his two or three months at Mont Louis in 1925 and a longer stay of around four months in 1926–27, Mackintosh produced at least ten larger watercolours (in addition to the flower studies) that show how rapidly his work was changing as his confidence grew. *Slate Roofs* (310) must be one of the first of these studies of Fetges with its slightly scrubbed look and lack of detail in the depiction of the houses and the fields behind them. Fetges was not an attractive village in the way that Palalda and Bouleternère had been – it had no church punctuating the skyline and was more a cluster of houses than a village – but Mackintosh was obviously fascinated by the way it clung to the steep hillside riven by deep gullies that had forced its inhabitants to build terraces and retaining walls (311); he had, after all, built the Glasgow School of Art atop its own precipice. Away from Fetges, on the other side of Mont Louis, lay the small village of La Llagonne where in 1925 Mackintosh made at least one (now-lost) study of its houses,

CHARLES RENNIE MACKINTOSH AND THE ART OF THE FOUR

ABOVE
311. Fetges, Pyrénées-Orientales, 2015

LEFT
312. Charles Rennie Mackintosh,
The Poor Man's Village, c1925,
watercolour, untraced

OVERLEAF, LEFT
313. Charles Rennie Mackintosh,
Village in the Mountains, c1924–25,
watercolour, 37.5 x 28 cm,
private collection

OVERLEAF, RIGHT
314. Charles Rennie Mackintosh,
Mountain Landscape, c1924–25,
watercolour, 37.5 x 28 cm,
The Hunterian, University of Glasgow

OPPOSITE
310. Charles Rennie Mackintosh, *Slate
Roofs*, c1925, watercolour, 37 x 27.8 cm,
Glasgow School of Art

LEFT
315. Harbour, Port Vendres, c1925

RIGHT
316. The Dining Room, Hôtel du Commerce, Port Vendres, c1925

OPPOSITE, CLOCKWISE FROM TOP LEFT
317. Charles Rennie Mackintosh,
Steamer Moored at the Quayside, with Two Gendarmes Standing at the Quay, c1927, watercolour and crayon, 27 x 20.8 cm, The Hunterian, University of Glasgow
318. Charles Rennie Mackintosh,
Steamers at the Quayside, c1927, watercolour and crayon, 25.2 x 21 cm, The Hunterian, University of Glasgow
319. Charles Rennie Mackintosh, *Men Unloading a Steamer at the Quayside*, c1927, watercolour and crayon, 25.3 x 21.1 cm, The Hunterian, University of Glasgow
320. Charles Rennie Mackintosh,
Steamer at the Quayside, c1927, watercolour and crayon, 25.2 x 21 cm, The Hunterian, University of Glasgow

The Poor Man's Village (312). Known only from a black-and-white photograph taken at the 1933 Memorial Exhibition at the McLellan Galleries, this painting, too, seems to have a softness of detail and a lack of specific focus. Then, turning his back on the village, he looked across the valley, with its intriguing outcrops of rock, and sketched the fields and the dark scrub and trees on the hills behind them (302, 303), again using the broader washes that appear in *Slate Roofs*.

After the tranquillity of the mountains, Charles and Margaret returned to the coast in December 1925, to Port Vendres where they remained for some months, probably until the end of June. This busy port was very different from the small fortified village of Mont Louis, which was in reality a military fort. Port Vendres was the closest French port to North Africa and its quaysides were filled daily with cargo ships and passenger steamers. The hectic pace of life in the harbour must have appealed to the Mackintoshes because they again took rooms in the Hôtel du Commerce, situated on the quayside, with rooms overlooking the constant arrivals and departures of the big ships (315). From its balconies Mackintosh had views over the town and used the vantage point to make several watercolours of the harbour, the distant houses above the big retaining wall and the *Douanes* (customs post) opposite the hotel. In addition, he made an untypical group of sketches of the life of the quay, showing steamers tied up and being unloaded, or simply berthed, while a couple of *douaniers* pass the time of day. Two of these small sketches reveal an architect's fascination with the structure of the ships (317–320), but none of them seems to have been the precursor of a larger painting. From his base it was only a kilometre or two to the entrance of the harbour where, on either side, Mackintosh found much to attract him. A lighthouse and ruined fort to the north and another fort, rocks and bays to the south of the harbour entrance kept him busy from December 1925 to the summer of 1926 and again in 1927, from March to the beginning of July. The route from the hotel to the forts – with its quiet streets and lanes, and vistas over shops and houses – provided an almost unending array of subjects to paint. On days when the weather, most frequently the wind, prevented him from painting, the hotel was his and Margaret's haven. They had separate rooms with balconies that gave a view over the new harbour without exposing them to its constant bustle. The dining

room (316), where they were occasionally the only diners, was the social hub of the hotel and the couple often dined with *le patron*, Monsieur Dejean, and his wife and chatted to the staff, especially the house boy, Kim, who practised his English on them and pestered them for their foreign stamps. There were outings to Collioure to see Edgar Hereford and Rudolph Ihlee, who had set up there, and walks in the foothills outside the town where they found an enchanting valley full of wild flowers – but even these did not distract Mackintosh from painting the town and its forts.

Few of Mackintosh's paintings made in Port Vendres in 1926 and 1927 are dated, but those that are give some clue to his development. *Port Vendres, La Ville* (321) is one of his most daring compositions, reflecting the varying topography of the town. The huge retaining walls around the old harbour clearly attracted Mackintosh, and feature both in this painting and in *La Rue du Soleil, Port Vendres* (336). For *Port Vendres, La Ville* he chose a viewpoint on the north side of the harbour in the upper streets of the town on the route to Le Fort Mauresque, leading us into the composition with a flight of sharply angled steps. The result is an unusually composed but descriptive account of the port; the more experimental features of some of the other paintings of 1926 are only hinted at in the tentative reflections of the houses in the water. In *The Lighthouse* (324) the water plays a more prominent part and, although this was a picture that Mackintosh was not fond of,[13] he was interested enough in the subject to make significant adjustments to what he saw in front of him. The wall in the foreground is, in fact, situated on the south side of the harbour approach and Mackintosh is looking at a lighthouse that is actually several hundred metres away (325). The sea is schematised in the painting to resemble a placid pond between the two promontories; the change from painting the sea as a flat plane of colour to a more modulated and tangible surface can be seen in most of the later Port Vendres paintings. These patterns were repeated in a later painting of the fort in *Collioure* (326), which otherwise offers a literal account of the massive Vauban fort that presides over the tiny fishing village.

Mackintosh's main focus for much of his time in Port Vendres in 1926 and 1927 were the forts that protected the entrance to the harbour. On the north side, in 1927, he painted *Le Fort Mauresque* (322). The fort, now almost completely demolished, was reconnoitred by Mackintosh for another painting on 15 May, a Sunday, which he always kept clear of painting duties.[14] No other picture by Mackintosh of this fort

TOP
322. Charles Rennie Mackintosh, *Le Fort Mauresque*, c1926, watercolour, untraced

ABOVE
323. Fort Mailly, Port Vendres, c1925

OPPOSITE
321. Charles Rennie Mackintosh, *Port Vendres, La Ville*, c1926–27, watercolour, 46 x 46 cm, Glasgow Museums

ABOVE
324. Charles Rennie Mackintosh, *The Lighthouse*, c1926, pencil and watercolour, 27 x 37.5 cm, private collection

RIGHT
325. Le Phare, Fort du Fanal, Port Vendres, Pyrénées-Orientales, 2015,

OPPOSITE
326. Charles Rennie Mackintosh, *Collioure*, c1926–27, watercolour, 37.9 x 46.5 cm, The Art Institute of Chicago, U.S.A.

exists (and he may never have painted others); it may simply not have held the attraction for a painter that was presented by Fort Mailly (323) across the harbour where Mackintosh began the first of several studies in 1926. *Port Vendres* (327) and *The Fort* (329) explore two aspects of the fort that has the harbour approach on one side, and on the other a ravine that provides a route to the southern lighthouse quay. The fort is now in ruins (328), blown up during the German evacuation at the end of the war, but in Mackintosh's time the structure might easily have reminded him of many Scottish castles and his own south elevation of the School of Art. *The Fort*, probably the later picture, shows Mackintosh again playing games with the landscape, pulling the lighthouse on the north bank into the left side of his painting. It is otherwise one of

the most accurate and carefully drawn of these paintings, balancing the mass of the buildings against the equally powerful landscape.

Following their by now regular practice of spending the high summer and early winter in the mountains, the Mackintoshes returned to Mont Louis, probably in July 1926. No flower drawings survive from this visit, but on his return to La Llagonne and Fetges Mackintosh developed the ideas started on his previous visit to Mont Louis. Worth Matravers must have been in his mind at La Llagonne as he made one straightforward view of the village with the church on the summit of the hill alongside the ruined tower and then turned through 180° to sit at the church to paint the village below and the valley beyond, with its sculptural

ABOVE
327. Charles Rennie Mackintosh,
Port Vendres, *c*1926–27, watercolour,
28.8 x 39.6 cm, private collection

RIGHT
328. Ruins of Fort Mailly,
Port Vendres, 2015

OPPOSITE
329. Charles Rennie Mackintosh,
The Fort, *c*1926–27, watercolour,
45 x 45.2 cm, The Hunterian,
University of Glasgow

ABOVE
330. Charles Rennie Mackintosh,
The Church of La Llagonne, c1926,
watercolour, 28 x 38.3 cm,
The Hunterian, University of Glasgow

RIGHT
331. La Llagonne, from the church, 2015

OPPOSITE
332. Charles Rennie Mackintosh,
The Village of La Llagonne, c1926,
watercolour, 45.7 x 45.7 cm,
Glasgow Museums

outcrops of rock. *The Church of La Llagonne* (330) is one of his most eloquent drawings, capturing the simplicity of life in this 'poor man's village', as he called it in his earlier picture (312). Its composition is almost perfect, from the green fields and crop strips in the foreground through the simple houses, white and grey with stone-slabbed roofs, to the blocky church on the hill – unsentimental but an accurate account of life in the mountains. *The Village of La Llagonne* (332) gives a different account of the village, showing the more organic arrangement of the houses built on the hillside below the church, a less ordered view than that from the fields. Little has changed today (331). As in *Mountain Village* (333), a painting of Fetges, Mackintosh ventured into La Llagonne, skirting round its edge to place the houses in the context of the fields that similarly surrounded it. At Fetges Mackintosh's advances were even more substantial, and he produced a

modern watercolour that he considered amongst his best – *Fetges* (287).[15] He wrote to Margaret, who had been offered £30 for it in London, '… to me it seems a perfectly absurd price (£30) for a picture like Fetges – I shall probably never do its like again.' The whole sheet of paper is covered in an intricate pattern which charts the relationships between nature and buildings on the mountainside. From the striated details of the foreground fields to the tiniest window of the most distant house, Mackintosh records in this assemblage of roofs, windows, buttresses, lanes and gardens a complete way of life. Below the village, a huge outcrop of rock in a ravine cried out for the artist's full attention and he made it the subject of his next picture at Fetges. *The Boulders* (334) is as much a painting of nature in the raw as it is about man's impact on it. These huge rocks were the reason for the village's haphazard arrangement around the gorge and

333. Charles Rennie Mackintosh,
Mountain Village, c1927,
watercolour, untraced

OPPOSITE
334. Charles Rennie Mackintosh,
The Boulders, c1925–26,
watercolour, 33.4 x 38 cm, The
Hunterian, University of Glasgow

they take centre stage. Again, Mackintosh has combined, or at least compressed, different views of the village, as the rocks are actually below it in the ravine, but he has lifted and moved them to the left and in front of the houses. The road up the mountain to Mont Louis clings to the buttressed wall between the rocks and the house in the right foreground – but far from looking up at these boulders, travellers along the road would be hardly aware of them in the ravine below

the retaining wall. This painting is further evidence that as he grew in artistic confidence Mackintosh began to make more imaginative images, not simply records of what was in front of him. In the spring of 1927 he returned to Port Vendres where his ideas would blossom.

On this visit, which was to be his final stay in the port, Mackintosh divided his time between the harbour and the promontory that contained Fort Mailly. It was also a time

335. Charles Rennie Mackintosh, *Port Vendres*, c1926–27, watercolour, 27.6 x 37.8 cm, British Museum, London

OPPOSITE
336. Charles Rennie Mackintosh, *La Rue du Soleil, Port Vendres*, 1927, watercolour, 40.5 x 39 cm, The Hunterian, University of Glasgow

that allows us some insight into Mackintosh's life in the town, both as artist and as observer. Margaret had returned to London for medical treatment in mid-May and Mackintosh wrote to her, almost daily, recounting his thoughts, his day, his worries and delights, and above all his love for her.[16] From these letters we learn which of his pictures he valued more, or less, the struggles he had to paint them – coping with children, flies, the wind – and his pleasure when a successful painting had been completed. In the later letters he talks about his experiments (though unfortunately he does not go into detail about them) and we learn that he finished *The Rock* (341), after a month's work, on 13 June when he also finished a painting called *Elephants*, which is now lost but was probably a still life of ceramic elephants that Margaret owned.[17] The more detailed manner of *Fetges* is apparent in two studies of the harbour – *Port Vendres* (335) and *La Rue du Soleil, Port Vendres* (336). These paintings are as much about the reflections in the water and Mackintosh's pleasure and ingenuity in recording them as they are about the town; the first was probably painted from his hotel bedroom which looked directly onto the customs house and the second is the view from a bay on the road to Fort Mailly. In each

337. The harbour, Port Vendres, from
rue du Soleil, 2015

OPPOSITE
338. Charles Rennie Mackintosh,
The Little Bay, Port Vendres, 1927,
watercolour, 39.3 x 39.4 cm, The Hunterian,
University of Glasgow

of these the focus is on the reflections in the water creating patterns that would not have been out of place in the textile designs he had made ten years earlier. Although the harbour was obviously protected from the Mediterranean's breakers at its entrance at Fort Mailly, near the quays it was wide enough to be affected by the winds that regularly beset the town (337); Mackintosh may have cursed the wind when it stopped him painting but he was happy to take advantage of its impact on the water — wave-like, deep ripples across a pool were created by the force of the wind, its changing direction combining with the effects of the tide to form continually varying patterns across the extent of the inner harbour. Other obsessions, with architectural detail and precision, are evident in the backgrounds of each painting. The buttressed retaining walls that so fascinated Mackintosh at Fetges are echoed here in the massive wall that underpins the houses on the hill and provided for a new quay in front of the wall, extending the harbour. A similar fascination with patterns in the water appears in *The Little Bay, Port Vendres* (338), which in the distance shows Mackintosh's vantage point for painting *La Rue du Soleil, Port Vendres*. The repeated diagonals of masts and gullies, staircase and railings, disturb an otherwise tranquil composition. Again the zigzags in the foreground hark back to patterns in his textiles.

According to his letters to Margaret, Mackintosh planned to devote June and July to working around the picturesque forts near the entrance to the harbour. Le Fort

339. Fort Mailly, 2015

OPPOSITE
340. Charles Rennie Mackintosh, *Le Fort Maillert*, 1927,
watercolour, 35.8 x 28.5 cm, Glasgow School of Art

Mauresque and Fort Mailly (or 'Fort Maillert' as Mackintosh called it) were part of a series of defensive forts dotted around the south-west Mediterranean coast of France. Mackintosh had earlier placed Fort Mailly in its landscape context, sitting on top of the rocky outcrop looking over the harbour and sea with, on its other side, a narrow track running through a deep ravine (327, 329). It was from this track that Mackintosh chose to paint *Le Fort Maillert* (340). Mackintosh regularly made adjustments to his compositions in these later watercolours and here he combined two viewpoints to create a more romantic and dramatic effect, giving emphasis to rocks that do not actually exist (339) and a pristine white wall of the fort sitting above them, when, in fact, the fort was somewhat rundown even in Mackintosh's time — and now it is a complete ruin. The real subject here is the patterns that Mackintosh makes with the different strata of the rocks, contrasting horizontal and vertical fissures with broad planes of smooth stone. Again, this seems to be as much a painting of remembered Scotland as of sunny Roussillon. To get to the fort Mackintosh would have had to pass a little bay in which stood a group of rocks, covered and uncovered by the changing tide. Not surprisingly, in his painting *The Rock* (341), Mackintosh rearranged these to make a more dramatic composition, introducing a non-existent shore and schematising the strata of the rocks. He worked on it for several weeks, recording the changes (which brought both triumphs and disappointments) in his letters to Margaret. The picture seems to have been started before Margaret left Port Vendres as in his first letter to her on 12 May he wrote, 'I had a good morning's work and the picture of the ROCK goes well.'[18] On 16 May he wrote, 'I have to commence my big Rock perhaps it will come out alright — but I seem to work very slowly.' It is not clear from some of the letters whether there were actually two paintings of the rock — certainly on 13 June he declared one finished, adding, 'I do think I must do the Rock again on a larger sheet.' In these letters he writes of the painting being much admired by Hereford and Ihlee, both usually slow to praise; while Margaret was in London Mackintosh saw them regularly, both in his hotel and their lodgings in Collioure. His plans for the rest of the summer, however, and for his return to Mont Louis were soon to be dramatically cut short.

His last letters to Margaret disclose Mackintosh's awareness of physical changes that were encroaching on his life and his work. He had noticed 'a button growing on the right hand side of the point of my nose that gives me a rather

comic appearance – nobody seems to mind so I don't mind.'[19] Other letters mention his tiredness, his loss of appetite and change in the taste of his tobacco, for which he blamed the French growers but which could well have been a symptom of oral cancer. Margaret, who had gone to London because of problems with her heart (and to try and sell some of Mackintosh's paintings) had a relapse just as she was about to return to France. Mackintosh rushed up to Dover to meet her so that he could accompany her on the long journey by train back to Port Vendres. They may have returned there, but Mackintosh's plans to revisit Mont Louis do not seem to have been fulfilled. Soon after Margaret's return Mackintosh himself fell ill and was advised by a doctor to return to London for treatment of what was later diagnosed as cancer of the tongue. Ihlee drove the Mackintoshes to the Channel coast; he told his wife that Mackintosh 'could not even speak. My husband said that M Mackintosh was very overcome and that it was a very difficult journey.'[20] Jessie Newbery met them in London having arranged for an appointment at a London clinic from where he was immediately referred to the Westminster Hospital. Cancer was confirmed and Mackintosh had an operation which deprived him of his speech. It was carried out, free of charge, by a surgeon who had married a girl from Paisley.[21] Margaret Morris rallied round, as did many of his London friends, and she tried to restore his speech though exercises. Mackintosh, not surprisingly, was unable to work, although he apparently was most happy to sit in the garden of the house in Willow Road, Hampstead, to which they moved after he left hospital. The disease travelled its course, however, and Mackintosh died on 10 December 1928.

341. Charles Rennie Mackintosh, *The Rock*, 1927, watercolour, 30.5 x 36.8 cm, private collection

EPILOGUE

AFTER Mackintosh's return to London and the diagnosis of his oral cancer he made no more paintings, or at least none that are recorded or survive. This was effectively the end of the creative life of The Four as Margaret, during the five years that she survived Mackintosh, seems not to have produced any work. In fact, apart from a tiny drawing for Queen Mary's Doll House[1], made around 1922, no paintings by Margaret, painted in either London or France, survive that are later than *The Legend of the Blackthorns* (*c*1921–22). Whether this was due to ill health or a withdrawal from artistic life following the death of her sister in 1921 is not known. Herbert MacNair had produced nothing since the death of his wife (in fact no painting later than 1912 is known) and seems to have been resolutely set against an artistic life, reputedly burning his own and Frances's surviving work around 1922.

Had Mackintosh's French watercolours been exhibited in London as he had hoped and planned, his achievements would not have gone unnoticed. This was a substantial body of work free from all of the *fin-de-siècle* connotations which might still have lingered in the memories of those who knew his work from before the war. Such an exhibition would have located Mackintosh firmly among his artist contemporaries, part of a decade where individuality was celebrated and where 'schools' as such were thin on the ground. He would almost certainly have been welcomed into an English tradition, rather than a Scottish one, as these watercolours reflect very different considerations from those of many contemporary painters back in Scotland, who were often inspired by French painters or the Glasgow Boys. Like his compatriots James McBey, Muirhead Bone, William Strang and D.Y. Cameron, Mackintosh would have fitted easily into a new English approach to landscape painting that were able to accommodate such diverse and individual talents as Graham Sutherland, Paul and John Nash, C.R.W. Nevinson, Stanley Spencer, Charles Ginner, Dora Carrington and, later, Cecil Collins, Eric Ravilious and Edward Bawden. Mackintosh's late works, in their quiet accomplishment and assured hand relate to a pattern that the Macdonald sisters had established in their later paintings – mature work that is sensitive and contemplative, building on many years of experience to crystallise earlier experiments into a new profundity, separate from but dependent on the work of youth.

In some ways The Four were at their most potent and inventive in their student years. The sisters, in particular, seem to have been driven to extend the boundaries of current taste, particularly in their designs for metalwork, which had few, if any, parallels among their contemporaries. It was this work which led to their selection for the Vienna Secession by Waerndorfer and Hoffmann in 1899–1900. What they actually submitted to that exhibition was to lead them off in new directions; for the Mackintoshes this meant continuing involvement in the decoration of interiors, while the MacNairs pursued the almost impenetrable imagery of Herbert's poetry and storytelling. For Herbert, whose hand was effectively unable to keep up with his effusive imagination, it led into a dead end; and Frances's later paintings, made before 1909, became diluted, her version of Jessie King's whimsy without the bite and invention of the work of the 1890s. Margaret was soon immersed in the complexities of new compositions for work in gesso, often commissions. As for Mackintosh, for all the charm and beauty of his drawings of flowers, they were more of an escape from the trials of professional life than an advancement of his creative vision. Each of The Four, with the exception of Herbert, overcame the guilt and regret induced by personal failure, eventually arriving at their own powerful responses to their respective circumstances. Sadly, Frances's powerful series of paintings produced after 1910, reflecting on the human condition, particularly the roles of women, was cut short by the strains of daily life and eventually by her early death. Margaret, deeply affected by the deaths of her mother and sister, found a new language that seems to have been silenced only by her own ill health. Mackintosh, adrift without the driving force of his life as an architect, took some time to find his own artistic salvation, only for its acknowledgment by the art world to be abruptly forestalled by his own early death.

In Glasgow, the style initiated by The Four was commercialised by other artists in the ten to fifteen years leading up to the outbreak of war in 1914. By the mid-1920s even that

had virtually disappeared, overtaken by changes in fashions for interior design. The Memorial Exhibition, arranged in the wake of the death of Margaret in 1933, effectively closed what was already an almost forgotten chapter in the history of Scottish art. The First World War had similar effects in all the cities and countries that had been so active in the new art movements of the 1890s and early 1900s. The style was dead, as were so many of its greatest proponents, supplanted by a new modernism – Art Deco and the International Style.

In the 1920s and 1930s many Scottish artists again looked towards France for inspiration, as J.D. Fergusson and S.J. Peploe had done in 1907. What these painters produced was in many ways a diluted version of Fauvism, the artists often revelling in the colour and freedom of brushwork encouraged by that style. It had little of the inventive originality of the work of The Four in Glasgow in the 1890s or of their later achievements after 1910. The Four had followed their own imaginations in their iconography, techniques and styles. What they produced became associated with a *fin-de-siècle* fashion that fell totally out of favour after the war. But perhaps more than any other group of British artists working from 1890–1914, they were entirely true to themselves, creating an inimitable personal visual and poetic language that, on the whole, was not dependant on contemporary developments in either Britain or Europe. Unlike the Glasgow Boys, who continued to work long after 1900, through the 1920s and 1930s, The Four enjoyed neither substantial access to the public arena of academies and institutes where they could show their work nor the commercial success of the Boys.

Unlike the Glasgow Boys who preceded them, and the Scottish Colourists who followed them, The Four had made a unique contribution to the arts in Scotland and further afield in Europe, particularly Austria and Germany. The Boys had been part of the Naturalist movement that swept Europe and America in the 1880s and 1890s, but they were followers rather than leaders, except in the context of British art. The Four, while similarly being part of an international movement that falls under the umbrella of Art Nouveau or Arts and Crafts, were at the forefront of this new style, driving it along, first of all within their own compass in Glasgow and Britain and then, from the later 1890s, in a European context. The works of art and ideas that they took to Vienna in 1900, Turin in 1902 and other exhibitions in Europe during the first decade of the twentieth century, were the products of their own imaginations, of their own experiences, not simple developments of existing contemporary ideas. The Four were a product of the 1890s; one might almost say that outside the 1890s they could not have existed or worked in the way that they did. I am sure, however, that their talents would have helped create a zeitgeist whatever the decade or century.

Their deaths – or withdrawal from artistic practice – brought about the virtual disappearance of their work from the public eye, a situation exacerbated by the huge social, cultural and economic changes that followed the First World War. Mackintosh's buildings remained as a public reminder, in Glasgow at least, of his architectural achievements, but even they were threatened with dismemberment or demolition. Had this happened, it would have brought about a total eradication of the public face of The Four. From the 1940s onwards, however, a small but growing group of academics, historians and aficionados of their work attempted to restore a public awareness of their achievements. Their efforts were echoed by similar activity across Europe as the 1890s and 1900s were recognised for plurality across the arts and not just for the major movements in painting provoked by Impressionism. As the discipline of art history developed, particularly in Britain where it had had a slow start, the doctrine of revisionism ensured that artists like The Four would eventually receive due reassessment. Their place in the history of the fine and decorative arts in Britain and Europe is now assured. It is now time to celebrate them and their beautiful and intriguing works of art on their own terms.

SELECT BIBLIOGRAPHY

'Arts and Crafts Exhibition, 1896 (3), The', *The Studio*, vol. 9, pp. 189–205.

Bennett, Mary, *The Art Sheds 1894–1905*, exhibition catalogue, Walker Art Gallery, Liverpool, 1981

Billcliffe, Roger, 'J.H. MacNair in Glasgow and Liverpool', *Walker Art Gallery Liverpool Annual Report and Bulletin*, vol. 1, 1970–71, pp. 48–74

Billcliffe, Roger, *Architectural Sketches & Flower Drawings by Charles Rennie Mackintosh*, Academy Editions, London, 1977

Billcliffe, Roger, *Mackintosh Watercolours*, John Murray, London, 1978, third edition, 1992

Billcliffe, Roger, *Mackintosh Textile Designs*, John Murray and The Fine Art Society, London, 1982

Billcliffe, Roger, *Charles Rennie Mackintosh: The Complete Furniture, Furniture Drawings & Interior Designs*, Cameron & Hollis, Moffat, fourth edition, 2008

Billcliffe, Roger, *Mackintosh Textile Designs*, Pomegranate, San Francisco, 1993

Bird, Elizabeth, 'Ghouls and Gas Pipes: Public Reaction to the Early Work of The Four', *Scottish Art Review*, vol. 14, 1975, pp. 13–16, 28

Bisson, Roderick Frederick, *The Sandon Studios Society and the Arts*, Parry Books, Liverpool, 1965

Burkhauser, Jude (ed.), *Glasgow Girls: Women in Art and Design 1880–1920*, Canongate Press, Edinburgh, 1990

Crichton, Robin, *Monsieur Mackintosh: The travels and paintings of Charles Rennie Mackintosh in the Pyrénées-Orientales 1923–1927*, Luath Press, Edinburgh, 2006

Crouch, Christopher, *Design Culture in Liverpool 1880–1914*, Liverpool University Press, 2002

Grogan, Elaine, *Beginnings: Charles Rennie Mackintosh's Early Sketches*, National Library of Ireland and Architectural Press, Dublin and Oxford, 2002

Helland, Janice, 'Frances Macdonald: The Self as Fin-de-Siècle Woman', *Woman's Art Journal*, vol. 14, 1993, pp. 15–22

Helland, Janice, 'The Critics and the Arts and Crafts: The Instance of Margaret Macdonald and Charles Rennie Mackintosh', *Art History*, vol. 17, 1994, pp. 209–227

Helland, Janice, *The Studios of Frances and Margaret Macdonald*, Manchester University Press, 1996

Holme, Charles (ed.), 'Modern British Domestic Architecture and Decoration', *The Studio Special Summer Number*, 1901

Holme, Charles (ed.), 'Modern Design in Jewellery and Fans', *The Studio Special Summer Number*, 1902

Howarth, Thomas, *Charles Rennie Mackintosh and the Modern Movement*, second edition, Routledge & Kegan Paul, London, 1977

'International Exhibition of Modern Decorative Art at Turin: The Scottish Section, The', *The Studio*, vol. 26, 1902, pp. 91–104

Kaplan, Wendy (ed.), *Charles Rennie Mackintosh*, Glasgow Museums and Abbeville, Glasgow and New York, 1996

Macaulay, James, *Charles Rennie Mackintosh*, W.W. Norton, New York and London, 2010

Moffat, Alistair, with Baxter, Colin, *Remembering Charles Rennie Mackintosh: An Illustrated Biography*, Colin Baxter Photography Ltd, Lanark, 1989

Morris, Talwin, 'Concerning the Work of Margaret Macdonald, Frances Macdonald, Charles Mackintosh and Herbert MacNair: An Appreciation', unpublished manuscript, collection Glasgow Museums E.46-5x, 1897

Neat, Timothy, *Part Seen, Part Imagined: Meaning and Symbolism in the Work of Charles Rennie Mackintosh and Margaret Macdonald*, Canongate Press, Edinburgh, 1994

Poole, Sue, 'An Examination of the Life and Work of the Designer James Herbert MacNair "A Man More Sinned Against than Sinning" ', Master of Design dissertation, University of Liverpool, 1990

Rawson, George, 'Francis Newbery and the Glasgow School of Art', PhD thesis, University of Glasgow, 1996

Reekie, Pamela, *Margaret Macdonald Mackintosh*, exhibition catalogue, Hunterian Art Gallery, University of Glasgow, 1983

Robertson, Pamela (ed.), *Charles Rennie Mackintosh: The Architectural Papers*, White Cockade, Wendlebury, 1990

Robertson, Pamela (ed.), *The Chronycle: The Letters of Charles Rennie Mackintosh to Margaret Macdonald Mackintosh 1927*, Glasgow, 2001

Robertson, Pamela (ed.), *Doves and Dreams: The Art of Frances Macdonald and James Herbert McNair*, Lund Humphries, Aldershot, 2006

Robertson, Pamela, and Long, Philip, *Charles Rennie Mackintosh in France: Landscape Watercolours*, National Galleries of Scotland, Edinburgh, 2005

White, Gleeson, 'Some Glasgow Designers and their Work. Part 1,' vol. 11, 1897, pp. 86–100; 'Some Glasgow Designers and their Work. Part 2', vol. 11, 1897, pp. 225–236

Wickre, Bille, 'Collaboration in the Work of Margaret Macdonald, Frances Macdonald, Charles Rennie Mackintosh and J. Herbert McNair', PhD thesis, University of Michigan, 1993

ABBREVIATIONS

Billcliffe, *Furniture*
Billcliffe, Roger, *Charles Rennie Mackintosh: The Complete Furniture, Furniture Drawings & Interior Designs*, Cameron & Hollis, Moffat, fourth edition 2008

Billcliffe, *Textiles*
Billcliffe, Roger, *Charles Rennie Mackintosh Textile Designs*, Pomegranate, San Francisco, 1993

Billcliffe, *Watercolours*
Billcliffe, Roger, *Mackintosh Watercolours*, John Murray, London, 1978; third edition, 1992

Burkhauser
Burkhauser, Jude (ed.), *Glasgow Girls: Women in Art and Design 1880–1920*, Canongate Press, Edinburgh, 1990

Chronycle
Robertson, Pamela (ed.), *The Chronycle: The Letters of Charles Rennie Mackintosh to Margaret Macdonald Mackintosh 1927*, Glasgow, 2001

CRM 1996
Kaplan, Wendy (ed.), *Charles Rennie Mackintosh*, Glasgow Museums and Abbeville, Glasgow and New York, 1996

GAC
Glasgow Art Club

Helland, *Studios*
Helland, Janice, *The Studios of Frances and Margaret Macdonald*, Manchester University Press, 1996

Howarth
Howarth, Thomas, *Charles Rennie Mackintosh and the Modern Movement*, second edition, Routledge & Kegan Paul, London, 1977

Hunterian
The Hunterian, University of Glasgow

ISSPG
International Society of Sculptors, Painters and Gravers

Moffat
Moffat, Alistair, with Colin Baxter, *Remembering Charles Rennie Mackintosh: An Illustrated Biography*, Colin Baxter Photography Ltd, Lanark, 1989

NOTES

Neat
Neat, Timothy, *Part Seen, Part Imagined: Meaning and Symbolism in the Work of Charles Rennie Mackintosh and Margaret Macdonald*, Canongate Press, Edinburgh, 1994

RGI
(Royal) Glasgow Institute of the Fine Arts

Robertson, *Doves*
Robertson, Pamela (ed.), *Doves and Dreams: The Art of Frances Macdonald and James Herbert McNair*, Lund Humphries, Aldershot, 2006

Reekie, *MMM*
Reekie, Pamela, *Margaret Macdonald Mackintosh*, exhibition catalogue, Hunterian Art Gallery, University of Glasgow, 1983

Robertson, *Papers*
Robertson, Pamela (ed.), *Charles Rennie Mackintosh: The Architectural Papers*, White Cockade, Wendlebury, 1990

RSW
(Royal) Scottish Society of Painters in Watercolour

PREFACE

1. *Mackintosh Watercolours*, Glasgow Art Gallery, July 1978; subsequently shown in 1978-79 at The Fine Art Society (Edinburgh and London), Brighton Art Gallery and Museum, and Dundee Art Gallery.
2. *Margaret Macdonald Mackintosh*, November 1983, Hunterian Art Gallery, University of Glasgow.
3. *Doves and Dreams*, August 2006–April 2007, Hunterian Art Gallery, University of Glasgow, and Walker Art Gallery, National Museums Liverpool.

CHAPTER ONE

1. Howarth, p. 25
2. *Ibid.*
3. *Charles Rennie Mackintosh, Margaret Macdonald Mackintosh, Memorial Exhibition*, Glasgow, 1933; catalogue introduction by Jessie Newbery, p. 1.
4. Howarth, p. 4; for records of prize winners, *see* Glasgow School of Art Archives.
5. Howarth lists Mackintosh's prizes, pp. 297–298; James Macaulay elaborates on these and also lists prizes awarded to The Four and others of their circle in his book *Charles Rennie Mackintosh* (2010), pp. 111–112
6. Collection: Hunterian
7. As recounted to Howarth in correspondence during the 1940s, Howarth pp. 18–19.
8. Robertson, *Papers*, p. 92
9. *Ibid.*, p. 95
10. Collection: British Museum, London
11. Robertson, *Papers*, p. 103
12. *Ibid.*, p. 118
13. Glasgow Institute of the Fine Arts, 1892: 778, *Palazzo Ca' d'Oro, Venice*; 796, *Venetian Palace*.
14. R. Eddington Smith, secretary of the Glasgow School of Art Club, recalled the event in a letter to *The Glasgow Evening News*, 17 February 1933, p. 6.
15. Timothy Neat, *Part Seen, Part Imagined: Meaning and Symbolism in the work of Charles Rennie Mackintosh and Margaret Macdonald*, 1994
16. At his meetings with Jessie Keppie in the 1940s Howarth was unable to persuade her to discuss her relationship with Mackintosh.
17. John Keppie, *Ely Cathedral*, 1891; collection: Hunterian.

CHAPTER TWO

1. Early biographical details of the Macdonald sisters can be found in Robertson, *MMM*; Robertson, *Doves*; Burkhauser; Helland, *Studios*.
2. Howarth, p. 25
3. *Ibid.*, note 1
4. At the Glasgow Institute in 1893 Frances showed *Corn Flowers* (310, £5); Margaret showed *Geraniums* (313, £4) and *Flags* (409, £4).
5. Glasgow Art Club considered designs for chimneypieces on 14 December 1892, *see* Glasgow Art Club Archive: Glasgow Art Club Council Minutes, Book 5, 14 December 1892.
6. 'Cartoon Supplement', *The Bailie*, Glasgow, 7 June 1893, p. 1
7. In 1893, at the Arts and Crafts Exhibition Society's show in London, Kellock Brown exhibited several pieces of metalwork that he had made to the design of Jessie Newbery.
8. These attributions were probably inspired by the provenance of the painting. It had been presented to the University of Glasgow as part of the Dunderdale gift of 1959–60. Dorothea Dunderdale was the adopted daughter of Charles Macdonald, brother of Frances and Margaret Macdonald, and she lived at the family home, Dunglass Castle until 1960. Much of the Dunderdale collection related specifically to the sisters but it also included a number of items painted or designed by Mackintosh or MacNair.
9. Howarth, pp. 180, 183
10. George Rawson, 'Francis Henry Newbery and the Glasgow School of Art', unpublished Ph.D. thesis, University of Glasgow, 1996, p. 161
11. *The Studio*, vol. i, September 1893, p. 231
12. *Ibid.*, p. 247

CHAPTER THREE

1. This cover is known only through a black and white photograph in the first edition of Howarth's monograph, where it is recorded as having been in the collection of Mrs Ritchie (Lucy Raeburn) before being given to Glasgow School of Art; the School has no record of its accession. The surviving issue of *The Magazine* for spring 1894 has a cover designed by Agnes Raeburn, who also provided a frontispiece. The latter features a naked woman with diaphanous wings, more like those of a fairy than of a traditionally rendered angel. The figure is innocuous and has none of the power and mystery of similar naked figures by The Four. The cover of this issue follows a similar arrangement to the lost Mackintosh design, two women against a tracery of stylised organic forms. But Raeburn's women are clothed and more innocently decorative than those drawn by Mackintosh. Perhaps Mackintosh's design was rejected as too risqué for the mainly female readership of *The Magazine*.
2. Rawson, p. 161, records that Newbery included *The Crucifixion and Ascension, Despair* (untraced),

Summer and *The Path of Life* (untraced) in the submission of student work to the National Competition in London in 1894.

3. Helland, *Studios*, p. 71 (note 51) records Frances Macdonald's choice of Malcolm Bell's *Burne-Jones, a Record and a Review* as a book prize in 1893.

4. It was exhibited at the ISSPG in London in 1899 (210).

5. Helland, *Studios*, pp. 36, 43, 157–158 (note 46).

6. Neat (p. 83) identifies it as *Dicentra eximia* – bleeding heart, a symbol of the Clan Mackintosh.

7. Ray McKenzie, 'Introduction: The Glasgow Boys' in *Glasgow Girls*, 1990, p. 190

8. *North British Daily Mail*, 9 November 1894, p. 5

9. *Quiz*, 15 November 1894, p. 13

10. *Glasgow Evening News*, 13 November 1894, p. 4

11. *Evening Times*, 5 February 1895

12. *Glasgow Evening News*, 17 November 1894

13. *Ibid.*

14. *Ibid.*, 2 February 1895; a reference to Mackintosh's father who was by now a senior officer in the Glasgow police force.

15. *Quiz*, 21 February 1895, p. 157

16. *Glasgow Evening News*, 22 May 1895

17. Posters by The Four were included in exhibitions at the Salon de l'Art Nouveau (Galerie Samuel Bing), Paris, December 1895–January 1896; and at the Royal Aquarium, London, in March 1896.

CHAPTER FOUR

1. Nelson Dawson, 'Concerning Repoussé Metal Work', *The Studio*, vol. ii, 1894 pp. 195–199

2. Collection: Hunterian, University of Glasgow

3. *The Studio*, vol. xi, 1897, p. 231

4. Neat (pp. 96–97) says the head represents Christ, indicated by the symbol of a fish protruding from the eye, which I interpret as the end of a tail feather.

5. Peacocks were often used by Aesthetic Movement and Arts and Crafts designers and could regularly be seen in contemporary exhibitions and journals.

6. A linen cupboard can be seen in photographs of Mackintosh's own bedroom in his parents' house (Billcliffe, *Furniture*, p. 36, 1897.B).

7. Talwin Morris then lived in Dunglass Castle, overlooking the Clyde at Bowling, and the settle was installed there. When he moved to Torwood, a small house on the hill above Dunglass, he seems to have left it behind, and it was acquired by the Macdonald family when they bought Dunglass in 1899.

8. Collection: Glasgow Museums

9. Billcliffe, *Furniture*, p. 36, D1896.4; collection: Hunterian, University of Glasgow. Morris also states that the decoration on the linen press (Billcliffe, *Furniture*, p. 36, 1896.8; collection: Glasgow School of Art) was also executed by Mackintosh.

10. Billcliffe, *Furniture*, 1896.8

11. A photograph at the Hunterian (Glaha 52929) shows that Mackintosh used this design as wall stencil in an unknown location, possibly the Buchanan Street Tea Rooms.

12. Crawford, pp. 50–51, *et passim*

13. Neat p. 103

14. Neat pp. 98–105

15. 11 May 1898 (collection: Werkbundarchiv, Museum der Dinge, Berlin). Herman Muthesius was attached to the German Embassy in London, charged with preparing a report on the success – both artistic and commercial – of British domestic architecture, which culminated in the publication of his seminal work, *Das Englische Haus*, in 1904–05. He became a close friend and international supporter of Charles and Margaret Mackintosh who were godparents to his elder son.

16. *Glasgow Herald*, 11 April 1894, p. 4

17. 28 April 1933; collection: Hunterian.

CHAPTER FIVE

1. *The Studio*, vol. xi, 1897, p. 90

2. *Ibid.*, p. 97

3. Mackintosh had also drawn honesty seed pods at West Kilbride in July or August 1895; *see* Elaine Grogan, *Beginnings: Charles Rennie Mackintosh's Early Sketches*, 1897, pl. 60.

4. *Dekorative Kunst*, vol. 3, 1898, p. 72

5. Talwin Morris, 'Concerning the Work of Margaret Macdonald, Frances Macdonald, Charles Mackintosh and Herbert MacNair: An Appreciation', unpublished manuscript; collection: Glasgow Museums, E.46-5x, 1897.

6. *Ibid.*

7. *The Studio*, vol. xi, 1897, p. 91

8. Helland, *Studios, passim*; Burkhauser, pp. 45–55, *et passim*.

9. Neat, pp. 94–96

10. *Exposition d'affiches françaises et étrangères*, Reims, 1896, no. 1384 McNair, Margaret and Frances Macdonald, Glasgow Institute poster; no. 1385 C.R. Mackintosh Glasgow Institute poster. I am grateful to Martin Hopkinson for this information.

11. For differing interpretations of the reception of the posters in London in 1896, *see* Howarth, p. 38, and Janice Helland, 'The Critics and the Arts and Crafts: The Instance of Margaret Macdonald and Charles Rennie Mackintosh', *Art History*, vol. 17, no. 2.

12. *The Studio*, vol. ix, 1896, pp. 202–204

13. Helland, *Studios*, pp. 80–81, *et passim*; Burkhauser, pp. 130–131, *et passim*.

14. Talwin Morris, 'Concerning the Work of Margaret Macdonald, Frances Macdonald, Charles Mackintosh and Herbert MacNair: An Appreciation', unpublished manuscript; collection: Glasgow Museums, E.46-5x, 1897

15. *Ibid.*

16. *The Studio*, vol. ix, 1896, p. 204

17. The Hunterian collection contains several sepia images – Glaha 52859-65. An illustration of the metal cover to the volume, *The Christmas Story*, appeared in *Dekorative Kunst*, vol. 2, 1898–99, p. 73 acknowledging the permission of 'Mr John Lane'.

18. *See* note 11 above.

19. Collection: Hunterian

CHAPTER SIX

1. Mackintosh had drawn honesty seedpods at West Kilbride in July or August 1895; *see* Elaine Grogan, *Beginnings: Charles Rennie Mackintosh's Early Sketches*, 1897, plate 60.

2. *The Studio*, vol. ix, 1896, pp. 202–204

3. Talwin Morris, 'Concerning the Work of Margaret Macdonald, Frances Macdonald, Charles Mackintosh and Herbert MacNair: An Appreciation', unpublished manuscript; collection: Glasgow Museums, E.46-5x, 1897.

4. Fernando Agnoletti (1875–1933) was a young Italian writer who became the lecturer in Italian language and literature at the University of Glasgow in 1902, staying in the city until 1910. He assisted Newbery with the organisation of the Scottish exhibits for the international exhibition Turin in 1902 and became friendly with the Mackintoshes. Mackintosh became godfather to his son, Bracio Robert Oberman Tosh Agnoletti, for whom he designed a set of cutlery. Agnoletti wrote important articles about the Willow Tea Rooms and The Hill House for German periodicals in 1904 and 1905.

5. Gleeson White, 'Some Glasgow Designers and their Work. Part 1', *The Studio*, vol. xi, 1897, pp. 86–100; 'Some Glasgow Designers and their Work. Part 2', vol. xi, pp. 225–236.

6. Mermaids were a frequent motif for MacNair, appearing, among other places, on the family tombstone he designed for Largs Cemetery in Ayrshire and in two leaded-glass panels in a cabinet that he seems to have made for personal use (*see* James Macaulay in *CRM*, 2010, pl. 191, p. 220, where the panels are wrongly attributed to Mackintosh).

7. Talwin Morris, in his unpublished manuscript (*see* note 3 above) asks his readers to excuse the non-appearance of MacNair's paintings in his article owing to the difficulties of adequately reproducing them. As a book designer for the Blackie publishing house he would have been intimately aware of the limitations of late nineteenth-century printing processes.

8. Robertson, *Doves*, p. 36

9. *Glasgow Herald*, 28 June 1898, p. 5

CHAPTER SEVEN

1. Charles Holme, ed., *Special Summer Number of The Studio: Modern British Domestic Architecture and Decoration*, 1901, pp. 110–115

2. Michael Holroyd, *Augustus John: A Biography*, volume 2: *The Years of Experience*, Heinemann, 1975, p. 350

3. Berta Zuckerkandl, 'Feuilleton. Die erste Kunstgewerbe-Ausstellung der Secession. I. Möbel', *Wiener Allgemeine Zeitung*, 4 November 1900, p. 3

4. In a letter from Mackintosh to Hermann Muthesius dated 12th July 1900, he wrote, 'Just now we are working at 2 large panels for the frieze 15 feet long x 5' 3 high. Miss Margaret Macdonald is doing one and I am doing the other.' Collection: Muthesius Nachlass, Werkbund Archiv, Berlin.

5. Billcliffe, *Furniture*, pp. 46–47

6. Walter Crane, 'Notes on Gesso Work', *The Studio*, vol. i, pp. 45–49

7. It is revealing here to see Macdonald developing a composition devised four or five years previously in the metal panel and watercolour showing the Annunciation (*see* plates 87 and 90); in some of the graphics included in *Ver Sacrum* in 1901 she continued in her variations of the design.

8. Although *Dekorative Kunst*, vol., 1902, p. 219, attributes this design to Margaret Macdonald, the full-size cartoon (collection: Hunterian, Glaha 41148) is in Mackintosh's hand.

9. *Ver Sacrum*, Vienna, vol. 23, 1901, pp. 393–406 and endpapers

10. The poster was found in one of several dusty portfolios that were transferred in 1968 from Liverpool Museum to the Walker Art Gallery in exchange for a fine collection of Arts and Crafts studio pottery. As a junior member of the curatorial staff at the Walker I was assigned to catalogue the contents of these portfolios, some of which had come into the museum's possession when the University of Liverpool closed its applied arts department, transferring it to Liverpool College of Art. It was not an exciting task until I came across MacNair's almost pristine drawing for the Academy poster. It sparked an interest in the Glasgow Style that continues to this day.

11. The competition was announced, with a closing date of 25 March 1901, in the December 1900 issue of *Zeitschrift für Innendekoration*.

12. Conversation with the author, 1977. Mary Newbery Sturrock (1892–1985) was presumably repeating conversations that her mother Jessie Newbery had had with her close friend Margaret Macdonald, when she told me that Margaret would often visit leading gynaecologists on her visits to Vienna, London, Turin, etc. to investigate the causes of the couple's inability to have children. Mary was shocked by my question as to whether Mackintosh had similar investigations: 'There was nothing wrong with Mackintosh', she replied indignantly.

CHAPTER EIGHT

1. For information about Fernando Agnoletti, *see* Chapter 6, note 4.

2. *The Studio*, vol. xxvi, July 1902, pp. 91–103

3. *Dekorative Kunst*, vol. v, 1902, p. 218

4. The most complete account and analysis of the Waerndorfer Music Room is to be found in the articles by Pamela Robertson and Peter Vergo in Hanna Egger, Pamela Robertson, Peter Vergo, Manfred Trummer, *Ein Moderner Nachmittag* [A Thoroughly Modern Afternoon], Vienna, 2000.

5. Letter from Mackintosh to Hermann Muthesius, 6 August 1902; collection: Werkbundarchiv (Hermann Muthesius Estate), Museum der Dinge, Berlin.

6. Letter from Mackintosh to Hermann Muthesius, around September 1902; collection: Werkbundarchiv (Hermann Muthesius Estate), Museum der Dinge, Berlin.

7. E.B. Kalas, *De la Tamise à la Sprée*, Reims, 1905

8. Pamela Robertson, 'Margaret Macdonald Mackintosh: The Seven Princessses', *Ein Moderner* Nachmittag, *see* note 4 above.

9. A.S. Levetus, 'Glasgow Artists in Vienna', *Glasgow Herald*, 29 May 1909, p.11

10. *Architecture and Artistic Crafts of the New Style*, Moscow, 22 December 1902 to *c*31 January 1903

11. The panel could have been designed by either Mackintosh or Margaret Macdonald.

12. Robertson, *Papers*, Mackintosh's two lectures on architecture, pp. 180–200 and pp. 201–211

13. Two manuscripts of lectures on the subject of architecture are in the collection of the Hunterian. In them, among other topics, Mackintosh explores the role of architecture as the summation of all of the arts and the architect as 'one of a body of artists possessing an intimate knowledge of the crafts', Robertson, *Papers*, pp. 180–211, *passim*.

14. Robertson, *Papers*, p. 224, Mackintosh's lecture on 'Seemliness'.

CHAPTER NINE

1. Helland, *Studios*, p.169, note 106

2. *Ibid.*, pp.171–172, notes 119, 120

3. Robertson, *Doves*, p. 53

4. Helland, *Studios*, pp. 134–139

5. Helland, *Studios*, pp. 151–152

CHAPTER TEN

1. Letter from Margaret Macdonald Mackintosh to Anna Geddes, 14 January 1915; collection: National Library of Scotland, MS/10582/16.

2. *Vista*, no. 4, pp. 100–101 (Autumn 1909). *Vista* was the magazine of the Glasgow School of Architecture Club, a Bourdon-inspired publication. Quoted by Gavin Stamp, 'The London Years', *CRM* 1996.

3. June Bedford and Ivor Davies, 'Remembering Charles Rennie Mackintosh: A Recorded Interview with Mrs. Mary Sturrock', *Connoisseur*, 183, 1973, pp. 80–88

4. *Ibid.*; in a letter from Walberswick to William Davidson, written on 18 June 1915, Mackintosh states that he had been in the village for almost ten months; collection: Hunterian, University of Glasgow.

5. *Waterfront Building, Walberswick*, oil on canvas, 51 x 43 cm; collection: Glasgow School of Art until destroyed in the 2014 fire there.

6. Desmond Chapman-Huston, 'Charles Rennie Mackintosh, his Life and Work,' *Artwork*, vol. vi, no. 21

7. Mackintosh to William Davidson, 19 June 1915; collection: Hunterian.

8. I am grateful to Dr Mike Gavin, Consultant Ophthalmologist at Gartnavel General Hospital, Glasgow, for enlightenment on this subject. Harry Barnes first mentioned Schwabe's observations to me at the time of the exhibition of Mackintosh's watercolours in 1978; his comments were reinforced, much later, when I read Oliver Sacks's book on neurological disorders, *The Mind's Eye*, 2010, and his subsequent memoir, *On the Move*, 2015.

9. Collection: Hunterian

10. Collection: Hunterian

11. Collection: Hunterian

12. Collection: Hunterian

13. Collection: Hunterian

14. June Bedford and Ivor Davies, 'Remembering Charles Rennie Mackintosh: A Recorded Interview with Mrs. Mary Sturrock', *Connoisseur*, 183, 1973, pp. 80–88

15. Bryan Webb and Peyton Skipwith, *Claud Lovat Fraser, Design*, Antique Collectors' Club, 2011, p. 78–9, Skipwith writes, p. 24, that Ambrose Heal introduced Foxton to Lovat Fraser in April 1918 (quoted by Emerson, CRM Society Journal, issue 100, spring 2016, p. 24, in an article which valuably explores the relationships between Mackintosh, his fellow designers, and the firms of Foxton and Sefton).

16. Collection: Hunterian

17. Manuscript description of the hall-parlour at 78 Derngate, Northampton, Howarth papers, University of Toronto Libraries

18. P. Robertson, 'The Making of a Painter' in *CRM* 1996, pp. 306–307

19. *See* Billcliffe, *Textiles*, p. 33; collection: Hunterian.

20. A full account of The Dug Out is given by Pamela Robertson, Joseph Sharples and Nicky Imri on the website *Mackintosh Architecture: Context, Making and Meaning*, 2014,

www.mackintosh-architecture.
gla.ac.uk/catalogue/freetext/
display/?rs=2&xml=chr&q=dug%20out

21. Howarth, pp. 145–146

22. Bedford, June and Ivor Davies, 'Remembering Charles Rennie Mackintosh: A Recorded Interview with Mrs. Mary Sturrock', *Connoisseur*, 183, 1973, pp. 80–88. Jessie Newbery, in her introduction to the Memorial Exhibition in 1933 similarly mentions two large decorations for Miss Cranston produced over the winter of 1914. She goes on to say that the Mackintoshes then spent two or three years in London, when it was actually over eight years, so perhaps there is more confusion here.

23. Howarth, p. 144, is the first writer to mention the use of *The Little Hills* in The Dug Out but does not give a source for his information; it was probably Mary Sturrock, the only other Mackintosh source to mention the panels by name.

24. It shows the group of *putti* at the bottom left corner of the composition but the foremost figure is seen in profile, not full face as in the executed panel. Otherwise the drawing shows the main elements of the composition in some detail and is squared up for enlargement (collection: Hunterian, University of Glasgow).

25. Howarth, p. 144, no. 2.

26. Helland, pp. 192–193, gives a good account of the symbolism associated with these two paintings.

27. She did, however, continue to send works to exhibitions. *The Sleeper* was sent to the International Exhibition of Water Colors in Chicago in 1922 and *La Mort Parfumée* appeared in the next exhibition there in 1923; Mackintosh showed at these annual exhibitions from 1922 to 1926.

28. Howarth, pp. 198–199, 210–11 gives a good account of these activities.

29. Letter from Margaret Macdonald Mackintosh to Jessie Newbery, December 1923; collection: Hunterian, University of Glasgow.

30. Pamela Robertson in *CRM* 1996, pp. 307–308. In a letter to William Davidson, 15 August 1919 (collection: Hunterian, University of Glasgow) Mackintosh wrote that 'we [are at work on a] large panel 6 feet square' intended for an exhibition in the Arts League of Service in October; no such panel is known but perhaps it was related to the 1923 exhibit.

31. International Exhibition of Water Colors, Art Institute of Chicago, May 1922; probably a view of the chain ferry across the Blyth at Walberswick, untraced. I am grateful to Richard Emerson for this information.

CHAPTER ELEVEN

1. Letter from Margaret Macdonald Mackintosh to Jessie Newbery, December 1923; collection: Hunterian.

2. Howarth, pp. 211–212.

3. Richard Emerson, 'The Architect and the Dancer, *Journal of the Charles Rennie Mackintosh Society*, vol. 98, spring 2014, pp. 23–14.

4. *Ibid.*, pp. 24–26

5. Letter from Margaret Macdonald Mackintosh to Jessie Newbery, December 1923; collection: Hunterian.

6. Much work has been done by Robin Crichton to identify the sites of many of these paintings – in fact only three or four remain to be located. His book, *Monsieur Mackintosh*, 2006, is an invaluable guide to Roussillon and Mackintosh's work there, and I gratefully acknowledge its assistance.

7. Collection: Hunterian

8. Moffat, pp. 109–110

9. Collection: Hunterian

10. Robin Crichton, *Monsieur Mackintosh: The travels and paintings of Charles Rennie Mackintosh in the Pyrénées-Orientales 1923–1927*, Luath Press, Edinburgh, 2006

11. Moffat, p. 79

12. *Chronycle*, p. 50; all quotations from *The Chronycle* appear courtesy The Hunterian, University of Glasgow.

13. *Chronycle*, p. 89

14. *Chronycle*, p. 55

15. *Chronycle*, pp. 88–89

16. Mackintosh's letters to Margaret were published in full, annotated by Pamela Robertson, in *Chronycle*

17. *Chronycle*, pp. 26, 79, note 97

18. *Chronycle*, p. 77

19. Moffat, p. 149

20. Moffat, p. 149

EPILOGUE

1. Reproduced in Billcliffe, *Watercolours*, p. 104

Page numbers in italics indicate references in captions. This index contains no text references to Frances Macdonald (later Macdonald MacNair), Margaret Macdonald (later Macdonald Mackintosh), Charles Rennie Mackintosh and James Herbert MacNair, although photographs including these individuals are indexed. Individual artworks are credited to their makers as FM (later FMM), MM (later MMM), CRM and JHM.

ACKNOWLEDGMENTS

This book has had a very long gestation. It was first mooted back in the early 1970s, when I worked in the University Art Collections, and I was encouraged to pursue it by Andrew McLaren Young, Richmond Professor of Fine Art at the University of Glasgow; and later by Frank Willett, first Director of the Hunterian Museum and Art Gallery. Trevor Walden, Director of Glasgow Museums, where I was Keeper of Fine Art, 1977–79, continued to believe in its value. Each of them, through the gift of access to their respective institution's collections and photographic records contributed to the book's (gradual) progress. At Glasgow School of Art, Sir Harry Jefferson Barnes allowed me access to the School's own collections of works, and provided a link with the world of Mackintosh through his marriage to Alice Schwabe, who had known Mackintosh in London, where Charles and Margaret had been close friends with her parents.

In more recent years when the project was revived, their successors, in various roles at each of these institutions, continued to provide support and access. At The Hunterian, Pamela Robertson, Anne Dulau and Graham Nisbet were unstinting in their help and encouragement; at Glasgow School of Art Peter Trowles answered innumerable questions, despite the serious distraction caused by the terrible fire at the School in May 2014; and at Glasgow Museums (now Glasgow Life) Alison Brown and Winnie Tyrrell were my links to the collections and photographic records. At The Hill House, Lorna Hepburn allowed me to roam and gave me access to work not on permanent display.

To all the other institutions that have opened their photographic archives for me, I offer my thanks for continuing access and permission to reproduce their holdings: Museum für angewandte Kunst and the Belvedere, Vienna; the Library of the University of Buffalo; The Detroit Institute of Arts; Museum für Kunst und Gewerbe, Hamburg; Walker Art Gallery, National Museums, Liverpool; Art and Heritage Collections, University of Liverpool; Tate Gallery, London; Victoria & Albert Museum, London; University Libraries of the State University of New York at Buffalo; the National Museums of Scotland, Edinburgh; Dublin City Gallery, The Hugh Lane Collection; Cranbrook Art Museum, Michigan; Crabtree Farm, Illinois; Christie's, London; Lyon and Turnbull, Edinburgh; The Fine Art Society, London.

Many individuals over the years have given help in all sorts of ways and it is impossible to list them all here – they know who they are and I thank them all. But some must have a particular mention: Robin Crichton for all of his work and advice on Mackintosh's period in France; Dr Pat Hiddleston for her hospitality in Port Vendres; Martin Hopkinson; Richard Emerson; Stuart Robertson; Dr Mike Gavin; my colleagues at my gallery in Glasgow for their forbearance when The Four became a distraction from more immediate tasks; all of the many private collectors who have given ungrudging access to their homes and collections, without whom much of the work in this book might have been lost to future generations.

At Frances Lincoln, John Nicoll encouraged me to revisit my earlier book, *Mackintosh Watercolours*, an idea pursued by Andrew Dunn. Nicki Davis, as editor at Frances Lincoln, has carefully nurtured those initiatives, as have Jill Hollis, who expertly edited the text and made many other contributions, and the book's designer Anne Wilson, who performed with the greatest flair and skill the unenviable task of accommodating a text and group of illustrations that proved to be longer and more numerous than expected.

Finally, my warmest thanks to my wife Christine McArthur. I have said before that her insight as an artist into my attempts to unravel art historical questions has been invaluable. I will say it again – doubly – as her experiences as student and tutor at Glasgow School of Art, which remained in many ways unchanged as a teaching institution from the 1890s to the 1970s, have also helped me to understand the processes at work there when The Four were themselves students.

RB

PICTURE CREDITS

The copyright of the illustrations is as indicated on the captions.

Those credited 'private collection' or 'untraced' are copyright of Roger Billcliffe, except where noted on the caption and image number 244 which is copyright of Christie's Images/Bridgeman Images. In addition: works belonging to Glasgow Museums are copyright of CSG CIC Glasgow Museums and Libraries Collections; works belonging to the Thomas B. Lockwood Collection are copyright of Rare and Special Books Collection, University Libraries, University at Buffalo, The State University of New York; image number 32 is copyright Peter Horree/Alamy Stock Photo; image number 125 is copyright Belvedere, Vienna/ Johannes Stoll; image number 160 is copyright of University of Liverpool Art Gallery and Collections/Bridgeman Images; image numbers 181 and 182 are copyright MAK/Mona Heiss; image number 196 is copyright MAK/Georg Mayer; image number 267 is copyright of Detroit Institute of Arts/Bridgeman Images.

The Publishers would like to thank those listed for permission to reproduce artworks and for supplying photographs. Every care has been taken to trace copyright holders. Any we have been unable to contact are invited to contact the Publishers so that a full acknowledgment may be given in subsequent editions.

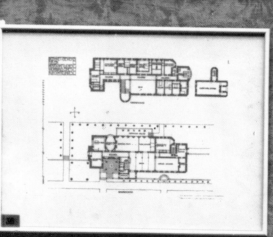